Aberdeenshire Library and information Service
www.aberdeenshire.gov.uk/libraries
Renewals Hotline 01224 661511

TOM GALLAGHER

The Illusion
of Freedom

Scotland Under Nationalism

HURST & COMPANY, LONDON

First published in the United Kingdom in 2009 by
C. Hurst & Co. (Publishers) Ltd.,
41 Great Russell Street, London, WC1B 3PL
© Tom Gallagher, 2009
All rights reserved.
Printed in India

The right of Tom Gallagher to be
identified as the author of this publication is asserted
by him in accordance with the Copyright, Designs and
Patents Act, 1988.

A Cataloguing-in-Publication data record for this book
is available from the British Library.

ISBN
978–1–85065–995–2 *hardback*
978–1–85065–996–9 *paperback*

www.hurstpub.co.uk

For Devorgilla and Gordon who can smell the coffee

CONTENTS

INTRODUCTION

This book explores the gradual disappearance of a dual identity among most of the five million people who inhabit Scotland. It argues that a collective outlook based primarily on a sense of Scottishness now enjoys a powerful momentum. But it is a brittle outlook that is unlikely to be the basis for creating a cohesive and achievement-orientated Scottish state, unless dramatic changes occur on the scale of those witnessed during the sixteenth century Reformation two hundred years later. Intellectually, this kind of transformation seems unlikely. In contrast to much of the rest of Europe, modern-day Scotland lacks a public culture of debates, periodicals, summer schools, or active civic groups prepared to challenge or improve established orthodoxies. It is also a country with shocking levels of interpersonal violence and a growing criminal culture to which political parties, and indeed the civil service and the police, appear reconciled.

Traditionally, Scots have combined a strong and enduring set of national attachments with a sense of loyalty to Britain, the 300–year-old Union state. Scotland greatly influenced Britain's evolution, even though England has been the dominant nation within the British Isles. It has a larger population, stronger economy, and the seat of government has always been located in England's capital, London. However, the modern English traditionally identified with Britain rather than England. English identity was usually vague and understated. In Victorian times, the highpoint of the British age, many capable minds active in public life and a range of intellectual pursuits invested tremendous effort into creating or strengthening institutions and symbols that would reinforce a sense of Britishness for well over another century.

In 1997, the 290th year of the political Union, Scotland obtained its own Parliament designed to regulate its own legal system and manage

1

the institutions of administrative devolution which it had acquired over the previous century. John Smith, the Scottish lawyer who led the Labour Party from 1992 to 1994, described the push for a Scottish government within the United Kingdom as the 'settled will of the Scottish people'.[1]

But devolution emerged at a time of disenchantment with the quality of political representation across nearly all of the western democracies. The most common responses from citizens were disengagement from politics or else support for populist causes. If the architects of the devolution settlement chose to rest on their laurels and simply preside over a new status quo, they were bound to be asking for trouble, perhaps a lot of it. But this is what happened.

Devolution occurred as its chief midwife, the Labour Party, returned to office intent on keeping alive core elements of Thatcherite ideology and indeed refining them. New Labour under Tony Blair moved far from its central beliefs. For nearly a decade Blair insisted, in the face of mounting scepticism, that the party could remain progressive without being attached to any fixed principles. In Scotland, the controversial policies of the Blair era and the continued failings of Scottish Labour meant that Labour was unable to reap an enduring electoral dividend from devolution.

Britishness started to become discredited as the outriders of radical capitalism, first under Margaret Thatcher and John Major, then under Tony Blair and Gordon Brown, privatised or drastically altered the character of institutions which had helped preserve an attachment to the Union state.

Among many Scots, embarrassment over their own once favourite son Gordon Brown's inept and damaging performance on the British stage is removing inhibitions. A rejection of Britishness could soon be followed by a complete rejection of the Union. Scots share the sense of disillusionment with the political process to be found across the United Kingdom, but a lot of them are ready to detach themselves completely from British arrangements and create an entirely separate state, so they have another option to consider.

The inexorable rise of the Scottish National Party (SNP) has been occurring at a time when the authority of British institutions has perhaps never been as brittle. The civil service, the police, the judiciary, and agencies which are supposed to regulate public life have lost much of their credibility through chronic incompetence, collusion in erecting

a semi-authoritarian state, and often self-serving behaviour. Lawyers, spin doctors, management consultants and quangos enforcing the orthodoxies of multiculturalism have been among the truest beneficiaries of the New Labour years. Until today Scotland has not really been-shaken by other crises which tested loyalties to the state, such as the French revolution, Chartism, interwar labour militancy, anti-Suez protests in 1956, or poll tax agitation at the end of the eighties. For part of the explanation, attention should be paid to the conservative nature of the social structure. Modern Scotland, until the last several decades, was dominated by an industrial working-class. Contrary to the heroic role devised by Marx and his followers, this class nearly everywhere has been gradualistic and even conservative in its outlook and Scotland has been no exception. Now it is fast disappearing, being replaced by different social categories and a very large underclass, none of which are as predictable in their political behaviour.

An electoral system designed to prevent any single party from using the Parliament at Holyrood as a platform for radical change failed to prevent pro-independence forces from attempting to usurp the devolution settlement. From 2007 the Nationalists have been in office. Technically a minority government, the Scottish National Party (SNP) has shown skill and vigour in exercising the powers of office. Its leader, Alex Salmond, has never appeared daunted by his responsibilities as First Minister, in contrast with each of his Labour predecessors.

The tenor of English politics has started to resemble that of Scotland. A strong sense of grievance has mounted against forces from near and afar, undermining the stability and good order which were supposed to be the bulwarks of English identity has mounted. Real anger has been displayed in 2009 by a normally phlegmatic people who rebelled electorally in large numbers againt ruling politicians who were seen as deceitful, arrogant, and far from competent in the execution of their duties. The far-right (6.2 percent) managed to obtain 39 percent of Labour's vote (15.7 percent) in the European elections bolstered especially by the desertion of working-class supporters in former Labour heartlands in the north of England. But the English are unlikely to decisively endorse extreme voices and they look set to re-endorse a chastened Tory party after its dozen years in the wilderness. Therefore, no force looks like emulating the SNP as a vehicle for the grievances which are to be found in the increasingly unhappy country next door to Scotland.

Even while it is in charge of a large budget and numerous institutions, the SNP can teach many English populists how to keep up a steady litany of complaints. Its period in office has coincided with an economic meltdown whose origins are to be found, at least in part, in the reckless culture of expansion of much of the Edinburgh financial sector. Alex Salmond, himself an economist by training, lavished praise on these buccaneering practices up to and beyond the time when Scotland's flagship banks were revealed to be near-insolvent crocks. But owing to his ability to manipulate national emotions, he has enjoyed the freedom to commit mistakes which might have set back the political careers of others. At the time of writing, the late winter of 2009, Scotland feels like a part of the communist bloc in the last years of the Cold War. Economic adversity is mounting but instead of clinging to old arrangements, there is a growing desire to strike out into the unknown and experiment with change. Numbing conformity is starting to recede as previously self-effacing social groups shed their deference. People you might expect to protect the status quo, in this case bureaucrats and pillars of the business community, are in the vanguard of those ready to bulldoze the old order.

But the winds of change which are buffeting Scotland offer the prospect of a political renewal or even transformation which is deeply ambiguous. As Tancredi remarks in Giuseppe di Lampedusa's novel *The Leopard*: 'if you want everything to remain the same, things will have to change.'[2] There is a deep-seated reluctance to transform Scotland from within on the part of Scotland's principal party of change, the SNP. Indeed, change on an epic scale has only occurred very rarely in a small country, during the Reformation and later in the course of the Industrial Revolution. Intellectually, there is a case to be made that the country is stagnant. Universities and the media struggle to find room for independent thought and a once lively spirit of debate has practically been extinguished in favour of recycling multicultural and now patriotic orthodoxies.

The SNP has the good fortune of being led by a redoubtable personality, Alex Salmond, much of whose impact stems from massaging the vanity and complacency of the Scots. The Scots are no petty people and have a stirring history behind them. They have become a second league nation not because of any intrinsic faults but due to being shackled to a much larger neighbour in a Union that constantly stifles their collective personality. Alex Salmond wants to end Scotland's sta-

tus as 'the invisible country of Europe', but he shows no desire to be a builder, creating a new political architecture emphasising democratic characteristics that have been rationed in a British political system, one with increasingly pronounced oligarchical features.

The SNP requires independence-minded people who are not independent-minded in their approach to power and basic issues of governance. For many years, the Scots endured a succession of powerful 'lairds', from the aristocracy to the industrial barons right down to the sprawling Labour-controlled bureaucracy. The SNP shows little sign of wishing to end Scotland's status as a managed society. There is every indication that, given the chance, it is poised to preserve and indeed refine a set of hierarchical institutions and practices in order to cement its political control. Both its rhetoric and its conduct in office points to the party being content with an essentially submissive people ready to be ruled over by more glamorous leaders than those in the Unionist era who will keep them unconnected from power or responsibility. Through populist gestures, Scottish solidarity is invoked when what is really desired is unquestioning conformity to a movement which believes that it has the capacity to look into heart of the nation and shape its destiny.

If independence arrives, the pluralist space will be a limited one due to this reinforcement of deference. It will be deference to a governing class and to newly invented traditions. Not to endorse them will likely be viewed as unpatriotic. But the SNP's claim to be the architect and guarantor of territorial self-rule cannot go uncontested. No other prominent force in British politics is as committed as the SNP to membership of an increasingly centralized European Union or to a raft of multicultural policies which entrench so-called group rights at the expense of individual citizenship. The party is also an enthusiastic champion of globalization. Alex Salmond schmoozes with American financial buccaneers and has plans to do likewise with desert sheiks, hoping that an upsurge in immigration and injections of investment capital will wake up a sleepy country. Of course under New Labour (with Thatcherism having prepared the way), England has already enjoyed this kind of revolution from above. For the last two decades, it was exposed to a more radical brand of globalization than in any other part of Europe. The pace of change has left much of England, especially its large urban conurbations, reeling. Immigrants who arrived hoping to fit into a society cherishing continuity and stability,

instead found a country where the design for living in order and harmony had been shattered. The newcomers who felt most comfortable in a society emphasising separation into communities based on ethnic, religious, or lifestyle identities belonged instead to mobilised groups (often religious) with international or parochial allegiances.

The unravelling of Britain thanks to imprudent economic and social policies carried out by politicians whose lack of historical perspective is just one indication of their absolute mediocrity, has made the task of the SNP in snapping the British link much easier to carry out. But the decline of Britain is a tale not without irony. The SNP is also dominated by the lawyers, spin doctors, full-time politicians and quango-crats who fill up so much of the political space in the rest of Britain. It is true that it has some well-known members with experience of life outside the political bubble, and who have entered politics not just to fulfil their egos, but, imbued with some notion of public service. But politicians relaxed with widely-dispersed political freedoms and who desire opportunities for individuals to make their voice count in politics tend not to flourish in the SNP. The party is increasingly dominated by technologists of power who believe that what the SNP stands for is patriotic and just even if, within a centralised European Union, Scotland would enjoy less practical freedom than it had for many years *after* the 1707 Union with England. Ironically, there are far more voices in England who now desire the kind of self-determination that used to be the goal of the SNP during the first five decades of its existence. Perhaps that is not surprising, because arguably the desire for individual freedom has been a much more powerful one in English history than in the story of Scotland. It has been an even more powerful impulse in the United States where, despite many setbacks, a vibrant democratic culture incorporating openness, mobility, and the pursuit of improvement in personal and collective terms, has attracted multitudes of people for three centuries. Alex Salmond feels it is a tragedy so that many people left Scotland to be caught up in such an undertaking and he shows no interest in promoting the decentralised political system with numerous checks and balances to be found in the USA.

Proportionately, Scotland provided a larger number of new Americans than most other nations. This should not come as a surprise. Many of these were Scots fleeing a hierarchical and unjust society as well as one where individual conduct was supervised to an extent unusual in much of the rest of western Europe. Scots have also emigrated,

of course, because the struggle for survival has always been a fierce one in a country with an often unforgiving climate and a poor soil.

The SNP has been organising barely-disguised political festivals designed to reconnect the descendants of emigrants with the land of their ancestors. The absorption with marketing a kitsch image of Scotland to an international audience has gone on even when Alex Salmond and his followers are supposedly preoccupied with the business of government. But they are disinclined to take a hard and unsentimental look at the social condition of Scotland, particularly in the urban communities stretching from Ayrshire to Fife which still contain the vast bulk of the population. If a social audit was carried out or else existing documentation on the deep malaise that marks urban Scottish living was reproduced in summary form, it might give more cerebral Nationalists pause for thought. The degree of alienation and dysfunctional and violent behaviour which is the norm in contemporary Scotland surely ought to impress itself upon the SNP the longer it stays in government. But its attitude to a dysfunctional society may prove to be as complacent as that of those in charge of Russia, where the Orthodox Slavic population is haemorrhaging due to similar social pathologies.

Emphasising the existence of this debilitating Scottish underbelly is akin to treason in the Nationalist lexicon. It is talking the nation down and puncturing national self-confidence. But I am comfortable in my skin as a Scot and happy to draw attention to maladies which need to be confronted if the country is to be prepared to take on major responsibilities in the time ahead. Scotland will fall on its face if absorption with national identity persists while appalling social problems are managed in the same way as before by an unaccountable state bureaucracy. All the signs indicate that the SNP hopes to establish a comfortable relationship with the same old groups which have dominated a complacent and inward-looking country for several generations. As well as the gargantuan state bureaucracy, the major professions, and well-placed elements in the business world, are already being invited to reinforce their status, power and material advantage by riding the wave of Scottish identity. They will quite possibly be joined by new ones from religious, ethnic, and lifestyle groups with whom the SNP has made strategic alliances to stack up votes. Thus a tight Scotland, hierarchical and closed in on itself, may well persist even as a new era is loudly proclaimed. A revolution in thought and behaviour will remain tantalisingly out of reach. Individualism and belief in progress

are likely to be frustrated by the strength of conformity and hierarchical forms of public behaviour, however much Scotland's egalitarian spirit continues to be invoked. The SNP shows no more readiness to trust the people and encourage their participation in decisions made in their name than the Eurocrats in Brussels or the establishment in London. This is not necessarily due to human failings though it is a tragedy that a politician as talented as Alex Salmond turns out to be so limited in his vision for Scotland. All the signs are that in a relatively poor nation, with a population used to being bossed around by an intrusive state, long-entrenched patterns of behaviour will be renewed if independence comes. The names of buildings, streets, and other landmarks will no doubt be changed, but the old order will go undisturbed. In many ways, independence for Scotland will be the equivalent of a multicultural left-leaning London borough having a seat at the United Nations. The similarities between New Labour and the SNP are quite compelling and have largely failed to be pointed out, perhaps because Old Labour hung on in Scotland for much longer.

This book is likely to be viewed as a spoiling operation written by someone who is deeply hostile to the concept of national self-determination. But I think it may well be very hard to prevent the SNP becoming the dominant party in Scotland whatever is written about it. If the recession turns into a slump, the party is well-positioned to lead mass opposition to the Brown government, especially if Westminster follows the Irish example and introduces wage cuts for the public sector workforce. The initiative has swung so completely away from Unionist political forces that Alex Salmond still enjoys runaway popularity despite his failure to deliver on many core manifesto promises, and of course despite the embarrassing gaffes he made about the financial crisis in 2008. If I have an aim, it is to encourage debate about the political future of Scotland, particularly among those drawn to the cause of nationalism, and to foster a realisation that change which is essentially superficial will leave intact failed policies in Scotland. This means there is a real possibility that Scotland will simply repeat many of the mistakes of the past and the cost could be much higher than before due to the absence of a British safety-net. This safety-net looks very threadbare and of course defective approaches to public life and the economy in London over many years have had very negative consequences for Scotland. But much of the depth and intensity of Scotland's problems stem from authoritarian and unimaginative char-

acteristics among elites and the wider society which are *internal* in their origins. They will be visited on the nation yet one more time if the claim that the source of most of the nation's ills are to be found in England is not vigorously contested.

In some quarters, no doubt, it will be a black mark against me that I have lived and taught in England for most of my adult life which has been punctuated by periods of research in the United States, the Balkans, and the Iberian peninsula. But I have never lost touch with Scotland. In the 1980s, I wrote two books on inter-communal strife that was religious in origin and I was fairly hopeful that Scotland was managing to conquer that particular pathology. In the early 1980s, a lowpoint in the struggle for self-government, I wrote dozens of letters to the press in support of devolution for Scotland and contributed to the *Claim of Right for Scotland* (edited by Owen Dudley Edwards and published by Polygon in 1988). I voted SNP as long ago as 1979 and as recently as 2007. Of course my reservations about the party have increased, but where I have the opportunity to support a candidate who appears to take public service seriously, the party affiliation usually proves of secondary importance. Two events fuelled my doubts about the SNP's ability to be an agent of change at home and a progressive influence on the wider world stage. One was the party's refusal to take part in the Scottish Constitutional Convention in 1988on very flimsy and partisan grounds. The other was Alex Salmond's denunciation of the NATO operation in 1999 designed to prevent the tyrannical nationalist Slobodan Milosevic from driving out most of the Albanian population from Kosovo. But for NATO's intervention, it is likely that this mainly Muslim population would have suffered a fate even more ignominious than many Palestinians did following the creation of the state of Israel in 1948. Throughout the 1990s, I campaigned for the EU and NATO, and the states shaping their policies, to take resolute action to stop the oppression of Muslim populations in the former Yugoslavia at the hands of ruthless warlords manipulating nationalism for their own power-conserving ends. Natural justice and the desire to prevent the radicalisation of Muslims, who were generally strong exponents of multicultural living in the Balkans, were strong motivating factors. With the exception of the late Margaret Ewing MP (and later MSP), the SNP was numb to this cause. I recall hearing Tom Nairn, for many decades the chief intellectual voice supporting Scottish independence, say at a lecture in Edinburgh

University in 1993 that the Muslims of Bosnia were a people condemned in all likelihood to disappear from history and that their plight was beyond redemption.

Salmond had taken the right side in 1988, discreetly aligning with those who wished to participate in a common Scottish front to secure devolution. But in 1999, he threw a political lifeline to Milosevic, a Nationalist tyrant, soon after arraigned for war crimes at The Hague, a gesture emulated by no other leader of any mainstream party in western Europe. Depressingly, nobody in the SNP challenged this foolhardy gesture which damaged the party's showing in the first elections for the Scottish Parliament. A decade later he is proud to say that no governing party in western Europe has done more than the SNP to integrate Muslims. Salmond appears to have been forgiven for his earlier Balkan record by his young and often religiously radical Muslim allies. However conformist the SNP's domestic policies, Salmond is ready to identify with other perceived 'underdogs' abroad, perhaps sensing that the tide is starting to go out for the West and that it is desirable to search for new allies in a multipolar world, irrespective of their flimsy democratic credentials.

In 2007 the SNP leader wrote to the governments of Zimbabwe and Burma enlisting their help in a failed bid for Scotland to be given observer status at meetings of signatories of the Nuclear Non-Proliferation Treaty.[3] Unlike spokesmen for the Labour, Liberal Democrat and Conservative Parties, he refused to repudiate a call from the Iranian ambassador to Britain in 2008 calling for closer ties between Scotland and his theocratic regime.[4]

The SNP still struggles to articulate a convincing image of the role Scotland will play in a constellation of nations, regional groupings, and wider continental blocs. Above all it fails to acknowledge that the world remains dangerous and history continues to be tragic, with ethnic extremism taken to genocidal lengths having far from exhausted itself and dangerous imperialist impulses still second nature in parts of the post-communist world.

Independence pursued in a pragmatic and principled manner, without needlessly antagonising ancient partners or international allies, could indeed usher in an era of promise for Scotland that might even be described as liberating. But instead a parade nationalism increasingly prevails, in which driven personalities are content to jettison crucial elements of national sovereignty in order to satisfy resentment

against England and the English, much of which is emotional and shallow in its content. Many of the signs point to the onset of an era of political restrictions under a party, and the interest groups with which it teams up, each of which is primarily driven by the imperative of acquiring and keeping power for its own sake. The 'wee hard men' of Scotland will continue to exert their influence and may indeed substantially increase it if a party driven in large measure by negativity and resentment becomes a permanent power in the land.

Alex Salmond and his allies have been so bound up with the struggle against English overlordship that they have absorbed the controlling and autocratic mindset of those whose influence over Scotland they wish to end. The real tragedy of Scottish Nationalism is that, under the guise of self-rule, it seems poised to give a fresh lease of life to hierarchical forms of government which disempower most citizens and lead inevitably to widespread alienation from the state and its values with a sense of patriotism being one of the biggest losers. Self-rule in which citizens have numerous access-points to the political process looks like being even more elusive under the SNP than it was in the past under its various pro-British rivals. What may well await Scotland is an era of noisy post-Unionism in which the Nationalists sing patriotic tunes while keeping alive the political arrangements which they once insisted made Scotland a nation in subjugation.

This book is divided into two parts. An historical approach is adopted in the first five chapters. They examine the evolution of Scotland, taking note of the formative experiences and events which shaped the modern state and its society and political culture. In the remaining four chapters the emphasis is on the character of modern nationalism, the policies of the SNP while in office, its plans for the future, and its very limited awareness of the transformation required in order to create a situation where sovereignty is really vested in Scotland's people.

My own readings and observations supplied much of the material for this book. I did, however, talk to a small number of people off the record, not all politically affiliated, who I thought possessed worthwhile insights about different facets of Scottish life. A reader's report from Dr Bernard Aspinwall, associated with Glasgow University for over five decades and an historian with perhaps unrivalled insights into Scotland's role in the wider Atlantic world, guided me in several very helpful directions and, more than once, saved me from error. Thanks are also due to the National Library of Scotland and its staff and to

the staff of the Scottish Room in the Edinburgh Central Library without whose assistance the book would have had a more difficult passage. Dr Davina Miller, head of the Department of Peace Studies, at Bradford University was a source of welcome support as the book was unfolding as was Professor Shaun Gregory. I am grateful also for the encouragement of Professor John Cusworth, Dean of the School of Social and International Studies at Bradford University, where I have taught for many years. Let me finally express my appreciation to Sally Blair and Xerxes Spencer who hosted me while I was a Fellow at the National Endowment for Democracy in Washington D.C. between March and August 2008. Many of the ideas for this book were hatched in this welcoming environment not least due to the discussions I had with a gregarious and well-informed staff and research fellows. This experience, and my travels in the USA during a momentous political year, confirmed that, at the start of the twenty-first century, the best of Europe in terms of civic endeavour, belief in freedom, and intellectual renown resides there.

Part One

1

1707–1918

Sir Walter Scott reckoned that 314 battles were fought between Scottish and English forces during the intermittent wars that raged between the two countries until 1707[1]. The War of Independence between 1296 and 1314 provides a rich and emotional seam of history which contemporary Nationalists have successfully quarried. William Wallace, the Renfrewshire laird who repulsed the invading forces of King Edward I before being betrayed and put to death in 1305, has long been a hero for Scots, irrespective of their political allegiances. His determination to expel the invaders from Scottish lands at a time when most other important figures were ready to compromise, as well as his courage and self-sacrificing conduct, have been remembered down the centuries and not only in Scotland. At the SNP's 1995 annual conference, the words that concluded party leader Alex Salmond's speech were: 'with Wallace—head and heart—the one word that encapsulated all our hopes—*freedom, freedom, freedom*'[2]. Mel Gibson's film 'Braveheart', very loosely based on the Wallace story, had appeared not long before. It won five Oscars and had an electrifying effect on movements which were not afraid to promote aggressive nationalism, such as the Italian Northern League and the Ku Klux Klan. It received its European premiere in the town of Stirling, where the imposing Wallace Monument has stood for over a century. In the nearby town of Falkirk, 'managers had to phone the police when cinema-goers started shouting

13

anti-English bile at the screen'[3]. In his speech, Salmond pointed out that 'the real villains of Scotland are not the English but the establishment leadership of Scotland who bought and sold their country for personal advancement.'[4] But in Scotland the film had a troubling effect on 'teenage audiences who it is said cheered every time Wallace killed an Englishman'.[5] The English are seen in a collective sense as an arrogant, effete, and often stupid bunch of marauders who deserved the treatment meted out to them. Salmond believed: 'That film had a profound effect ... there aren't many films which are truly important, but this is one'.[6] However, the cultural commentator Colin McArthur, who explored the global impact of the film, worried about these effects: 'It's a xenophobic film. With young men in particular, it has done terrible things to their attitude towards England.'[7]

Despite terrible events like the English massacre of the inhabitants of Berwick in 1296, further English exactions in Scotland in the years ahead, and murderous Scottish counter-attacks in the north of England, there was much peaceful interaction between the elites of England and Scotland in the centuries that lay ahead. Nevertheless, Wallace has become an unambiguous symbol representing the Scottish desire for freedom and self-reliance. John Balliol, and those others who signed the document of submission to Edward I known as the Ragman's Roll, appeared ready to squander their nation's liberty. Balliol, however, may come to be viewed more sympathetically, especially if Scotland does detach itself from England but finds that its sovereignty is greatly circumscribed by membership of the European Union. For twenty years, it has been official SNP policy to dilute Scottish independence within a centralising European Union which treats expressions of nationalism with barely-concealed contempt. So the cultural ascendancy of Wallace may in fact be of short duration and prove to be a tactical gambit on the part of a party whose noisy nationalism, I propose to argue in these pages, only extends to severing ties with its currently weakened larger neighbour and hides a preoccupation with preserving aspects of Scottish life that stand in the way of genuine national renewal.

Scotland preserved its independence but failed to overcome chronic internal differences which were perhaps unavoidable owing to the topography of the country and its ethnic and linguistic make-up. Sharp cleavage between Highland Gaelic society and the less unruly Lowlands lasted for centuries. The sixteenth century philosopher John

Mair talked of 'the wild Scots' and the 'householding Scots'.[8] Others who came after him saw the Highlanders as a branch of the 'uncivilized' and 'dangerous' Irish who required equally firm subjugation. In 1889, A.J. Balfour, one of the first politicians to hold the post of secretary for Scotland, questioned the idea of Scotland as 'a great unity', arguing that essentially the Lowlands resembled the North of England and that the fundamental dividing line was not at the border between Scotland and England, but in fact much further north.[9]

From the sixteenth century, shared attachment to the Protestant religion, albeit in different forms, brought Scots and English closer, weakening the power of old antagonisms. Language was a decreasing barrier and men and women on either side of the border communicated with one another with relative ease. Internally, Scotland contained much greater differentiation in terms of language, religion, literacy, social organization, and ethnicity.[10]

Scottish artists and craftsmen found an outlet for their talents in England irrespective of political tensions. In the first half of the eighteenth century James Gibbs, an architect from Aberdeen, designed some of the finest neoclassical buildings erected in London, as well as in Cambridge and Oxford. William Adam and his sons, Robert and James, later in the century became the most successful architects and interior decorators of their age. To Allan Massie, these are clear signs that 'there was sufficient cultural community between Scotland and England for a Scots artist to work comfortably and acceptably south of the Border.'[11]

Contemporary Nationalists like Paul Henderson Scott see the winding up of the Scottish Parliament in 1707 as a huge historical reversal for Scotland. It is not unknown to hear Nationalists call overtly for the restoration of freedoms lost then. But Scotland was run by a tight-knit oligarchy in 1707. Parliament was their tool. There were social characteristics which suggested that Scotland was more progressive than England. Top of the list were the higher rate of literacy and the existence of a popular if highly intrusive state religion, Presbyterianism which was collegiate and even proto-democratic in some aspects unlike the hierarchical Anglican Church in England. Many Scots must have felt some attachment to their Parliament given the number of petitions submitted from the burghs denouncing the impending Act of Union. But there was a strong Unionist tradition which can be traced back to the Scottish philosopher John Mair, who published his 'History of

Greater Britain' in 1521. Scottish Unionism was a homegrown idea which established itself in Scotland a century before the 1603 Union of the Crowns.[12]

The historian Colin Kidd argues that '[I]f anything, Unionism began as an anti-English idea. In particular, Unionism was touted by Scots as an alternative to the English vision of Britain as an empire.'[13] John Knox viewed England as a progressive influence. He acquired an English accent, his first wife was English, and it was to that country he sent his sons to be educated. By contrast, Murray Pittock, a historian with Nationalist sympathies, has claimed the existence of 'a tendency (which can be found as far back as the medieval period) to self-define in terms of being as different from the English as possible'.[14]

Scottish King James VI's succession to the English throne in 1603 meant that from then on Scotland was constitutionally linked to England. But the Union of Crowns was a purely dynastic Union. It did not create a new state, Scotland retaining separate legal institutions and other defining features which had been influenced by a centuries-long alliance with France. A dynastic Union could work only as long as the Crown was associated with continuity and stability. But the two kingdoms of the Stuarts witnessed upheaval and civil war in the seventeenth century. A totally new situation emerged after the deposition of James II in 1688. The English Parliament invited the Dutch king, William of Orange, to replace him. England was now a constitutional monarchy and the Crown was tied to the English Parliament. It would be hard for Scotland to avoid falling into the English political orbit unless the dynastic Union was cancelled or else the two Parliaments were united on terms that the dominant political forces in Scotland could accept. Matters came to a head in 1701, when the English Parliament unilaterally altered the line of succession to the throne. Under the Act of Settlement, the throne passed to the Electress of Hanover and her descendants on condition that they were Protestants. Anglo-Scottish relations were already strained after the collapse of the ambitious Darien Scheme, meant to open up global commerce to Scotland and into which one-fifth of the nation's wealth had been poured. The City of London was blamed for a debacle which perhaps had more to do with Scottish recklessness than English hostility. In 1703 the Scottish Parliament passed the Act of Security stipulating that the successor to Queen Anne must be a Protestant but that it was not necessary for him or her to be successor to the throne of England. England felt men-

aced by continental enemies, notably France. Fearing a potential threat on its northern frontier, it passed the Aliens Act of 1705, declaring all Scots in England to be aliens and threatening to sever trade between the two countries. This demonstration of 'shock and awe' was designed to lead to a closer union after decades of English indifference and even hostility to such a project.

The Union of Parliaments could have occurred a century earlier and indeed was proposed by King James I early in his reign as a British monarch. But it was rejected by the English then, as it was by them again in the 1660s when proposed by the Earl of Lauderdale, the king's minister in Scotland. English Parliamentarians, churchmen, and City financiers had not warmed to the Scots who had descended on London in the entourage of James I or who had been such a disputatious and sometimes contradictory element in the civil-war of the 1640s. Oliver Cromwell incorporated Scotland in his British republic after twice defeating pro-royalist Scottish armies. The diarist John Nicoll described the rule of his commanders in terms which seem unfashionable today: 'And to speak truth, the Englishes were more indulgent and merciful to the Scots nor [than] was the Scots to their own countrymen and neighbors, as was too evident, and their justice exceeded the Scots in many things ...'[15]

The Union fell far short of annexation. Pressure had undoubtedly been exercised by England in order to ensure that the Union of Crowns of 1603 was followed by the Union of Parliaments of 1707. But this was a voluntary agreement following protracted negotiations. Scotland was losing its Parliament, but it lacked the influential position in Scottish life which the English Parliament enjoyed in England. Admission to English markets was probably of far more importance to ambitious Scots and the treaty of 1707 provided for free trade and a common fiscal system.

Following the Union, England refrained from interfering with the identities and powers of more important institutions shaping Scottish public life and the country's overall identity. Whereas one state now existed with a single Parliament, there remained two systems of law and two established churches. The autonomy not just of the legal system and the Presbyterian church was preserved but also that of local government and education. Education was arguably of greater importance in Scotland than anywhere else in Europe. The country had five universities, more than twice the number to be found in England. Par-

ish and burgh schools provided recruits from across society, professional Scots who sought advancement abroad and often achieved renown. By 1707, an extensive system of parish level education already covered much of the country. Along with poor relief, education was the responsibility of the Church of Scotland (the Kirk) and local landowners. The Kirk had a minister permanently based in almost all of the 900 parishes in Scotland. He was usually supported by a Kirk session or permanent committee of lay elders. They were not just drawn from the wealthy and privileged but were selected on the basis of merit and piety. The Kirk session regulated community life and functioned without much intrusion from central authority. As well as its educational role, it provided a safety-net for the poor, and regulated the moral behaviour of parishioners. The Kirk dealt with offences violating its religious tenets but it also handled lesser offences such as theft and assault, acting as a lower court for the judicial authorities in Edinburgh.[16]

Arguably the hold of these institutions was strengthened for at least another century. But Scottish autonomy ensured that the liberalising tendencies in England, which weakened the grip of a ruling oligarchy and attracted the admiration of continental minds like Voltaire, resonated north of the border only among small groups of intellectuals who usually kept out of politics. Adam Smith, in *The Wealth of Nations*, was guilty of hyperbole when he hailed the Act of Union because with it 'the middling and inferior ranks of people in Scotland gained a complete deliverance from the power of an aristocracy which had always before oppressed them'.[17]

When a serious attempt was made to restore the Jacobite Charles Edward Stuart to the throne, in 1745, the subsequent oppression did not bring the autonomy of Scotland into question. Rather it was accomplished amidst the survival of existing Scottish legal institutions, and not with their replacement by some kind of emergency junta directed from London.[18]

A character in Scott's *The Heart of Midlothian* recalled wistfully: 'when we had a king, and a chancellor, and parliament, o' our an, we could aye peeble them wi' stanes when they werena guide bairns ...'[19] But the loss of a local Parliament was scarcely felt since it was elected on a tiny franchise and dominated by an unrepresentative section of the population, who did not take the business of law-making very seriously. Scotland's collective identity was recognised, and arguably deep-

ened, within a multi-national state. The country also became less polarised following the subjugation of Jacobitism in the Highlands, though the ruthlessness employed by the Duke of Cumberland left deep anger. But resentment over the depopulation of the Highlands by clan chiefs and landlords wishing to rationalise their holdings and throw off any sense of obligation to members of extended families who once had owed them allegiance, would prove far more enduring. Until 1750, the Highlands and Islands had held about thirty percent of Scotland's population. The bulk, however, was to be found in three Lowland areas: the north-east had 18 per cent, the east coast counties no less than 20 per cent, and all the west and south-west only 20 per cent.[20] The dramatic economic changes that occurred over the next century would lead to a remarkable concentration of population in the central Lowlands.

The Union offered Scottish merchants access to the markets of the rapidly-expanding British Empire. It enabled them to trade with the American colonies in profitable commodities such as tobacco, sugar, and rum, affording them the protection of the British navy. It created the biggest free-trade zone in Europe and increasingly appeared to be a good bargain.[21] Whatever risk there had been of Scotland becoming an economic appendage of its bustling larger neighbour faded as merchants, particularly in Glasgow, responded with innovation and ruthlessness to the economic opportunities of the age. It was Scots traders who introduced slavery into eighteenth century Florida.[22] An aggressive business ethic enabled the Scots to establish economic primacy over their English rivals in the expanding British Empire. They had always emigrated in disproportionately greater numbers than the English. No longer were they drawn to serve in European empires, or as businessmen in the ports of the Baltic or soldiers in the service of continental dynasties. Instead they engaged with furious energy in the construction of a vast overseas empire the likes of which the world had never seen. Their success, in some eyes, sprang from a Calvinist ideology promoting hard work and a confident assurance born of awareness of enjoying membership of God's elect.[23] The energy and self-confidence released following the Union suggested that this was far from being the end of 'a long song' of freedom. It provided unparalleled opportunities for educated Scots at home, in England and in the empire, where Scottish soldiers also acquired fulfilment and renown. A backlash against 'Scots on the make', orchestrated by the radical

19

agitator John Wilkes, briefly swept London during the premiership of the Earl of Bute, a Scottish nobleman. His ally, John Churchill wrote in 1763:

> 'Into our places, states and beds they creep,
> They've sense to get what we want sense to keep.'[24]

Perhaps not until the start of the twenty-first century, when purveyors of defensive Englishness in the London print media, notably Simon Heffer, pen newspaper articles with titles such as 'Scots have brought Britain to its knees', have similar levels of animosity been reached.[25] But this was an era of the integration of Scots into an emerging British community shaped around commerce, war and empire. Scots came to be trusted by the rulers of the state. Many previously Jacobite families were absorbed into imperial service. They, and most Scots (outside the south-west), showed conspicuous loyalty to the colonial side during the American War of Independence—more so than the English. During 1775–76 over seventy addresses in favour of subduing the American rebels by force were submitted by Scottish counties and town councils, almost as many as came from the whole of England.[26] These pro-crown petitions were overshadowed by numerous others from England (and also Ulster) advocating conciliation, but with few Scottish counterparts. Top English military figures refused commissions against the American colonists even at the risk of facing court martial. But between 1775 and 1778, of the thirteen British regiments engaged against the rebel Americans, fully ten were Scottish, seven from the previously rebellious Highlands.[27] The Scotland of insurrection, associated with the Covenanting South-west, was now overshadowed by the Scotland which Edmund Burke described as 'tinctured with notions of despotism'.[28] Arguably, this Scotland would hold the initiative in politics, if not wholly in the realm of ideas, for many years to come.

In the city of Edinburgh a counterweight was to be found among a group of intellectuals in a city now without political diversions owing to the absence of a court or a parliament. They sharpened their minds to 'examine the physical world and human society, the nature of experience, the basis of knowledge and belief'.[29] In an optimistic age, they displayed great trust in reason and its capacity to provide explanations for economic and social developments in a fast-changing world. They made contributions that continue to be seen as decisive in a whole range of fields. T.M. Devine has catalogued the Scottish achievement

during a century when the country became famed for its own Enlightenment:

'David Hume was the greatest philosopher in the English language. Adam Smith, through his masterpiece *The Wealth of Nations* (1776) and other works, is recognised as the major influence on the development of economics. Adam Ferguson, William Robertson and James Hutton were at the cutting edge of what became the disciplines respectively of sociology, history and geology. Thomas Reid developed "common sense" philosophy. The work of William Adam and that of his sons, especially Robert, made Scottish architects famed throughout the Continent. Joseph Black discovered both carbon dioxide and latent heat. William Cullen and the brothers William and John Hunter helped to make Scottish medical education the most progressive in Europe in the later eighteenth century. John Miller powerfully advanced understanding of the nature of social change over time and the interaction between law and philosophy. James Watt refined the separate condenser for the steam engine and so generated the essential source of power for the first Industrial Revolution'[30]

Several men of the Edinburgh Enlightenment would have heartily concurred with the historian Norman Stone that: 'We Scots need [the English] because otherwise we would have slaughtered each other in a ghastly turned-inwards energy, which is after all the history of Scotland, pre-unification.'[31] But England did not exert a powerful cultural or ideological influence until well into the second century of the Union. The state of England had emerged through various historical contingencies and the date when it was formed is unclear. It never began but rather evolved sometime between 899 and 956.[32] After 1707, its ruling family were subordinate to a tight-knit oligarchy. Episcopalianism, the counterpart in Scotland of the Anglican church, was weak in most part of the country. English universities posed no serious threat to their more numerous Scottish counterparts.

Scottish thinkers and those intimately connected to Scotland also provided England with an important sense of itself. The historian David Morse has written:

It was Hume and Mackintosh who laid the foundation for a modern history of England. It was Adam Smith who elaborated an economic theory that could serve as a framework for England's destiny as a trading nation. It was James Mill who in his classic *History of British India* (1818) mapped out Britain's future as an imperial power and legislator for mankind. It was Sir Walter Scott who in *Ivanhoe* produced the definitive myth of a proud Saxon race indomitably struggling against the Norman yoke. It was Thomas Carlyle who

extended and developed this into a philosophy of the English character and a critique of industrialisation, and while Macaulay, who was perhaps the one single writer to produce a view of England that was more influential than Carlyle's, was not Anglo-Scottish, [he] was deeply influenced by the ideals of the Scottish Enlightenment ... from 1852 to 1856 [he was] MP for Edinburgh itself.'[33]

Many of the journalists on English newspapers and periodicals were disproportionately recruited from Scotland, a state of affairs that would last for centuries. This was in no small measure due the existence of a class of educated workers who in localities from Paisley to the Moray Firth set up their own reading societies and mutual improvement associations. By 1796–97 there were thirty-five reading societies in and around Glasgow and Paisley, many of them based in weaving communities.[34] Craftsmen in Scotland had long enjoyed high literacy levels. Between 1640 and 1770, it is estimated that seventy-four percent of Scottish weavers were literate, compared to fifty-two percent in northern England.[35] This was the culture that produced Ramsay Macdonald the Labour statesman who served as secretary of the Lossiemouth Mutual Improvement Association in the 1880s before heading for London. A ragman who kept a book propped up against his barrow presented it to the young MacDonald when he showed an interest. It was a translation of Thucydides.[36]

The intellectual renaissance Scotland witnessed had roots in a society where there were pockets of ordinary people who discussed literature, current affairs and religion on a regular basis. But this had little impact on politics. Throughout the Hanoverian era, the country was under a series of powerful managers who were given a free hand by London. Henry Dundas, the First Viscount Melville, was the supreme example. It was perhaps not until the time of Gordon Brown that a Scot exercised comparable influence at the heart of the state. Besides his Scottish power-base, Melville was treasurer of the navy and the dominant figure in the military struggle against first revolutionary and then imperial France. He built up a system of patron-client relations which enabled Scotland to be smoothly administered even as it was beginning to be transformed by the frantic pace of economic change. Favours, promotions, and pensions were dispensed to a range of local interests and clients and he operated with sufficient dexterity to enable this form of political management to endure for half-a-century. Such adept manipulation enabled enterprising and well-placed Scots to rise

in the Union state. This channel of upward mobility had centuries of life ahead of it and would be a chief legitimising feature of the Union. At the end of the 1820s, when the second Lord Melville refused to serve in the government of George Canning, no Scottish manager could be found to replace him and gradually Scotland began to fall under direct Whitehall control.[37]

In a privileged order, well-placed individuals were able to get their own way by manipulating legal and political structures, but they were not untouchable. In the eighteenth century an independent judiciary was beginning to check the executive. But, long before Britain, it was in the USA that democracy would make its mark. The USA consolidated its freedom thanks to the existence of shared values and a sense of common endeavour. The shared common purpose of already settled Europeans and newcomers provided the foundation for a new cultural identity.[38] The early USA was influenced by some Scottish egalitarian features such as the parish state. It collected and distributed poor relief, punished religious as well as minor civil offences, educated most children in the rural areas, and buried the dead.[39] But in Scotland, the parish state failed to be a foundation for the broader democratisation of Scottish life.

Despite the educational tradition in Scotland which encompassed the wider community and emphasised breadth of study rather than narrow specialism, it was America and not Scotland which saw the most complete flowering of enlightenment thinking.[40] It was in the democratic republic of Washington under Jefferson that the Enlightenment's 'core values of order, tolerance, rationality and progressive improvement' found their most fertile soil.[41] Scotland was too confined by European traditions of subordination and servility. In America, newly-arrived peasants who had been evicted from their homes in both lowland and highland districts of Scotland now had the chance to acquire land and develop a sense of civic responsibility. In their former homeland that was an impossible dream for nearly all of them. Already before independence, back in eighteenth century Europe, America was seen as 'the best poor man's country'.[42] 'By commanding higher wages and thereby often becoming the owners of farms, workers in America could form families sooner than was commonly done in Europe.'[43]

Political Nationalists were later often resentful that Scots dissipated their energies abroad rather than transforming their own homeland. There were restless and violent figures who displayed their furious

energy in efforts to subdue native Americans and project British power in the empire. But arguably Scots in this era were a progressive force in the world. The historian Bernard Aspinwall believes that many Scots in America, by 'combining Christian sense of duty, economic interest, and enlightened benevolence...made a vital contribution to the national sense of identity'.[44] Unlike the Irish or a host of East European migrants from subjugated nationalities, Scotland lacked an alien oppressor, so most of the time there was little energy to right wrongs back home. Instead, it was often the inhumanity of Scots in dominating positions which drove them to board an emigrant ship, not the existence of English overlordship.

Despite the lack of organic ties between Scotland and North Americans of Scottish descent, Alex Salmond has targeted North America as a source of potential financial support. On a visit to the USA in Tartan Week during 2008, he made comparisons between Scotland, as many of its citizens contemplated independence, and a newly-independent USA. But such comparisons do not bear scrutiny. The colonies were composed of Europeans and their descendants, many of whom had arrived as indentured labourers, that is, the lowest class of free men, but who became free to work for themselves after their period of contracted servitude was completed.[45] Records for the state of Maryland in the seventeenth century show that more than ninety percent became landowners. In the Scotland of subsequent centuries, such self-reliance decreased as the state acquired an increasing ascendancy over people's lives. Relations of subordination and command bound the people to a modern leviathan state which replaced the exclusive and arbitrary one to be found in aristocratic Europe.[46] It is true that the holding captive of Africans and their descendents in parts of the USA would create a deep fault-line in American life that would not be overcome by the emancipation of the slaves in 1861. For nearly a century, white supremacists would oppress them and many more of their descendants. But, arguably Scotland faced a more enduring history of religious and ethnic strife which stunted the nation's growth far more completely than slavery had in the USA. One damaging result was that, unlike in the early USA, it was hard to project a composite Scottish identity based on solidarity and trust that could be the basis for a common endeavour.

Centuries of authoritarian political habits and social mistrust ensured that political radicalism rarely made itself felt. This is despite the stubborn persistence of an image of Scotland as a place where the

views of ordinary people somehow counted in the greater scheme of things. Much was made of the fact that the National Covenant of 1638, designed to resist the imposition of a form of Anglicanism on Presbyterian Scotland, was signed by all classes across the Lowlands. But this dispute remained strictly religious in character and the democratic vestiges of Presbyterianism failed to influence economic life or the social order, where a strict hierarchy prevailed. Scotland lacked a tradition of struggle for the rights of subjects against the crown. Public controversies centred around ecclesiastical issues for three centuries after the Reformation. The Statistical Account for Scotland of the 1790s reckoned that in the environs of Dumfries, 'the vulgar read almost nothing but books on religious subjects. Many of them are too fond of controversial divinity.'[47] In the first half of the nineteenth century, when the country was convulsed by the effects of the Industrial Revolution, the only serious public upheaval occurred in 1843. It was fought out in the General Assembly of the Church of Scotland over the issue of patronage. Should parishioners choose their own ministers or have them imposed upon them by patrons? The London government's backing for the conservative option split the Kirk but it did not lead to any wider political radicalisation.

Ultimately, the main impact of this schism would be to severely weaken the influence of Presbyterianism over national life after an uninterrupted ascendancy of three hundred years.[48] No non-state body with such authority and reach is likely to exist again. In the 1790s, when the improving MP Sir John Sinclair drew up the First Statistical Account, a parish by parish account of conditions of life in Scotland, it depended on the civic voluntarism of the ministers of the Kirk in around one thousand parishes. A second undertaking in the 1840s provided invaluable information about Scotland at a time of incredible change. But a third statistical account was abandoned soon after it got started in the mid-1940s. Boffins and bean counters in the Scottish Office now map the evolving shape of the nation in often impenetrable reports. When, in the 1990s and beyond, MSPs like the SNP's Michael Russell and Christopher Harvie sought to take the pulse of the nation or else speak out frankly about several of its less heroic characteristics, they were assailed by the media for daring to hold up a mirror to Scotland's face.[49] By now the Kirk had retreated into small-town Scotland or middle-class suburbia. A contrast can be drawn with the Netherlands, where the reformed Protestant tradition was able to retain a

broader influence for longer on national affairs because it kept its nerve and was not sidetracked by theological disputes or collisions with the state over issues that, in retrospect, appear of secondary importance.

Perhaps only through revolutionary agitation at home could the Scottish hierarchical order have been effectively confronted. The most extended period of instability Scotland experienced after the Reformation came during the civil war of the 1640s and its aftermath. The English Parliamentary forces produced radicals who championed universal suffrage and a government that promoted the welfare of all its subjects. East Anglia, already associated with insurrections against arbitrary power such as Wat Tyler's rebellion of 1381, was the focal point of resistance to Stuart despotism. Levellers, Diggers, and Quakers, often from other parts of England, stood for a democratic and collective tradition in English history for which there is no Scottish counterpart until the twentieth century (despite occasional isolated flare-ups such as the 1820 'Radical War'). By contrast, in Scotland the 1640s were dominated by theological issues and none among the protagonists had a vision of the kind of society that should replace royal despotism. By the 1670s, the Covenanters were engaged in violent resistance to prevent the state having any role in ordering their religious beliefs and practices. The bravery and resolve of the Covenanting martyrs was impressive, but their dogmatism was unattractive and offers a passing resemblance to movements of contemporary religious fundamentalism. Neither the Covenanting struggles, nor indeed the Great Disruption which rent asunder Presbyterianism in the early 1840s, showed any potential to move in a radical political or social direction. Religious disputes in Scotland appear to have an all-encompassing character which, more often than not, has been lacking in England.

Scots grew accustomed to the religious state, and then its secular offshoots, exercising a prominent role in their lives. The local state continued to have a theocratic overlay until the industrial era, with rudimentary social welfare and punishment administered by the Kirk Session. The American historian Wallace Notestein has described the hold of the Kirk in pre-industrial Scotland:

'Elders constituted themselves committees to walk round the village, peer into windows, open doors, and even go through houses to see the Sabbath was being kept in the strictest degree ...

How the Scots stood for such observation is hard to understand. An Englishman knew that his house was his castle, but a Scotsman's house was no such thing ... Indoors and out he was subject to the discipline of the Kirk and he could do nothing about it. The verdicts of the elders were backed up by local authorities, and failure to conform was punished by fines and humiliation. The pious Scot had allowed himself to become a slave of the Kirk.'[50]

Trade-union activity grew at a much slower pace than in England owing to the ruthlessness with which the law responded to industrial unrest. There was no counterpart in England to the transportation of the Scottish radical republican Thomas Muir to Botany Bay in 1793. Admittedly, the French monarch had just been guillotined and there were fears that the reign of terror could spread across the Channel. Later, Emperor Napoleon I became the travelling salesman for nationalism across much of the continent. Revolution had renewed France and the French armies went east and south, claiming to be the liberators of other peoples. But when the French behaved in an overbearing way, attempting to incorporate the territories they occupied into a French Empire, revolts flared up. Napoleon ended up being defeated by the forces of nationalism, which the Spaniards, the Germans, and the Russians used against him.

In post-Napoleonic Europe, nationalism and the struggle for representative democracy went hand in hand. But political ferment in Scotland was absent. The best-known event of the 1820s was the visit in 1822 of George IV to Scotland, the first time a British monarch had set foot in the country since 1651. It was organised by the novelist Sir Walter Scott, who viewed it as a means of healing some of Scotland's deep wounds, reconciling Jacobite and Whig, Highlands and Lowlands, and reinforcing loyalty to the crown.[51]

Scott created a set of myths about the British past which strengthened the process of Anglo-Scottish reconciliation already underway by 1815, when his major novels began to appear. An English cult of Scotland grew up which coincided with the growth of tourism. Scott had depicted Scotland's turbulent past in a broadly un-threatening and accessible way. It was the romantic-seeming Highlanders with their kilts, bagpipes, rich oral culture, and martial traditions who most captured the imagination of English readers and tourists. Ironically, thanks to the interest paid in the fictional and indeed sometimes contrived aspects of a culture that, in practice, was in steady retreat, the Celtic image of Scotland has endured. Metropolitan sponsorship, from

the royal house downwards, ensured that a pre-modern identity sprang to life in Scotland. Its momentum has continued, leading the anthropologist Malcolm Chapman to make the shrewd observation that the strength of this culture really derives from metropolitan forces defining the peripheral 'other'.[52] Celtic enthusiasts, probably mainly English until up to the Second World War, were not deterred by their lack of knowledge of the realities of life in the 'Celtic Fringe'. Nor indeed has this deterred intellectuals in the Celtic countries who have largely since replaced them as interpreters of the Celtic 'consciousness'. They were lampooned by Flann O'Brien in his novel *The Poor Mouth*, in which cultural commissars in de Valera's Ireland base a phoney Irishness on peasants in the West of Ireland.[53]

Of course, there were many pro-Union Scots who still wished to preserve a separate identity from the larger partner nation. Accordingly, the rehabilitation of aspects of Highland culture was tolerated. This helped to bridge the severe cultural cleavage within Scotland between Lowland and Highland society, many in the former having regarded Highlanders as backward and a danger to good order until a few generations earlier.

During this period, the glens and islands of the Highlands were being emptied of people, many of whom joined the ranks of the industrial proletariat whom Karl Marx nominated as the chief agent of historical change. Many Scots who had profited from the industrial revolution viewed their workers as the chief threat to the political order. Following the Reform Act of 1832, the Scottish governing elite did not hesitate to take exceptional measures to crush precocious working-class movements. This was demonstrated by the ruthless treatment of the strike leaders of the Glasgow Cotton Spinner's Association in 1837–38. After a long period in custody they received sentences of transportation despite the fact that the most serious charges laid against them were not proven. Trade-unionism was slow to recover from the attentions of a local draconian state. Sidney and Beatrice Webb claimed that in 1892, 4.9 percent of the population of England and Wales were members of trade-unions but the figure in Scotland was only 3.7 percent.[54] Strong-willed policemen like Archibald Alison, the Sheriff of Lanarkshire, imposed order on an overcrowded and tumultuous mid-Victorian Glasgow. The city's middle-class leaders armed themselves with stringent measures to control health, public order and fire. Police were able to visit working-

class housing at any hour of the day or night to check on overcrowding. Generations of workers became used to these authoritarian practices and the city was usually politically quiescent despite its reputation for drunkenness and related disorder.[55]

Even when the number of voters went up in 1832, from 4,500 to 65,000, political continuity rather than radical change was a hallmark of the times. The middle-classes were ready to be partners in the established political process. Scotland's universities were more numerous and more modern in their educational standards than the English ones. But they were not hotbeds of radicalism, despite the influence of scholars like Francis Hutcheson of Glasgow University. The universities were geared towards producing active and broadly educated citizens who were able to find an outlet for their energies in Britain and its empire. In the century after 1750, Oxford and Cambridge produced only 500 medical doctors whereas Scotland educated 10,000.[56]

Plenty of positions were to be found at home for talented individuals whose counterparts on the continent were often drawn towards radical politics due to the sway of reactionary monarchies. By the 1830s, Scotland's civil society was already absorbed with running a vast array of public bodies set up to cope with the social challenges of industrialisation and urbanisation. Power was decentralised and, after 1832, it was the Scottish bourgeoisie which largely governed this civic Scotland. The Scottish Burgh Reform Act of 1833 created an extensive local state that was run by the emerging bourgeoisie and reflected its often narrow political and religious outlook. Scots lawyers staffed the new bureaucracy and its inspectors were doctors, surveyors and architects.[57] So before the onset of large central bureaucracies, Scotland was largely self-governing and had been for much of the time since 1707.[58]

This long-term political stability proved a secure foundation for Scottish innovation to be displayed in the economic realm. The eighteenth century saw the emergence of a reliable currency and credit facilities which stimulated Scotland's growth during the industrial revolution. Steel mills, shipyards, and engineering foundries required vast amounts of capital. Scottish banking supplied much of it. Indeed, in the century-and-a-half after the Union, Scotland pioneered a number of crucial innovations without which it is hard to see how capitalism could have surged ahead. In 1726 the Royal Bank of Scotland (RBS) invented the overdraft; the first retail bank branch network was established in 1777 by the British Linen Bank (much later absorbed by

Halifax Bank of Scotland (HBOS); in 1777 the RBS produced the first coloured bank notes and in 1826 it went on to issue the first double-sided banknotes in a bid to thwart counterfeiters; and, as late as 1997, it was the RBS which became the first British bank to launch a fully-fledged internet banking service.[59] Today, the Scottish reputation for thrift is fading into history but it once had a respectable lineage and stemmed, in no small part, from the Trustee Savings Bank movement which was founded in 1810 in a small Dumfriesshire parish by the Rev Henry Duncan.[60]

Despite the commercial ascendancy of Glasgow, it was Edinburgh that remained the pre-eminent centre for banking and finance. Newer and smaller Glasgow banks were unable to compete with Edinburgh's two long-established commercial banks which had consolidated their positions before the industrial revolution and would briefly, at the zenith of the post-1980s economic boom, be pace-setters at a global level in financial management.

But in the midst of this surging enterprise, a downtrodden working-class lived and toiled often in the harshest of circumstances. It is therefore not surprising that between 1830 and 1913 around two million people emigrated from Scotland, a figure that excludes the 600,000 who moved south of the border. So great was the haemorrhage that it placed Scotland near the top of the European emigration league, up with Ireland and Norway.[61] An 'emigration ideology' existed, which was unusual in a country that had become one of the wealthiest in the world after pioneering major industrial breakthroughs. London and the Empire would be irresistible magnets for restless and talented Scots. Wages, significantly lower than to be found in much of England, encouraged an exodus of people to North America and Australasia throughout the nineteenth and into the twentieth centuries. Given low purchasing power, the internal market was too small to provide a viable consumer base for entrepreneurs who instead would prosper in far flung corners of the Empire. More Scots would probably have stayed if they had been convinced there was a chance they would rise materially, but the struggle to exist continued to be an arduous one even as the country became a global economic power in the decades before 1914. Appalling living conditions and health standards for a very high proportion of Scots told their own story. One of the most articulate critics of the industrial order was the expatriate Scottish historian Thomas Carlyle. He railed against the dehumanising effects

of industrialism from a stern moral perspective. But his remedy for the social miseries linked with the machine age were authoritarian and suffused with racism. Along with the less well-known Robert Knox he insisted on the 'absolute superiority of the Saxon and Teutonic stock of Lowland Scotland and England over the benighted Celts of Ireland and the Scottish Highlands'.[62]

Other commentators drawn from the nineteenth century Scottish intelligentsia were also fixated on race while being less judgmental. According to Colin Kidd, '[M]any ... believed that the Scottish Lowlands were peopled by a Teutonic race, a Germanic people who shared vital racial characteristics with their southern neighbours.[63] Margaret Macarthur, author of a popular school history textbook, and the Glasgow physician Ebenezer Duncan believed that Scottish Lowlanders had remained more purely 'English' in blood and speech than those on the southern side of the border who had been Normanised.[64] Duncan, president of the Sanitary Association of Scotland, defied the convention of the day by arguing that the Celtic element of the population, predominating around Glasgow, were also more virtuous. He gave as evidence for this claim the higher rate of illegitimacy of inhabitants of cities in the east of the country.[65]

These were not concerns which overly preoccupied those toiling in Scotland's mills and factories. Radical working-class protests, which culminated in a small-scale and desperate uprising in 1820, invoked Bruce and Wallace but slogans also referred to the Magna Carta and the rights of 'Britons'.[66] Nationalism, such as it was, would prove a largely middle-class affair. For many economically secure Scots, the country's sovereignty remained entrenched in the Treaty of Union. Accordingly, most came to accept its underlying political social and economic realities. Sir Walter Scott played an important role in accomplishing this accommodation of sentiment with practical circumstances. Writing in 1969 when electoral nationalism still had to make its presence felt, the Edinburgh historian Nicholas Phillipson believed Scott was able to 'conjure up the picture of the Scotsman as the romantic realist, as one in whom conflicts between fact and fancy are transcended by sheer force of character. In short, he taught Scotsmen to see themselves as men whose reason is on the side of the Union and whose emotions are not, and in whose confusion lies their national character.'[67] Phillipson went on to claim that 'Scott showed Scotsmen how to express their nationalism by focusing their confused national

emotions upon inessentials' like the need to preserve Scottish banknotes, or petition that the present Queen Elizabeth should be the First of Great Britain, or protest against the use of terms like 'Scotch' or 'North Britain'. 'By validating the making of a fuss about nothing, Scott gave to middle-class Scotsmen and to Scottish nationalism—an ideology of noisy inaction.'[68]

But there was unease and even resentment among watchful Scots who saw, as the nineteenth century progressed, plenty of evidence that Scotland was ruled by an English, rather than a British government. At times, it was impossible to conceal the predominance of English interests over Scottish ones. By 1898 this had become such an issue for a numerous body of Scots that Queen Victoria was presented with a petition on the subject. Addressed to Her Majesty from her 'loyal Scottish subjects' it forcefully asserted that when 'England' is used instead of 'Britain', 'the Treaty [of Union] is violated and the honour of Scotland is attacked'.[69]

Noticing the shortlived National Association for the Vindication of Scottish Rights, which rose and fell in the 1850s, *The Times* was unperturbed. It wrote: 'The separate nationalism of Scotland is happily in these days an anachronism.'[70] The evidence was compelling. Most Scots were comfortable with a dual identity that was Scottish and British. Rising nationalisms on the continent were usually committed to forging a strong and interventionist state. But middle-class Scots preferred voluntary efforts to active state interference and usually obtained personal fulfilment by embracing the laissez-faire ideology that shaped a lot of Victorian thought. It is no coincidence that Samuel Smiles, the apostle of self-help in this era, was from Haddington in East Lothian, a region which had seen the birth of the agricultural improvements a century earlier that would transform much of rural Scotland.

There was no difficulty in raising the subscriptions to build an expensive memorial to Sir Walter Scott in the shadow of Edinburgh Castle soon after his death in 1832. Edinburgh itself was already in the process of reconstructing itself 'as an elaborate symbol for Scotland'.[71] In the 1760s, the preoccupation had been a different one. Edinburgh's New Town, designed by James Craig, had been a celebration of British patriotism and an assertion of Scotland's and the city's role within the Union.[72] But the Castle, in its modern form, is a late nineteenth century creation. By 1850, the Royal Scottish Academy Building and the National Gallery had both been built in classical Greek style as if to

assert the authority of the city even though it was already surpassed economically by Glasgow.

Although there was no strong momentum to imagine a political community encompassing Scotland alone, a cult around the medieval freedom fighter William Wallace was noticeable in mid-Victorian Scotland. Whereas other patriotic monuments failed to materialise because of an insufficiency of donations, an imposing 220 foot tower, the National Wallace Monument, was erected near Stirling between 1859 and 1869 and became a gathering place for those who revered his memory. The foundation stone was laid in Stirling on 24 June 1861 in front of 50,000 people. The mock-medieval tower had been commissioned by Stirling council. A massive statue of a chained lion locked in struggle with a python, designed by the artist Joseph Noel Paton, had been rejected perhaps because of the uncomfortable implications for English visitors.[73] At least half those in attendance in 1861 were in some kind of official uniform and so this was no early manifestation of separatism. 'It was widely believed that by defeating the English, Wallace gained independence for Scotland and allowed Scotland to join with England as an equal, which now guaranteed peace between the two nations.'[74]

Wallace perhaps had his contemporary counterparts in mainland Europe, freedom fighters like the Hungarian Lajos Kossuth or Italy's Giuseppe Garibaldi who took on, respectively, the might of imperial Russia and the Bourbons of southern Italy, while avoiding paying with their lives. In exile, they were given rousing receptions by middle-class Scots who made generous donations to their freedom struggles and indeed others. 250 volunteers, in tartan shorts and bonnets with Scottish thistles, left Glasgow to join Garibaldi's liberation army in the mid-1850s.[75] But most nationally-minded Scots at that time felt politically fulfilled and did not sense they were under a yoke of English oppression.[76] Scotland was substantially self-governing and to some eyes it was even playing the major part in running what was the most powerful empire the world had yet seen. Wallace deserved to be honoured because without his stand and sacrifice Scotland might not have preserved the political and cultural integrity which enabled it to enter the Union as a largely intact separate entity. A Scotland which had not accomplished this national struggle for liberation would have crumpled and finally been absorbed by its more powerful neighbour. So the cult of Wallace which many un-radical Scots indulged in was their way

of saying that the Union was no takeover, men of valour had assured this could not so easily be accomplished, but instead a partnership enabling the smaller country to show that it was more than the equal of England in crucial economic and imperial undertakings. It should also be noted that, in the period from 1830 to 1860, it was not only Wallace but Sir Walter Scott, Robert Burns and King Robert the Bruce who were used as symbols of Scottish patriotism to celebrate Scotland's full equality with England.[77]

From the 1880s a Scottish Office based in Edinburgh drew up policies and took the powers from the boards which had run Scotland since the Union. It promoted the interests of Scottish elites and from 1892 the holder was allocated a place in the Cabinet. From 1926 the post was filled by a secretary of state. From 1945 the Scottish elite would start to include luminaries of the Labour Party and its ancillary bodies. Not unnaturally, their attachment to British approaches outweighed any sympathies for home rule. But well-known pioneers of socialism such as Keir Hardie and Ramsay MacDonald had been supportive of home rule early in their careers. It was a position that the Liberal champion of reform William Ewart Gladstone also appeared to embrace quite late in his career. He was a member of a prosperous Liverpool Scots family whose acquaintance with Scott's novels and poems shaped his political understanding of Scotland and its people and his conception of how best he could serve their political interests. Gladstone believed Scottish nationality was alive and well and thought it advisable not to equate the Union with unthinking centralization, advice spurned by a successor as prime minister exactly a century later.[78] During the Midlothian campaign of 1879 when he embarked on an arduous schedule of rallies to win a seat in traditional Tory territory, he promised that Ireland would not be offered a form of autonomy that was not also available to Scotland and the different portions of the United Kingdom: 'If we can make arrangements under which Ireland, Scotland, and portions of England can deal with questions of special and local interest to themselves more efficiently than parliament now can that, I say, will be the attainment of a great national good.'[79]

For the next half-a-century or more, political nationalism was driven by a desire to improve the Union of 1707, strengthening the Scottish dimension, rather than pursuing outright separation.[80] The Scottish Home Rule Association, founded in 1886, went on to publish pam-

phlets and support candidates for public office who were known to favour the restoration of a Parliament.[81] It was federalist in scope and also comfortable with the concept of the British Empire, while perhaps seeing it as an outlet for Scottish energies that might have been better harnessed at home. An Imperial Federation League championed the idea of the Scots as an imperial race, and the leading Liberal politician, Lord Rosebery, served as its president from 1886 to 1992. Andrew Carnegie, the Scots-American industrialist and philanthropist, was perhaps the best-known advocate of such a racial alliance. His Scottish residence, Skibo Castle, overlooking the Dornoch Firth, 'flew the imagined flag of his projected racial union, the stars and stripes and the Union flag sewn together'.[82]

Much later, unionism and nationalism would come to appear diametrically opposed. But until the 1940s, there was a strong middle ground characterised by a desire for greater decentralisation as well as 'shared assumptions of hibernophobia, anti-Catholicism, and imperialism ...'.[83] In England, the Edwardian era was a time of ferment but Scotland remained politically quiescent. The economy showed ominous signs of running out of steam in the face of accelerating competition from the USA, Germany, and Japan. Most industrialists neglected to devote energy towards innovating the products produced in their shipyards and engineering works. The Clyde lagged behind in adopting the new technology of turbines, diesel engines and welding for its shipyards.[84] There was a tendency to rely on established products rather than pioneering new designs which is what rivals in Germany and North America were doing. Family-run engineering businesses usually started to go downhill after the first generation. Indeed, it is not easy to recall any industrial giants even from the period before 1914 when Glasgow and its satellite towns 'produced one-half of British marine engine horsepower, one-third of railway locomotives and rolling stock, one-third of the shipping tonnage, and about a fifth of the steel'.[85]

The West of Scotland's industrial bourgeoisie was parochial and complacent. Civic and philanthropic endeavour produced Kelvingrove Art Gallery, the neo-gothic pile of Glasgow University, and the City Chambers. But few of Glasgow's economic magnates possessed Florentine impulses which would have led them to nurture local artistic talent irrespective of the commercial possibilities that it contained. A designer possessing the genius of Charles Rennie Mackintosh needed such patronage in order for his talent to be given full flower. But his archi-

tectural and design innovations left a philistine business class unmoved. Compared to Barcelona or Antwerp, Glasgow was culturally stagnant and inward-looking. Arguably, it never really acted like it was 'the Second City of the Empire', however keen its merchant princes and city fathers were on the title. It took its lead from London politically and the business class failed to create the close-knit associations that would have strengthened awareness of what it was necessary to do in order to survive in the future. It failed to place sharp and influential figures in Parliamentary seats who could lobby for West of Scotland interests at Westminster. There was also a lack of synergy between finance capital and industry. Glasgow and Edinburgh, though only separated by sixty miles, had their backs to one another, and their respective industrial and financial elites displayed little willingness to join forces in order to preserve the autonomy of Scottish capital.[86]

Clydeside industrialists spurned investment in new technologies in favour of labour intensive production. Unskilled workers were readily available due to a continuing flow of immigrants mainly from Ireland. Wage levels continued to be lower than in much of the rest of industrial Britain. So was trade-union membership, one third less than in England and Wales by the Edwardian era. Industrial Scotland avoided the raw economic confrontations which in South Wales and Liverpool pitched entire communities against troops sent to impose order.[87] Protestant clergymen, powerful employers and autocratic lairds still held sway over numerous localities. Their domination was matched by that of Catholic clergy in communities mainly comprising Irish immigrants and their descendants. The coal mines were Scotland's largest employer but working-class solidarity was impeded by religious friction particularly in Lanarkshire. In 1906 Scotland elected only two Labour MPs as opposed to thirty-six in the rest of Britain. Given the aggressive stance of many employers to trade-unionism, ideologically diverse forces closed ranks to prevent the labour cause being submerged. Marxist and Catholic Socialist thinking was more influential than in England. But it is hard to envisage what authority the left would have had if civil war had erupted in Ulster due to the complete deadlock produced by the Home Rule crisis and passions that had been enflamed in the west of Scotland. It was the Glasgow capitalist Andrew Bonar Law who as Tory leader initiated a deep political crisis by advocating force to resist the Liberal government's devolution plans for Ireland. He was clearly able to rely on the backing of religious forces to which skilled

workers often deferred. At its General Assembly in 1914, the Church of Scotland voted to honour ties of 'race and religion' with its Ulster co-religionists.[88]

When this British constitutional crisis was swiftly relegated by the eruption of a cataclysmic European war, patriotic fervour was more intense than elsewhere in Britain, if the volume of military enlistments is taken as a reliable guide. 26.8 percent of Scottish miners joined up in the first year of fighting and a disproportionately high number were killed.[89] 'At the hands of the Industrialists and the Kirk session, Scotland wilfully mutilated itself,' the novelist Eric Linklater concluded.[90] During an age of heightened nationalism in Europe following the collapse of the dynastic empires and the promotion of the doctrine of national self-determination, Scotland would largely turn inwards, lacking the collective energy and resolve to strike out in any fresh direction.

2

1918–1967

Economically adrift for much of the twentieth-century, Scotland's partnership with a larger and wealthier neighbour was enormously beneficial in the first two centuries of the Union. However, its industries suffered due to the absence of a state which was responsive to their needs and possessed a capacity to sponsor innovations and protect them from adverse economic trends. Scotland may not have suffered from the lack of a Parliament in the century after 1707 but the absence of a legislature able to stimulate and protect strategic industry was proving a real handicap by the time of the Act of Union's bicentenary. Before the First World War, Scotland was exporting more capital per head than any other part of Britain—£110 against the English average of £90.[1] There was no pressure from London for a more home-centred and diversified investment strategy. Britain was a leviathan state which lacked a flexible and capable bureaucracy able to act as a guardian for the industries generating much of the country's wealth. But in Scotland, and even more so in the industrialised English regions, there was no critical mass of opinion pressing for the state to be downscaled in order that the communication gap between remote power-centres and provincial wealth creators be narrowed, and a developmental agenda be pursued to enable British industry to survive increasingly challenging conditions.

Perhaps until the arrival in the Scottish Parliament in 2007 of Christopher Harvie, a respected historian with strong comparative insights, there was no elected figure able or willing to place Scotland's long-term industrial development in a European framework. The holder of a chair in British Studies at the University of Tübingen, he has made painful and telling comparisons between Scotland and the

39

German province of Baden-Wurttemberg in which this university town is located.

In the Wilhelmine Germany of 1906 Baden-Wurttemberg, in the south-west, had the same population as Scotland. It was then mainly composed of peasant farmers and had about half Scotland's GDP per head. By the mid-1980s, after four decades of German federalism and with Scotland under centralised rule from London, Scottish GDP had fallen to almost half that of Baden-Wurttemberg. The population of this German *Land* had risen to nine million and it had become the headquarters of world-renowned firms like Daimler-Benz, Porsche, and Robert Bosch. Manufacturing comprised over forty percent of its GDP while Scotland's had fallen to under twenty-five percent. Scottish unemployment in the mid-1980s was almost three times greater at around fifteen percent.[2]

Scotland's claim to economic distinctiveness increasingly derived from its financial sector. Eventually, it would cast aside its reputation for dependability and thrift and throw itself into a reckless frenzy of speculation and risk-taking which led to the near-collapse of its two main financial institutions in 2008. By contrast, a province like Baden-Wurttemberg retained a deep-seated belief in the value of manufacturing industry and the need for a financial sector that would preserve Germany's economic competitive advantage with wise long-term investment decisions.

Professor Harvie, a longstanding member of the Labour Party, abandoned this allegiance in the late 1980s, in no small part owing to the absence of a decentralisation tendency in England.[3] He encountered the same apathy in the 1980s which had greeted the Speaker's Conference on devolution, set up in 1919, to try and reach a state-wide solution to the escalating Irish crisis. Scots were reeling from disastrous war losses and in many places appeared more absorbed with erecting war memorials to honour their pronounced national role in the carnage than in planning for the future. Some intellectuals were influenced by the appearance of small European nations which had acquired statehood following the disappearance of major empires that went down to defeat in the First World War. Scotland soon acquired a movement committed to full independence. But it existed in an obscure twilight realm, experiencing unrelenting electoral rejection as well as the schisms and infighting that assail political movements doomed to be far ahead of their time.

Scotland's heavy industries were pulverised by the depressed conditions which existed for much of the 1920s and which, by the early 1930s, had escalated into a full-scale slump. An overvalued currency in the 1920s prevented recovery and was a glaring example (with others to follow) that the economic health of industrial centres like Clydeside, critically dependent mainly on export markets, was not a high priority in Whitehall or the City of London. Scottish economic concerns were often axed before English ones in a process of rationalisation that devastated part of Scotland's industrial base. A century of widening Parliamentary democracy had not given rise to an articulate national or even regional lobby in Scotland capable of defending core requirements necessary for something resembling a *Scottish* economy to remain in existence. Industrialists had been jolted by wartime industrial militancy in the shipyards. The eruption of well-supported rent strikes on Clydeside at this time suggested that working-class men and women were discarding their passivity in large numbers. The leaders of Soviet Russia appointed John Maclean, the best-known of the Clydeside Marxists, Soviet consul in Glasgow and efforts were made in 1918 to transform Glasgow Trades Council into a revolutionary soviet. Government leaders panicked, encircling George Square in Glasgow with tanks in early 1919. But the alliance between socialist agitators and craftsmen keen to preserve their status failed to blossom into a revolution. It is true that low municipal rents were achieved and political radicals appeared to dominate the Scottish Left for most of the 1920s. But they were fragmented into Communists and members of the Independent Labour Party (ILP). The defeat of the 1926 General Strike marked the end of the radical Left's ascendancy. Half-a-million Scots emigrated in the 1920s, despairing of being able to enjoy a civilised existence in their own localities. In every year between 1927 and 1939, unemployment in Scotland was higher than the national average. In July 1933 it was twenty-eight percent, compared with sixteen percent in England and Wales.[4] Average income per head had dropped in the late 1920s from ninety-two percent of the British average to eighty-six percent by 1933.[5] In the eyes of a sharp observer of the national condition like the poet Edwin Muir, the severity of the slump appeared to put in question Scotland's ability to survive as a coherent community. According to the historian T.C. Smout, he found 'a smashed and emptied country (emptied of population, spirit and innate character)'.[6]

Despair was resisted by those who threw themselves into the Communist movement. Over the sixty years the Soviet Union continued to exist as an alternative vision, it possessed an influence on Scottish political life masked by its lack of electoral success. For many, the appeal of Catholicism also burned brightly at this time and the Iona Community, whose architect was Rev George MacLeod, demonstrated the possibilities of a progressive form of Scottish Protestantism. This had lain dormant since the era of Rev Thomas Chalmers, a century earlier, when he 'was decisive in awakening Christian conscience to urban deprivation'.[7]

Lord MacLeod of Fuinary, as George MacLeod eventually became, strove not without success to provide space for Christian fellowship and social renewal in lives blighted by the slump. He obtained financial backing from Sir James Lithgow, the shipbuilder, for a project whose left-wing dimensions were hard to conceal. But such inter-class partnerships failed to irrigate a sterile political landscape. The Conservatives would dominate much of the inter-war period after the near-collapse of the Liberal Party (it had fifty-eight out of seventy Scottish seats in 1910) and a temporary collapse of Labour in 1931. The Unionist Party, the name adopted by the Conservatives and their anti Irish Home Rule Liberal allies from 1911 onwards, seemed best-placed to contain the Left, whose strength turned out to be over-estimated. Left-wing rivalries, a deficiency of vision, and the struggle for survival that was the story of many working-class lives, ensured that the Labour Party was unable to perform strongly against the political Right. A comparison with Wales is instructive where, in contrast to Scotland, Labour held its own in the 1931 election and revived powerfully in 1935. Both Wales and Scotland gave birth to fully-fledged Nationalist Parties, Plaid Cymru in 1925 and the National Party of Scotland (NPS) in 1928.

The NPS was committed to self-government for Scotland with 'independent national status within the British family of nations, together with the reconstruction of Scottish national life'.[8] It combined Nationalists from many different backgrounds, including ex-members of the ILP. Sir Patrick Dollan, who had tamed the left in Glasgow by the mid-1930s, described the NPS as 'a mutual admiration society for struggling poets and novelists and of no use to the working-class'.[9] In 1934, John McCormick, the chief impresario of nationalism for the next twenty years, rearranged the Nationalist cast. A merger was accom-

plished with the more right-wing Scottish Party, formed in 1931 and thus the Scottish National Party (SNP) came into being. It was conservative in style and it would not be until the era of Alex Salmond that separatism would acquire the colourful and unconventional stamp it briefly enjoyed when the poet Hugh MacDiarmid-and other intellectuals were associated with it. Men of principle and ability were not lacking, but the SNP in the 1930s was unable to offer a compelling message that could penetrate a parochial and downbeat society. Anger against England was hard to keep going for long since the ties of Union remained extraordinarily close and had arguably been strengthened by the First World War. Anglophobia, and a desire to follow the Irish along a separatist political path, were eclipsed within the Nationalist camp by a desire to reform the Union and protect Scotland's role within the British Empire. As the 1930s wore on, Scotland grew more at war with itself thanks to class divisions, sharpened since 1914, as well as deep-seated inter-cultural antagonisms between Protestants and Catholics.

Glasgow retained a powerful individual identity. It was a self-made city on the American model.[10] Facing economic adversity, it continued to be influenced by American civic, economic and religious patterns to which it had powerfully contributed during its era of civic and economic dynamism before 1914. Unsurprisingly, a city that was second-to-none in its appetite for Hollywood cinematic products was stony ground for continental-style nationalism.

Previously, the loudest exponents of political autonomy within Great Britain had been Irish Catholics which hardly advanced this cause in Scotland itself. Most Scots associated the Union with progress and civilization, like the Ulster Protestants to whom many Scots were joined by shared religious and political instincts. The fact that the Catholic majority in Ireland, by contrast, associated the Union with coercion and failure merely seemed to confirm that they were a race apart. The demand for Irish Home Rule held up the political traffic at Westminster for three decades before 1914. This polarising issue did little to promote empathy between Scots and Scotland's growing Catholic population of Irish descent. They had become a visible presence in industrial Scotland in the generation after the Great Irish Famine of the mid-1840s. It would take well over a century before this minority was on the road to integration. Even after the Second World War, the Church and Nation Committee of the Church of Scotland,

widely viewed as 'the surrogate Parliament of a stateless nation', was demanding that Scottish workers be protected from economic pressure from a despised minority.[11] It did not matter that, for some time, this community had been mainly Scottish-born. Nor that most of its male members had shown loyalty to Britain by joining its armed forces in large numbers in two world wars. Its existence was viewed as an unmitigated disaster gnawing away at the heritage of the Protestant Reformation. In 1923 a report of the Church and Nation Committee entitled *The Menace of the Irish Race to our Scottish Nationality* demanded that means be found to 'preserve Scotland and the Scottish race' and 'to secure to future generations the traditions, ideals, and faith of a great people unspoiled and inviolate'.[12]

In the rest of mainland Britain, sectarian antagonism was on the wane and there was no support at the heart of the state for the kind of punitive measures favoured by anti-Irish forces in Scotland. But the violent separation of most of Ireland from Britain, achieved in the early 1920s, and the presence of a visible and numerous minority strongly Irish in character and outlook (according to disapproving Scots), put a brake on Scottish separatism. The Irish path to freedom had come at a prohibitive cost. It culminated in civil-war among the Nationalists and the island's partition. Religious tensions in Scotland suggested that Home Rule could prove turbulent and an opportunity for fringe populist parties to enjoy the kind of breakthrough they had been unable to achieve in Westminster. Self-rule for Canada, Australia and New Zealand appeared normal given their distance from the imperial motherland. And Scotland was not a young country, but one that felt the burden of its years after the slaughter of a large percentage of its young men in World War I and the sharp economic downturn that was not so long in following. The Nationalist poet, Hugh McDiarmid, was at least seventy-five years ahead of his time when he wrote in 1926 that 'the so-called "Irish invasion" of Scotland' was 'destined ... to be the best thing that happened to it for over 200 years at least ...'.[13] Such an opinion would be shared by few in the Nationalist movement. As late as 1982, by which time the SNP was striving to bury what remained of its anti Irish-Catholic image, its then president, William Wolfe, chose the moment of the first ever papal visit to Scotland to express hostile views about the international record of the Catholic church (views which he later apologised for).[14]

The writer Eric Linklater, in a book called *The Lion and the Unicorn* which was published in 1935, observed: 'People degenerate when they lose control of their own affairs ... To any nation, the essential vitamin is responsibility ... By means of its association with England, Scotland became insular ...'.[15] His fellow Orcadian, the poet Edwin Muir, ascribed Scotland's predicament not to English overlordship but to the sway exercised by a dehumanising economic system. He believed in 1934 that 'A hundred years of socialism would do more to restore Scotland to health and weld it into a real nation than a thousand years—if that were conceivable—of Nationalist government ... for even if the country were governed by Scotsmen, the economic conflicts within it could still generate the same intestine hatreds as they do now, and would still deserve to do so.'[16]

Muir's views were shared by the radical educationalist A.S. Neill, whose liberal school, Summerhill, it is hard to envisage flourishing in Scotland. Writing also in the 1930s, Neill (born and raised in the north-east town of Forfar) believed that Scottish education had already lost much of its distinctiveness and he was convinced that:

'...Home Rule would [not] make a scrap of difference to Scotland; the rulers (finance, monopoly capital, vested interests etc) would simply make Edinburgh their headquarters instead of Westminster. In political matters, Scotland is a nowhere. It accepts British rule with due servility and, when London pulls the imperial strings, the docile Scot forms fours and musters to fight for the all-powerful master.'[17]

After 2007 the SNP would be dominated by figures—numerous solicitors as well as members of new industries, management, the media, and marketing—who were convinced that they had the formula to transform Scotland in a purposeful and enlightened direction. Their insights are probably really no more acute than those of the pioneers of the 1930s but they operated in a much more favourable environment. The challenge faced by the early SNP was to politicise the national cause in the eyes of Scots. Nationalism had been ubiquitous for a long time but it was usually non-political and focussed on cultural, sporting and religious aspects of life. It was scarcely a threat to the ruling elite as shown by the way in which the monarchy from King George IV onwards had cultivated Scottish symbols, with Queen Victoria taking this to remarkable lengths.

Intellectuals adopted a Celtic identity to give Scotland a distinguishing marker that set it apart from England. The Greeks had referred to

the tribes occupying the Balkans as 'Celts' and the Romans adopted this name for the Gauls on both sides of the Alps.[18] But the name disappeared until the eighteenth century produced a vogue for untamed peoples left untouched by urban living or commerce. It was James Macpherson, a Gaelic-speaking Highlander who, in 1760, popularised a modern Celtic identity by manufacturing an epic poem, *Ossian*, supposedly based on third century manuscripts. It enjoyed international success and secured Macpherson the patronage and status he had sought (when he died he was buried at his own expense in Westminster Abbey). The Celtic identity slowly became politicised as intellectuals, initially small in number, looked for a vehicle to express their discontent towards the domination of England. To be Celtic enabled a separation to be made from the 'Saxon' English, the Sassenachs, though for centuries this term was applied by the inhabitants of the Highlands to their Lowland neighbours.[19]

As the twentieth century wore on, increasing numbers of Lowlanders would grow comfortable with an identity that provided a handy means of establishing a difference from the English. After 1989, twenty years of economic progress in Ireland made many Scots drop their deep reticence towards their neighbour. Energetic academics like Murray Pittock, responsible for a string of books depicting Jacobitism in progressive terms, encouraged (by his writings) Scottish students of the humanities to regard Scotland and Ireland as brothers united in resisting a cultural colonialism emanating from England.[20] It had taken nearly a century to politicise this form of Celtic Romanticism. It would receive official backing once Alex Salmond was installed as first minister. In a way this was a validation for the missionary work of Ruaridh Erskine of Marr who, nearly a century earlier, had tried and failed to subvert an identity which accommodated both Scottishness and Britishness. But most Scots preferred this dual identity and the small number prepared to consider nationalism worth voting for, desired a form that offered not Celtic escapism but some answers to the burning economic and political questions of the age.

Nationalists enjoyed a presence at Glasgow University between the world wars. The novelist Compton Mackenzie, one of a series of Catholic intellectuals often with tenuous family connections to Scotland who promoted Scottishness in the arts and sometimes politics, succeeded in being elected rector of Glasgow University in 1931. The third Marquis of Bute (1847–1900) (although a Unionist)and, much

later, the academic polymath Owen Dudley Edwards, are distinguished examples of this genre. Elsewhere, the university world has often been a springboard for a stateless nationalism like Scotland's. But this was politically a highly conformist world until the 1940s. In previous generations, the Scottish universities had been a recruiting ground for ambitious young professionals who wished to make their way in London, the imperial service, and sometimes the 'ancient universities' of Oxford and Cambridge. Each of the Scottish universities had its own distinctive ethos, and members of the upper classes on both sides of the border were drawn to St Andrews and Edinburgh down to the end of the twentieth-century. Scotland has usually been unable to keep its most sparkling minds. In recent times, there are two who undoubtedly qualify. Firstly, Neil McGregor (born in Glasgow in 1946) who trained in languages, philosophy, and law at Oxford, Edinburgh, and the École Normale Superiere in Paris before commencing a career as an outstanding public servant, first as Director of the National Gallery from 1987 to 2002 and then as Director of the British Museum from 2002 until now; and, secondly, Niall Ferguson (also Glasgow born and educated, completing a history degree at Magdalen College, Oxford) and who, from a chair at Harvard, has become perhaps the world's best known television historian thanks to books on financial, American, and British imperial history.

The strength of over-arching British culture that was the product of the interaction of the different national and regional cultures within the United Kingdom remained throughout most of this period. For well over a century energetic and talented Scots had produced important works which helped to shape the boundaries and content of a British culture and disseminate its influence far and wide. The compendium of knowledge known as the *Encyclopaedia Britannica* was devised and produced by an Edinburgh printer, William Smellie, and for a century after 1801 remained a Scottish publication. The *Oxford English Dictionary* and the *Dictionary of National Biography* also greatly enriched the national culture and were created by Scots. The prominence of Scots in publishing and in journalism over many decades was striking. A Scot, William Archer, may even have a strong claim to be the father of the modern British theatre, a medium not normally associated with the Scots. Massie believes that 'the imprinting on England of Scottish ideas, Scottish ethics and what [Robert Louis] Stevenson called "a Scots accent of the mind"', had a catalytic

effect on the formation of a durable British culture.[21] Scots cultural Nationalists chafed at what they viewed as a monumental waste of talent. But given the notorious unwillingness of Edinburgh to capitalise on its cultural advantages, or of Scottish governments since 1999 to stimulate good quality cultural initiatives, what would they have achieved if operating within an exclusively Scottish orbit? George Malcolm Thomson, the most talented of the Nationalist propagandists writing in Scotland at the end of the 1920s seemed to realise this. He chose a London-based career in the Beaverbrook press after playing an active role in the events which brought about the creation of the Scottish National Party in 1934.

London-based Scots like the novelist and administrator John Buchan were ready to support home rule. As Member of Parliament for the Scottish Universities from 1927 to 1935, he argued for the devolution of political power to Edinburgh. But among conservatives, he was an isolated figure. In 1932 unimaginative Glasgow capitalists showed their hand when political nationalism briefly looked as if it might be the wave of the future. They were the mainstay of a petition drawn up in 1932 which made a 'declaration of its definite and absolute objection to the setting up of a national Parliament for Scotland; it is convinced that the interests of Scotland are so interwoven [with England] ... that Home Rule ... would be altogether contrary to the interests of the country; affirms that England and Scotland have become indivisibly one ... and hereby constitutes itself as a committee to take such steps as may be deemed requisite to oppose any proposal for a Scottish Parliament'.[22]

Previously, it was working-class movements which had alarmed the industrial capitalists and this declaration, dubbed the 'Ragman's Roll' in memory of the submission of Scottish nobles to King Edward I, showed how seriously the Nationalist threat was taken. Nationalism, by now, was also losing what favour it had enjoyed on the Scottish Left. Indeed by the mid-1930s, the charismatic left-winger James Maxton had come to associate nationalism with fascism.[23] He believed the pre-eminent struggle was between capitalism and socialism and the extent of the world economic slump convinced him of the need for a fundamental re-ordering of society. Edwin Muir, who found a demoralised country on a tour he made in 1934, had started out sympathetic to the cause of political nationalism. But after revisiting Glasgow, where he had spent some of his younger years, the enormity of the

economic collapse convinced him that the Nationalist movement had little to offer; it 'is at most a symptom or a by-product of historical conditions, not a genuine factor in them'.[24] Today, even if the recession becomes a full-scale slump, it is highly unlikely that nationalism can be relegated as easily as it was in the Scotland of the 1930s.

Economic gloom undoubtedly diminished appetite for any leap into the political unknown. Britain developed new industries in the 1930s. Cars, later aeroplanes, plastics, artificial fibres and electrical goods provided plenty of new employment, but mainly in the South. The most important of these new industries, car manufacturing and electrical goods, had only two percent of their British workforce in Scotland.[25]

Clydeside's reputation for stormy industrial relations may have deterred investors but by the 1930s the Labour Party had been turned into a conventional force which no longer challenged the social system. The sense of optimism and idealism which had defined the Scottish Left in 1918 turned out to be a fleeting phantom. The ten Glasgow ILP MPs who were returned to Westminster in 1922 promised to cause an upheaval but several became ornaments of the place. David Kirkwood, the strike-leader from the Clyde, had briefly issued threats to dukes and duchesses but it was Winston Churchill no less who wrote the foreword for Kirkwood's memoirs, published in 1935: 'David Kirkwood has so many friends of all parties in the House of Commons ... Everyone thinks him a grand fellow, if handled the right way'.[26]

The party fell under the control of pragmatic organisers, some of whom, like Patrick Dollan, had militant pasts. He established Labour's domination of municipal politics in Glasgow from 1933 onwards before being knighted and appointed head of the development agency for one of the new post-war towns, East Kilbride. The transition of the party from social movement to local voting machine was paralleled by the rise of a deeply unadventurous trade-union wing. By 1945, Willie Elger, a diligent official who had isolated radicals in the union movement, was deputy lord-lieutenant of Glasgow. He ensured that Labour switched from 'a radical, almost messianic party of idealists into a social democratic party run on mechanistic lines'.[27] Its ability to deliver social reforms won it votes but many who wished it to be a force for fundamental change were disappointed. Core activists in municipal politics were often related to one another which weakened Labour's ethical image. In urban strongholds, the size of the Labour movement

was surprisingly small. This demobilisation on the left ensured that in the 1945 general election the Scottish swing against Churchill's Conservatives was one of the smallest anywhere in Britain.

Once again, emigration appeared more fulfilling than devoting time and energy to changing the political face of Scotland. During the early 1930s, 40,000 Scots left to make better lives elsewhere.[28] But the Second World War reinforced the threadbare fabric of Britishness. In his memoirs, the science-fiction writer Brian Aldiss has recalled the warmth of the reception received by mainly English troops, destined for the overseas front, from ordinary residents of Glasgow:

'The troop train wound through the poor suburbs and peeling tenements of Glasgow. Here citizens turned out to wave and cheer and toss buns and ciggies to the troops. Improvised banners hung from slum windows, saying GOOD LUCK lads and similar encouragement. Women waved Union Jacks. Bright of eye, the troops jostled at the train windows, waving back. No one on the train will ever forget those warm Scottish hearts.'[29]

Nationalism was not damaged in Scotland by the horrific crimes committed in the name of fascism. Autonomist movements elsewhere in Western Europe fell under suspicion as numerous academics and opinion makers insisted that fascism was the logical outcome of a form of politics which gave undue stress to control over a territory by mobilised ethnic forces. But in Britain, defence of the homeland had been a means by which people had been mobilised to resist totalitarianism in the war years. Scotland had been administered by Tom Johnston who was far from numb to patriotic feeling, later being a signatory of McCormick's pro-home rule Scottish Covenant. Even at the height of Labour centralization, this quasi-Nationalist initiative collected two million signatures in favour of home rule at the end of the 1940s. Its advocacy of Scottish self-government within the United Kingdom resonated with churches, trade-unions and chambers of commerce alike. As Lord Kilbrandon, the chairman of the Royal Commission on the Constitution which sat from 1969 to 1973 later argued:

'It would be hard throughout the familiar world to find a parallel for a country which had its own judicature and legal system, its own executive and administration, but no legislature, its laws being made within another and technically foreign jurisdiction, by an assembly in which it had only a small minority of members, but to which its executive was democratically responsible.'[30]

Although Westminster remained unmoved, it was a sign of how, beneath the surface of a country recovering from war and depression, the idea that Scotland was a partner nation not a vassal region continued to resonate with large numbers of people. The feeling that the sovereignty of the Scottish people continued to live on due to the rights vested in the Treaty of Union was given expression after an insensitive decision by Churchill. During his final premiership, he decided that the new monarch should be called Elizabeth II, although she was the first by that title in the history of Scotland.

But such symbolic slights occurred during an era of overdue social reform which reinforced the Union. During the Second World War, the Kirk's General Assembly set up a 'Commission for the Interpretation of God's Will in the Present Crisis'. It was convened by a leading Scottish theologian and churchman, Prof John Baillie. The Baillie Commission presented annual reports to the General Assembly from 1941 to 1945. In the judgment of Professor Duncan Forester, the Bailie Commission 'played no small part in swinging public opinion, not only Christian opinion, in Scotland behind a model of post-war Britain as an egalitarian welfare state'.[31]

There were also recurring historical episodes which maintained a sense of Britishness. The Empire, in which Scots played a disproportionate role, was vitally important even into the first half of the twentieth-century. The war against Nazism enabled Scots to fight and work alongside other Britons to preserve freedom against a force dedicated to wiping out many of the advances in civilization witnessed in centuries past. With the creation of the welfare state after 1945, the British state developed important social and economic legitimacy. Now it promised to look after its citizens from cradle to grave. Since Scotland endured worse poverty and health and poorer incomes than the rest of the United Kingdom, the British link was undoubtedly strengthened by the social reforms of the 1945–51 Labour government. The nationalisation of strategic industries also played a part. The railways, coal, steel, and other industries fell under British state ownership. The state provided heating and lighting for millions of ordinary homes, tended to people's needs when unemployed or in poor health, and gave them an entitlement to a secure pension. In Scotland, unemployment benefit, child allowances, universal state retirement pensions, and improved access to higher-quality education arguably squashed whatever discontent there was with the Union in wider society.

Universal economic and social provision courtesy of the state required increased centralisation. John McCormick described this as 'the new and spurious nationalism of Greater London' which he believed needed 'counterpoise if what we all unconsciously recognise as British is to survive'.[32] The Tories briefly rode the wave of Unionist nationalism, claiming that Scotland was being denationalised thanks to socialist controls emanating from London. A well-led party on the political right could have capitalised on a vague but persistent sense of disempowerment by restoring a tier of political decision-making to Scotland. After all, Scottish identity was increasingly determined by the institutions of government. The legal system and the church were of diminishing importance. If the Conservatives were able to reflect the dual position of being upholders of the Union while being guardians of Scottish autonomy, they could have bolstered what was a fairly strong electoral position for much of the 1950s. At the 1955 general election, the party obtained 50.1 percent of the Scottish vote. And down to the present no other party has managed to obtain an overall majority of the popular vote in Scotland.[33] But in office the Tories preferred to tinker with the machinery of government. The size and duties of the Scottish Office expanded in the 1950s just as they had under pre-1940 Conservative governments. Under-secretary of state for Scotland for most of the 1920s, Walter Elliot was largely responsible for bringing most of the Scottish civil service from London to Edinburgh and reorganising it into departments for health, education, and home affairs.[34] By 1937, he was the secretary of state and, along with one Parliamentary under-secretary, he supervised 2,400 civil servants By the 1950s there were three under-secretaries. This was a decade when the convention was established that all issues to do with administering Scotland should be handled by the Scottish Office. The emergence of a separate and, in some ways, distinctive arm of government in Scottish went in tandem with the growing influence of the British state over people's lives.[35]

By now the parties were led by second-ranking figures none of whom possessed the vision of a Tom Johnston or even Elliot himself. If the Union was to continue to be seen as a fair compromise, ways would need to be found for the government of Scotland to reflect and defend Scottish interests more effectively, but such views were espoused by few. The Scottish establishment may have isolated figures like John McCormick, who died penniless in his mid-fifties struggling to raise a

family. His application to be admitted to the Scottish Bar as an advocate was rejected and he even lost his partnership in the law firm which he himself had founded. Ian Hamilton, the young lawyer who snatched the Stone of Destiny from Westminster Abbey on Christmas Eve 1950, remarked that 'the great and the good feared him as a danger to their mediocrity. They smothered him to death.'[36]

John McCormick's efforts to build a trans-party home rule consensus failed to overcome the desire to hoard power; a desire which united the Labour and Tory parties. Up to, and beyond, McCormick's death in 1961, the failure of alliance-building behind national objectives discredited such efforts in the minds of perhaps most Nationalists. It may well help to explain their reluctance to work in concert with pro-devolutionists in later phases of politics.

Conformist impulses were not merely confined to Unionist elites. The unorthodox are customarily given far less room to breath in Scotland than in England, irrespective of who rules. This is perhaps unlikely to change even if independence is secured. Scotland was ill-led in the immediate post-war decades. Clement Attlee struggled to find capable figures to serve as Scottish secretary and, under Labour, there were three holders of the post between 1945 and 1951. James Stuart, the aristocrat who was in occupation from 1951 to 1957, was described by one conservative-minded commentator as 'deplorable and ineffective'.[37]

A chance to modernise production came along after 1945. Industrial rivals in mainland Europe and Japan would be reeling from the devastation of war for nearly another decade. But management was uninspiring, particularly in ship-building. Christopher Harvie has described 'family managerial dynasties ... suicidally conservative, in design, marketing, research and labour relations'.[38] Allan Massie concurred, believing that by the 1950s, 'the Clyde seemed to represent all that was worst in British industry: restrictive work practices, obsolete ideologies, weak, unimaginative, and ever more desperate management, inefficiency, over-manning, shortsightedness.'[39] There were, however, smaller specialist shipyards which attained Scandinavian standards of craftsmanship and equable labour relations, but they were unable to survive the general downturn of the industry by the close of the 1950s. Scottish inventiveness was also responsible for the marine stabiliser and fibre glass, but the absence of long-term planning and, crucially the unavailability of capital, meant such technological breakthroughs were denied capital investment. Instead, it was Britain's vanquished

enemies which were able to renew themselves industrially with these innovations. The island nation preferred to ride out the boom rather than re-equip and opt for greater mechanisation which was bound to lead to confrontation with already restive trade-unions.[40] By 1958, the country was in the grip of a severe slowdown. Unemployment doubled to over 100,000 in the space of a few years. The slogan of Macmillan's Tories in the 1959 election, 'you've never had it so good', had a distinctly hollow ring to it.[41]

Poor results in Scotland for the governing party obliged it to try and shore up a declining industrial economy by locating new economic plants there whose viability was questioned by some economists. These were usually low-skill, low-technology branch plants and assembly factories rather than facilities where executive decisions were made and research was carried out. Government failed to work in a steady and evolving partnership with industry in contrast with the wartime losers, Germany and Japan, where the banks and the state were vital in re-equipping plants and upgrading them to be at the cutting edge of new industrial technologies. But the state's approach to accelerating economic decline was unimaginative and there was a dearth of entrepreneurial talent in the business sector to devise strategies that would enable traditional industries to recover and hold their own.

Hastily-devised factories were built under the aegis of an interventionist state. In most cases, they would have a lifespan of only several decades. In 1958, Ravenscraig in Lanarkshire became the site of a steel strip mill which appeared better suited to South Wales. Following the loss of five Tory seats in Scotland in 1959, a year of advance for the party nearly everywhere else, the British Motor Corporation (BMC) was persuaded to open a car plant in Bathgate, West Lothian, which eventually employed 5,600 workers. Soon after, Rootes set up a plant at Linwood in Renfrewshire. BMC and other car giants lacked the expertise to manage their expensive empire of new factories set up at government behest.[42] In Scotland, each of these plants required strong financial incentives from the government in order to become a reality and this would be the story for much of their troubled lives.[43]

It has even been claimed: 'the idea that Ravenscraig steel would supply Bathgate and Linwood (motor plants) and thus make them viable was little better than a pyramid-scheme, where individual operations of doubtful viability were expected to succeed through an artificial structure of supply designed to foment demand.'[44]

The veteran socialist Jimmy Reid, who was prominent in the Communist Party from the 1960s onwards, believed that the bedrock of Scottish society was sound and that it was radical economic adjustments that were needed in order for Scotland to flourish. In an autobiographical volume, he wrote:

'In essence, the Scottish social character is based on the concept of the extended family. In the slums of the lowlands it took new forms in a kinship of the poor. The most popular Scottish saying is, "We are all Jock Tamson's bairns"—another expression of the Scottish sense of kinship that goes beyond the immediate family ultimately to embrace humanity. No wonder the Scots were so prominent ... in the emergent Labour movement, whose earliest principles were based on fraternity.'.[45]

But others had a less rosy outlook. Alan Taylor, the journalist, wrote of the post-war years: 'Scotland in the fifties and even the early sixties was a grim place. Those who could escape did, many of them ex-servicemen who had discovered that not all of the world was grey and damp and depressed.'[46]

In the 1950s much of the urban working-classes and the unemployed were being decanted from inner-city tenements to vast housing schemes. The homes enjoyed more amenities and the environment was healthier but these were soulless dwellings, especially the high-rise flats which were thrown up in Glasgow perhaps faster than anywhere else in Western Europe. Arguably, class divisions widened due to the isolation of these housing estates. Avenues for upward mobility also started to silt up, trapping sections of the working-class in poverty, isolation, and self-destructive behaviour. Occasionally, remarkable individuals like the former violent offender James Boyle proved able to transform their lives by releasing the inner spark and talent that lay dormant within. But it was the brother of James Boyle who wrote to him when he was learning things in Barlinnie Special Unit: 'We're not meant to be educated. All these books you're reading, all this art stuff—this is not our world. Stop this.'[47]

In the post-war decades, a centrally-run state appeared to be the best means of ensuring that the interests of the working-class and those who represented them would be heeded in the allocation of state resources. In 1958 the Labour Party in Scotland had stated quite plainly that 'Scotland's problems can best be solved by socialist planning on a United Kingdom scale ... Only socialist planning which will channel industry to Scotland can preserve our national vitality.'[48] Even

Tom Johnston had written in 1952 that a Scottish Parliament might have nothing to administer but 'an emigration system, a glorified Poor Law and a graveyard'.[49] Certainly this appeared to be the dismal position into which an independent Ireland had fallen. The stagnation of Eamon de Valera's 'Free State' was no attractive role model for anti-Unionists in Scotland but it was the nearest one to hand. The persistence of a British outlook even among figures with a home rule background helped to explain the strength of opposition to devolution from Labour activists in the mid-1970, even when the impetus for it was coming directly from Downing Street.

3

1967–1979

In the Britain of the 1960s there was a strong backlash against an 'establishment' of corporate institutions and traditional bodies which pulled the levers of power from behind the scene. Dissident journalists and academics, as well as the political Left and CND, led the assault. But except in the case of CND, Scotland was surprisingly untouched by this upsurge of radicalism from below. A large number of talented intellectuals retained their Communist Party affiliations, which only reduced their wider influence. Edinburgh, the centre of many national institutions, remained a stuffy and closed city not captured politically by Labour until the 1980s. There were no arenas for debate or major events in the calendar at which new ideas could be proposed and then applied to the body politic. Scotland was unable to maintain a serious political magazine much beyond the 1980s. No Scottish version of *Private Eye* appeared despite the plethora of corruption cases it could have sunk its teeth into. The Edinburgh Festival spawned a blizzard of comedy shows and provided much excuse for bacchanalia but it failed to stimulate summer schools or memorable political occasions which spilled over into regular politics. Scotland, at least in terms of political discourse, remained an introverted society in which there was a preference for assembling behind established positions rather than engaging with fresh ideas. Heretics challenging conventions usually only made a name for themselves by moving south. This was certainly true in the case of the psychiatrist R.D. Laing, who shook up the profession by arguing that the family was a cause of much of the misery and psychotic illness in society. From a middle-class Presbyterian family in Glasgow, by the early 1960s he had become a 'celebrity shrink' with consulting rooms in the West End of London. He prescribed the hal-

lucinogenic drug LSD (when it was still legal), claiming it could help the process of 'spiritual unblocking'. Laing had faded from view by the time of his death in 1989. His ideas acquired mounting influence among state agencies in his native Scotland, as controversial decisions over adoption and taking children into custody from the Orkney Isles and elsewhere would prove in the decades ahead.

Willie Ross encapsulated Scottish traditionalism at a time of adaptation and change in the rest of Britain. He was an able and intimidating figure who dominated Scottish Labour politics for nearly twenty years. George Galloway recalled: 'When I came into Scottish politics, Willie Ross was the leader and when you were in his presence, it was like being in the presence of the President of the USA.'[1] But he did not leave a strong party behind him. His main importance rests with his exploitation of the fact that, in order for Labour to be in office centrally, it needed a phalanx of seats in Scotland. This enabled him to prise resources from London. But a diminishing number of Scots were convinced that as a result the country was a full partner in Britain's economic development. Most of the industrial plants were low-grade branch-line developments unable to survive economic downturns which marked the United Kingdom economy until at least the 1990s. Ross was a provincial magnate good at wheeling and dealing. His economic acquisitions did not directly strengthen the Labour Party which was weak and under-performing. The uninspiring nature of the party's representatives, especially in inner city seats, meant that its dominance in fact rested on uneasy foundations.

This was demonstrated when a by-election was called to enable the Labour incumbent to occupy a plum job in the public sector. Winifred Ewing, a Glasgow solicitor and the SNP candidate, won a sensational victory on 21 November 1967, becoming MP for the industrial Lanarkshire seat of Hamilton where previously Labour had enjoyed a nearly 20,000 strong majority. The scale of the triumph, with the Nationalists enjoying a thirty-seven percent swing in their favour, convulsed Scottish politics.

Scots had found an outlet for political discontent. They were not alone in feeling disengaged from politics. Across Britain, there was mounting dissatisfaction with the existing system of government. An attitude survey conducted for the Kilbrandon Commission found that only five percent thought it worked 'extremely well', forty-nine percent saw room for major improvement and fifty-five percent felt 'very' or 'fairly' powerless in the face of government.[2]

The conditions which enabled a monolithic two-party system to thrive in Scotland for at least thirty years were in fact beginning to recede in the 1960s. Social mobility was once again increasing thanks to the diversification of the economy and the impact of post-1945 social reforms. Scotland remained conservative socially and it took longer for the 'youth revolution' and the onset of the permissive society to alter attitudes and behaviour patterns. But political restiveness was definitely on the increase. This was shown in the early 1960s when the siting of Polaris nuclear submarines at a US naval base on the Clyde sparked a campaign of protest that would last many decades. For Judith Hart, who campaigned against Polaris both before and after being elected as a Labour MP, the meaning of Polaris was that 'Scotland already suffering economic injustice and social injustice ... was to be the fall guy if there were to be a nuclear war.'[3] This gave the issue a sharp Scottish dimension and meant that young political activists who might have found a home in the Labour Party gravitated instead to the SNP.

The disappearance of the Empire also left an important psychological void. For several hundred years it had been the only joint enterprise with the English where Scots could say with certainty that not only had they held their own but outmatched them whether as soldiers, administrators, merchants, missionaries or politicians.

Britain was finding it increasingly difficult to establish a secure position in a fast-changing world. It withdrew from empire and was unsure of what its new role would be. It suffered a period of relative economic decline from the 1950s followed by intermittent social conflict lasting thirty years. Joining the European Union in 1973 marked the start of a decrease in economic sovereignty. For decades it was involved in a debilitating ethno-religious conflict in Northern Ireland which sapped the confidence of governing elites. The political malaise was already evident in 1966 as a damaging dock strike led to a run on the pound. The Wilson government was forced to devalue sterling in 1967. Harold Wilson's insistence that 'the pound in your pocket' had not really lost its value was an insult to the intelligence of many voters and his government's credibility never really recovered.

Labour retained its grip because in working-class areas it controlled the machinery of an autocratic state. Except at rare moments such as the Clydeside rent strikes of the First World War, individuals were often ill-equipped to deal with a paternalist and downright bossy state.

They needed mediating structures rooted in neighbourhood, voluntary association, and church to strengthen them when confronting unreceptive bureaucracies. But if they lived in deprived working-class communities, such agencies were usually thin on the ground.

Owner-occupation, at only thirty-one percent of total housing stock, was at a much lower level in Scotland than the rest of Western Europe in the 1960s. Between 1967 and 1970 public housing construction in Scotland accounted for over eighty percent of houses that were completed, the only country coming close to matching this being Communist Romania at fifty-seven percent.[4] It is not altogether surprising that Tony Benn's ideas for new-style politics which emerged in the early 1970s did not have a big take-up in urban Scotland. The idea of reinforcing democratic citizenship and placing the democratic state on pluralist and participatory lines was too radical an up-ending of the existing hierarchical patterns either in municipal politics or the world of the trade-unions. Instead of a diffusion of power, it was Benn's ideas on public ownership and using the state to preserve jobs which enabled the rebellious cabinet minister to become a credible figure among parts of the working-class on Clydeside.

He played a prominent role in the campaign to save Upper Clyde Shipbuilders in 1971. This fight for the right to work in an endangered Clydeside shipyard lasted sixteen months and on 23 June 1972, 80,000 people marched to a rally on Glasgow Green in support of the workers who had occupied the yard. The Heath government did a 'U turn' and agreed to fund the yard's continuation, several members of his government claiming afterwards that they feared civil violence would spread from Belfast (then enduring its worst year of violence in the thirty-years of conflict in Ulster) to Glasgow. Jock Bruce Gardyne, Parliamentary secretary to the Scottish secretary claimed that the decision to retreat occurred when the chief constable of Glasgow said he would need an extra 15,000 men if he was asked to clear the yards of workers.[5]

Nationalism was unable to absorb economic anger. Frustrated voters could temporarily project their hopes and dreams on the SNP. But the party, having never held office, was untested. As recently as the 1950s, it had been composed of a shrunken band of enthusiasts whose impatience with the unwillingness of most Scots to see the political light could lead to searing quarrels. The party's then leader, the medical doctor Robert McIntyre, later told a well-known journalist 'he

believed it was only the existence of the SNP as an organised political force which had prevented the wider Nationalist movement from descending into sporadic violence. 'The wilder forces', he said, 'had been contained.'[6] But the initiative had switched from gradualists wishing to build a less centralised Union, whose political home was increasingly the Liberal Party, to those committed to complete separation, however much tactical differences sometimes gave way to noisy strife between them.

Douglas Henderson, a student leader at Edinburgh University, helped set up a breakaway Nationalist party in the mid-1950s. At this time, he got into hot water for telling his audience that any English people in the hall who had the sense should 'get out of Scotland now while the going is still good ... while they are still in one piece'.[7] Dr McIntyre riposted by saying that the Scots were 'not good haters ... Our quarrel is not with the ordinary person in England and we do not want to build up a virulent anti-English feeling in Scotland ... We must maintain ... our own self-respect. In that way we will be successful.'[8]

It was difficult to stir up radical nationalism because external oppression was lacking. Scots did not need to look far away to glimpse small nations whose freedom had been obliterated by the might of the Soviet Empire and there was no comparison. But there was a sense that the Union had been a genuine partnership and that the English senior partner was too readily forgetting that.

Willie Ross used simmering unhappiness with Scotland's place in the Union to argue vigorously in Cabinet for more economic opportunities to be channelled to Scotland. The economic situation was certainly growing despondent in the 1960s. Gavin McCrone's detailed survey in 1965, showed a nine percent growth rate for the period 1954–60 (half the United Kingdom level) and income per head of thirteen percent which was lower than the United Kingdom average.[9] This was effective political ammunition for the Nationalists. Sir John Toothill's 'Enquiry into the Scottish Economy' published in 1961 had pointed to the danger of what it called the branch plant syndrome: plants run from a long distance and without control over markets or technologies.[10] As well as identifying several of the chief problems at the root of the economic malaise, it revived the concept of regional planning. But it rejected any bold measures of economic devolution which might have led to collaboration between the state and Scottish industry and finance in order to try and relaunch a viable industrial base in Scotland.[11]

So the time was far away when any of the Nationalists' rivals felt the need to steal their political clothes.

Andrew Marr has written that, 'If Scotland came close to being seen as an interventionists' economy, dependent on subsidy and corporatism, it was [Willie] Ross who was partly to blame.'[12] Within a few years of Labour taking office in 1964, public spending in Scotland was a fifth higher per head than in England. It is reckoned that between 1966 and 1971, Labour spent £641 million creating 105,000 jobs, but 156,000 jobs were lost in agriculture and heavy industry during the same period.[13]

But economic marginalisation persisted. In 1972, Scotland came ninth out of ten British regions in research and development expenditure, and government research funding allocated to Scotland between 1964 and 1973 was only 5.1 percent of the British total.[14] It was the Tories not Labour, however, who suffered the earliest credibility problem. The party's official title until 1965 was the Scottish Unionist party. It emphasised its commitment to preserving a political Union in which Scotland had an increasingly subordinate role at a time when increasing numbers of Scots were choosing as their core identity Scottishness and not Britishness. Here was a conservative political force which, unlike its counterparts in other parts of Europe, could not wrap itself safely in the national flag.[15] It had enjoyed a brief recovery in the 1950s by linking London-based socialist planning with the 'denationalisation' of Scotland as major Scottish firms struggled to survive in a climate where the public sector enjoyed the first call on resources. In 1955, it did what no other party has managed to do in modern times, and won a majority of the Scottish vote. But the party often appeared as out-of-touch from mainstream opinion as Labour was. Both drew their strength from rival class interests. Neither of them produced a figure with the wide appeal enjoyed by Jo Grimond, once the sole Scottish Liberal MP who became the United Kingdom leader of the party in 1956 and brought it back from years of irrelevancy.

As nationalism slowly emerged as a major political alternative, the Tories mounted a series of feeble and opportunist gestures, extending from Edward Heath's Declaration of Perth in 1968 to Michael Forsyth's 1996 decision to return a symbol of nationhood, the Stone of Scone, to Scotland while adamantly refusing to revamp the Union for a different age. Edward Heath, the Conservative Party leader, had stunned delegates at the Scottish Conservatives Perth conference when he

declared: 'We are pledged to give the people of Scotland genuine participation in the making of decisions that affect them and to do so within the historic unity of the United Kingdom.'[16] The use of the phrase 'genuine participation' was a concession from Heath that Scots perhaps had some reason to feel that they had been consigned to the margins of the British political process. In 1967, he proposed a fast-track constitutional committee to look at devolution, one that would bypass the cumbersome workings of a royal commission. He stated openly that his recommendation to it would be 'the creation of an elected Scottish assembly to sit in Scotland'.[17]

But these were gimmicks driven by short-term electoral calculations and there was never any effort to launch an imaginative long-term initiative designed to project the party as an authentically Scottish force. This would have been hard to accomplish for a number of reasons. Its elected representatives were drawn from rural Scotland and figures with working-class or even urban professional backgrounds, ready to engage in fresh thinking about how to expand the party's narrow social base, often did not receive preferment.

Resistance from old-guard Tory figures would come later to what was viewed as a dangerous slide towards political deviation by Edward Heath, supposedly an arch-defender of the Anglo-Scottish Union. In the Labour Party, Willie Ross refused to make any concession to devolutionary sentiment. According to his Cabinet colleague, Richard Crossman, he was 'determined to treat nationalism as a mere emotional attitude which can be cured by economic policies alone'.[18] In private Ross could express disdain for English ways which marked him out in some eyes as a cultural Nationalist. He was an enthusiast for the poetry of Robert Burns and a Kirk elder. The last thing he therefore could be described as was a force for anglicanisation but his patriotic leanings were firmly non-political and at the 1968 Scottish Labour Party conference he damned the Nationalists as 'Tartan Tories', ensuring that the gathering rejected devolution by a large majority. John Mackintosh was the sole Labour MP at that time prepared to publicly repudiate the Ross line. In Wales, conditions were different. The Welsh secretary, Cledwyn Hughes, favoured an elected Welsh Council and he had a Cabinet ally in Richard Crossman. Such dissentient views resulted in Harold Wilson deciding, in 1968, to set up a Royal Commission into the workings of the British Constitution.

THE ILLUSION OF FREEDOM

The survey of national opinion carried out by the Kilbrandon Royal Commission indicated that Scots and Welsh people tended to think of themselves as Scottish and Welsh first. The Commissioners concluded:

'The many discussions we have had with the Scots and the Welsh have given ample evidence of the existence of this sense of nationhood often strongly felt even by those who have no desire to see much change in the existing arrangements for the government of Scotland and Wales and who are proud also of their British nationality.'[19]

The Kilbrandon Commission contained a majority report which called for a Scottish Senate or Scottish Convention of 100 members, elected by proportional representation and with wide-ranging powers. There would be a Scottish Cabinet headed by a Scottish prime minister. But to compensate for this, the Scottish secretaryship would be abolished and the number of Scottish MPs at Westminster would be cut from seventy-one to fifty-seven.[20]

The Labour Party rejected these conclusions and fought the general election of February 1974 opposed to home rule. The success of the SNP, which captured seven seats, nearly all from the Conservatives, produced a change of mind in London. Labour was in office as a minority government and if there was no let up in the SNP advance, its chances of ever again forming a majority government appeared threatened. But the Scottish party was reluctant to fall into line. However, the party's Scottish Council was merely a regional branch possessing little more autonomy than the East Midlands Labour Party.[21] The leadership used the trade-union block vote before a special conference held in September 1974 agreed to endorse devolution.[22] The summoning of the Scottish organiser of the Labour Party in London the previous month to impress the new line on recalcitrant constituency parties had more than a whiff of the style of the Kremlin, which used to summon its subordinates in the 'People's Democracies' for hurried consultations when popular unrest grew dangerously high. In the October 1974 general election, Labour in Scotland even produced its own election broadcast, one entirely devoted to devolution, a 'Parliament' being promised complete with powers of taxation and revenue collection.[23] Roy Jenkins, who ended his House of Commons career representing a Glasgow seat for the Liberal Democrats, recalled that as a Labour Cabinet minister, devolution was purely a device to contain the Nationalists and there was no interest in producing 'a good constitutional settlement for Scotland and the United Kingdom'.[24] Indeed, civil

64

servants urged ministers to delay arrangements for devolution as long as possible in the hope that the appeal of the SNP would wane. If this didn't happen, one Treasury official even urged discreet support for an independence movement designed to detach Orkney and Shetland from an independent Scotland.[25]

The Unionist reflexes of the Tory Party soon re-asserted themselves. Even Ted Heath gave vent to strong feelings about the real danger of Britain breaking up at a meeting of world notables convened by the economist J.K. Galbraith in July 1976 to discuss 'the Age of Uncertainty'. The historian Arthur M. Schlesinger Jr. recalled how Heath 'was much concerned about the rise of nationalism in the British Isles, especially about Scotland. Scottish nationalism, he said, fuelled by "greed and revenge" had become a serious movement and he did not exclude the possibility of an independent Scotland before very long.'[26] The young Gordon Brown had written in the same year that the SNP 'was guided, if not dominated, by men of business and commercial experience. Anyone could see that they could run an establishment.'[27] This was also the view of Richard Funkhouser, a hard-headed US diplomat who, in 1974, rejected an ambassadorship in the Persian Gulf to become American consul in Edinburgh, normally regarded as a backwater post. He believed that extracting North Sea oil at a time when ease of access to Middle East supplies was increasingly uncertain would be vital for maintaining the ascendancy of the West. He saw that a self-governing Scotland under the SNP was unlikely to jeopardise that goal which even made Tony Benn suspect that he might be a secret paymaster for the SNP.[28]

In the mid-1970s the SNP was no longer viewed as the temporary beneficiary of a protest vote. The Nationalists appeared capable of breaking up the two-party system, something which the Liberals had never succeeded in doing despite their relatively strong position in Scotland.

The discovery and commercial exploitation of oil in the North Sea gave Nationalist claims a new seriousness by indicating that an independent Scotland might indeed be self-sufficient thanks to this black gold beyond its shores. The case for Scottish nationalism had always been couched more in economic than social or cultural terms in comparison with Nationalist movements in Spain, Canada or indeed Wales. A report drawn up in 1975 by Gavin McCrone, chief economic adviser to successive secretaries of state in the first half of the 1970s,

boldly suggested that there was now overwhelming evidence that, for the first time since the Act of Union, Scotland could derive more economic advantage from being outside rather than within the Union.

In an eighteen-page document circulated to leading Whitehall figures in April 1975, McCrone wrote:

'... all that is wrong with the SNP estimate (of oil production) is that it is too low; there is a prospect of Government oil revenues in 1980 which could greatly increase the present Government revenue in Scotland from all sources and could even be comparable in size to the whole of Scottish national income in 1970.'[29]

It is surprising that even with these cautious estimates, the SNP did not make a more resounding economic case for full independence. As McCrone pointed out, an independent Scotland could have expected to have had massive surpluses both on its budget and balance of payments. With proper husbanding of resources, this situation could have been expected to persist long into the future. It would have enabled Scottish industry to re-equip and the depleted social infrastructure of the country to have been renewed. Scotland's pool of unemployed could have been used in the job of national reconstruction with incomes growing thanks to the increased productivity. In a passage that must have caused deep apprehension in Whitehall and among his political masters nearer home, McCrone wrote that 'for the first time since the Act of Union was passed, it can now be credibly argued that Scotland's economic advantage lies in its repeal'.

He went on to write that 'when this situation comes to be fully appreciated in the years ahead, it is likely to have a major impact on Scottish politics'.[30] Only on social and political grounds could it be possible to make a convincing case for maintaining the Union, in other words around a defence of the cultural and social British link, one that was already starting to lose its lustre in the 1970s and which would become steadily more frayed as the century wore on. But the SNP failed to make political capital with the oil weapon which dropped from view after 1975. Polls in that year revealed that most Scottish voters saw oil as a British resource, albeit one from which Scots ought to have specific advantages[31]. A campaigner as gifted as Alex Salmond would probably have been able to translate the benefits of oil wealth into practical terms that would have given many sceptical Scottish voters at least pause for thought. But the SNP was dominated by earnest, not to say colourless, leaders in the 1970s and later. Not until Jim Sil-

lars joined the party in 1980 did it have someone with clear economic acumen whose comments on financial issues even his opponents sometimes noted.

If the SNP had not been a solidly eurosceptic party right through the 1970s, it could also have made much more running with the oil issue. Not without effect, its opponents attacked it for wishing to condemn Scotland to isolation by going it alone. But if the policy of Independence in Europe had been adopted in the mid-1970s and not in 1988, the SNP could probably have won round many Scots to the belief that it was prepared to exchange one union with another that had a much securer future ahead of it.

McCrone, who never entered politics and went on to distinguish himself in various public endeavours, described how Scotland might have enjoyed unprecedented international influence thanks to being 'the major producer of oil in Western Europe':

'...other countries would be extremely foolish if they did not seek to do all they could to accommodate Scottish interests. For Scotland the net cost of the Common Agricultural Policy, which features so large in British discussions, would be at most some £40 million a year, a small sum compared with the balance of payments gain from North Sea oil. The more common policies come to be decided in Brussels in the years ahead, the more Scotland would benefit from having her own Commissioner in the EEC as of right and her own voice in the Council of Ministers instead of relying on the indirect, and so far hardly satisfactory, form of vicarious representation through United Kingdom departments.'[32]

There was fear that Scotland could present a challenge to the integrity and viability of the British state as formidable as that posed by the conflict in Northern Ireland, though probably not laced with the same degree of violence.

In 1975, the setting up of the Scottish Development Agency, intended to modernise Scotland's industrial base, was a response to claims for a share of North Sea oil revenue. But there was no strong political will to use the oil windfall to promote indigenous economic development that was sustainable in the long-term. Successive London governments, along with British oil companies and bankers, were keen on very fast extraction in order to correct a high balance of payments deficit and boost profit margins. Fast extraction meant that technology would be imported even if it was assembled locally by US companies.[33] An alternative model was offered by Norway which proceeded more

slowly to ensure that its economy enjoyed a long-term technological boost and a locally-controlled supply industry.

The White Paper entitled *Our Changing Democracy* was published in December 1975. It proposed a Scottish Assembly of 142 members, funded by a block grant and with control over many Scottish Office functions but with no revenue-raising powers.

Christopher Harvie has described it as 'essentially a Whitehall creation' where ministers and civil servants successfully resisted granting any significant degree of autonomy to the Assembly:

'Housing was devolved, but mortgages—and so private housing policy—withheld. Education went north—but not universities … transport, but not railways; law, but not courts or judges; local government, but not police. The Secretary of State still retained substantial powers: over agriculture, fisheries, most of law and order, electricity, large areas of economic policy'.[34]

It even lacked control over the Scottish Development Agency.

Devolution was opposed by Unionist-minded Labour politicians, particularly in the North-East-of England where they were convinced that regions like theirs would lose out to an autonomous Scotland. The first devolution bill was defeated in February 1977 by twenty-nine votes, with twenty-nine rebel Labour MPs voting with the opposition.

The party had capable and dynamic people on the left and if they had succeeded in getting into Parliament during the first Nationalist high-tide in the 1970s they could have boosted the SNP's image in working-class Scotland. But most of the eleven MPs who sat in Parliament from 1974 to 1979 represented small town, rural, and fishing constituencies. They have been unfairly characterised as reactionary by Labour detractors but they were often elected on an anti-Tory vote and most belonged to the moderate right or centre of politics. No by-election occurred during the first half of Parliament, when the SNP was doing well in the polls, nor did the party win any well-known converts from Labour. The limited nature of its breakthrough was perhaps first revealed during the 1975 referendum on whether Britain should remain within the EU (as it later became known). A poll at the start of the year had shown forty-five percent of Scots were opposed to EEC membership compared with twenty-nine percent in favour.[35] The SNP was in the '…' camp and so were many Labour activists but they could not mobilise their vote and, on a sixty-one percent turnout 58.4 percent of Scottish voters backed remaining inside the EU. Abandoning the European economic entity was too much of a leap into the

unknown and the SNP, as well as others backing devolution, proved unable to combat Scottish pessimism and doubt by offering a convincing blueprint for economic self-sufficiency.

The SNP's breakthrough in 1974 appeared to be the result of a period of unusual turbulence in British politics rather than a major shift in voting allegiances in Scotland. The failure of Margo MacDonald to join her eleven SNP colleagues in Parliament after February 1974 meant the party lacked anyone with strong working-class credentials and indeed a charismatic presence. Instead, it was Winifred Ewing, the first Nationalist to win a post-war by-election, who became a defining image for the party in the 1970s. Despite her Celtic associations which included warm friendships with the likes of Ulster Nationalist and Nobel Peace Prize winner John Hume, she often came across as a haughty and know-all lawyer. Her bourgeois manner eased Labour's task of depicting the Nationalists as Tories who were seeking a new way of stitching up ordinary Scots by parading a bogus patriotism. It was a tactic which the SNP was unable to counter effectively until the era of resistance to the poll tax. The ruthless way that Labour played the Tartan Tory card certainly envenomed relations between Labour and SNP supporters for a generation and made it much easier for the Tories to rule Scotland even on a steadily diminishing vote.

Rising Labour figures such as John Smith and Donald Dewar had a strong commitment to devolution. But a party which drew its activists from local government and the trade-unions was sceptical. The secretary to the Scottish Labour Party told the Kilbrandon Commission: 'there is no such thing as a separate political will for Scotland.'[36]

Devolution was meant to disable the SNP and prevent it challenging Labour in a part of the realm in whose waters prodigious oil wealth had been located. With the exception of John Mackintosh, no supporter of devolution in the Labour ranks defended it with enthusiasm. In Tam Dalyell, the Labour MP for West Lothian, the whole scheme found a formidable opponent.

No front-rank politician at Westminster felt that the sudden emergence of a Scottish Question actually provided an opportunity to 'philosophise seriously about the British Constitution and how best to reform it'.[37] But the SNP still appeared to be a deadly danger capable of eating into Labour's Scottish vote. Bruce Millan, the unexciting economist who replaced Willie Ross as secretary of state in 1976 had publicly stated in October of that year that if the government reneged

on devolution, the Labour Party would not be a 'credible force' in the next election.[38] As late as February 1977, when the first devolution bill was rejected, Frank McElhone MP privately feared that the party was in danger of losing twenty seats to the SNP.[39]

As a result of the Liberal-Labour pact negotiated by James Callaghan, a new Scotland Bill was brought forward in November 1977. It proposed a 142–seat assembly elected under the Westminster voting system with a first secretary heading the administration, though the secretary of state would enjoy a final say in Scottish business—a confusing division of responsibility. On 14 December 1977 John Smith, the minister responsible for piloting devolution through Parliament, found himself alone in the debate on the third reading with no Labour MPs there to support him.[40] Even those holding Scottish seats where the SNP had come in a strong second were unable to show much enthusiasm for this government's chief piece of legislation. They remained committed to an interventionist central state deploying economic power to protect fragile local economies, and lacked the inclination or imagination to grasp how territorial power exercised at local level might also accomplish that.

The death in 1978 of John Mackintosh, aged just 48, removed one of the few convincing proponents for devolution on the Labour side. It was the need to halt the Nationalists which forced most Labour worthies in Scotland, prodded sharply from London, to embrace devolution. By 1977, there were signs that the effort might be unnecessary after all. When a by-election was held in Glasgow Garscadden in April 1978, Labour's Donald Dewar was returned with forty-five percent of the vote. The seat was dependent on naval shipbuilding on the Clyde and the SNP's candidate, a well-known unilateral disarmer, Keith Bovey, perhaps did well to get thirty-two percent of the vote.[41] But nevertheless this was a disappointing result for the SNP, who had won all the wards in the Parliamentary seat in the local council elections of 1976. The tide was now going out for the party. The SNP had failed to use its slogan: 'It's Scotland's Oil' to strong effect. With more flair, voters might have been shown how London's short-term strategy for fast depletion of the oil wealth without benefit to local communities, was deeply inimical to Scotland's interests (and indeed to Britain's as a whole). Norway's social democratic use of oil wealth would be a talisman much later on for the SNP but only after it had endured long years in the electoral doldrums.

Then the government lost control of Parliament and was unable even to prevent rebel backbenchers like George Cunningham, a Scot representing Islington, from introducing clauses that emaciated the bill. He ensured that not only would devolution have to win a majority of the votes cast; it would also have to secure the support of forty percent of those eligible to vote. The Scotland Act was finally passed in February 1978 by 313 to 287 with eleven Labour MPs voting against.

The worst winter since 1947 and a rash of strikes by public sector workers diminished the general appetite for change. Economic anxieties pushed devolution to the sidelines and there was no politician with the ability to demonstrate how more accessible government could make a difference to the economic prospects of millions of ordinary Scots. During the 1975 referendum on whether Britain should remain in the EU the government had placed resources at the disposal of the 'Yes' campaign, but on this occasion there was no such support. Parliament was hopelessly split into rival campaigning groups based around each of the main parties as well as two cross-party movements with little coordination occurring between them.

The SNP had been equivocal about devolution, especially the truncated version the Scots were finally offered, fearing that it might rule out indefinitely the chance of acquiring independence. But there was far less opposition to devolution from Nationalists than there was from inside the Labour Party. Tam Dalyell, who combined a lofty patrician style with a populist's instinct for generating subliminal fears about change, had no equal on the Labour 'Yes' side. A fellow Old Etonian, the former Tory prime minister Sir Alec Douglas Home, drove Tories away from change with an intervention late in the campaign. He argued that the legislation was flawed and unworkable and hinted that only through its rejection could a future Conservative government come up with something better. Since he had been closely aligned with Ted Heath's devolution initiative of the late 1960s, his words carried plenty of weight.

Rows of empty seats confronted James Callaghan when he addressed a 'Yes' rally in Glasgow on the eve of the referendum.[42] Urban apathy was matched by rural fears of a Parliament dominated by Glasgow councillors and Edinburgh lawyers. Campaigners in rural areas where the SNP had done well found there was unhappiness at the prospect of central belt control. Such fears might have been met if a proportional electoral system had been designated for the Scottish Assembly as

recommended by the late John Mackintosh MP.[43] In the national referendum held on 1 March 1979 strong 'No' votes were recorded in most places outside central Scotland. The lack of enthusiasm among Scots for the particular devolution scheme on offer was indicated by the low turnout of 63.8 percent. Although the bill was approved by a slender majority—77,435 out of 2,384, 439 voting—it failed to reach the forty percent minimum approval level demanded by Westminster. Thirty-three percent of the total electorate approved devolution, which in the eyes of its critics was an unsatisfactory level of support for so major a constitutional change.

Professor Tom Devine, a later supporter of devolved power wrote: 'The truth was that less than a third of the electorate had actually voted for the most important constitutional change in Scotland's history since the Union of 1707 and the detailed results of the referendum demonstrated conclusively that the Scottish people were hopelessly divided on the issue.'[44]

Bernard Donoughue, Callaghan's chief political adviser, wondered in his diaries if 'our subsidies and handouts' had not 'corrupted them'.[45] There was deepening gloom about the state of Britain due to debilitating clashes between capital and labour with the government seen as a helpless and increasingly discredited spectator. But there was no longer a head of steam behind the Nationalist campaign capable of convincing large numbers of Scots that a new form of limited self-government could enable Scotland to free itself of the defects that seemed to be making Britain ungovernable.

The production of oil coincided with three decades when the global economy enjoyed steady expansion. If it had been accompanied by a stronger desire to break with a failed model of Unionism which had confined Scotland to being a peripheral region of Britain, then a new economic chapter could indeed have been opened, perhaps as significant as the industrial and commercial take-off which occurred from the 1760s onwards. Arguably, the prospects for self-government were much brighter in the last quarter of the twentieth-century than in the first decade or more of the one to follow. But the desire for a renegotiation of the terms of the Union was not widely-held and a sense of dependency on London remained palpable.

4

1979–1997

In a 1975 pamphlet called *The Scottish Conservative Party: A Model for a New Dimension*, authored by two young activists destined for higher things, the key passage asserted that 'internal reform of the party must now seek to prepare it for a future where a Scottish Assembly is a permanent feature of political life, and where under its aegis constitutional affairs will assume still greater significance'. Its authors were Michael Forsyth and David McLetchie. In the intervening decades, as acolytes of the Conservative leader Margaret Thatcher, they spurned their own advice.[1] Instead, they and another former devolutionist, Malcolm Rifkind, abandoned a form of Unionism which emphasised diversity within the Union in favour of one that sought to make Scotland conform to the free market values of the south-east of England.[2] This embrace of unitary centralism proved to be an act of *hara-kiri* by the Scottish Conservatives, creating levels of alienation towards the political Union never previously witnessed.

Ironically, one of Margaret Thatcher's early decisions as Conservative Party leader was to attend a rally in Edinburgh and pledge support for Scottish devolution with an elected Assembly. She told a gathering of party loyalists, many of whom must have choked on her words: 'we are absolutely in tune with the theme of devolution. The establishment of a Scottish Assembly must be a top priority to ensure that more decisions affecting Scotland are taken in Scotland by Scots.'[3] But she dissected the first devolution bill when it was debated in Parliament in December 1976 without revealing her own views on home rule for Scotland. She sat on the fence for tactical reasons—if the government fell and elections were called, then the Tories might be required to call upon the SNP to support a government.

73

To stabilise modern states possessing highly conscious ethnic groups, political science has devised the concept of 'the mutual veto'. Usually built into the constitutional arrangements are devices which give minorities a veto preventing central state actions which pose an obvious threat to their integrity or well-being. In Anglo-Scottish relations an informal veto applied over a long period. English politicians did not unduly interfere in the governance of Scotland. But this prudent impulse was cast aside during the Thatcher years. Scotland became a 'managed' territory which needed to comply with the neo-liberal agenda then shaping government policy irrespective of the wishes of most of its citizens. The consensus desiring a moderate level of control over domestic affairs was dismissed. Thatcher claimed that the real spirit of Scotland, an entrepreneurial and highly individualistic one with no need of an intrusive state, was merely lying dormant.

At times she sounded like one of those earnest middle-class revolutionaries who believed they were able to divine the insurrectionary spirit lurking in the soul of the working-classes, which was bound to be released once Marxist propaganda penetrated the consciousness of the toiling masses. Like the Labour collectivisers, she intended to use the machinery of the state to impose a set of radical policies that could not be eroded by intermediate institutions. In her memoirs she complained of Scotland as an outpost of dependency culture and believed the Scottish Office 'added a layer of bureaucracy standing in the way of the reforms which were paying such dividends in England'.[4] One of her party allies was Quintin Hogg who had warned in the 1970s of an 'elective dictatorship'. A decade earlier, he had argued for a kind of participatory Conservatism different in scope from her autocratic version: 'Political liberty is nothing else but the diffusion of power. If power is not to be abused, it must be spread as widely as possible throughout the community.'[5]

Margaret Thatcher's Tory populism was made possible by the defection of many skilled working-class voters in England. But their Scottish counterparts stayed loyal to Labour, as shown by the 1979 electoral defeat of Teddy Taylor, her most enthusiastic Scottish acolyte. He was a dedicated constituency MP which, for fifteen years, enabled him to hold on to a seat that was strongly working-class in character. His successor, John Maxton, nephew of the pre-1945 radical, was Oxford-born. Throughout the 1980s and 1990s, Labour became the preferred party of the middle-classes in Scotland by a commanding margin. It

made sense. Public sector professionals dominated the middle-classes. They felt strong attachment to institutions like the British welfare state which appeared likely to fall under threat if the Thatcherite revolution deepened. Since they looked to a United Kingdom-wide job market for advancement, Scottish Nationalism held relatively few attractions for them.

The Party had capable middle-class leaders who would almost all have gone two decades later when devolution finally arrived. One of them, John Smith, the architect of the devolution legislation of the 1970s, was asked about the importance of his national identity shortly before he became the leader of the Labour Party:

Sue Lawley: 'You're Scottish. How important is that to you?

John Smith: Oh it's very important, I think ... I live in Scotland, I'm very much born and brought up there, I like it very much. I've got a deep loyalty to Scotland and I suppose I think the Scots are *the* people of the UK and I'm not saying this with prejudice to the others but I feel we have the most developed sense of this. I feel that these days anyway ...'[6]

Donald Dewar, another West of Scotland lawyer, would play the pre-eminent role in the second act of the devolution drama in the 1990s. His by-election victory at Garscadden in 1977 had halted the SNP advance. However, he was a cultural Nationalist, very knowledgeable about the art and history of his native land—but never a political separatist. He had also been committed to a devolved Scotland right through his political life which bestowed credibility upon him. The BBC's Brian Taylor summed him up as:

'... highly intelligent, extremely witty and with a range of observation and understanding far beyond the narrow party focus occupied by so many in politics. Dewar is a character forged by his easily tolerable foibles. He is a quite remarkable blend: a professed pessimist, perhaps, without remotely being a misanthropist. An admirer of humanity, alert to its faults.'[7]

By the end of the 1970s the SNP had been pushed back to the margins with a mere two MPs. It had failed to establish a power-base in any one region or win over any particular social grouping, institution or age-group.[8] It enjoyed some standing among several Edinburgh merchant bankers who would remain associated with the cause in the lean years but Scottish capital was deaf to the Nationalist drumbeat.

In 1979, the SNP even stood a candidate against Jim Sillars, who had quit British Labour to form a pro-independence Scottish Labour

Party in 1976. It soon proved to be a tactical mistake. The party became an arena for clashes between middle-class ideologues and soon succumbed to the infiltration of Trotskyites. The SNP challenge in Ayrshire South ensured Sillars' defeat and the relegation of a man who perhaps could have urged working-class voters to look with more sympathy at nationalism in the early years of Thatcherism.

In 1975 the Scottish Office economist Gavin McCrone had written that 'If, in five years' time North Sea oil is contributing massively to the United Kingdom budget, while the economic and social condition of West Central Scotland continues in the poor state that it is in today, it would be hard to imagine conditions more favourable to the growth of support for the Nationalist movement.'[9]

By the end of 1980 inflation in Britain stood at fifteen percent, unemployment was 8.8 percent and manufacturing output had fallen by nine percent. A quarter of British manufacturing would be gone by the close of the Thatcher era, as high interest rates discouraged industrial investment and a high-valued pound throttled exports. It was the most severe economic downturn in half-a-century.

At the start of the year, Jim Sillars (soon to join the SNP), expressed his belief to a Scottish writer that: 'Civil disobedience will make Scotland ungovernable within three to four years ... If Scotland votes Labour at the next general election and gets another Tory government, then the forces of necessity will drive people to endorse our campaign.'[10] However, in the 1983 general election, the Nationalists won just two seats, only came second in seven others and lost fifty-three of their seventy-one deposits.

Gordon Wilson, the party's somewhat under-valued leader in that dismal decade, recalled that the Nationalists, 'went mad' in the aftermath of the 1979 referendum and general election. Policies on devolution, on Europe and NATO were altered. Wilson said the party which he led had become 'anti-everything'.[11] A noisy splinter group had been formed in 1978: *Siol nan Gaidheal* (Seed of the Gaels) was deeply anti-British and opposed to the kind of compromises the SNP appeared to be entertaining. Its members were later expelled from the SNP and within a decade the body had disbanded.

What helped to prolong the electoral weakness of the SNP, was the rise of the SDP-Liberal Alliance. This anti-Tory reformist party was able to make a strong impact across a much wider range of Scottish seats than the SNP was capable of doing. The numbness of the profes-

sional classes to the SNP has been somewhat overlooked as an obstacle impeding its rise. Normally, a party pressing the claims of a stateless nation for independence can rely on strong middle-class support, if the country is urban with large professional classes. Scotland is one of the most urbanised societies in Europe, but the SNP found converting urban professionals to its cause a thankless task. Edinburgh, strongly bourgeois in character, was stony ground for the SNP until 2007. But this is perhaps less a verdict on nationalism and more a sign of the detachment of the Scottish professional classes from politics. The legal and financial professions had been satisfied with the considerable freedoms they enjoyed to puruse their activities. A large state sector had grown up which became attached to the Parliamentary Left but was often debarred from activity in politics. The detachment of the middle-classes from politics stretched back in fact to the dawn of electoral democracy. During the era of Liberal ascendancy, MPs for Scottish seats were often English lawyers. Following the restoration of Tory fortunes after 1918, the landed aristocracy was much more prominent than urban professionals among MPs, a factor inhibiting that party in the long-term. Their visibility suggests that the image of Scotland as a stronghold of democratic egalitarianism may be overdone. The New Zealand historian H.J. Hanham, writing in the 1960s, claimed that it 'is the sense of social hierarchy that the outsider notices, not the native democracy'.[12] Thirty years later, Thatcherism made Scotland appear far more egalitarian than England to many outside commentators.

Adherence to the Parliamentary Left was a gesture of defensiveness not radical defiance. In some parts of Scotland workers reacted to factory closures with sit-ins and occupations. A then unknown twenty-eight-year-old SNP activist, Alex Salmond, produced a pamphlet called *The Scottish Resistance* which was a compendium of work-place occupations, and with it was able to reach out beyond full-time union officials to shop stewards.[13] But the party lacked the confidence to engage in unconventional political acts that could demonstrate the lack of legitimacy of the Tories in Scotland. It had succeeded in making nationalism palatable for the Tory-dominated North-East of Scotland, a region which had not previously been known for its political volatility. Its most solid support base appeared to be among voters afraid of militant agitation of the kind associated with Arthur Scargill and the Trotskyite campaigner Tommy Sheridan. Accordingly, bold

and imaginative gestures like the snatching of the Stone of Scone in 1950 were absent from the 1980s when the SNP was led by Gordon Wilson, a low-key solicitor who had his hands full trying to preserve unity in a party traumatised by the dashing of its political hopes at the end of the 1970s.

Support for the SNP fell from eighteen percent in 1979 to eleven percent in 1983, rising only to fourteen percent in 1987. But, in the 1980s, nationalism, far from fading out, began to influence the thinking of the rest of non-Tory Scotland—but with the SNP a bystander. After 1987, Donald Dewar, the shadow secretary of state for Scotland described Labour's plans for devolution as 'Independence in the UK'. Dewar was a mixture of the patriotic visionary and the calculating urban politician. In October 1988, he endorsed the proposed Constitutional Convention, a civic and cross-party body campaigning for the establishment of an elected Scottish Assembly, declaring in a speech at Stirling University that: 'Scots are going to have to learn to live dangerously for a while.'[14]

Upon being established in 1989, the Convention declared that sovereignty in Scotland lay with the Scottish people and not with Westminster. It was the culmination of the efforts of the Campaign for a Scottish Assembly that had been set up in March 1980 following the failure of Labour's devolution scheme. It provided a forum for home rulers from several parties to keep the cause of self-government alive.[15] After Labour's third consecutive defeat in 1987 it invited Professor Sir Robert Grieve to chair a committee of prominent Scots to explore how the democratic deficit could be overcome. The Constitutional Steering Committee deliberated between January and June 1988 and in July 1988 a document, largely composed by Grieve and Jim Ross, the retired civil servant who had drawn up the devolution legislation a decade earlier, was released.[16] A Claim of Right for Scotland questioned the legitimacy of the Conservative government to rule over Scotland with its flimsy electoral base. It stated: 'We hold ourselves fully justified in registering a general Claim of Right on behalf of Scotland, namely that Scotland has the right to insist on articulating is own demands and grievances rather than have them articulated for it by a government utterly unrepresentative of Scots.'[17] The Claim of Right obtained the endorsement of the General Assembly of the Church of Scotland in 1989. Its Church and Nation Committee quoted the late Judge, Lord Cooper, who, in a 1953 judgment on John McCormick's

attempt to drop II from the new Queen Elizabeth's title, stated: 'The principle of the unlimited sovereignty of parliament is a distinctly English principle which has no counterpart in Scottish constitutional law.'

It is unlikely that devolution would have been such a priority if Thatcher had been deposed by her party colleagues not in 1990 but in 1982 or 1983. But her luck in winning a short and extremely risky war with Argentina, and the disunity of her opponents to the left, enabled her to overturn the post-war consensus in key respects.

Contrary to received wisdom, her economic policies were in some ways as short-sighted and statist as those of her chief opponent on the left, the miners' leader, Arthur Scargill. North Sea oil was used to redress a mounting balance of payments deficit as Britain started to import more industrial goods than she exported. It would also pay for the burgeoning dole queues which had been a direct consequence of the deflationary policies that marked Thatcher's first term. Whereas Norway followed a low-depletion policy in order to husband its hydrocarbon wealth, there was a rush by London to extract both oil and gas as speedily as possible. Over 150 million oil and gas tons were extracted until 1988 without the energy windfall being used to pioneer economic innovations that could provide jobs and overall security for the densely-populated island.[18]

The Tories, in power for eighteen years, were prepared to offer Scots either the unaltered Union or else independence if they chose to cast their votes for that option. Malcolm Bruce, the Scottish Liberal Democrat leader complained: 'If Scotland votes for separation, it can have it. But if it votes for reform, it can't. Where's the democracy in that?'[19] By 1987, the Tories were compelled to put aside standard democratic procedures when the party's MPs in Scotland slumped from twenty-two to ten. The Scottish Select Committee in the House of Commons was suspended in order to enable the Scottish secretary, Malcolm Rifkind, to appoint a ministerial team.[20]

Devolution was acquiring new significance for the Scottish Left, much of which had been sceptical about abandoning common British arrangements for governance. It was seen as a way of insulating Scotland from some of the unsettling neo-liberal reforms of Margaret Thatcher. Scottish local government, dominated by Labour, exemplified the shifting mood. In the 1970s Labour councillors had been openly sceptical about devolution but in 1986, the Convention of Scot-

tish Local Authorities (COSLA), representing all Scottish local authorities, gave its backing to the idea of a Scottish Assembly for the first time, by eighty-nine votes to twenty.[21] Many members were unnerved by the Tory creation of an internal market in the NHS. This involved setting up a whole new tier of quangos (quasi-autonomous non-governmental organizations), that is, public bodies outside the civil service and local government, to oversee the changes. The volume of appointments made both to Health Boards and NHS trusts almost overwhelmed civil servants and their political masters.[22]

By the end of the Tory period in office, across Britain 400,000 officials had been recruited to manage public service institutions at local level. Centralist quangos multiplied as well and the politicised nature of some of these appointments did much to undermine the legitimacy of the state.[23]

The community charge, or poll tax, imposed on Scotland in 1989, a year before it was introduced in England and Wales, was deeply resented. Local government finance had become a vexed issue, especially in Scotland. Thatcher believed that 'rates', a tax on property, was an attack on the principle of self-improvement. Revaluation of property invariably meant higher bills for millions of homeowners and businesses. In England and Wales, such revaluations could be postponed, but this was not possible under Scottish procedures. Beleaguered Tory politicians were faced with a revolt from their supporters. They had long been resentful of the fact that council rents which they helped to subsidise were around half those in the south.[24] It was thanks to the lobbying of ordinary Conservatives that the new tax would be introduced in Scotland first. Alarm mounted among pragmatic Tories when it emerged that over eighty percent of those affected across Britain would be paying more. Scottish Tories demonstrated their isolation by not being conspicuous among those who tried to introduce a system that bore some relation to people's ability to pay. By 1990, 700,000 summary warrants for non-payment of the tax had been issued in Scotland. Over the next three years, no less than 2.5 million summary warrants were issued for non-payment of the poll tax in a country of some five million people.[25] Tens of thousands of people dropped off the electoral role. By 1991–92, the third year of the poll tax, local authorities were raising only 75.6 percent of the money they needed to fund their budgets.

Thatcher was removed from power for this huge miscalculation. In 1994 her successor, John Major, abolished the local government structure which had been imposed by a Conservative government twenty years earlier. A two-tier structure of regions and districts was replaced by thirty-two unitary local authorities in which it was assumed that the Tories would have a greater chance of exercising influence. Ironically, this smoothed the path for devolution. Strathclyde, the largest of the regions, contained over half the Scottish population. Any devolved Parliament would not have found it easy to coexist with such a municipal colossus. Nevertheless, it was dismantled without taking into account the wishes of local citizens who had resoundingly rejected the Conservatives in successive elections. In 1992, Charles Gray, the last leader of Strathclyde Regional Council and described in the press as 'Scotland's most powerful local government politician', issued a measured but unmistakable call for the use of 'legal civil disobedience' as a last resort. He said: 'there may come a time, if the government remains totally intransigent to the wishes of the Scottish people, when we may have to step across the line and live dangerously.'[26]

It was not just Thatcher's unyielding centralism which alienated mainstream voices in institutional Scotland, but also her increasingly radical economic agenda. Chancellor Lawson visited Scotland and criticised its inhabitants for their continuing attachment to the 'dependency culture'.[27]

The whole idea of an 'enterprise culture' centred on unfettered economic individualism was abhorrent to both the Calvinist and Catholic traditions in Scotland, according to the historian, David Marquand.[28] The 1980s was an era when previously sharp religious tensions diminished in intensity due to the weight of the political heresy being imposed from London. In the past, Presbyterian influence had ensured that a sense of Scottish identity largely excluded working-class Catholics. Just as race had created alliances between poor whites and the overseer class in the post-Civil War American Deep South, in Victorian Scotland and beyond communal hostility to the Irish Catholics had encouraged a similar trans-class alliance of Protestant workers and their employers.[29] In Northern Ireland, the sectarian battle-lines had led to a horrifying undeclared civil war lasting for decades. At its height in the 1980s, Scotland put aside its own religious factionalism and closed ranks against what seemed like a new version of English overlordship.

In 1988, Thatcher attended the Scottish Cup final at Glasgow's Hampden Stadium between Celtic and Dundee United and was resoundingly booed by many of the fans. She was greatly surprised by the number of Irish tricolours. She was also surprised by the reaction of ministers at the General Assembly of the same year when she delivered a carefully prepared speech arguing that her free market policies were steeped in a brand of Christian ethics that had once been influential in Calvinist Scotland. What became known as 'the Sermon on the Mound' would be one of the standard points of reference for the Thatcher era. She insisted that the real Scottish virtue was rugged individualism, but even before the era of welfare collectivism the evidence for such a claim was far from compelling. One historian has argued that during, as well as before, the twentieth-century, Scotland was dominated by entrenched interest groups beholden to a corporate ideology.[30] Neal Ascherson, drawing on evidence not just from home but especially the Empire, also refutes Thatcher's image:

'With few exceptions, Scottish enterprise has never been individualistic. On the contrary, it has been a matter of small authoritarian oligarchies, tightly controlling their own recruitment and run as a disciplined collective for the benefit of the group—usually a family, sometimes a particular district, and often both'.[31]

The Presbyterian Church's chief policy-making body itself declared in 1989:

'It is our conclusion that it is not possible to resolve the question of the democratic control of Scottish affairs and the setting up of a Scottish assembly apart from a fundamental shift in our constitutional thinking away from the notion of the unlimited or absolute sovereignty of the British Parliament towards the historic and reformed constitutional principle of limited or relative sovereignty.'[32]

The idea of civic nationalism was promoted by Scotland's civic and media commentators to give an intellectual coherence to the nation's rejection of Thatcherite values. The trade-unions, churches, opposition parties, and local government—basically those who had been frozen out of the governmental decision-making loop by the Conservatives—took on the task of speaking for civic society.[33] Perhaps appropriately it was Canon Kenyon Wright, secretary of the Scottish Churches' Council who became the main public voice of the devolutionists.

Kenyon Wright was aware of the limitations of the campaign for home rule. In a refreshingly open memoir, he quoted a Scottish news-

paper which had written in 1995 that 'The politicians leading the campaign for constitutional reform should learn the lesson. Too many of their decisions have been about constitutional mechanics, not enough about how a Parliament would enable Scotland to nurture the things it holds in regard, for example education. It is up to them to put passion back into the constitutional debate.' This had been written the day after a huge public march in Glasgow protesting against school cuts which had mobilised the crowds that pro-devolutionists had rarely been able to muster.[34]

The high-point of the devolution campaign occurred on 30 March 1989 when fifty-eight Labour and Liberal Democrat MPs signed a Covenant and organisations from across Scottish public life formed themselves into the imposing sounding Scottish Constitutional Convention. The main absentees were the SNP and the Conservatives. The only non-corporatist right-of-centre body represented was the Federation of Small Businesses. To one English sympathiser, it recalled the dissident Czech manifesto, 'Charter 77' as well as two British forerunners—the People's Charter of 1838 and 'Magna Carta' of 1215.[35] By 1994, the original 348 signatories had swollen to 44,000.

The SNP excluded itself in a gesture of tactical ineptitude which probably limited the extent of any recovery in its electoral fortunes. In 1988 it won 21.3 percent of the vote in the district elections, almost double its vote four years before, and it maintained that degree of support into the early 1990s.[36] This was a time when the SNP was seeking to outflank Labour by campaigning actively against Thatcherite policies, notably the poll tax, all of which made it harder for its Labour opponents to denounce its members as 'Tartan Tories'. In 1989 concessions were made to entice the SNP to join the Constitutional Convention. Its terms of reference were changed to include an assertion of 'the right of the Scottish people to secure the implementation of [that] scheme'. It was already clear that it would proceed by consensus so, despite its strong presence, Labour would not be able to steamroller proceedings. But Jim Sillars, who enjoyed unprecedented influence in the party due to having won Glasgow Govan in a by-election in 1988, abruptly announced that the SNP was not taking part. Gordon Wilson believed the SNP leadership had been outwitted by Labour. He told the journalist Brian Taylor that Labour 'had succeeded with their maximum objective, which was to freeze us into an extreme position'.[37] At the SNP's national council in March 1988, Isobel Lindsay, a well-

known party member who had become prominent in the Convention, was heckled and attacked as a traitor. She had warned previously that if the SNP rejected the Convention, it would have 'alienated the very sections in Scottish politics and society which have been moving towards us'.[38] She declined to renew her party membership after Salmond accused her of being more Unionist than top establishment figures in Labour and Tory ranks.[39] The SNP's poll ratings started to slide once its aversion to cooperating with other non-Unionist forces had become clear.[40] Labour had outmanoeuvred the SNP and contained the challenge from the Nationalists which had opened up after their win in Govan.[41]

Sillars failed to hold Govan in the 1992 general election. According to a Labour admirer, he made a mistake by writing regularly for *The Sun*, whose hostility to Labour and trade-unionism offended traditional Labour voters in Govan who had swung to Sillars in the 1988 by-election.[42] Sillars then quit active politics, denouncing the voters as '90 minute patriots' with an immature attitude to the key issues confronting Scotland.

Inside the Convention, the SNP might have been well-placed to strengthen its ties with civil society. About eighty percent of Scotland's MPs and MEPs attended its meetings and fifty-nine of Scotland's local authorities nominated representatives to attend.[43]

But Labour's failure to return to power in 1992 took the wind out of its sails. Kenyon Wright said it would have to 'take stock' and a period of drift followed. According to James Mitchell, 'the limitations ... of the Convention were fully exposed. It had never been a public body which could call on popular support. It had failed to devise a strategy to deal with the return of a Conservative government, and it had made only limited impact in devising a scheme of Home Rule. The last role should have been its primary if not sole function.'[44]

In 1992, the Scottish Tory vote went up from 24 to 25.6 percent of the total just as many of its opponents were predicting massive losses for the party. The anti-Tory parties had not been enthusiastic about going out to campaign on the devolution issue, whereas, during the final years of Tory rule, Michael Forsyth was ready to try and whip up popular suspicions about the 'Tartan tax' planned by his opponents.[45] Prime Minister John Major's Scottish viceroy claimed that if the Convention's plan to arm the devolved government with the power to vary the basic rate of income tax by up to three pence in the pound ever

happened, Scots would end up with lighter pay packets than people in England doing the same job. It would be a tax on being Scottish, he argued.[46] He also pulled off various theatrics as Scottish secretary before going down to defeat in his Stirling seat in 1997. One of the boldest was to return the Stone of Destiny to Scotland on St Andrew's Day in 1996 with great pomp and ceremony. Three of the original four conspirators who had spirited the emblem of Scottish nationhood away from Westminster Abbey on Christmas Day in 1950 were present at the ceremony.[47]

These desperate gestures of Unionist nationalism showed that Forsyth was well aware that his predecessor as Scottish secretary Malcolm Rifkind's dismissal of devolution was the height of complacency. He must also have known that the number of people describing themselves as 'Scottish' and 'more Scottish than British' in opinion polls had been steadily increasing since 1987, while the number describing themselves as 'British' and 'more British than Scottish' was plummeting.[48]

A Tory devolutionist in the 1970s, by the time he was Foreign Secretary in the mid-1990s Rifkind had declared, that the result of the 1979 referendum showed that 'we got it wrong … If two-thirds of Scots aren't interested in supporting devolution then there is no basis for fundamental constitutional change which would affect the United Kingdom as a whole and does not even have support in Scotland.'[49]

But the governments he had served in had undermined the belief in 'the enduring values of a single British state'.[50]

Scottish Conservatives finally reached their nemesis in May 1997. Their percentage of the vote was a derisory 17.5 at the general election of that month. They had paid a steep electoral price for standing against the changing political tide in Scotland. The party had been consumed by infighting ever since the last years of Thatcher's rule when she imposed the radical free-marketeer, Michael Forsyth, on an already dispirited and divided party. He sought to sideline consensual Tories and he even brought in a young US right-winger, Grover Norquist, to try and turn the Scottish Tories into a lean, mean fighting machine. Norquist had championed low tax policies in the Reagan era, and once long-departed from Scotland enjoyed the distinction of persuading a large part of the conservative political base in the USA that George W. Bush was the best candidate for the Republican presidential nomination in 2000.

The new Labour government proposed a Scottish Parliament which would have greater powers than the Assembly envisaged in the late 1970s. Its powers would extend to economic development, universities, important transport matters, financial assistance to industry and the police, as well as the ability to vary the basic rate of income tax. The 1990 Convention blueprint for self-government, *Towards Scotland's Parliament*, had envisaged a financing scheme based on assigned revenues but this had been removed by 1995 as an internal Labour memo of 17 November of that year showed. In a handwritten note from Jack McConnell, the party's General Secretary in Scotland, to George Robertson, Labour's shadow Scottish secretary, it was recommended that financing would be through a block grant and that Parliament would have the ability to raise or lower the standard rate of income tax by three percent for Scottish resident tax payers. This pledge was 'put in more restrained and acceptable language' than before with 'other taxation specifically ruled out'. McConnell's aide-memoire summed up other changes, including the designation of immigration as a United Kingdom responsibility; the removal of references to a Scottish Civil Service; and the scaling back of the new Parliament's role in European talks, removing any entitlement of a 'right' for Scotland to lead on issues such as fisheries. McConnell concluded the memo with an undisguised note of self-satisfaction: 'Pretty impressive work, I think.'.[51] He would later be the Labour figure with the lengthiest experience in implementing the devolution scheme and as Scotland's first minister he showed a clear aversion to extending the original power, a position that arguably contributed to his party's electoral defeat in 2007.

Until 1996 Labour had indicated that a general election would provide the necessary mandate for devolution. But the 1979 debacle made many in the party reluctant to wage another referendum campaign. This was somewhat odd 'since the signatories of the Claim of Right, having celebrated the sovereignty of the Scottish people, now seemed to want to prevent the Scots expressing it'.[52] But at senior levels of the party the case for putting the proposal directly to the Scottish electorate was forcefully made in the run-up to the 1997 general election.[53] Tony Blair, who had succeeded John Smith as Labour's leader upon his death in 1994, was unsure how large Labour's majority would be despite the multiple failures of John Major's government. He was also mindful that previous attempts at transferring power not only to Scot-

land but to Ireland had met with fierce obstructionism in Parliament. Blair was reluctant to throw the Tories a potential lifeline by making the tax-raising clause merely dependent on the outcome of a Westminster election. This would enable his opponents to argue that the era of a spendthrift Labour government was far from over. But a referendum would strengthen the legitimacy of the devolution scheme and reduce the likelihood that the Tories would seek to wreck it by Parliamentary obstructionism.

The way it was done went down badly in Scotland. Without consultation with the Constitutional Convention or its own Scottish leaders, New Labour (as the party now preferred to call itself) announced, on 26 June 1996, that it would hold a referendum on devolution. The story was leaked in advance to the press and it led to fears that Tony Blair was walking away from the devolution agenda that had been firmed up under his predecessor.[54] Several months of confusion followed in which Labour found it difficult to agree on whether there would be a second question on tax-raising powers. Tony Blair earned the distrust of party heavyweights on the executive who agreed with him on most other issues, because of his approach to devolution. A more transparent and consultative approach could have avoided the public wrangling and displays of Labour incoherence which gave the press such a field day.[55]

The decision to hold a referendum took some senior Labour figures in Scotland by surprise and John McAllion, a front-bench spokesman, resigned upon being told by the Scottish Lib Dem leader that it had been announced.[56] It then proved difficult to obtain majority support within the ranks of Scottish Labour itself for a second question on tax-raising powers, and this was only secured by the narrowest of majorities.

The referendum was held on 11 September 1997, which happened to be the seven hundredth anniversary of William Wallace's victory over the English at the battle of Stirling Bridge. The SNP backed the devolution scheme (except for Jim Sillars and Margo MacDonald, two contrarians who urged abstention) and the referendum was a rare episode of cooperation with the Labour Party. Alex Salmond spelled out his attitude to the new Parliament, declaring in May 1999: 'Making a success of running some of our affairs is the best grounding for people wanting to run ALL our affairs.'[57]

Sean Connery, the party's most famous supporter, addressed a cross-party rally in Edinburgh on the Sunday before the referendum, telling the audience: 'This entire issue is above and beyond any political party.'[58] Alex Salmond was on record as saying that devolution was his second preference after independence. Many SNP sceptics were troubled that a party of independence was now arguing for devolution. They assumed that devolution was likely to impede the chances of independence ever being realised, but were persuaded by pragmatists that it could offer a stepping stone towards complete self-government if handled in an astute manner.

On 21 August Bruce Patullo, the Bank of Scotland Governor, attacked the proposed tax power for the Scottish Parliament.[59] This was seen as the most significant business intervention. But it was no longer possible to view the pace-setters of the business community in Scotland as Unionist in their reflexes. Both the insurance companies Standard Life and Scottish Widows issued statements that they were neither for nor against a Scottish Parliament.[60]

On 11 September 1997, two questions were put to the Scottish electorate: Are you in favour of a Scottish Parliament? And should it have tax-varying powers? To the first question, the reply was 'Yes' 1,775, 045, 'No' 614,000; to the second, the answer was 'Yes' 1,512, 889, 'No' 870. 263. This was a large vote in favour of devolution but the turnout at 61.4 percent was actually lower than in 1979 at 63.8 percent.

The highest 'Yes' votes, of eighty-four and eighty-five percent, were returned by Glasgow and West Dunbartonshire, parts of Scotland which Edwin Muir had described as denationalised in character sixty years earlier.[61]

The Scotland Bill was introduced to the House of Commons on 18 December 1997. 'In well under 300 days we have set in train the biggest change in 300 years of Scottish history,' Dewar declared.[62] His bill contained a clause expressly entrenching the supremacy of the Westminster Parliament over the one in Scotland. But politically it was unlikely to be subordinate since, under the Scotland Act, it would be representing the people of Scotland and a new locus of political power would in fact be formed.[63] Lord Sewel, a Scottish Office minister, told Parliament in July 1998 that '... we would expect a Convention to be established that Westminster would not normally legislate with regard to devolved matters without the consent of the Scottish Parliament.'

The constitutional expert Vernon Bogdanor believed in 1999 that 'the relationship between Westminster and Edinburgh would be quasi-federal in normal times and unitary in crisis times. For the formal assertion of parliamentary supremacy will become empty when it is no longer accompanied by a real political supremacy.'[64]

The bill went through all stages in both Houses of Parliament to receive the royal assent on 19 November 1998. Much careful preparation had gone into it and the endorsement provided by obtaining the consent of a majority of the Scottish people dissuaded Tory opponents from attempting to rip it apart on the floor of Parliament. The final Act substantially reflected the content of the original White Paper and it had the backing of a majority of English MPs.

Dewar had a great eye for detail which proved an asset during meetings of the Cabinet Committee to decide the terms of the devolution settlement. He managed to obtain for Scotland a Parliament with exclusive legislative responsibility in most fields of domestic policy.

According to historian David Marquand, this was a remarkable document 'judged against the background of the previous 300 years of British history ... It was far more innovative than the previous devolution statutes for Scotland and Wales and departed far more radically from cherished British constitutional principles.'[65] But it contained none of the fiscal levers required for significant social and economic change, apart from the entitlement to vary income tax. There were clear anomalies, with Holyrood having responsibility for justice but not for drugs or firearms.[66] The executive lacked the power to raise loans, one which even the tiniest local council possessed.

There were two important dissimilarities with Westminster. The Parliament would be run on a four-year fixed term basis unless after twenty-eight days no first minister was able to enjoy majority support, and MSPs voted for an earlier dissolution by a two-thirds majority. It was also to be elected under an additional member system (AMS). Under this system, an elector casts two votes. The first is for a candidate to represent a constituency, while the second is for a party. Once the constituency seats are filled, the other seats are allocated to candidates on the party lists so as to ensure that parties obtain a share of seats roughly proportional to their percentage of votes. This system retains the territorial link between members and constituencies while ensuring proportionality which the system for election to the House of

Commons, popularly known as 'first past the post', has never been able to do.

This was meant to allay fears that the new Parliament would be dominated by a Labour Party fixated on the concerns of central Scotland, particularly the Glasgow conurbation. Beyond the populous Central Belt support for devolution in the 1970s had often been shallow. It was feared that people in rural and small town communities could be easily persuaded by opponents of devolution that rule from Edinburgh would be just as remote as rule from London.[67]

A proportional election system seemed to rule out the likelihood of the SNP coming to the top. Asked in 1997 if the precise electoral system chosen had been designed to thwart such an eventuality, the Labour Party's Scottish general secretary, Jack McConnell, candidly remarked 'Correct'.[68]

The Nationalist campaign in 1999 had more resources than any previous one and was more professional, but it could not match the combination of Labour's Scottish and London organisations when working in tandem.[69] ICM polls and focus groups for the *Scotsman*, and anecdotal evidence from election doorsteps, indicated that Alex Salmond's intervention in the Kosovo crisis (see Chapter 7) had been a serious error. It indicated a failure of the SNP to reflect Scottish opinion or display progressive and humanitarian concern to the wider world. Neither did the SNP's plan to raise tax by one percent go down well. Meanwhile, the vast New Labour spin machine had moved to Scotland and turned its attention to the Nationalists. 'Millbank on Clyde', as it become known, acted with its then efficiency, generating the message that 'separatism' meant a messy and expensive divorce from the rest of the United Kingdom.

But in 1999, the SNP's voting performance was better than its 1997 general election result. They obtained thirty-five seats instead of the twenty-eight they would have won had the 1997 result been repeated.[70] Labour was still basking in popularity and it was an indication that the SNP was predisposed to do well in a political system more Scottish in its focus than ever before.

'The Scottish Parliament, which adjourned on the 25th day of March in the year 1707, is hereby reconvened.' With these words Winifred Ewing, as 'mother' of the devolved Scottish Parliament, opened its first sitting after the swearing in of MSPs on 12 May 1999. The election had produced a gender-balanced Labour group with twenty-eight males and

twenty-eight females. The Nationalists returned twenty-eight men and fifteen women. The Lib Dems comprised fifteen men and two women, while for the Tories there were fifteen men and three women.[71]

On 13 May 1999 Donald Dewar was elected first minister. This was appropriate since he had argued for home rule when the cause met with plenty of disfavour within the Labour movement. It remained to be seen to what extent Labour would be willing to innovate and surrender central control. Polls showed a preference for a new political start, not just for the old methods of backroom politics to be transferred from London to Edinburgh.

The outcome of the proportional election system was that no party had the mandate to govern alone. A coalition was formed between Labour and the Lib Dems. The smaller party had been irrelevant in much of industrial Scotland since the 1910 election, when it had dominated Glasgow politics only to be supplanted by the Labour Party and a revived Unionist Tory party in subsequent generations. The new *Partnership for Scotland* was the first enduring coalition in peacetime British politics since 1922.

In retrospect, Labour enacted devolution on defensive grounds: 'Devolution was supposed to stall the SNP... But it was also intended to protect Scotland from social policies enacted by Westminster which were thought inimical to the interests and ethos of Scotland.'[72] Complacency was not hard to find in Labour ranks, suggesting the impetus behind change would be limited. George Robertson had said: 'Devolution will kill the Scottish National Party stone dead.'[73] But earlier polls in 1999 suggested a lead for the Nationalists over Labour of as much as fourteen per cent.[74]

Voters were volatile and would remain so. A Gallup survey in April 1999 found twenty-five percent of Scottish voters wished total independence as their preferred option with sixty-nine percent preferring a Scottish Parliament with substantial powers. This was the preferred option even of thirty-six percent of voters intending to vote SNP.[75]

Jack McConnell, soon to be in charge of the devolved institution, summed up Labour's complacency, indeed inertia, when he wrote in 1999:

'By 1997, Labour's re-invention was so complete that political dominance stretched way beyond an electoral landslide. The battle of ideas had been won and the opposition was marginalised. Key to this success was not just that policy had been refined and modernised but the party had been too.'[76]

Given such a mood, it is hardly surprising there was a failure to prepare for a challenging new order of responsibilities. This would have involved redefining the relationship between London Labour and Scottish Labour; also ensuring that people of calibre were chosen in large numbers to represent Labour at Holyrood. Blairite modernisers were placed in charge of a panel that interviewed all candidates to see if they were suitable. This selection committee started a damaging trend by ensuring that the party lists were dominated by colourless and uninspiring figures, who had come up through local government or else the party machine. Left-wingers and figures from the ultra-devolutionist wing of the party, such as Ian Smart, Bob McLean, and Isobel Lindsay, were excluded, people who could have injected the enthusiasm and commitment for devolution which often appeared lacking during the years of Labour rule that lay ahead.[77] Dewar even told a Labour gala dinner in 1998 that the veteran Labour figure Dennis Canavan 'was not good enough'.[78] One minister turned to the journalist Brian Taylor and asked: 'How did we end up with so many numpties?'[79] The decision to reject Dennis Canavan exploded in the party's face when he stood as an independent in Falkirk West, defeating the official Labour candidate and serving as a much respected MSP for the next eight years.

Scottish Labour's complacency meant there was no sense that its continued standing would depend on making devolution work. It had not known the rejection and decline which had overcome the English party in the late 1970s. Hostility to the unions was less marked than in England because of the large public sector and the unions retained their influence inside the party after this had been eroded in England. The importance of local government was also much stronger in the Scottish Labour Party.

But Labour would need to try harder to retain the loyalties of its broad support base. The era of the centralised Union had ended and a new one requiring a different set of political skills was getting underway. Failure risked the possibility that many people would prefer a completely post-British world, one in which Labour might have very little place.

Part Two

5

DEVOLUTION UNDER LABOUR

In 2004, the then first minister, Jack McConnell, asked for Jim Sillars' help as he struggled to prepare a speech to mark the opening of the Holyrood Parliament on 9 October. It was therefore the thoughts of one of Scotland's most eloquent Nationalists which went into his speech:

'... the building is not the Scottish Parliament. This magnificent building can inspire admiration for its design and its detail but it cannot, by its mere existence, influence opinions or judgments on public policy. It is we who are elected to serve who form the human institution that is the Scottish Parliament. It is how we perform our duties, how we advance or inhibit the progress of this nation, in our conduct and the decisions we make, that will chart the future course of Scotland.'[1]

Labour squeamishness about Nationalist symbols meant that it missed the chance to demonstrate how the work of the Scottish Parliament since 1999 had contributed to national progress. It continued to be fearful of patriotic symbols, sometimes to absurd degrees, rather than realising that these could be expropriated and were nobody's monopoly. But among the electorate, the mood was beginning to change. Whereas in 1997 only two in five Scottish voters believed that parties were only interested in people's votes, by the time of the Scottish Social Attitudes Survey of 2000, nearly three quarters took that view.[2] It found greater expectations in Scotland: sixty-six percent said

the system of governing Britain could be improved quite a lot, compared with sixty-one percent in England 2000).[3]

The political scientist John Curtice found that: 'compared with 1997 when Labour first came to office, Scots are less likely to think that their political system can respond to the demands they make of it, less willing to trust politicians and political institutions to make the right decisions, and more likely to think that Britain's system of government is in need of improving.'[4]

The credibility of the party governing Scotland was not helped by finding itself still a subordinate element in the British party with few powers of initiative. The case for this was vigorously made by Matthew Taylor, a former assistant general secretary of the Labour Party. In May 1999, he openly argued that the emergence of distinct Scottish Labour policies would jeopardise the presentation of a uniform British Labour 'brand' and that devolution did not give Scottish members the right to create a separate political platform.[5]

Perhaps it was hard to challenge this view when the central party machine appeared so effective, but resistance to strategy and presentation being devised in London mounted as New Labour's organisational prowess declined due to falling membership, internal splits and the drying up of funds.

Disconcertingly, Labour appeared to lack an ambitious policy-making agenda once it took charge of the Scottish government. Labour's goal was equality and the end of poverty, but the beneficiaries of its largesse are not politically mobilised. Too often Labour has preferred a dependent support base which should know its place and be grateful for what it receives. Resentment inevitably bubbles up especially when the possessors of such an arrogant mindset are revealed as people sometimes devoid of talent and integrity. Both in government and opposition, rebellions break out at by-elections in working-class seats which Labour loses, or only narrowly retains.

After 1999, Labour also clung to the image of being an 'ideas-free zone' which had been its hallmark when Willie Ross was its dominating figure. John Mackintosh had written as early as 1976:

'... the Labour Party in Scotland has aged and lost dynamism. Its one absorbing interest has been jobs (saving rather than creating jobs) and capital projects such as schools and houses. But the original idealistic vision of a kind of society socialists wanted, of the point of building schools and

houses, tended to fade out and now the social purpose of the party is far from clear.'[6]

Competent figures in terms of honouring constituency duties who shun executive responsibilities have been the norm. The career of someone like Michael Martin MP is not atypical except for its ultimate destination. By 2009 this former railway worker had served for thirty years in Parliament, the last eight of which as Speaker of the House of Commons. His judgments have occasionally been questioned, as in 2008, when he allowed the police to search the office of a Conservative shadow minister, Damian Green, without a warrant. In 2002 he rebuked Ian Duncan-Smith, then Tory party leader, for raising 'party matters' during Prime Minister's Questions which suggested that he had momentarily forgotten the role of this inquisitorial aspect of Parliament. Afterwards, he reportedly described the criticism he got as 'an attack on every working-class person from Clydeside'.[7]

Speaker Martin's son Paul has represented an adjacent part of Glasgow at Holyrood since 2003. Family teams in politics are increasingly evident on all sides. But with Labour on the defensive in a crumbling regional stronghold, it is in this party that the challenge of renewal is arguably most urgently needed. By 2007, Labour's lack of an active youth base was becoming a growing handicap. As early as the 1990s young left-wingers who would automatically have joined Labour in the past were gravitating to the SNP, to the dismay of some Labour MPs. Some, such as Christine McKelvie, reached the Scottish Parliament. She has turned up regularly outside the Dungavel Detention Centre in Lanarkshire to protest at the mistreatment of asylum seekers whose request to remain in Britain has been disallowed. By the early 1990s, the SNP already had a younger age profile and a stronger presence at university than any party rival.[8] So, unlike Labour in England, the Scottish Labour Party was confronted with a strong left-wing alternative. Labour's best chance of containing the Nationalists was to deepen the devolution process and exercise existing powers in a credible manner. Arguably, it did neither, and by its second term was seen as having run out of steam. Its candidates were often not appreciably better than the SNP's despite its dominating role in Scottish politics. Figures from 2000 revealed that the petit-bourgeoisie in Scotland was nearly twice as likely to belong to the left than in England, and many from this influential and often politically attuned part of society were

Nationalist in their sympathies, which gave the party a larger pool of talent from which to draw.[9]

Donald Dewar, the prudent architect of the devolution scheme, became Scotland's first minister for just over a year. He admitted to the broadcaster Fiona Ross that 'he lacked "the killer instinct" of John Smith when it came to dealing with troublemakers, preferring to avoid confrontation.'[10] He was unlikely to confront London with the need for Labour in Scotland to cease being a branch office of the London operation in order to strengthen its credibility. Its vassal status impaired its ability to develop a clear identity and matching self-confidence as it assumed unprecedented responsibilities at Holyrood. The party lacked a man of action capable of linking devolution with more responsive government in the eyes of Scottish voters. Tom Johnston, the wartime coalition's secretary of state for Scotland, had boosted the quality of government between 1940 and 1945 by using informal authority obtained from Winston Churchill to improve social and economic conditions. Dewar was too insecure a figure, good at jousting with the Tories and the Nationalists but lacking both the vision and the control over an effective party machine, to be able to exploit the fruits of devolution to his party's advantage. He died long before the first Parliament had got halfway through its life, but if his health had been more robust it is still unlikely that he could have laid the groundwork for an effective Labour ascendancy.

The 1997 White Paper on devolution included plans for a new Parliamentary building which it was then assumed would cost between £10 and £40 million. Long-favoured as the site was the old Royal High School on Edinburgh's Calton Hill. It was an imposing neo-Greek building, central and accessible, designed by Thomas Hamilton and according to one prominent home ruler 'an outstanding example of Scotland's built heritage'.[11] But the idea fell into disfavour among many Labour figures in case it could become an icon of nationalism. Limited space was also felt to rule it out. Donald Dewar played the key role in choosing the location. Initially, he favoured a waterfront location at Leith, Edinburgh's port, described by Brian Meek of Edinburgh council's Tory group as 'the prostitutes' capital of Scotland and about as accessible as a drainpipe'.[12] Later, he opted for a new building on a former brewery site at the foot of the Royal Mile opposite Holyrood Palace.[13]

This was a curious decision for a politician who, at least through his reading habits, had shown a rare feel for Scotland's past. He went for a symbol not of existing Scotland but instead of the 'New Britain', a Catalan architect being commissioned just as New Labour was about to embark on bold policies of globalisation which opened up the economy and the labour market to waves of people and capital from elsewhere. Enric Miralles was a conceptual designer seen as one of the architectural world's most avant-garde architects. One of the five people on the selection panel was the BBC current affairs journalist Kirsty Wark. She had argued that 'the new building should not be classical or modernist on the grounds that these styles are too closely associated with dictatorship.'[14] Even though many of the public buildings of Washington DC, home to the world's oldest democracy, had been built to classical designs until well into the twentieth-century, such a view raised few murmurs of dissent.

No tough-minded Parliamentarian made it his or her business to try to halt the spiralling costs of the Holyrood Parliament. Sir David Steel, the first presiding officer, gave an impassioned defence of the project when some if its flaws became apparent, imploring: 'Courage, brothers, do not stumble!'[15] Only 17 out of 129 MSPs even bothered to take part in the visit organised for them to view the site.[16] One supporter put down complaints about the £430 million bill to 'a self-lacerating inwardness which took almost no account of vast cost overruns elsewhere'.[17] He singled out the 'adventurous new design'[18] and took consolation from the 'critical acclaim' accorded to Holyrood: the Parliament has won eight major architectural awards, including the 2005 Stirling prize.[19]

The management of the project was left to civil servants and the costly debacle suggested that there were plenty of administrative and managerial shortcomings across the Scottish Office.[20]. What resulted was a 'politicians palace' similar in appearance to a utilitarian bus station and whose inner foyer had less light than was found in a typical Highland bothy.

Perhaps the harshest criticism came from Bill Jamieson, the executive editor of the *Scotsman*, who observed in 2005:

'Scots are still struggling to come to terms with how a building of such debatable aesthetics could come to represent the devolution aspiration ... The distraught angles, the Gothic over-fussiness, the dark, depressing low concrete-ceilinged foyer as if to provide cool relief from the searing Caledonian

sun: all this looks faintly ridiculous at the foot of the splendidly Hanseatic Royal Mile ... Any sense of Scottish vernacular has been expunged. The whole shows a disrespect bordering on contempt for Scottish history, culture and sensibility.'[21]

The Holyrood affair lingered on for four years but already in 2000 the Executive had been blown off course by the Section 28 imbroglio. A fierce storm erupted after the Executive announced that it was going to scrap the 1988 Clause 22 which had outlawed providing education about homosexuality in schools, linking this with the promotion of homosexuality. Wendy Alexander, the communities minister, was responsible for this operation and it caused sharp divisions in Cabinet, particularly along gender lines. Abortion had been deliberatedly omitted from the competency of the Scottish Parliament by Donald Dewar in case it exposed such dangerous fault-lines in the Labour-supporting bloc.[22]

A 'Keep the Clause' campaign quickly sprang up in response. It was run by the media consultant and former editor of the *Sun*, Jack Irvine. He had earlier been recruited to defend a business link between the Bank of Scotland and the well-known US tele-evangelist Pat Robertson. The Bank hoped to establish a foothold in the USA by using a company owned by Robertston to sell financial services there. But a wave of protest to the link built up owing to anti-gay remarks by this former US candidate for the presidency. It culminated in Robertson declaring in May 1999 that Scotland was 'a dark land where homosexuals have incredibly strong influence'.[23] The Bank of Scotland scrapped the deal but the soundness of this claim was weakened when the tabloid rival to the *Sun*, the *Daily Record*, spearheaded a campaign for the retention of Clause 22. Cardinal Winning gave it his backing and, in January 2000, described homosexuality as 'a perversion'.[24] The Executive failed to make its purpose clear to voters. Nor was it shown, until a later backlash started, that existing guidelines on teaching materials already proscribed those advocating a gay lifestyle.

In response an alliance sprang up which mobilised Scottish opinion against the proposal. Brian Soutar, arguably Scotland's most dynamic businessman, provided the cash, Cardinal Winning the legitimacy and the *Daily Record* the publicity.[25] £1 million was ploughed into the campaign. It culminated in a referendum on Clause 22, the results of which were announced on 30 May 2000 at a press conference where Souter offered a strong defence of family values. Over a million Scots

voted to retain Clause 22. Liberals took comfort from the fact that the turnout was lower than in local council elections. The 34.5 percent who participated were well below the 71.5 percent who returned their ballot papers when Strathclyde Regional Council held a postal ballot on water privatisation in 1994. Nevertheless, the result unnerved an Executive which had been blown off course by this populist challenge during its first year of existence.[26]

Criticism came from the Moderator of the Church of Scotland and also from the left-wing icon and journalist Jimmy Reid who, writing of Brian Souter, said he 'has money but little else. He is a religious funda-mentalist and we know from bitter experience what a pain in the ass they can be.'[27] But Reid went on to admit that Souter 'spoke with far greater elegance, power and passion than many of our Parliamentari-ans in Edinburgh or at Westminster' as he announced that 86.8 percent of the more than one million Scots who had voted in his referendum were for keeping the Clause.[28]

The journalist Iain MacWhirter was angry because Parliament failed to realise that it had the power of democratic legitimacy behind it. Ministers retreated in a bid to get the populist campaign off their backs. A replacement clause was announced for Section 28 and fresh guidelines on sex education were to be made legally binding with the word 'marriage' included, steps which the government had previously said it wouldn't take.[29] A veteran newspaper editor asked a younger colleague at the height of the frenzy, 'Could we all have got it wrong? Is this what Scotland is really like?'[30] Mike Watson MSP, who never wavered in his opposition to the retention of Section 28, was in no doubt about it: 'Scotland does not conform to the tolerant and inclu-sive society which many who live here confidently claim it to be.'[31]

Before the campaign acquired traction, a Mori Poll on Section 28 found contradictory views among the public, with men being far more conservative than women. Fifty-nine percent of respondents agreed that children should be taught that homosexuality is neither right nor wrong, and should be tolerated as a way of life. But sixty percent agreed that the ban should remain and schools should not be allowed to promote the teaching of homosexuality to our children. Only thirty-six percent agreed that the ban should end and schools should decide on how homosexuality is taught to our children. Of these forty-three percent were women.[32]

MSP salaries increased faster than most other occupational groups. By 2005 they could earn more than £100,000 a year for a fairly short working week. They meet in plenary for only nine hours a week and can look forward to fourteen weeks of holidays (admittedly less than at Westminster).[33] No new political stars were born in any of the parties, figures who had an impressive aptitude for government and were able to relay their drive and commitment to the public. Instead, there was a rapid turnover of ministers in key portfolios with the talent pool proving increasingly meagre as party caucuses went for safe candidates who were all too often nonentities who struggled to hold down government office. The inveterate anti-devolutionist Gerald Warner maintained his hostility. [34] But sometimes the ardent home ruler Iain MacWhirter sounded remarkably similar:

'if we have ministers sitting weekly "in cabinet" then the least we can expect is that they do what ministers are paid to do: govern. Instead we have the pathetic...gang of ex-councillors fixing and botching. The men who run the inner cabinet of the Executive have instincts and reflexes wholly unsuited to their new role ...'[35]

The pool of Labour talent from which a first minister could draw to form a government was not immense. Peering down on the Labour benches from the press gallery of Holyrood, Brian Taylor observed: 'there are still too many pedestrian speeches, still too many who find the concept of debate foreign, still too many who seem incapable of offering a comment without reading it out, still too many who have forgotten that they are making the law of Scotland, not tying to remit a motion at a Labour conference.'[36]

In the mid-1940s, the novelist Naomi Mitchison, who celebrated her centenary in November 1997, wrote to the veteran Nationalist Roland Muirhead:

'It seems to me that you are bound to assume that a self-governing Scotland is going to be immediately morally better, and I don't see it unless *there has also been a revolution.* I can't see how the people who are likely to govern Scotland under any democratic system are going to be any different from the undoubted Scots who are in positions of local power.'

Christopher Harvie optimistically asserted: 'They *were* going to be different, because half the MSPs would be women.'[37] But except for a soon to be Independent MSP Margo MacDonald, many of the women had been nominated by small caucuses within their parties and many had a background in state bodies or quangos. The journalist Bill

Jamieson complained that in parliamentary terms 'the other Scotland of free, voluntary and private institutions and initiative, is squeezed and crowded out'.[38] He was also scathing about the think-tanks, campaigning groups and assorted lobbies who received very large public subsidies from the Executive, which often preferred to confine policy consultations to these 'favoured few'.[39] At least Parliament had a committee system which was praised for being 'much more effective and democratic' than its Westminster counterpart. A sympathetic academic believed it sought to produce consensual reform by consulting widely among civic bodies.[40] But groups like small shopkeepers, other small business people, and the religiously-minded sometimes found themselves frozen out of an assembly where secular multiculturalism soon emerged as the prevailing establishment orthodoxy.

Some of Parliament's members have acquired the habit of passing motions denouncing the work of historians like Michael Fry and journalists like Fraser Nelson which has offended their outlook.[41] Once, in 2007, while attending a debate on human rights, I was bemused to find that an usher had been ordered by a superior monitoring the spectator's gallery to stop me reading a book which I had turned to during a turgid speech. Hundreds of children from all over Scotland are taken to view the proceedings which at times, especially First Minister's Question Time, are hardly more edifying than a typically noisy playground scene. Staff dealing with the public are generally excellent but one wonders will those who observe the workings of Parliament close up view it as a promising vision of a new Scotland, or else an arena where age-old conformity and partisanship are given a fresh lease of life?

Parliament has often been preoccupied by narrow cultural issues, above all since 2007. Economic issues are often squeezed out and do not usually result in memorable debates. As administrations have come and gone, the public sector's grip on the economy has remained unassailable. By 2006, Alan Massie was complaining that 'we have the old statist Scotland, averse to innovation, suspicious of enterprise, dominated by an over-heavy public sector'.[42] Between 2001 and 2005, civil service numbers grew by 51,000 to 577,000 and half of all Executive spending went on wages. At the end of 2005, there were 36,500 more people employed full-time by the Scottish Executive and local authorities than in 1997, a rise of nine percent. A figure that included quangos and public corporations would be closer to eleven percent.[43]

Overall, twenty-eight percent of the Scottish workforce was employed by the government in 2004 against twenty-four percent for the United Kingdom as a whole.[44]

A study produced in 2005 suggested that Scotland is the only region in the United Kingdom to have experienced a substantial deterioration in her competitiveness over 1997–2005, her ranking falling from fourth to eighth of twelve regions over that period.[45] Inevitably, sceptics asked 'how such a massive increase in Scotland in the machinery, scope ... and expense of government can yield so little in the way of wider benefit and enhanced result'.[46]

In Scottish Enterprise, the Executive had one of the biggest public sector economic agencies in Europe with an annual budget of some £450 million. But its success in luring high-quality, labour-intensive investment has been patchy. Wendy Alexander, the enterprise minister, briefly tried to develop a new economic strategy based on creating high-value products but she was allegedly frustrated by the lack of support from Jack McConnell, and she resigned in May 2002. Her successor, Iain Gray, a former community worker, lost his seat in the 2003 elections after which the post was held by two prominent Liberal Democrats.[47]

The power vacuum in a London-dominated Scottish Labour Party weakened its ability to convey authority in Scotland. It now had unprecedented governing responsibilities but its identity and self-confidence often seemed nebulous. This was particularly apparent after Donald Dewar's death on October 2000. It was the chancellor of the exchequer, Gordon Brown, who influenced the succession, blocking Jack McConnell and ensuring that Henry McLeish was the new Scottish leader. But McConnell's margin of defeat was relatively narrow, only eight votes when Labour's MSPs and members of the party's executive committee made their choice.[48]. Later, when his own leadership of the country plunged into crisis, there were commentators prepared to say that Brown's hold over Labour in Scotland was exaggerated.

McLeish had been a local authority planning officer who rose in the Labour ranks from councillor to an MP at Westminster, becoming minister of state at the Scottish Office prior to devolution. He was one of the few well-known Westminster MPs who opted for a career at Holyrood. An ex-professional football player, he enjoyed good links with the media and appeared to be less absorbed in the political game

than other Labour figures who had reached the top. But he was unable to impose his authority on strong-minded figures like Wendy Alexander who successfully defied him in 2001 by refusing to accept responsibility for water in her Cabinet portfolio.[49] McLeish resigned in November 2001 after mishandling a financial discrepancy in his constituency office which became known as 'Officegate'. No personal impropriety was involved but he showed himself lacking in survival skills as he was harried by Tory opponents and the media to the point of resignation.

It was tragic that McLeish's abilities were tested and found wanting. He understood how vital it was that defending core Scottish interests be seen not as the mission of one party alone. He caused uproar when, upon being received by George W. Bush, he described himself as 'the leader of my nation'. A stronger figure at Labour's helm in the post-Dewar period could have done much to establish the authority of a devolution settlement run by pro-Union parties.

Jack McConnell was elected unopposed as leader on 17 November 2002. His relations with Gordon Brown were poor. Brown had originally backed Wendy Alexander against McLeish in 2001, only for her to pull out after an attack of self-doubt.[50] His unsureness of touch in dealing with his own Scottish bailiwick would merely presage far worse disasters after he became prime minister and head of United Kingdom Labour in July 2007.

McConnell's background was unusual for a Labour figure. He grew up on a sheep farm on the Isle of Arran. His baptism in Labour politics took place at Stirling University, following which he spent nine years teaching maths. He spent two years running the Stirling local authority where, unusually, the competition between Labour and the Tories still remained fierce. He also associated himself with Scottish Labour Action, a pro-devolution group which emerged after Labour's third consecutive electoral defeat in 1987. But his career became more conventional from 1992 onwards, the year in which he was chosen as general secretary of the Labour Party. McConnell discarded his links with a group known as Labour's neo-Nationalists and cemented them instead with the party in Lanarkshire, where machine politics were popularly believed to reign supreme. Upon becoming first minister, he sacked most of his former Cabinet colleagues. Of the women in the Cabinet only Wendy Alexander remained and she was given a punish-

ing new remit covering Transport, Enterprise and Lifelong Learning which she walked away from after six months.

Thanks to the self-effacing image of their leader, Jim Wallace, it is often forgotten that the Liberal Democrats shared office with Labour for the first two Holyrood terms. For a long period the Lib Dems in Scotland had made a vital contribution to the party's fortunes in Britain; in 1993, more than half the Lib Dem MPs represented Scottish constituencies.

The coalition endured for eight years, which is far longer than is customary in continental Europe where cohabitation of this kind is the norm. But Labour and the Liberal Democrats were awkward partners. The Lib Dems needed to consult with activists before reaching decisions. This was done fairly openly, whereas Labour bargained privately with its trade-union and municipal power-blocs before agreeing a decision.[51] The group of Labour MSPs were often left in the dark about decisions reached by the Executive. A breakdown in communications occurred over how to react to the first Members Bill to be submitted to the Scottish Parliament. It aimed to abolish warrant sales, a centuries old system of debt collection through the forced sale of personal property. Scottish Labour had opposed the practice as long ago as 1893. But proposing the motion was a keen rival Tommy Sheridan, then the sole MSP for the Scottish Socialist Party. The executive vacillated, Jim Wallace, then justice minister, being extremely cautious about proceeding. It was only after many complications that the Sheridan Bill was passed in April 2000.[52]

It was undoubtedly a mistake for the Lab-Lib Dem coalition not to press for an important say in shaping British fishing policy, since Scotland has seventy percent of the United Kingdom fleet. The agriculture and fisheries minister was the Lib Dem Ross Finnie, who represented a West Coast constituency. His reluctance to demand that Scottish fishing interests be a United Kingdom priority weakened the Lib Dems in its North-East stronghold. It is unlikely that before 2007, 10 Downing Street would have felt it necessary to shape policy around the need to deflect the SNP since the separatists then appeared moribund. But it would have improved the standing of the coalition partners, particularly the Liberals, if Edinburgh had been included in fishing negotiations with the EU.

Labour made a significant concession to the Lib Dems by agreeing to their demand that the system for local authority elections be made

proportional. The introduction of the Single Transferable Vote at the 2007 local elections caused massive confusion among voters but it weakened Labour hegemony in all but its tightest strongholds in the West of Scotland. McConnell risked the wrath of his backwoodsmen by backing down to the Lib Dems, who had threatened to quit the coalition if Labour refused to make this concession. The party will face stronger competition even in its heartland areas and in many places anti-Labour coalitions succeeded in reducing the number of councils which Labour controlled.

Indeed, the SNP emerged as the party with the largest number of councillors. Arguably, the Nationalists pose a less immediate threat to Labour than to the Liberal Democrats who may be harmed by an innovation designed to promote greater electoral parity.

But in 2007 it was Labour that lost control of all but two of the thirty-two local councils where it had enjoyed a majority, sometimes for decades. This paralleled a decline in the powers of patronage it used to enjoy thanks to a reduction in the role of the state as an economic provider. Labour had particularly benefited from the state's dominance of the housing sector. In 1981 fifty-two percent of Scotland's housing was council housing and only thirty-six percent owner-occupied. But after several decades of a freeze on new council house building, and the sale of many existing ones, council housing made up a mere twenty-two percent of Scotland's housing stock. Labour had to adjust to new conditions where it could no longer rely on the votes of working-class families dependent on its patronage.[53]

Jack McConnell probably realised that one-party dominance was soon likely to be a thing of the past and that the party would have to become more professional and less complacent in order to stay ahead of its rivals. Overall, Labour and the Lib Dems showed an appetite for cooperation that was unusual in British politics, especially during McConnell's period as first minister. Lib Dem leaders found that he was someone they could do business with. Both parties worked well in seeking to combat the intercultural conflict among certain Lowland Scots of Protestant and Catholic extraction known as sectarianism.[54]

Brian Taylor, the BBC journalist, who often writes about Scotland in a positive vein, had no hesitation in declaring in the year devolution finally arrived: 'The West of Scotland in particular remains sadly sectarian, even today. Indeed, it is one of the most depressing aspects of Scotland ...'[55] When Jack McConnell moved to Wishaw, near Glas-

gow, sectarian graffiti was daubed on his house within weeks.[56] One of the most imaginative steps of his government was to convene annual summits on sectarianism, bringing together church leaders and community figures to take the heat out of an intercultural fault-line in Scottish life that refused to disappear. Behind the scenes, he also worked hard to ensure that the disruptive aspects of parades and marches with a partisan image were toned down.

But the most significant departure was a clause in the Criminal Justice Act, creating a new offence of sectarianism. It was doggedly pushed by Donald Gorrie, a Lib Dem who established a reputation as a creatively independent MSP, and who was prepared to draw attention to awkward issues which the party groupings preferred to overlook.

In 2001, the persistence of sectarian tensions in Scotland had been dramatically highlighted when Frank Roy, the Labour MP for Motherwell and Wishaw warned the Irish prime minister, Bertie Ahern, that it would be unsafe for him to pay a visit to his Lanarkshire constituency in order to unveil a memorial at the Carfin grotto to Irish emigrants. This was because the event coincided with an Old Firm match in Glasgow, and Roy feared that post-match tensions could spill over and disfigure the event. He faxed a warning to the Irish consul-general in Edinburgh and the Irish prime minister cancelled the trip. But Frank Roy conveyed a very damaging impression of the atmosphere in his own constituency and he was required to quit his junior post in the government.[57]

Earlier, in 1994, the by-election held in Monklands East following the death of the then Labour Party leader, John Smith, was a sad reflection of the staying power of rancour loosely-based around religion. Monklands Council was already in the spotlight owing to the nepotistic behaviour of a group of councillors. It comprised the towns of Airdrie (wholly situated in Smith's Monklands East constituency) and Coatbridge (which was mainly Catholic, and mostly located in the neighbouring Monklands West constituency). Lanarkshire politics has always been tribal, something that has become much more accentuated in the post-war era when a lack of electoral competition caused the effective emergence of one-party states.[58]

The abuse of power had not been along strictly religious lines but relations between Labour and the SNP perhaps reached a new low in this by-election. On the night of the count, Labour's Helen Liddell, who narrowly held the seat, was spat on, and had to endure jeers of 'scum'

and 'Fenian bastard' from banner-waving Nationalists (hotly denied by the SNP).[59] Alex Salmond accused Labour of smearing the SNP by alleging Protestant bias when canvassing Catholic voters but one journalist has alleged that 'the behaviour of fringe supporters ... had sickened Salmond to the point of questioning his current vocation'.[60]

Donald Gorrie's law enabled the authorities to define an offence as a religiously aggravated one if there was evidence that sectarianism had lain behind it. In 2007, a report from the Crown Office revealed that offences of bigotry were up to sixty times more likely in Glasgow than much of the rest of the country. No less than one in 500 people in Glasgow have been charged with a religiously aggravated offence since 2003, when the new offence was introduced. This compares with a figure of one in 29,000 in the Grampian region, where only eight incidents had been recorded in four years.[61]

One of the unmistakable advantages of parliamentary devolution was that it increased the speed of Scottish legislation. Maria Fyfe, Labour MP for Glasgow Maryhill from 1987 to 2001, observed: 'When I saw that list of bills for the first year, it brought home to me the effect which the Scottish Parliament would have on the lives of Scots. Eight new acts of parliament relating specifically to Scotland was probably as many as I have seen in my entire time in the House of Commons! We usually get Scottish legislation rolled up into one big act every five years and this was such a change!'[62]

Among the landmark laws passed was the Abolition of Feudal Tenure Act (2000); the Water Industry Act (2002) that confirmed the non-privatised status of Scottish Water; and the Land Tenure Act (2003) that gave community groups right of purchase when land they live on is put on the market, as well as giving the public rights of 'responsible' access to walk on the land. Mention has already been made of the Abolition of Poinding and Warrant Sales (2000) which prevents the auction of a debtor's possessions; it was the achievement of backbench MSP Tommy Sheridan. There is more scope at Holyrood for legislation initiated by backbenchers than at Westminster. In total no less than eighty-nine acts were passed between 1999 and 2005.

Under Jack McConnell, some imaginative decisions were taken designed to improve the social fabric of Scotland. Perhaps the most ambitious was 'Project Scotland', a volunteering initiative launched in the spring of 2005 and based on the American Peace Corps or the United Kingdom's Voluntary Service Overseas. But it was meant to

give young people opportunities to help improve Scotland's own battered social fabric. Young people were given a subsistence allowance and the opportunity to have valuable experience working with existing voluntary as well as public bodies. In 2004, the Retired and Senior Volunteers Programme was launched. It trained and supported 1,600 volunteers usually aged fifty and above to assist children in becoming literate, and to provide services for patients, as well as mentoring and befriending. These were initiatives he was careful to ensure had all-party support and which showed the devolution scheme at its innovative best.[63]

However, in his latter years as first minister, McConnell appeared to be presiding over an anaemic government lacking a sense of purpose or an ability to project its message. This was also a time when Labour lost touch with major support groups. There was bound to be dissatisfaction in Scotland at the Blair government's tendency to govern from the centre or even somewhat to the right of it: 'The Scottish centre is to the left of the centre in England.'[64] Trade-unions were alienated by the decision to embrace the Private Finance Initiative (PFI) which enables private business to contribute financially to the construction of public infrastructure projects in return for handsome long-term economic returns.[65] It was a proposal the Conservatives rejected under John Major because it was viewed as incurring losses for the state.

The Edinburgh architect Malcolm Fraser emerged as a redoubtable Scottish critic of PFI. In 2006–7, he was deputy chairman of Architecture and Design Scotland (A&DS) whose remit requires it to advocate 'the benefits of good design of public building projects'. He chaired 'design reviews' for scores of new school projects that were 'so poor that I despaired for the lives of the children whose education would be blighted by them'.[66] Writing in 2007, he pointed out that 'study after study has shown the process to be inherently wasteful, and the buildings it produces to be more expensive, taking longer to build, and to be of significantly lower quality than those built directly with public funds'.[67] A BBC poll conducted before the May 2007 elections for the Scottish Parliament found that voters put the need to 'ensure that all state schools and hospitals are built and run by public bodies rather than private companies' at the top of a list of twenty-five policy issues they were presented with.[68]

Labour under McConnell weakened its links with civil society by failing to react to allegations about the use of Prestwick Airport for US

rendition flights of terror suspects and by supporting London's decision to prolong the life of the Trident nuclear programme. A huge march in Glasgow in February 2003, coinciding with a United Kingdom Labour spring conference in the city, included many Labour supporters and people from many walks of life and every age group. Their restiveness grew as some of the worst predictions about the violence likely to engulf Iraq following an ill-prepared Anglo-American intervention came to pass. Susan Deacon was one of five Labour MSPs to vote against the party position on the war in March 2003. The journalist Lesley Riddoch found it difficult to get Labour Parliamentarians to defend the government's Iraq policy: 'During the Iraq war, the BBC production team with whom I worked, spent hours every morning calling Scottish Labour MPs who were prepared to defend the government's stance in theory, but unavailable to speak any lunchtime in practice.'[69]

On 4 November 2004 three soldiers from Fife, Sgt Stuart Gray, Pte Paul Lowe, and Pte Scott McArdle, were killed by a suicide bomb as they were supporting the deployment of American troops in central Iraq. They were the first Black Watch casualties in Iraq as well as the first British victims of suicide attacks there. Opposition to the war grew and Labour's image suffered when eight days after these fatalities, one of its leading figures, Lord Watson of Invergowrie, was arrested after arson in an Edinburgh hotel on the occasion of the press-sponsored Scottish Politician of the Year awards. The MSP and former Cabinet member denied setting fire to a curtain after quarrelling with hotel staff. But the deed was caught on CCTV which led to a sentence of sixteen months imprisonment.[70]

Labour's biggest difficulties came from some of the leaders of the Catholic church.

In 2000 Cardinal Winning described the Parliament as 'an utter failure'.[71] Its first presiding officer, David Steel, would have been an unpopular figure due to his securing the legalisation of abortion in 1966. He had come third in the ballot for private members' bills that year and initially he had wished to reform the law outlawing homosexuality 'until he realised the level of hostility in Scotland where it remained a criminal offence long after the law was changed in the rest of the country'.[72] Steel later settled into a conventional political career but he had been a rare Scottish backbencher prepared to challenge powerful vested interests.

In October 1999, while in Brussels, Cardinal Winning delivered a speech in which he described Scottish Nationalism as 'mature, respectful of democracy and international in outlook'.[73] In January 2000 Tony Blair spoke out in support of repealing Section 28 at Question Time, with a solemn-faced Cardinal Winning observing from the House of Commons gallery. Blair was already taking instruction in Roman Catholicism under the guidance of his wife.[74] But three years earlier, Winning had described Blair's Christianity as a sham because he was not prepared to tighten up New Labour's policy on abortion.[75]

The composer James MacMillan, perhaps Scotland's best-known lay Catholic, disagreed with his church leaders over nationalism: 'I believe in the Union. I believe that my views are much closer to the views of most Catholics in Scotland.'[76] But he wrote in 2005: 'The Scottish Parliament has proved incapable of doing the basics of governance: it has consistently squandered any claim of right to extending its powers; and there is a legitimate argument in proposing a curtailment of its activities.'[77] Later, at a moment of deep vulnerability for Labour, he fiercely rounded on it:

'Nowadays, Christian beliefs are being dumped contemptuously by the Labour Party. In the long run, in places such as the West of Scotland, the party will be fatally weakened by it ... The new middle-class Labour activist is quite happy to use the urban poor as voting fodder, paying lip-service to the mantra of relieving economic inequalities ... What they are far more passionate about, though, is the promotion of ... "recreational individualism and lifestyle liberalism".'[78]

But some commentators were reluctant to see Catholicism as a monolith. Iain MacWhirter believed that 'Winning's ... views on contraception and abortion, and now Section 28, have led many Catholics to cease regarding him as a source of guidance on questions of personal morality.'[79] A 1997 BBC survey with a sample of 400 Catholics found that sixty-eight percent favoured a woman's right to choose whether to bring a child to conception and fifty-one percent disagreed with the church's public involvement in politics.[80] This enabled Curtice to detect in Scotland: '...a country that is gradually becoming more liberal in its social attitudes, [and] a country in which such issues as sexuality and abortion are considered to be ones where individuals decide for themselves what is right and wrong rather than having to accept a moral code imposed on them by social institutions'.[81]

The devolved Parliament did not fare too well in this climate of disengagement from not just spiritual but also group attachments. Turnout fell from fifty-eight to just forty-nine percent in 2003. The two main rivals were in the doldrums, which enabled the Greens and the Trotskyite-dominated Scottish Socialist Party to make strong showings. In 2003, the decline in Labour's share of the vote compared with 1999 was 4.2 percent, slightly less than the 4.9 percent drop experienced by the SNP under John Swinney. It is worth noting that Labour's share of the 1999 vote had already been well below what the party normally expected to achieve in United Kingdom elections. This indicated that customary Labour voters in British contests viewed the party less sympathetically in Scottish ones, where its role of defending Scottish interests could not be performed so convincingly.[82] Even in lean periods, the SNP benefited from the readiness of Conservatives and a lesser number of Labour supporters to give them their second preferences.

In his second term, McConnell was absorbed with a range of social problems and he sought to take firm measures against rising youth crime; measures which an increasingly bureaucratised police sometimes displayed scant enthusiasm for. Occasionally, his work took him beyond Scotland. Under his two predecessors, he had enjoyed responsibility for Scotland's relations with Europe. Later, as first minister, he was elected chairman of the Regional Assemblies of the EU. It appeared to be yet another offshoot of the Brussels labyrinth which had regular meetings but whose purpose was never clearly defined.[83] Whenever he was involved in United Kingdom-led delegations to Brussels, he seemed content to remain in the ante-room along with other Scottish ministers This was leaked at the end of 2005, much to the embarrassment of the Executive.[84] But it is unlikely McConnell would have had much to say even if he had been a full participant at such talks. The 1997 White Paper on devolution categorically states: 'Relations with Europe were the responsibility of the United Kingdom government'. But it later adds: 'the Scottish Parliament will have an important role in those aspects of European Union business which affect devolved areas.'[85]

In a speech before the 1999 election, Alex Salmond had told the European Institute in Brussels that Scotland would not be satisfied with 'subsumed' involvement in EU matters. He warned: 'If the UK position is to be given in the Council of Ministers, it must never be

given without either an assent from Scotland or a dissent from Scotland. Our democracy demands nothing less.'[86]

In order to puncture the SNP's policy flagship of 'Independence in Europe', it would have been advisable for Scottish Labour to have been far more proactive at the European level. It also seemed only common sense for Labour to try and snatch as many patriotic cards as it could from the SNP. It is surprising that McConnell was so timid in this respect. As a young pro-devolution militant in 1989, he had even floated the idea of running an unofficial referendum on Scotland's constitutional future alongside regional council elections. But upon becoming the party's general secretary, he quickly emphasised British priorities and established an electoral base in Lanarkshire, where his previous radicalism would have fallen on stony ground.[87]

The party neglected even simple propaganda tasks. With Labour figures like Keir Hardie and Tom Johnston, Churchill's wartime secretary of state, it should have been easy enough to devise a stirring narrative showing the party's century of struggle for self-government. But Scottish Labour failed to invest the devolution experiment with any grandeur or sense of occasion. Most of the time, it urged the voters to return it to office because of its commitment to maintaining a large and poorly performing welfare state. Its members were drawn from a narrow occupational spectrum, with local government figures, trade-unionists, and quangocrats predominating. They were not representative of society at large and it was easy to portray them (often unfairly) as careerists obsessed with exploiting the system to their own advantage.

Labour's aloof and autocratic stance towards the voters was reflected in the party's own internal arrangements. Holyrood Parliamentarians had little leverage over the Executive, which preferred to interact with the unions and local government power blocs. Relations between Edinburgh and London were often cold and distant. Undoubtedly if John Smith had lived, this and perhaps many other features of Labour rule would have been different. Tony Blair didn't even turn up for the opening of the new Parliament building in 2003. It indicated how little emotional investment he had in the success of self-government. Certainly, he neglected Scotland after devolution, preferring to bestride the world stage—only looking north when he needed to shore up electoral support. In his second term, one of Jack McConnell's colleagues remarked: 'People would be shocked if they knew how little

they spoke. Jack only speaks to the prime minister three or four times a year. He has absolutely no interest in what we do.'[88] There was an obvious contrast with Northern Ireland where Blair believed that a large part of his legacy would lie. The 1998 Good Friday Agreement was far more radical and innovative than Scottish devolution. The stark nature of the challenge to the political order meant there was a readiness to depart more substantially from British constitutional principles. It is unlikely either Blair or Brown contemplated that in Labour's third term, Scotland could prove a bigger headache for the party than a Northern Ireland finally coming to terms with the peace settlement.

A series of events were scheduled early in 2007 to commemorate the three hundredth anniversary of the Act of Union, but they coincided with a surge of support for the SNP and had little resonance. The only popular gesture in favour of the Union was a march by the Orange Order in March 2007 along Edinburgh's historic Royal Mile. Although little-reported by the media, it attracted several tens of thousand of supporters and numerous marching bands.

With elections for Holyrood drawing closer, top United Kingdom Labour figures delivered speeches in Scotland early in 2007 warning of 'uncertainty and instability'. These were the words of Tony Blair when he addressed Labour at its conference in Oban. Dire economic consequences were forecast if Scots switched their loyalties to the SNP. The *Economist* commented: 'It is hard to think of an approach that more richly deserves to fail. It demeans the Scots by brutally reminding them of their dependency, while at the same time stoking resentment in England about the way Labour bribes its restive vassal in the north to go on voting for it. Unattractive though the SNP is in many ways, Labour's relationship with Scotland is even more so.'[89]

Months away from becoming prime minister, Gordon Brown didn't see the need to reconnect with his Scottish base by looking again at the devolution settlement. In May 2007, he openly stated that the financial powers enjoyed by Holyrood were sufficient and there was no need to re-examine the Scotland Act. But most Scots polled on the issue had previously declared a preference for widening the devolution powers in this area. Greater responsibility for Scotland's finances might have led voters to adopt a more hard-headed approach to the emotion-laden cries of the SNP. Its members were fired up in the spring election campaign and ably led by Alex Salmond, who made often brilliant use of

the media. McConnell, by contrast, appeared to be an unimaginative technocrat who spoke managerial language and failed to connect with the public. He appeared to go through the motions of campaigning and was often abrupt and introspective, displaying a visible lack of enthusiasm for engaging in the electoral cut and thrust. In speeches and interviews, his tone of voice could be hectoring and impatient. He seemed keen to get the election out of the way. Too often, he sounded like the leader of a one-party state suddenly thrust into a political fight where his opponents were able to out-class him.

Labour held its own in the West of Scotland but lost a lot of ground everywhere else, enabling the SNP to be the largest party with a historic forty-seven seats to Labour's forty-six. Several of the Labour Party's most talented figures lost seats and it would pay dearly for their absence when it faced successive leadership crises during the early years of SNP power. The break-up of the Scottish Socialist Party resulted in many of its supporters crossing over to the SNP, which was perhaps enough of a shift to guarantee success for the SNP.

The Liberal Democrats lost just one seat, but in doing so they also lost their king-making role once it became clear that the SNP would stick to its manifesto commitment to hold a referendum on independence. The Lib Dems had made its abandonment a pre-condition for entering into coalition talks. Labour's gloom was deepened by the clearly inadequate way simultaneous elections for Holyrood and for local councils elected under PR had been planned. It led to a huge number of rejected ballots among voters used to a simpler system and who were baffled by two different kinds of proportional contests.

Labour had been responsible for various good and overdue laws passed at Holyrood which changed the condition of Scotland for the better. But there was no single big idea which the party could extract symbolic capital from to reinforce the loyalty of voters. The often lacklustre way in which it governed the devolved institutions left too many voters unimpressed. Accordingly, it failed to cement its position as the majority force in Scottish politics. Labour appeared to have lost its coherence on socio-economic as well as international issues. It was hard to see what the party really stood for. This gave a great advantage to a trans-class force like the SNP, which in the past had struggled to put forward a coherent economic programme.

Any inquest on post-devolution Labour would need to ask why the party had been unable to adapt to a new set of circumstances. It had

long been used to opposition and now found itself thrust into making an ambitious experiment in Scottish self-government work. Many of its MSPs and ministers had been content operating in the one-party environment that often prevailed in Labour's Scottish heartlands. This was a smaller canvass where energies had been absorbed in shaping planning policy and allocating elected council posts. Here they imposed their will on weak rivals, but at Holyrood they had to argue for their policies convincingly in front of an alert and sceptical media. Figures like Henry McLeish found the scrutiny of the opposition unnerving. He lacked the will to exercise power in a decisive manner. Jack McConnell was more purposeful. But after 2002, Labour failed to behave as if devolution was an essential and welcome part of its ideology and practice. It failed to find places in Parliament for people who had been involved in the civic wing of the pro-devolution movement. There were even times when its approach resembled that of the party in the 1970s, when devolution was a tiresome gesture designed to buy off local discontent. A high price was paid in 2007 for this negligence. The nightmare for Labour was that this setback very soon began to have the hallmarks of a serious decline in its fortunes that would be hard to reverse.

FINALLY GOVERNING SCOTLAND: 2007–09

The SNP's 2007 breakthrough came out of the blue. Writing of the state of the Union in 2005, Tom Devine, Scotland's best-known historian, claimed that 'arguably it is more secure now than it has been at any time since the 1960s and 1970s when Scottish nationalism seemed to have achieved an unstoppable momentum. In 2005 the SNP is becalmed with less than 20 per cent of the popular vote in Scotland and the pro-Union parties are in the ascendant in the Scottish Parliament.'[1] The writer Alan Massie claimed soon after that 'Devolution is a reality that is here to stay. To dream or pretend otherwise is sheer Jacobitism ...'[2]

At the 2005 general election, the SNP obtained only eighteen percent of the Scottish vote and fell behind the Liberal Democrats who continued to benefit in Scotland from the popularity of their then leader, Charles Kennedy. Internal dissension had damaged the SNP for some years. John Swinney, Alex Salmond's replacement as leader in 2000, failed to establish his authority or win success in the 2003 Holyrood elections. In 2003, Michael Russell, a Swinney supporter, warned that the 2003 election campaign had left the party appearing to be 'self-absorbed and fractious—lacking both ideological cohesion and a thought through, clearly achievable, modern aim'.[3] After he openly warned that Swinney's time was up and that he would be receiving a visit from 'the men in grey kilts' (language for party elders), Swinney stood down.[4] Nicola Sturgeon, though an icy personality in the style of Willie Ross, was thought to appeal to some of the aspirational middle-classes. She jockeyed for position but it was Alex Salmond who returned as a 'unity' candidate.

In 2007, the SNP fought an unabashedly populist campaign. Instead of just the party's name appearing on the ballot paper it was preceded by the words 'Alex Salmond for First Minister'. He returned to Holyrood, from which he had absented himself since 2001, by targeting the Lib Dem Gordon seat in Aberdeenshire. A well-funded presidential-style campaign, using telephone polling, planes flying over the seat with SNP slogans, and lavish advertising overwhelmed the Lib Dem efforts, which continued to be based on local issues. The explosion of populism in the hitherto tranquil Don valley was the first sign that the SNP was going to disregard the conventions of devolved politics and work out its own singular approach to capturing and consolidating power. Salmond wished to show that his party was no longer the impotent voice of protest. It could wield power in a responsible manner. While campaigning, it projected a neat trans-class message. It combined Labour's core themes of fairness and social justice with wishing to use the state to promote enterprise and harness the potential of individuals to transform their environment for the better. This was an attractive message capable of motivating a wide range of Scots and it enabled the SNP to edge narrowly ahead of Labour nearly everywhere outside the greater Glasgow conurbation.

The devolved system is designed to promote consensus. While campaigning, Salmond indicated that he had changed. As the *Times* put it: 'Gone is the football-mad, pie-eating "smart Alex", spicing up his condescending jibes with Scottish argot. Now he speaks the Queen's English and practices the art of compromise.'[5] But within days of taking office, he made it plain that pragmatism was not for him. A coalition with the Liberal Democrats would have given the SNP a stable majority and enabled it to carry out a full legislative programme. The differences between the parties were not great on most issues of public policy. But the Lib Dems wished the SNP to put aside its intention to hold a referendum on Scottish independence and Salmond point-blank refused.

There was no shortage of commentators who assumed that the SNP would find itself out of its depth and painfully humbled by its time in office. The 1924 Labour government was perhaps the last time an untried radical force had tasted power in a minority situation, and it was soon overwhelmed, lasting only nine months in office, harried by the media and double-crossed by wilier rivals. There were times, over the Clause 28 controversy and the debacle surrounding the fall of

Henry McLeish in 2001, when Scottish Labour had appeared to be just as out of its depth as Ramsay MacDonald and his trade-union-leaders-turned-ministers three-quarters-of-a century earlier. But under Salmond, history would not repeat itself.

Another prediction was that a minority SNP government would be unable to establish its authority over the civil service. But before very long, it was clear that relations were harmonious. Salmond was able to spend long periods electioneering without looking over his shoulder to see what his officials were doing. They seemed content to administer the country as he pursued essentially political tasks. One of these tasks was 'the national conversation' to promote a 'Yes' vote in the referendum on independence. In 2008, one journalist complained that 'Sir John Elvidge (the English-born permanent secretary) has been too relaxed in relation to the participation of civil servants in Mr Salmond's "national conversation", which is a blatantly party political exercise.'[6]

Resentment had long existed in parts of the Edinburgh civil service at the overbearing attitude of Whitehall. Before 2007 London froze Edinburgh out of discussions on EU matters that were of concern to Scotland. Jack McConnell had failed to make an issue of this and assert Scottish interests. Understandably, there were top officials who desired more assertive political masters, ones who were not going to be flattened by the Whitehall juggernaut. For Salmond, strengthening the independent-minded outlook of the Scottish administration was bound to be vital to his plans.

Accordingly, unstated assumptions about the role of the Scottish part of the British civil service were about to be tested. The official view was that the 'home' civil service functioned as a single entity, with the Scottish administration being part of this wider organisation. But plenty of evidence existed that New St Andrew's House in Edinburgh was not a branch office of Whitehall. It was a territorially-based structure staffed mostly by Scottish civil servants, so it enjoyed autonomy while still being an integral part of the Whitehall structure. Civil servants who stood up to Whitehall rose in the Scottish Office. Rhodri Morgan, the first minister of Wales observed: 'You promoted staff in the Scottish Office who had put one over Whitehall. You promoted staff in the Welsh Office on the basis of whether they had kept their nose clean in Whitehall.'[7] Officials worked well with ministers prepared to uphold what were seen as important Scottish interests 'while

maintaining an essentially united body of policy north and south of the border'.[8]

Before the SNP's arrival in office, two academics, Charlie Jeffery and Daniel Wincott, were still able to identify 'a repository of common values and shared understandings of "how to do things"'. This widely-held outlook facilitated informal policy coordination of sometimes awkward issues by officials. But they also drew attention to shifting allegiances as 'career structures and policy practice diverge between United Kingdom central government and devolved government'.[9] Upon the arrival of the SNP and the outbreak, almost immediately, of sharp differences with the London government on many issues, Scottish civil servants found themselves in the middle. Pragmatic responses based on the search for a compromise did not interest Alex Salmond, and officials became the loyal adjuncts of his government (whatever views they might have had in private about his tactics). Cross-border civil service links inevitably frayed as the SNP government acquired complete control over the Edinburgh civil service. Some observers detected a split in civil service ranks between impartial figures and those who had gone over to the Nationalists, some to an evangelical degree.[10] If the SNP tightens its grip on power, then the fate that befell Whitehall might await the Edinburgh civil servants: New Labour domesticated the central civil service, preferring it to be a political conveyor-belt for the government and reducing its role as a provider of advice to the government and also a restraint on short-term political instincts.

It was widely assumed that local government would impose a brake on SNP ambitions. Under a proportional electoral system, Labour's grip had weakened but it was still the majority party in many places. The SNP derived much benefit from the deal struck with the Council of Scottish Local Authorities (COSLA) and its Labour chairman, Pat Watters, in 2007. Under it, Scottish local authorities were persuaded to freeze their council taxes for a year, which enabled the government to claim genuine savings to local rate payers. Salmond proclaimed this deal to be a 'historic concordat'.

It was likewise thought that the business of government would prove too onerous for a minority party that had never previously held office, since the other parties would relentlessly wear down Salmond's inexperienced team. But the SNP took a minimalist approach to administration that would have delighted any radical neo-liberal. Instead, it was the opposition that was plunged into crisis. Labour had three lead-

ers in the space of a year. By June 2008, Nicol Stephen, the leader of the Liberal Democrats, had quit, opting to spend more time with his family (perhaps aware of how vulnerable his party was becoming to the SNP in the North-East of Scotland).

Finally, there was no shortage of journalists who privately insisted that it was only a matter of time before Salmond would over-reach himself with an incautious remark or reckless political initiative. They noted that he knew how to get personal and loved a jibe at the expense of his opponents, not necessarily all politicians. In two years, he has gone deep into uncharted waters, transforming his office into a personal vehicle and dispensing with normal mediating structures in order to get his way. But not even his praise for the prowess of the Scottish banks right up until their recent meltdown has dented his popularity. In 2009, with the economy in severe crisis, he was the only major politician in Scotland who enjoyed positive ratings.

Salmond has motivated colleagues in a once fractious party, most of whom still fail to measure up to him in terms of ability. In the 1930s stern lawyers, bigoted academics, and fiery poets were unable to get along. All that has now changed, as the still ubiquitous lawyers and Parliamentarians, often drawn from public service backgrounds, flank Alex Salmond as he offers interchangeably romantic and hardheaded versions of the Nationalist message.

Perhaps the only one who can measure up to Salmond is Nicola Sturgeon, not yet forty and the deputy first minister and minister of health. The daughter of an electrician, she joined the SNP in 1986 aged sixteen. An earnest politician, she possesses a sense of commitment which is now unusual among many younger Scots. She is hoping to provide a role model, especially for young Scottish women, many of whom are not turned on by a Salmond style that can appear very clunky and macho at times. Her 'discipline, intellectual rigour and debating skills' have given the SNP 'much-needed credibility'.[11] Working smoothly with Salmond, she has established her authority inside the party and ensures that garrulous colleagues at Holyrood do not embarrass the party with their disclosures. This is a far cry from the past. The SNP has been beset by public rows, most notably in 1999 when the *Scotsman* hosted an uninhibited correspondence between Jim Sillars and Alex Salmond. At one point, the SNP leader said of Sillars: 'his contribution for many years has been entirely negative. His talent

could have been really important for Scotland's cause. What a pity that he wasted it.'[12]

Sillars continues to berate his former ally on the Nationalist left from the sidelines but Scottish solidarity has become the mantra of the SNP. As long as it is seen to 'stand up for Scotland', the SNP believes it will remain a power in the land. Observers think many Scots will be ready to use it as 'an insurance policy' against the United Kingdom government. When he came to power, Salmond pledged to cooperate with Westminster and be constructive in his dealings with the London government. But soon there were a series of clashes, with the first minister announcing that Whitehall was trying to exceed its prerogative. Scottish ministers accused London-based ones of refusing to consult with them on a range of issues. They in turn accused the SNP government of sabotaging important social policies, such as one that would force drug addicts to seek help or lose state benefits by withholding information about the extent of the drug addiction crisis in Scotland.[13]

The spending review of 9 October 2007 resulted in the Scottish government being allocated an additional £3.4 billion in central government money over the following three years. This amounted to a rise of 1.4 percent a year compared with an annual average 5.2 percent increase between 2001 and 2008. The pace of public spending is slowing throughout Britain, but Salmond argued that Scotland was being deliberately penalised.[14] By October 2008, the media was claiming that senior Labour ministers were warning all Whitehall departments not to share information with the Scottish government which could be used by the SNP for political purposes.[15]

Salmond said he had been subjected to 'unreasonable behaviour' and intolerable interference from Westminster over plans to introduce a local income tax and replace public private partnerships (PPPs) for large-scale government projects, first with public bonds and later with finance from Middle East investment funds. The SNP appears to be making capital from these disputes. It is relaying the message that the SNP is standing up for Scottish interest against an arrogant Whitehall machine. This is likely to be a vote-winner. A poll in March 2007 showed that forty-three percent of respondents did not want the SNP government to cooperate with Westminster when Scotland's interests were being harmed, and eighteen percent wanted no cooperation at all.[16]

In the face of another complaint from Salmond that 'relations between the Scotland and United Kingdom governments are in danger of collapsing because of a "campaign of aggression" being waged by Labour ministers at Westminster', the journalist Bill Jamieson, a doughty critic of the SNP leader, compared him with the militant trade-unionist Fred Kite, immortalised by Peter Sellars in the 1959 film classic 'I'm All Right Jack':

'His fight-picking fulminations this week were not those of a dignified First Minister. Here is the grand-standing little shop-steward out of 'I'm All Right Jack', a tartanised Fred Kite sweeping through the works canteen, peep—peeping on his whistle between the parrot cries of "Diabolical Liberty".'[17]

Many voters are likely to judge the SNP on the extent to which it can shield them from austerity measures. The party now runs councils across Scotland in big cities like Edinburgh as well as smaller communities. The Scottish government may find it hard to dodge blame for a reduction of council services and for a retreat from its own pledges on smaller class sizes and free school meals.[18] In Fife, when the SNP-run council introduced charges and cut back services, unpopularity incurred. Labour exploited this in a crucial 2008 by-election which it had been expected to lose.

Nevertheless, the SNP can afford to take initiatives which might be suspect if they came from Labour or the Tories. It operates outside the arena of class and interest group politics which limit the freedom of the traditional players. This was shown by Salmond's ability to strike up an alliance with the American capitalist Donald Trump, without disapproval from his left-wing supporters. In 2007, Trump had applied to build a £1 billion golf tourism venue on a coastal conservation area twenty miles north of Aberdeen. Labour and SNP politicians had previously displayed a rare consensus in support of the plan. Not only was Jack McConnell a keen golfer but he had appointed Trump as an unofficial ambassador for Scotland, joining a select band that includes Rod Stewart and Sean Connery. But the plan was rejected on the casting vote of the chairman of the planning committee, Martin Ford, a Liberal Democrat and keen conservationist.[19] Without an appeal even having been lodged by Trump, the government took the unusual step of calling in his planning application.[20]

Holyrood's local government committee then investigated what happened once the government intervened. The resort is in Alex Salmond's constituency of Gordon and he was accused of 'exceptionally poor

123

judgment' by Duncan McNeil, the committee's Labour convenor, for arranging a meeting between the developers and the Scottish government's chief planner.[21] Donald Trump entered the fray by declaring publicly that Salmond was 'an amazing man' and a credit to his country.[22] The late mother of the property tycoon comes from the island of Lewis and, at the height of the controversy, he paid his first visit in many years to meet his Gaelic-speaking first cousins, touching down at Stornoway in a private Boeing 727.[23] Robert Brown, a Lib Dem MSP on the Holyrood committee, said that government members had failed to preserve 'a proper balance between competing interests required by the due process of the planning system and by the ministerial code'.[24]

Nevertheless, in November 2008, the finance minister, John Swinney, gave the go-ahead for the Trump development, arguing that Scotland badly needs to create tourist and sporting venues conforming to international standards. Councillor Martin Ford said that 'a billionaire's vanity project had been put ahead of the protection of Scotland's natural heritage' but the tide of local support for it meant that he was isolated even within his own party.[25]

As well as wooing American capitalists, the SNP has been neutralising the political Right at home. It has won backing for successive budgets from the Scottish Conservatives, even though the concessions the party has obtained in return appear nebulous. The sharp unpopularity which the United Kingdom Tories experienced for nearly a decade after 1997 produced a steady drift towards the SNP from their ranks. Its tone and profile were appealing to many Tories who were disorientated by the abrupt shifts in Tory identity from One Nation paternalism to untrammelled economic liberalism. Today Scottish Conservatism appears as cut off from major social and economic groupings as the SNP used to be. David Cameron has shown impatience with the failure of the Scottish party to engineer the electoral recovery which has occurred in Wales as well as England in recent years It is unlikely that Scottish Tories will be beneficiaries of the economic crisis into which the United Kingdom plunged in 2008. Because of the global nature of the downturn, many Edinburgh financial workers who might have found work outside Scotland will have to endure unemployment at home. They might prove a dangerous class in Scotland. No longer is business in general numb to the Nationalist message. Jim Faulds, chairman of the Dunfermline Building Society when

it collapsed in 2009 with massive debts, sounded every inch the Nationalist when he fulminated against the Treasury response to DBS's difficulties (even though he is not publicly affiliated to the SNP).[26]

The vulnerable condition of the British economy, thanks to profligate spending and unwise decisions, as well as its greater exposure to globalisation, has weakened Scottish attachment to Britain. Scottish Conservatives currently lack politicians of the calibre of Teddy Taylor or even George Younger who were able to summon up enthusiasm for the Unionist cause. The SNP's image as a party with national rather than sectional priorities makes it appealing to voters influenced more by a party's collective identity and less by specific policies. As long as the Tories remain unsure of their purpose, they are unlikely to be able to do much about halting many of the Nationalists' plans.

The SNP is less worried by the intentions of its opponents and more afraid that most voters will get to like SNP-run devolution and will be unwilling to extend their ambitions to full independence. A poll by MRUK published in March 2008 found support for independence unusually low at twenty-three percent, (nearly a year later a YouGov poll found the figure rising to twenty-nine percent). Only one other poll has found it that low in recent years. In 2008 forty-five percent preferred the devolved Parliament to continue but with more powers.[27] The SNP dreads being blown off the independence path and becoming absorbed with managing a public administration that has grown massive in size.[28] Accordingly, the party has tried to point out that it should not be judged on its ability to run the devolved administration, since there is only so much that can be achieved under home rule however dedicated those who hold office. It is constantly on the look-out for ways of radicalising the opinion of Scots and making the party their chief reference-point.

Probably no other party in modern British politics has been able to accommodate as many social types and economic viewpoints as the SNP. To preserve its own cohesion, it is important that the national question, and not potentially divisive policy issues, is what people automatically think about when turning to the SNP. That is why the SNP needs to try and control the way Scottish politics is viewed and debated. To preserve its own internal stability and transmit an attractive message, it will be important that its own world view of an embattled Scotland struggling for justice be absorbed by the media.

Thus the SNP has almost fetishised the image of Scotland as a victimised nation. In the early stages of the financial crisis, Salmond issued 'a bellicose demand that Whitehall hand Holyrood £1 billion of "Scotland's money". On close examination, this turned out to be a sensible request for a Barnett formula share (see chapter 7) of new government spending.' So the request had legitimacy. 'But Salmond's demand was belligerent and confrontational.'[29] The government' s response to the global recession 'was to stick its hand out and ask for more cash'.[30]

Financial constraints weaken the Salmond government's room to manoeuvre, which is why he is anxious to ensure that he and his party are not judged by the yardsticks applied to other ruling parties: their performance as good economic stewards. Instead, bold stands are taken on issues where existing policy has troubled large numbers of Scots. Perhaps the most emotive is energy supply, and particularly the nuclear issue. Nuclear plants at Hunterston and Torness are reaching the end of their working lives and will need to be replaced. The SNP has made it clear that it will block planning applications to build any new plants. Although nuclear energy does not add to the carbon footprint, environmentalists oppose it because of the problems in disposing of radioactive material. This mainly middle-class group is articulate and active in public affairs, so it makes sense for the SNP to court it.

The government's target of generating fifty percent of Scotland's energy from renewable sources by 2020 is bound to impress many greens.[31] Scotland has up to twenty-five percent of Europe's potential wind power as well as a long jagged coastline with a great potential for wave and tidal power. But many of the technologies in the renewable energy field are still in their infancy and have yet to be proven on a commercial scale.[32] Salmond appears to recognise this because he has given his support for new coal-fired power stations as long as they can be fitted with technology (which does not exist yet) to capture and store carbon dioxide, the gas associated with global warming.[33] Accordingly, it is proposed that Scotland's future electricity supplies should be based on 'clean' fossil-fuel power stations and renewable energy. But in a letter to the first minister, Dr James Hansen, head of NASA's Goddard Institute for Space Studies, said: 'carbon capture and storage readiness is not an adequate solution. It is a sham that does not guarantee that a single tonne of carbon will be captured in practice. Alternative approaches must be considered which ensure an effective

moratorium on new unabated coal power.' Duncan McLaren, director of Friends of the Earth Scotland, strongly supported the NASA scientist's criticism of coal-fired stations and he asked the first minister to 'accept graciously the input from one of the world's leading experts on climate change and be grateful that he's showing an interest in Scotland's potential for world leadership in these matters'.[34] Allan Wilson, a former Labour minister, said there was no such thing as 'clean coal' and nuclear was the only option in order to meet climate reduction obligations.[35] Salmond's unequivocal hostility to all things nuclear appears ready to lure him into the trap of relying on a major source of pollution. It is doubtful if any government would dismantle coal-fired power stations if the cleaner technology proved economically unattainable.

But even the Council of Economic Advisers (CEA), created by Salmond to guide him on economic policy, has warned that intransigence over energy policy could cost Scotland dear.[36] The CEA was meant to show that the SNP was ready to employ all the talents to plot a bold new path for Scotland. But its analysis of both the SNP's plans for nuclear energy and its commitment to overseas investment to build public sector capital projects has been at variance with the first minister's outlook. He has scorned the pragmatism of these 'wise men' in a style that evokes another bold ideologue, Margaret Thatcher. The CEA is chaired by Sir George Mathewson, former Royal Bank of Scotland chairman and a strong supporter of independence. He urged Salmond to appoint independent consultants to try and determine what were the costs associated with each of the energy options. Whitehall is planning a new generation of nuclear plants in England and it could be that in the future Scotland will need to import energy from across the border if Salmond's renewable energy vision is not accompanied by the necessary technological breakthroughs.

In seeking to rid Scotland of nuclear weapons, the SNP appears to have more room to manoeuvre. Although defence policy is an issue reserved to Westminster, the SNP believes that it has powers in terms of planning and transport that can make it difficult for the nuclear base at Faslane to remain in existence.[37] On 22 October 2007, after a meeting with anti-nuclear campaigners, the Scottish government announced that it was setting up a group to see how existing laws might be used to stop missiles being moved around the Trident submarine base on the river Clyde—rendering it useless. Salmond has written

to the 189 countries that have signed the Nuclear Non-Proliferation Treaty, seeking observer status for the government at the next review of the treaty (receiving twenty replies, none apparently encouraging).[38]

But the issue resonates with the radical left in Scotland, which might play a crucial role in determining how close the SNP gets to achieving its separatist ambitions. Today it is Trotskyites who are in the ascendancy. In the mid-1970s, they proved to be a disruptive force, capsizing Nationalist initiatives like the short-lived Scottish Labour Party founded by Jim Sillars in 1976. But nowadays many are willing to dance to the SNP's tune. The Nationalist blogosphere contains many converts from Trotskyism, inspired by Salmond's wish to quit NATO, evict nuclear warheads from the Clyde, and pursue a neutralist foreign policy. Arguably, cultural and educational changes, and the retreat of mainstream social groups from participation in politics, has boosted the influence of the far-Left in Scotland. The Scottish Socialist Party won seven seats in the 2003 Holyrood election only to later undergo a messy split. There is evidence that it was far-left voters who contributed to the SNP's narrow victory in 2007. It is likely that the far-Left will return to Holyrood in a future election and it could challenge Labour, even in currently safe Glasgow, if an outspoken figure like George Galloway decides to relocate to the city. It would suit the SNP if pro-independence people from a Trotskyite background mounted such a challenge; the decline of Labour support in Glasgow could prove crucial in paving the way for independence.

Salmond has never hidden his disdain for British institutions nor denied that a sense of Britishness always eluded him. He has sent Robin Naysmith, once his principal private secretary, to the United States where he sits in the British Embassy in Washington as counsellor with a brief that includes making the case for independence.[39] Once upon being asked which historical figure, living or dead, he most admired, Salmond replied: 'Oliver Cromwell is my favourite Englishman ... although Guy Fawkes comes a close second. He had the right idea for the Westminster parliament building!'[40] In the Royal Navy, his father had been known as 'Uncle Joe' on account of his radical views; later, when he became a civil servant, he converted to nationalism.[41]

In 1998 one journalist found Salmond hankering to change the name of the SNP. "I've always wanted to call it the Scottish Independence Party. It's a much better encapsulation of what we are about. Independence is our idea, and our politics are social-democrat. I'm a post-

Nationalist.'[42] He has sought to project the party as a kind of liberation movement, not a party to be judged in conventional terms; and he does not flinch from identifying with figures from Scotland's past who have suffered at the hands of English might. In 2008, he took time out of a busy schedule to view the death warrant of Mary Queen of Scots, a figure whom he repeatedly called 'injured Mary' when speaking in Edinburgh on 22 January 2009.[43] There is no greater exponent of the cult of William Wallace at the top of his party. The seven hundredth anniversary of Wallace's execution fell on 23 August 2005 and three SNP Parliamentarians retraced the route he took to his execution at Smithfield. Angus Macneill, MP for the Western Isles said: 'we are the political heirs of William Wallace.' Alex Salmond's message for the occasion breathed defiance:

'700 years on and William Wallace still has the establishment scared stiff. Note the absence of an official commemoration planned for today, the anniversary of the execution of Scotland's greatest national hero ...

'When the film Braveheart was produced ten year ago, most of the establishment were horrified but the film went on to triumph to popular and international acclaim—and the story of Wallace was restored to a new generation of Scots...

'The story of Wallace and the release of Braveheart—was certainly a factor in spurring Scotland on to the restoration of our national Parliament.'[44]

To some on the far-Left, Salmond might appear to be a figure in the mould of the Irish Nationalist leader, Michael Collins, ready to upstage the British and erode their power in the way other anti-colonial freedom fighters have done from Nasser to Nkrumah. He appears to be a cultural warrior poised to sweep away the sense of inferiority which has kept Scotland in the shadow of its larger neighbour. In a collection of essays published in 1989, two academics argued that understanding of Scottish culture and history has been blighted by the phenomenon of what they call 'inferiorism'. This is a concept adapted from the work of the Martinique-born writer Franz Fanon, who used it to describe the way in which a colonial people internalise the imperial power's judgment of them as an inferior culture. According to the Church of Scotland minister William Storrar, Scotland, a small nation under the hegemony of a once major world power, has internalised that sense of uniformity...'[45]

Salmond is ready to challenge the tacit understandings and unwritten conventions that still shape British government. In this respect, he

is rather like Ian Paisley, with whom he developed a friendship during late night sittings in the House of Commons. There is perhaps no other politician from the Celtic parts of Britain who has emulated his confrontational brand of politics to such obvious effect.

In terms of Scottish politics, Salmond is unusual—ambitious, self-confident, and far from over-awed by the structures of power which he intends to supplant completely rather than modify. Past Scottish power-holders, on the left, have been rigid or insecure persons. Willie Ross, Donald Dewar, and Gordon Brown were remote and often self-absorbed figures, though Dewar was more approachable than the glacial Ross or the introverted Brown. It was outsiders, destined never to exercise power, figures like Jimmy Maxton, Jimmy Reid or Margo MacDonald who enjoyed popular affection. Surrounded by the trappings of office, Salmond is very informal and approachable, enjoys a joke, and appears to blend in neatly to any social situation. His amiability allows many Scots to view him as 'the people's friend', a rare accolade for a politician during an era of mounting scepticism towards their like the world over. Carefully chosen interviews with veteran journalist Ian Jack or popular crime writer Ian Rankin have sought to emphasise his reasonableness. His path is smoothed by the apparent decision of the *Herald* newspaper, once Scotland's largest-selling broadsheet, to gradually retreat from its Unionism while sometimes adopting a world view sympathetic to multiculturalism and critical of the conduct of major Western powers.

Neither this press organ nor any other branch of the Scottish media now includes figures on the left who view the SNP government's alliance with religious groupings as a retreat from progressive politics. This is in contrast with the press in London where left-wing journalists who have consistently argued against government collusion with non-violent Islamists include such prominent figures as Martin Bright, Joan Smith, David Aaronovitch, and Nick Cohen. Arguably, the absence of counterparts in the Scottish media hardly reinforces the case for print and electronic media organs that are more Scottish in their focus. Overall, the Scottish media treats politics far more like a soap opera than its London counterparts. It is disinclined to examine the fierce clashes now occurring just beneath the surface of politics as parties position themselves for elections in 2010, possibly including a referendum on independence.

With a few headline-seeking events, Salmond has sought to bring politics closer to the people. Thus, on 5 August 2008, he convened the Cabinet in Inverness. A journalist wrote: 'There was a general sense that the first Minister had gone on too long—taking up an hour of yesterday's hour-and-a-quarter session all on his own ...Two-thirds of those present were invited by the Scottish government. These people tended to be councillors, quangocrats, people with public roles and functions ... The other 40 tickets had gone out to the general populace, some of which, the ones not snapped up by party activists, had actually found their way into the hands of members of the public, but they were considerably in the minority.'[46]

As long as he appears to have what it takes to put the nation on the winning side of history, none of his colleagues seem to resent the degree to which the first minister basks in the limelight. The evidence is persuasive that he has carved out a favourable image for the SNP among many Scots who were previously numb to its charms.

Polls taken in the first half of the current Parliament show the popularity of both the SNP and its leader to be holding up surprisingly well. It is too easily forgotten that the party is judged by many voters on emotional criteria and not by its stewardship of the economy or ability to build schools or keep Scotland's streets safe. Many still see its role even when in government as standing up to an arrogant and untrustworthy set of overlords down the road in London. A lot of voters are not up in arms about the freeze on building projects or by the SNP's infatuation with a local income tax as long as Salmond and his troops act as vigilant defenders of the national cause.

No doubt to his delight, Salmond has realised that there is a big appetite for the kind of populist politics which bypasses institutions and procedures and makes a direct appeal to raw emotions. Scotland is experimenting with this high octane kind of politics very late in its democratic existence. England had already dabbled in populism generated from the top in the early 1980s. Margaret Thatcher used Nationalist rhetoric and symbolism to sweep away the tired economic consensus and replace it with one emphasising individualism and free market capitalism. Just like today's SNP, she was helped by the existence of an unimpressive and divided opposition. But it was an unexpected event, in the shape of the 1982 Falklands War which enabled her radical right-wing views to triumph. Pressure of events on a dispirited British state, over-extended at home and abroad, could produce a

similar dividend for the SNP, leading perhaps to the eclipse of the Unionist era in Scotland.

With its assured manipulation of popular sentiment, the SNP appears capable of transmitting a single message thanks to the homogenisation of culture and identity. Repeated alteration of council boundaries ensure that Scottish local authorities possess only a vestigial hold on peoples affections. Regional cleavages, such as the long-standing one between Highlands and Lowlands, have diminished in importance. So has the far more problematic Protestant versus Catholic cleavage.

From 2001 the SNP appeared to enjoy equal support across all classes except the petit bourgeoisie, where they scored a high thirty-two percent.[47] Ever ready to capture new recruits, Salmond has courted high-profile Scots, and in August 2007 even Labour's Henry McLeish was prepared to say that the SNP 'has been uncompromising in its defence of Scotland's interests'.[48] McLeish is now marginalised politically, though still offering thoughtful perspectives on Scottish politics. The SNP benefits from the fact that growing numbers of Scots are isolated from important institutions which in past epochs were important reference points, such as a religious body, a trade-union or professional group, or some alternative local form of identity. They are more rootless politically and this enables the SNP to project itself as a surrogate family.

As the figures below indicate, a much higher proportion of members than in the population as a whole is not religious in outlook:[49]

Table 1: Religion Party membership Population

	Party membership	Population
No Religion	42.6	33.0
Church of Scotland	37.4	42.4
Roman Catholic	10.4	15.9
Other	6.9	

The Scottish Social Attitudes Survey of 2000 found that people who stayed away from civic activism were often strongly Nationalist in outlook; this group tended not to participate in many social networks[50] and perhaps was more drawn to membership of a hierarchical movement that was often personality-driven.

The trend in Scotland has been for a strong community life to atrophy and people to become detached from institutions with which they

may have previously enjoyed close ties. The decision, in 2004, to remove the headquarters of the Royal Bank of Scotland from the centre of Edinburgh to a purpose-built complex near the city's airport was emblematic in this respect. From now on the bankers met only other bankers. Other businesses isolated themselves from their customers and the central life of cities decayed.[51]

Historically, Scotland has been a less individualistic country than England. Corporate interests have always been influential in Scotland with mobilised groups based on religious, mercantile and professional concerns often exercising discretionary sway over the state and even the justice system in centuries past. To the outside world, the SNP has always liked to project its *civic* Nationalist character. To be authentic, this trait is one that requires the individual citizen to be able to count politically not just at election time, and it must enable territorially-based communities to have some influence over decision-making. Individual self-reliance as well as community solidarity are characteristics usually visible where civic nationalism is a basis for politics. But under the SNP there have been no shortage of signs of a desire to see Scotland based around group identities, some ethnic, others professional, but all managed by the state.

The groupings that have flourished in Scotland like no others are the quasi-autonomous non-governmental organizations, better known as quangos. These are an archipelago of boards, commissions, and committees that play an important auxiliary role in the administration. Neither elected nor fully accountable, these bodies and their membership are controlled by the government of Scotland. The number of those employed in quangos in the third quarter of 2008 was 37,300, an increase of 1.2 percent on the same quarter of the previous year.[52] Alex Salmond had promised there would be a 'bonfire' of quangos but his party was instrumental in paving the way for new publicly-funded bodies, most notably the Scottish Islamic Foundation, whose chief executive was a leading member of the SNP. Meanwhile, the unemployment figures for the autumn of 2008 showed a rise of 12,000.

The SNP is well-aware how unreliable many Scots are in their voting habits, so it is an understandable instinct for the party to try and influence the quangocracy and draw key parts of it towards the SNP. One group the party has singled out for special attention is the so-called 'creative community'. The government has prioritised turning the Scottish Arts Council into a much larger entity to be called Creative Scot-

THE ILLUSION OF FREEDOM

land. Hitherto, the government left this arts body to its own devices but under new legislation, it will be able to give it advice. It has always been clear Salmond sees fostering a cultural outlook that is Scottish rather than British in character as a key objective in order to secure independence. So armed with these new powers, it is conceivable that the arts community might find itself pressurised by the government to assist in the realisation of the SNP's cultural objectives. Unimpressed by the SNP's plans for the arts, Holyrood voted down the Creative Scotland proposal in June 2008 but it is being brought back in 2009.

The mass media is one of the key institutions which ought to enable Scots to become acquainted with the appearance of their country and some of its values. Understandably, Salmond is preoccupied with ensuring that the British element is diluted and that a Scottish dimension becomes dominant in influencing perceptions of the wider environment. During the wilderness years, when the SNP was far from the seats of power, it was in television and radio studios that Salmond spent a large part of his time. In 1998, one journalist described a day spent with him in these terms:

'We are on the Aberdeen bypass when the public relations man at party headquarters in Edinburgh calls on the mobile to report that Gordon Brown has dropped plans for a new tax on North Sea oil. Salmond instructs the driver to divert to Grampian TV. Arriving unannounced, he offers an interview. Undeterred when Grampian's newsroom rebuffs him, Salmond directs the driver round the corner to the BBC's Aberdeen studios. There he is made welcome, recording an interview that will be broadcast the next morning. On the way out of town, he slips into an independent radio station for one last fix.'[53]

Salmond is demanding a separate Six O'Clock News programme for the BBC in Scotland and one of his first decisions after May 2007 was to set up a commission on the future of broadcasting, which he hopes will result in control of radio and television being devolved to Holyrood. He has complained about a drop in the BBC's spending in Scotland, saying that 'it is just not acceptable that networks which purport to serve the whole of the UK should marginalise the creative community in Scotland.'[54] The commission asked the BBC to review its policy for Scottish programmes but it also stated that legislative powers for broadcasting should remain with the United Kingdom government.[55]

With Scottish press titles like the *Herald* in Glasgow and the *Scotsman* in Edinburgh facing a steep fall in revenue, talk is increasingly heard of supposed icons of the Scottish print industry receiving subsi-

dies from the state in order to continue.[56] It is reasonable to ask how this will affect their coverage of events at a time when political battle-lines are being drawn and much of the media is content to treat politics as a spectacle in which crucial issues rarely get discussed. In Norway and Sweden much of the print media enjoys a financial input from the state and arguably it has resulted in stifling conformity (with articles that raise questions about the success of Scandinavian multiculturalism rarely obtaining exposure). The fact that many Scottish quangos have been busy rewriting policy prospectuses to fall into line with the mantra from the SNP of a 'diverse and inclusive' Scotland suggests that state influence over the media is bound to come at a price. State influence over the academic world might also be further extended. University chiefs were alarmed when the government demanded that economics be a greater priority in university curricula at a time when 'the dismal science' has failed to distinguish itself in its analyses of the reckless phase of turn-of-the century capitalism.

Perhaps Nationalists took heart when one of the nation's most Unionist bastions, St Andrews University, appointed Louise Richardson as its new principal. Richardson admitted in the *Financial Times* that she 'could have joined the IRA in a heartbeat' while growing up in the Republic of Ireland. This respected international relations expert made headlines in the same article by describing terrorists as people 'like you and me'.[57] This might have been true of many, though not all, militant Irish Nationalists, as the remarkable evolution of Martin McGuinness would suggest. But not all conflicts are political, or stem from who has power over whom. Islamic terrorists are often not driven by a political agenda; indeed their carelessness about their own lives, and especially those of others, suggests that temporal matters have no real value for many of them.[58] Some liberal secularists find this hard to comprehend and Scotland may find itself on a difficult learning curve if the Salmond government takes advantage of a changing academic climate to promote Scotland as a centre for dialogue between terrorists and the institutions and states with which they are locked in conflict.

Scotland has not always found it easy to accommodate its minorities. For many years, Salmond has made no secret of wishing to make electoral headway among ethno-religious groups hitherto numb to the SNP message by operating through influential religious figures. In the 1970s, the refusal of working-class Catholics to drop their Labour

sympathies in no small measure prevented the party making a break-through in West-central Scotland, where it needed to enjoy success if it was to challenge Unionist forces. Since then, close ties between the Catholic community and Labour have frayed. The SNP has tried to quicken this process. The party has become an uncritical defender of state-funded Catholic schools. For some years Salmond was a regular contributor to *Flourish*, the newspaper of the Archdiocese of Glasgow.[59] He has tried to exploit the Catholic Church's deep unhappiness over the retreat of the Christian perspective on lifestyle issues and questions of morality inside the Labour Party.

Patrick Reilly, a well-known Catholic and retired academic, wrote in the wake of Labour's shock defeat at the 2008 Glasgow East by-election:

'In previous ages, Catholics looked to the right to discern their enemies—Tories, Nationalists, Unionists who sympathised with Stormont. Sectarian bigots attacked Catholics for being Catholic, which is why Catholics once turned so instinctively to Labour as their prime protectors. Now shockingly, they are forced to look left to identify their enemies. Catholics are now attacked for being Christian by left-wing ideologues who wish to eradicate religion itself and who see in the Catholic Church in Scotland a key barrier to the complete secular society they seek to establish.'[60]

Many Glasgow East voters were Roman Catholic, and even a decade before a poll showed that ties between Labour and Scotland's largest religious minority were fraying. In 1998, an opinion poll for the *Scotsman* showed that fifty-eight percent of Catholics would vote 'Yes' to independence in a referendum as opposed to fifty-one percent of non-Catholics. The analysis, by ICM ... showed that support for the SNP among Catholics has risen threefold since 1974, while there has been a dramatic decline in their support for Labour during that period. In October 1974 Labour was just six points ahead of the SNP in Scotland but among Catholics it had a sixty-three-point lead.[61]

But it is not clear to what extent Catholicism remained a strong reference point for such voters. A process of secularisation had occurred among Catholics, as revealed by low attendance at weekly church services and increasing rates of mixed marriages. The Catholic Church has been one of the biggest casualties as people have become detached from institutions which may previously have greatly influenced their lives. The SNP, very secular in its composition, has been one of the chief beneficiaries as Scots increasingly lead private lives based around

their role as consumers rather than citizens. It has been a bonus for the party that it has been able to keep the official church within its orbit. The late Cardinal Winning's disenchantment with Labour was well-known but in 2006, his successor, Keith Patrick O'Brien surpassed him when he predicted that independence is coming 'before too long' and he would be 'happy' if Scotland broke from the United Kingdom.[62]

On 12 October 2008, in a letter to parishioners read out at Masses in the run-up to a vital by-election in Glenrothes, Cardinal O'Brien urged all Catholics to consider Labour's position on abortion, the ban on Catholics succeeding to the throne and nuclear weapons before casting their vote.[63] This was just the boldest in a series of barely-disguised gestures of support for nationalism. Normally, Nationalist movements have had to bend churches to their will, particularly in central and eastern Europe, in order to clear the way for acquiring the absolute allegiance of populations perhaps still numb to the Nationalist message. In that part of Europe, the clergy were often reduced to being civil servants under the thumb of a secular state which even appointed the church's bishops. But Salmond has tried to turn official Scottish Catholicism into an adjunct of his party's interests by mounting a charm offensive, flattering princes of the Church and drawing them close to his party even when its voting behaviour on issues like abortion is little different from Labour's. The subordination of the church to a powerful state dates at least from the Byzantine Empire. Interestingly, Salmond was once asked: 'If you could visit any time in history for just 24 hours, which would you choose and why?' His answer was: 'The peak of the Byzantine Empire, because it was a sophisticated society, cloaked in mystery, which I would love to know more about.'[64]

Arguably, Byzantine is the correct term to use in describing the SNP's stance towards the Catholic Church. SNP-inclined bishops appear to have been disarmed by the vocal stance which the SNP has taken on symbolic issues such as repealing the clause in the Act of Settlement which prevents a Catholic ascending the throne or being married to its occupant. In 2008 the Brown government took steps to abolish this clause, which dates from 1701, but most Catholics are probably even unaware of its existence and it is likely to have zero impact on lives still affected by sectarianism in Central Scotland. Similarly, the SNP has styled itself as the defender of Catholic schools but no other party is seeking to abolish them (and this stance may have

much to do with the past widespread hostility inside the SNP to such schools).

Where the party is reluctant to take an active stand is in combating sectarianism, often with an anti-Catholic dimension. Salmond claimed in 1995 that he had been 'the first politician in Scotland' to address the issue of sectarianism in public speeches.[65] But grappling with inter-communal friction on religious grounds is unglamorous work which is unlikely to yield any immediate political benefit. Arguably, it also reveals an unattractive fault-line in society which, if given undue attention, might cause many Scots to assume the nation is too divided to merit independence. Under Jack McConnell, sectarianism was energetically pursued. The former first minister praised Nil By Mouth, a charity which led the fight against sectarianism since being founded in 2000 even though it made 'life difficult for politicians by telling home truths without fear or favour'.[66] But in 2008 it emerged that it was likely to lose all state funding, resulting in its potential closure. Instead, Salmond now promotes 'Sense on Sectarianism' which seems to be an amalgam of various 'stakeholders'—football clubs, etc—which the SNP government may well obtain advantage from working with. The first minister had already dropped the annual anti-sectarian summits and patient behind-the-scenes work mainly pioneered by Labour to reduce communal tension with distant religious origins. Stewart Maxwell, communities' minister until February 2009, even claimed that sectarianism was no worse than other problems such as racism or obesity so it need not be singled out for special treatment.[67]

The Catholic Church remained tight-lipped as the SNP ditched projects which shed unwelcome light on a problem that harmed the bold self-image the SNP wished to project for Scotland. But in 2006, Cardinal O'Brien had said that sectarianism was 'sadly deeper, wider and altogether more pervasive' than drink-fuelled, post-match rivalry. 'It is not poverty, alcohol or football which underpins most cases of religiously aggravated crime in Scotland, but blatant anti-Catholicism...'[68] However, when the SNP showed that in practice it was surprisingly untroubled by the issue, the Catholic Church held its peace, whereas it was unsparing in chastising the Labour Party for numerous shortcomings. It remains to be seen if O'Brien's main place in history will be as chief recruiting sergeant for a political party which skilfully covers up its mainly secular outlook. Priests and bishops across Europe

severely damaged the credibility of the Catholic faith by acting as such for rival European nationalisms in the First World War.

Hopefully, Cardinal O'Brien will spurn such a role. In April 2009, he delivered his first criticism of the Salmond government when he complained that it had left the country on the edge of an 'abyss of social collapse'.[69] But if Scotland's cardinal helps push the nation towards being a tartan multicultural statelet, he could inflict damage on the faith that familiar enemies of Catholicism in Scotland could only dream of causing in the past.

Unlike the Catholics, Scotland's Muslims are a young community. They have been no strangers to prejudice but they have also benefited from a number of developments which have quickened their path towards acceptance. Much ethnic antagonism in Glasgow (where Muslims mostly reside) continued to be absorbed by the stubbornly-enduring intercultural conflict between adherents of rival Protestant and Catholic causes. Secondly, their arrival coincided with state efforts, through legislation and numerous action plans, to counteract racial prejudice.

Compared with other Muslim communities located in different parts of urban Britain, Scotland's Muslims are a cosmopolitan community, with strong secular leanings, many of whom hail from Pakistan's somewhat commercially-orientated Punjab rather than from villages in Kashmir which are often feudal in character. In the past, they have given active backing to secular and democratic leaders like the late Benazir Bhutto, rather than for mullahs or military figures who exploited religious tensions to cling to power. In 1997 Mohammed Sarwar became the first Pakistani-born Muslim to be elected to Parliament when he became Labour MP for Glasgow Govan (later Glasgow Central). He has been a moderate voice on international issues with a Muslim dimension and there is plenty of evidence that most of the time such issues, to do with the Middle East or South Asian politics, do not resonate strongly with Scottish Muslims.

For many years, Alex Salmond has cultivated young Muslim activists, as well as businessmen, speaking at charity events. But he has chosen to ignore the advice of the recent High Commissioner for Pakistan, Dr Maleha Lodhi who, when speaking at Glasgow University in 2007, urged Muslims to speak up for themselves and not allow the loudest voices to be seen as their natural representatives.[70] Instead, Salmond works through energetic young religious purists who have advocated the return of the Islamic Caliphate, sometimes display an

139

absorption with ending Western influence in the Middle East, or who are ready to make a case for the incorporation of Sharia law into British jurisprudence.[71] Their greatest breakthrough has been to win the backing of the SNP government for state-financed Muslim schools, despite their often poor record at producing pupils at ease within a secular society. This is the main goal of the Scottish Islamic Foundation (SIF), a pressure group which in 2008 obtained a grant of £419,000 from the Scottish government while more moderate Muslim groups were left empty-handed. This is nearly one-third of the funding issued by the Equalities Unit to religious bodies since 2007 and the disproportionate nature of the funding allocation brought expressions of concern from MSPs in other parties.[72] It also raised broader questions about whether such large sums of public money should be used to promote a particular religion, or indeed a version of that faith.[73] It may also indicate the proprietorial role which the SNP is showing towards the state and its resources before it even manages to achieve political domination.[74]

Osama Saeed, SIF's chief executive, has declared that he wants to see the emergence of overtly Islamic schools and that he has studied such schools in England where children are taught the Koran, girls wear the hijab, and boys and girls are segregated.[75] Saeed is the SNP candidate for the Westminster seat of Glasgow Central, which makes it all the more noteworthy that the Equality Unit at Holyrood issued such a huge grant to SIF.

It is an inauspicious start for any state-backed religious schools to be seen as the gift of one political party, or adhere to a narrow version of a faith in which less rigid forms are also prevalent. Contrary to myth, state-funded Catholic denominational schools were backed by all the major Scottish parties after 1918, not just Labour, which for most of the twentieth century was the beneficiary of much Catholic voting support. Moreover, those who managed and taught in Catholic schools were committed to the success of British institutions which they hoped some, at least, of their pupils would gravitate to, and also respectful of a good many of Scotland's own best traditions based on a combination of self-reliance and community solidarity. These schools produced many pupils who distinguished themselves in military service during World War II and in Korea.[76]

By contrast, Osama Saeed has been outspoken about the need for Western influence to be greatly reduced in the Middle East and SIF is

unafraid to invite to one of its weekend events Kamal Helbawy, formerly the Egyptian Muslim Brotherhood's main spokesman in Western Europe.[77] There is no evidence, or suggestion that the SIF follows orders from any foreign Islamist source and those leading officials who also hold offices in the SNP appear genuine in their commitment to many of its secular goals. But in his personal blog, *Rolled Up Trousers*, Saeed has vehemently criticised the publication in 2007 of the Danish cartoons depicting Mohammed: 'You just don't do pictures of the Prophet, period. It's a cultural thing, accept it and respect it'.[78] Writing in the *Guardian* in 2005, he stated that 'a restored caliphate is entirely compatible with democratically accountable institutions' while he also simultaneously defended Sharia law, whose aim he believes 'is to create a peaceful and just society'.[79] Osama Saeed's brother Sohaib, chair of the SIF's 'dialogue and education' working group, has defended the controversial Egyptian preacher Yusuf al-Qaradawi.[80] He set up a 'Sheikh Qaradawi Appreciation society' on Facebook following the British Home Office's 2008 decision to ban the preacher from entering Britain after comments surfaced in which he defended suicide attacks against Israel.[81]

These are highly traditional Muslims, imbued with energy and a range of political skills, who are drawn to public life and wish to create a Muslim community that is simultaneously pious and dynamic, remaining in close contact with South Asia and parts of the Middle East.[82] They are progressive and responsible when compared with those ultras who are committed to achieving theocratic governments in many different countries by indiscriminate violence. What is difficult to understand is why a party like the SNP, whose membership base is not very religious in its orientation, nevertheless is prepared to promote a group committed to a Europeanised version of Islam that is highly evangelical and wishes to live according to Sharia precepts within Europe today. This 'Euro-Islam' is encapsulated by the high-profile Muslim scholar and commentator, Tariq Ramadan, grandson of the founder of the Muslim Brotherhood, Hassan al-Banna. He was the chief speaker at the SIF's first showcase event, the Scottish Muslim Futures conference held at Hampden Park in Glasgow on 30 November 2008, a thinly-attended affair.[83] Until now, Scottish Muslims have been less socially isolated and more integrated than their counterparts in many other parts of Britain. So it is striking that the SNP has

selected as its dialogue partner a grouping which is introspective and quite rigid in its theology.

Ed Husain, author of a best selling book charting his own absorption with, and subsequent rejection of, politicised Islam, believes the spiritual integrity of Islam can best be preserved by ensuring that the religion does not become a political instrument in the hands of narrow forces.[84] In April 2009, he felt it necessary to criticise the SNP's alliance with Islamists who 'are promoting religious separatism'.[85] Amanullah de Sondy, a lecturer in Islamic Studies at Glasgow University, also represents a more pluralised and outward-looking form of Islam. Ample evidence for this is provided on his blog: *progressivescottishmuslims.blogspot.com*. But he is not consulted by the SNP, (nor does it reach out to intellectual counterparts among Roman Catholics, such as those who produce the monthly magazine, *Open House*). The party would probably find de Sondy's warning that denominational schools will 'leave young Muslims vulnerable to extremist pressures' inconvenient.[86] It might also find it hard to engage with dialogue partners from the Muslim community if they request that the SNP base its approach to Muslims on more than just vote-gathering terms. The SNP issued a harsh rebuttal of Muslim critics of its high-profile Islamist members on 24 April 2009: 'The Quilliam Foundation [the main voice of pro-integration British Muslims] has zero credibility...the very last thing we need is people with no knowledge of Scotland spreading nastiness and smears'.[87]

It will be ironic if the SNP's engagement with a narrow section of opinion among Scottish Muslims has the effect of ghettoising what ought to be one of the most outward looking Muslim communities in Britain. Elections in Bangladesh in December 2008 and Indonesia in April 2009, two of the world's most populous Muslim countries, witnessed sharp setbacks for religious parties. This seemed to indicate that mainly Muslim electorates prefer their faith to be expressed in a spiritual form and not in political activism. And Alex Salmond ought to be mindful of Scotland's past, when mobilised religious groups imposed their Christian orthodoxies in ways that arguably stifled Scotland's long-term development.

One of the last noteworthy events in Scotland before the Union of 1707 was the execution, in 1697, of the twenty-one-year-old Edinburgh student, Thomas Aikenhead, on a charge of blasphemy. It is an event Nationalist historians prefer to skirt around since it reveals the

intolerance that existed in pre-Union times. Aikenhead's mistake was to deride Christianity in public. He was hauled before the Scottish Privy Council and placed on trial before a jury of fifteen Edinburgh citizens who found him guilty, the judge prescribing the death sentence. The English historian Thomas Babington Macaulay, MP for Edinburgh in the 1850s, described the affair as 'a crime such as has never polluted this island'.[88]

Yet in 2005 the Blair government drew up a bill which would have outlawed any behavior deemed 'abusive' or 'insulting' to a faith.[89] The Racial and Religious Hatred Bill was described in a Parliamentary debate by the Conservative MP Michael Gove as threatening 'the most significant undermining of religious liberty since 1688. I mention the seventeenth century advisedly, because that was the last time in this country when questions of political and religious strife put lives at risk on the mainland of the United Kingdom.'[90]

This bill was diluted by the House of Lords after a campaign which managed to combine secularists and evangelical Christians. But it only lost by one vote. If carried into law, it is quite possible that it would have been used as widely as anti-terror legislation has been by a Labour government desperate to retain the support of Muslim pressure groups. On 27 March 2009, a not dissimilar ruling was passed by the United Nations Human Rights Council at the behest of Pakistan, against the 'defamation' of religion. This was seen, in numerous quarters, as an attempt to alter the concept of human rights so as to protect the interests of communities of believers rather than the rights of individuals.[91] Human rights groups believed that it would further curb freedom of expression, particularly in Muslim countries—whose delegates overwhelmingly supported the resolution along with colleagues from sub-Saharan African countries which are among the most religious in the world.[92]

Alex Salmond ought to be more conscious of the fact that struggles to preserve the neutrality of the public space were only won with difficulty in Scotland and freedom of expression is under threat right across the world. He ought to be approaching Muslims as individual citizens and not as a group whose religious identity is their most vital attribute. It is what a party leader motivated by a civic nationalism, promoting individual self-reliance, would naturally do. It is what responsible Nationalist movements learned to do in Europe from the nineteenth century onwards, as once all-powerful religious movements

were compelled to allow democratic self-government in which basic human rights were protected from unaccountable special interests. It should be a priority in particular for women MSPs who are Nationalists, especially as the evidence mounts that radicalised young women are playing an active role in Islamic terrorism. They stayed silent when Osama Saeed issued an unsympathetic statement in the wake of Benazir Bhutto's assassination at the end of 2007: no mention was made of her commitment to the causes of democracy and human rights and, instead, she was described as a 'prime minister with a less than impressive record. At US prompting, she returned to Pakistan despite warnings that there would be bloodshed. Despite this, she put not just her own life at risk but her followers' too.'[93]

In December 2008, Salmond attended the launch of the Strathclyde Police Muslim Association. Soon after, the name of its main spokesman, Sergeant Amar Shakoor, with his official police title, appeared at the bottom of a letter to the *Herald* strongly criticising Israel's conduct in Gaza.[94] If a Holyrood administration allows a public agency like the police to abandon its political neutrality and engage in controversy around emotive issues, it erodes its credibility, probably hampering the efforts of the police to stem the revival of inter-confessional tensions as well as ones between secular and religious interests.

Using multicultural levers to manipulate religious identity and indeed the wider shape of society is a policy previously associated with left-leaning urban conurbations in England. The strategy of celebrating cultural distinctiveness and shaping the delivery of services around it has been seen as a cause of tension in ethnically mixed and mainly working class communities by figures like Trevor Phillips, head of the Equality Commission, previously a supporter of such social engineering. As early as 2004, he declared that the term multiculturalism had ceased to be useful. Instead it was necessary to 'assert a core Britishness' for all citizens, which meant stressing shared values such as believing in democracy and the rule of law.'[95] But it is clear that the Working Group on Religions and Faith Relations which has been tasked by the Salmond government to find clear guidelines for promoting intercommunity understanding, is not going to emphasise Britishness. The danger is that the SNP will find a rubric for franchising control of education, policing, and other policy areas to mobilised factions inside and outside ethnic minorities. Individual citizenship will count for little. Instead, the party will be content to rule through a

large bureaucracy guided by multicultural precepts that are increasingly discredited elsewhere.

In 2008 Kenan Malik warned of the damage done to integration by state-led policies encouraging separatism:

'Only over the past two decades have minority groups sought to define themselves primarily by their differences. Why? Because they have been encouraged to do so by a society that has become wary of the notion of common values ... In this process, the very meanings of equality and social justice have been redefined, from the right to be treated the same despite one's cultural and ethnic differences, to the right to be treated differently because of them.

'The consequence has been the fragmentation of society, as different communities assert their particular identities and compete with each other for resources and recognition. The old universalising language of equality has been replaced by the new and divisive language of identity.'[96]

The SNP is very outspoken about collective values shaped around a Scottish ethnicity and it feels comfortable in collaborating with subgroups promoting an ethno-religious identity within a loose Scottish ambit. But unless it can also convincingly articulate a set of common values based around how to manage the public space, it could find that a synthetic Scottishness is unable to retain the loyalty of those still small numbers of hyphenated Scots whose core attachments are international and often narrowly religious.

The well-known commentator Andrew Marr recalled how Tom Johnston, perhaps the most admired pre-1945 Scottish socialist, depicted Presbyterian witch-burning in a history of the Scottish working classes: 'For a century and a half every burgh and parish in Scotland seems to have offered to Heaven its regular incense of burning flesh—human flesh, the flesh of the mothers and grandmothers of the labouring poor.' Marr himself went on to write that '[John] Knox ... was perhaps Khomenei's predecessor in more than dark clothing and beard. Like Islam, militant Presbyterianism was embraced by millions of ordinary people despite, or sometimes because of, its harshness.'[97]

Marr definitely overreacts here. Presbyterianism has far more positive attributes than this. But Salmond should heed some of the missteps taken in Scotland's past and endeavour not to repeat them, even if he believes a progressive cause can somehow justify this. He seems convinced that he can remake the political face of Scotland with improbable alliances without worrying overmuch about the long-term consequences. In 2007 he remarked: 'I'm a great fan of Harold Wilson: you know he achieved a lot in two years with a minority administra-

tion and then won a comfortable majority. Wilson was a brilliant political improviser.'[98] Wilson's achievements in the end were small-scale. He bequeathed the nation the Open University and kept its armed forces out of Vietnam. But he caused no major harm, which cannot be said of several of his successors. If Salmond balkanises parts of Scotland in order to supposedly liberate the nation, a hollow victory could be the end result. The French philosopher Bernard-Henri Levy wrote in 2008 that 'The post-left that flirts with groups like the Muslim Brotherhood is left no more.'[99] The same surely applies to Nationalists who jettison Enlightenment traditions, based on citizens enjoying a degree of self-rule, in favour of stifling orthodoxy based around a range of identities managed by the state. They too easily forget the damage done, in the past, to the fabric of the nation as a result of churches and the power-holders allied to them insisting on what ideas be permitted to circulate in the public space. A party dominated by individuals detached from religion but well capable of displaying the controlling mindset associated with Scottish Protestantism and Catholicism at their most unenlightened, needs to show more historical awareness. Otherwise, Scotland may be destined to repeat mistakes that for long years impeded its democratic development.

THE GREAT SEDUCTION

HOW TO MAKE SEPARATISM PALATABLE

Alex Salmond often shows the trait found in ardent Nationalists of wishing to recreate the nation in his own image. He combines burning ambition and formidable self-belief with a willingness to take risks. As independence looks more attainable for the SNP than at any time in its seventy-five-year history, it is likely that he will gamble with high stakes if it enables him to secure that prize. His most famous political gamble to date occurred in March 1999 during the crisis in Kosovo. NATO, in its first military action since being created in 1949, was carrying out bombing raids in Kosovo and Serbia in order to compel the Serbian strongman Slobodan Milosevic to end his onslaught on the Albanians of Kosovo, two-thirds of whom he had driven out at the point of a gun. The campaign for the first elections for the Scottish Parliament was in full swing. Early polls made the SNP a strong challenger to Labour. As the choice of the most suitable politician to head the home rule Parliament, Alex Salmond had drawn level with Donald Dewar, the architect of Scottish devolution.

But that was before Alex Salmond's election broadcast on 29 March 1999, in which he condemned NATO's intervention as 'an unpardonable folly'. Comparisons were made between the NATO raids, still then mainly being carried out against Yugoslav military targets, with those of the Luftwaffe, Salmond mentioning the London blitz and the bombings of Clydebank. His comparison of NATO's pilots with Hitler's prompted the then Foreign Secretary, Robin Cook, to say he would be 'the toast of Belgrade'.[1] It was clear that Milosevic was banking on voices like Salmond's to undermine the NATO offensive against

him so that peace talks could be arranged, by which time most of the Albanians would be living in refugee camps far away from their homeland. But the resolve of the NATO states held and it was Milosevic who within six weeks was suing for peace. Meanwhile, Salmond's attempt to exploit an international issue for his own party ends blew up in his face. Labour swept to victory, a quarter of Scots saying that Salmond's condemnation of NATO's action in Yugoslavia made them less likely to vote SNP.

Salmond had sat in Westminster throughout the 1990s when Milosevic had launched successive wars against nations, first the Slovenes, then the Croats, and most horrifically of all against the Muslims of Bosnia, when each of them refused to capitulate to his demand for the creation of a greater Serbia out of federal Yugoslavia. Rarely had the SNP leader registered any concern about the rights of small nations being violated and the tragic toll in killings and destruction. This silence is particularly telling considering how voluble Salmond has been in recent years about the rights of Muslims in lands where it is perceived that they languish under Western-backed oppression. At the SNP conference in 2004, he called for the impeachment of Tony Blair over Iraq and lashed out at George Bush for good measure.[2]

The BBC's Brian Taylor has written: 'One senior strategist suggested to me that ... it [the 1999 broadcast] had perhaps cost the party three to four seats, either in terms of key marginals or numbers from the top-up lists.'[3] In 2001, Salmond finally expressed his regret about the language he had used.[4]

Scotland has never seen a politician quite like him. He is clearly a restless and driven figure whose natural chemistry seems to draw him to revel in dispute. In the Celtic world, perhaps the nearest example is Andrew Jackson, the first populist to take American politics by storm, sweeping in from the frontier to capture the White House in 1829 on an electoral platform championing the common man. Jackson was the 'quintessential "tribal chieftain", a Scots-Irish leader, melding together the two ancient concepts of the warrior aristocracy and popular egalitarianism'.[5] An egalitarian manner combined with a desire for deference are two seemingly contradictory elements in Salmond's make-up. He stands for national resurrection but leaves little room for a national conversation since the way to redemption has already been mapped out. He aims to obtain the consent of Scots for independence by building up his personal authority. He wants to take bold steps and

be granted the degree of authority over the nation and its destiny that he exercises over his own party. He has well-placed followers inside the party. Then there are the usually *anonymous* bloggers, known as 'cybernats', who mount a protective shield around him in the media and pour anathemas on any who dare to argue that his performance is less than a stellar one.

Often he demonstrates a particular ruthlessness in the cut and thrust of politics. He ensured that several thoughtful programmes launched by Jack McConnell to strengthen the participation of young people and the elderly in reconstructing Scotland were axed, despite the voluntary commitment of thousands of Scots and the cross-party support these schemes had previously enjoyed. But he still insisted on the emergence of a new confidence among the Scottish people, 'young and old alike' coinciding with the advent of his government.[6] As for McConnell, he was excluded from the celebrations when Glasgow was chosen as the venue for the 2014 Commonwealth Games, despite the fact that most of the work to secure this prize had been carried out by the coalition government he had presided over.[7]

Salmond seeks to lower inhibitions about separatism by saying that 'a social union' will survive independence. He claimed at the 2007 election that, 'When Scotland becomes Independent, England will lose a surly lodger and gain a good neighbour.'[8] But one of his early decisions was to discriminate against English students in Scotland by ensuring that they became the only ones in Britain required to pay top-up fees, a move which has stoked up English resentment, perhaps not unintentionally.[9] He has deployed an armoury of Byzantine skills to sideline Parliament despite being outnumbered by the other parties. It has been an arena for adversarial politics sometimes as bad as anything witnessed at Westminster during the polarisation of the Thatcher years. There has been a reluctance to address vital issues of the day. Indeed, at the height of the banking emergency which saw the Edinburgh financial sector plunged into a deep crisis, the SNP spurned requests for a full-scale debate at Holyrood. Economists for whom a Council was created to provide him with advice have also been snubbed, and even those Scottish capitalists who augmented the SNP's electoral war chest had to go public in 2009 about their concerns that he was putting his ideological agenda ahead of the need to take swift action to prevent the Scottish economy spiralling into depression.[10]

But as long as he enjoys the kind of high personal standing denied to any previous modern political figure in Scotland, none of this may matter too much. Signs of the hold Salmond has over Scottish affections are not hard to see. There is no outcry over the fact that he sits not only in Holyrood but retains a seat at Westminster. A poll published on the first anniversary of his election showed that sixty-nine percent of respondents believe that he stands up for Scotland. A resounding thirty percent would trust him with their wallets. Fifty-three percent believed him likeable. Forty-three percent honest (a remarkable concession to the politics trade and an undeniable tribute to Salmond). Voters were split when asked: 'does he have the best ideas for improving people's lives?. Thirty-four percent said 'No' and thirty-one percent 'Yes'. Obviously, if he can win over the doubters, it will increase support for independence.[11]

How best to interpret the strong approval ratings of the first minister and to a lesser degree the SNP, after May 2007? Is it a welcome correction to the low standing most parties have enjoyed in the eyes of the public both in Scotland and across the United Kingdom for at least a decade, culminating in the expenses scandal which undermined the legitimacy of both Houses of Parliament in London in 2009.? Will it stimulate greater interest in politics and higher levels of participation? Or is there a risk that much of the public will become unduly trusting towards politicians whose articulation of patriotic sentiments gives them a strong influence and that the quality of representation might even suffer as a result?

Salmond flays those who talk down the nation but this enables many of his party's initiatives to escape close scrutiny, never mind criticism. He has used his control of the government machine and his unprecedented access to the media to promote a discourse about Scotland and where it is going that fits clearly within Nationalist parameters. He transformed an initiative by the previous government to mark the 250th anniversary of the birth of the poet Robert Burns in 2009 into a cleverly stage-managed event promoting a heightened form of Scottishness. 'Homecoming Scotland 2009' was designed to attract members of the Scottish Diaspora back not just as tourists but as investors, residents and advocates of their ancestral nation. The Foreign Office was not approached by Salmond's government despite the international dimension of the event.

Robert Burns was a bohemian spirit from an age of personal and political restrictions and it would be understandable if Salmond and his supporters hoped that his unconventionality rubbed off on contemporary Scots. The educationalist A.S. Neill, writing in the 1930s, summed up the impact of Burns on many Scots then and little has subsequently changed:

'The Scots do not admire Burns because he wrote lovely lyrics; few of them are able to distinguish between a Burns song and a song by Harry Lauder. They admire Burns because he said and did all the things they have wanted to do themselves. Robert Burns is the national unconscious, the creativity that Calvinism dammed up at birth.[12]

Overlooked by this cultural extravaganza is England where of course the overwhelming majority of the Scottish diaspora continue to reside. Rather, the emphasis is on the United States which contains the largest number of wealthy people of Scottish ancestry on the planet. In the 1930s, the SNP activist Arthur Donaldson, on a scouting mission to the USA to see if an Irish-style diaspora movement could assist the separatist cause back home, had dolefully reported that such efforts were futile: high-achieving Scots were not weighed down with bitter memories of the Highland clearances that could be exploited politically.[13] Nevertheless, a Scots-Irish culture had stubbornly endured in the Appalachian Mountains extending from Western Pennsylvania to Georgia and some of its members had been identified with the pro-slavery cause in the American civil war as well as dogmatic Protestantism. Far from being a backward white culture, the US Senator James Webb believed that the self-reliance, belief in equality, individualism and courage often shown on the battlefield by this group made an enormous contribution to American social identity, especially after they migrated from the South in large numbers from the 1930s onwards.[14] Trent Lott, a conservative Republican Senator from Mississippi, got a bill through Congress which became law in 1998, declaring that 6 April would be National Tartan Day 'to recognise the outstanding achievements and contributions made by Scottish Americans to the United States'.[15] By 2008 Alex Salmond had managed to have it renamed 'Scotland Week', and he presided over a week of events in April of that year in which he linked the American struggle for freedom with contemporary events in Scotland.[16] By 2009, he had persuaded Senator Webb to chair a 'Senate Friends of Scotland' caucus to which no less than thirty senators aligned.[17]

Not unnaturally, he hopes to win over high-profile figures boasting Scottish ancestry to his movement. He has had great success with Sean Connery, who is probably the world's best-known Scot. He has been a long-term contributor to party funds and according to Murray Grigor, who co-wrote the star's memoirs, 'Sean is really the "president over the water" as far as the SNP is concerned.'[18] He has a closer relationship with Salmond than with any previous SNP leader. The *Scotsman* newspaper found a 'senior Scottish government source' who was prepared to state: 'they are both men's men, people with a bit of verve and pizzazz about them and they like that about each other.'[19] In any referendum on independence, SNP strategists make no secret of their desire to make strong use of Sean Connery in the campaign.

Watching with mounting dismay the SNP's breakthroughs onto the international scene, Jim Murphy, the Scottish secretary, admitted that 'Labour's reticence about the symbols and emotion of patriotism, enabled the SNP superficially to conflate patriotism and separatism,' in the way it promoted the events of the Homecoming year.[20] The Burns extravaganza followed hard on the heels of an effort to promote Scotland as a scene of 'winter festivals' starting with St Andrew's day. An expression of concern came from Robert Brown, a Glasgow Lib Dem MSP:

'I am not keen on national days that are too closely linked to the political philosophies of the government of the day, whether it be led by Alex Salmond and the SNP or by Gordon Brown, who is promoting the British national day ...'
'... I resent the idea that my national and personal identity can be imposed and restricted by any Government ...'[21]

Even as thousands of Scots find their incomes start to be drastically curtailed by the deepening recession, Salmond was unperturbed about lavishing much official time and expenditure on the Year of Homecoming. It was reminiscent of the nationwide festival which, in 1953, the Irish government promoted also in the midst of an economic slump. *An Tostal* was designed to make the world more aware of Ireland's ancient culture, its missionary role, and heroic traditions of martial valour. The satirical writer Flann O'Brien directed his savage wit at the affair and its goal of lifting 'the citizens' civil spirit to the level of their spiritual inheritance'.[22] Unfortunately, such writers are lacking in Scotland, or at least the outlets for their work are unavailable, which enables an orgy of self-congratulation to burnish the nation's cultural kitsch as no previous event has done.

THE GREAT SEDUCTION

Whether it is receiving the American capitalist Donald Trump or welcoming back to Scotland Tom Nairn, the first post-1945 Marxist to champion Scottish nationalism, there are few avenues Alex Salmond will not venture down in order to make the SNP appear in touch with important contemporary trends. He caters brilliantly for the Scots need for diversion, even at times deploying his gawky humour and barbed wit to claim the role of Scotland's chief entertainer. But he is probably aware that most Scots will still only join him part of the way on the political journey he wishes to take. The circumstances are still unlikely in which a majority of Scots would vote for complete independence in a referendum. Perhaps instead he hopes that the initiative for removing Scotland from the Union might come from England if it moves in a Nationalist direction of its own.

The well-known commentator Simon Heffer frequently uses his column in the *Daily Telegraph* to excoriate the Scots for exploiting the Union in ways which might well draw applause from Alex Salmond. In one of his quieter moments, he wrote in 2007: 'I feel England and Scotland will only ever be happy together if they are politically apart.'[23] In the same article he argued that 'Britain is now more a term of geography than of politics.' He placed the blame on New Labour, and one of that party's MPs, the decidedly independent-minded Frank Field, seemed to agree with him. Upon Gordon Brown becoming prime minister, Field criticised him for his reluctance to 'confront the most fundamental of political questions of identity: what basic beliefs do we still hold in common and how should our primary loyalty to the country in which we live be expressed in tangible terms'.[24] Soon he had reached the conclusion that 'the English question is the great giant of British politics that is now beginning to awake from slumber.'[25] He cited educational and health benefits enjoyed by those living in Scotland and denied to citizens who lived in England even though all parts of the United Kingdom were still financed from a common revenue source. Polling evidence suggested that such issues were starting to resonate with voters even before the shrill voices of nationalism emanated from the seat of power north of the border. A poll in November 2006 asked the same or equivalent sets of questions about attitudes to the Union on both sides of the border. It found that resistance to having MPs with Scottish seats in the Cabinet or even as prime minister was limited. Six months earlier, Alan Duncan, a member of the Tory Shadow Cabinet, had tried to make an issue of this when he told the

BBC's Politics Show 'it is almost impossible now to have a Scottish prime minister because it would be at odds with the basic construction of the British Constitution'.[26] But more than three-fifths of people in England questioned in the ICM poll felt it wrong that Scottish MPs can vote on what happens to health and education in England while, since 1999, English MPs have lacked a say on these matters in Scotland. The poll made big headlines because it showed that fifty-nine percent of English voters said it was time for England to become an independent country, higher than the number of Scots (fifty-two percent) preferring this option for themselves.[27]

It may well be that the independence these English respondents desired was less absolute in character than what the SNP intends for Scotland. In many places, particularly ones affected by rapid social change, the English perspective had grown more sombre. Scottish slurs, easily laughed off in more confident times were starting to hit home. Jack McConnell's admission at the time of the 2006 European Football Championships that he would not support England in a sporting competition even if Scotland was not involved caused plenty of offence at the time. But in the 2007 ICM poll no fewer than seventy percent of people in England said they would support Scotland when it was playing someone other than England.

During the last phase of the Blair premiership, there was indignation when an unpopular government facing regular Labour rebellions could secure large parts of its legislative programme 'only with the help of its loyal Scots'.[28] Even an internationalist, like the ecological campaigner George Monbiot, was arguing in 2009 that 'England has become a colony. It is governed by a Scotsman who uses foreign mercenaries— Scottish, Welsh, and Irish MPs to suppress parliamentary revolts over purely English affairs.'[29] It was therefore not surprising that a Conservative-led campaign against Scottish MPs being able to vote on so-called English-only matters has gathered pace. But the memories of these outraged Tories is conveniently short. During the half-century of Unionist rule in Northern Ireland, no Conservatives were to be found who complained about Ulster MPs voting on English legislation. The explanation may well stem from the fact that between 1920 and 1972 the Conservative party enjoyed a loose alliance with the Ulster Unionists. According to Lord Sewel, an academic formerly at the University of Aberdeen who helped shape central government thinking on devolution, 'a spurious constitutional issue has been raised to the level

of high principle in order to compensate the Conservative Party for its failure to secure anything but token Parliamentary representation in Scotland'.[30]

In May 2006 Lord Baker, who had talked Mrs Thatcher into imposing the poll tax, wrote to the *Daily Telegraph* complaining that the appointment of two Scots (John Reid as home secretary and Douglas Alexander as transport secretary) was 'an affront to all English voters' because both of them would 'have to make controversial decisions in a country no part of which they represent'.[31] But Scotland was denied rule by its own elected representatives over a much more extended period, from 1979 to 1997, the sensitivities of which Kenneth Baker appeared to be blissfully unaware.

It is not such political anomalies which appear likely to deepen dissensions among the peoples of the Union, but instead economic ones, especially during a time of gathering recession. Since the SNP formed the government at Holyrood, the funding system for devolution has increasingly been in the spotlight.

The allocation of financial increments between Scotland and England has, since the end of the 1970s, been regulated by what is known as the Barnett Formula. It was first introduced by Joel Barnett, the chief secretary of the treasury from 1978–79, when the advent of devolution appeared likely. It was meant to allocate changes in public expenditure between the countries of the United Kingdom based on their respective population sizes. It was not a needs-based formula.[32] Another intention was to avert continuous wrangling among the territorial secretaries of state for special treatment. A broader intention was ultimately to narrow the gap in spending between Scotland and England which had grown in Scotland's favour in previous decades. By 2005, public expenditure was seventeen percent higher than in the rest of the United Kingdom with Scotland raising 8.2 percent of the total United Kingdom revenue (excluding North Sea oil reserves). As a result, the Scottish Executive's Government Expenditure and Revenue in Scotland 2003–04 (GERS) put the national deficit (excluding North Sea oil revenues) at £11.2 billion. This deficit is reduced to just under £7 billion if all North Sea oil revenues are allocated to Scotland.[33]

Under Barnett, proportional increases or decreases in spending had been agreed which gave eighty-five percent to England, ten percent to Scotland and five percent to Wales. The formula was only supposed to last for one year (1978–79), but it was preserved by George Younger,

Scottish secretary for the first six years of the Thatcher administration. He retained it because 'he realised that it prevented traumatic annual negotiations' with the Treasury.[34]

The Treasury announced in December 1997 that the Barnett Formula would be updated annually according to the changing population ratio. This was to ensure that Barnett's original intention to rein back Scottish spending was achieved, as its architect from his seat in the House of Lords has regularly pointed out.[35] Scotland's increase was to be smaller than England's with more resources being directed at disadvantaged regions whose needs had not received the same priority in the past.

After the hour of devolution finally came, Professor Neil Kay wrote in 1998: 'The corrosive effect of the Barnett squeeze on Scottish public spending could institutionalise a source of tension and conflict between Holyrood and Westminster.'[36] The case for higher Scottish spending rests on the claim that the country's spending needs are greater, particularly due to the existence of a scattered population across a relatively large land mass, thus involving greater demands on transport and telecommunications. These are considerations which have helped to preserve the status quo arrived at in 1979.

In practice, the Barnett approach does not require the Scottish government to exercise undue financial discipline and leaves it dependent on a block grant from Westminster. Barnett himself declared in the House of Lords in 2007 that the formula to which his name has been long attached is overdue for a review 'to see that we have one based on genuine need'.[37] But Lord Forsyth of Drumlean went further, arguing:

'It will clearly be untenable for Scotland to continue to receive more expenditure per head while implementing policies such as having free tuition fees for Scottish students when English students have to pay … and having free care for the elderly north of the Border. I accept that the Scottish Parliament is entitled to take these decisions, but it has to do so in the context of a funding system that is seen to be fair to all parts of the United Kingdom.'[38]

But to base public expenditure on a territory's ability to raise its own funding may undermine a core value sustaining the Union. According to Lord Sewel:

'the Union is founded on solidarity which means that the resources of the entire nation are available to sustain and support any part of the Union that experiences hardship and disadvantage. The more prosperous assist the less

prosperous. A fragmented territorial approach would simply condemn disadvantaged areas to become more disadvantaged, while tax-rich areas would be in the selfishly advantageous position of retaining all their tax income.'[39]

From within Scotland itself, there have been growing calls for fiscal autonomy which would involve Scots raising and spending their own taxes while forwarding a portion of them to Whitehall for United Kingdom services. This would lead to a system of parity across the United Kingdom based on the needs of different regions and districts. It would be hard to avoid a reduction in the block grant in Scotland which might result in Holyrood having to use its dormant power of raising income tax by up to three pence in the pound.[40] By 2008, the Labour Party in Scotland appeared prepared to move in this direction which would be a major step towards economic self-determination.

The SNP has its own bold plans for funding. It wishes to finance public projects by attracting foreign funds into an investment scheme called the Scottish Futures Trust. But this has been slow to acquire momentum. Besides, the Devolution Act does not permit the Scottish government to raise loans even though local authorities enjoy this right. In a Parliament supposedly motivated by consensual principles, then the need to avoid important capital projects falling behind schedule might have been expected to produce agreement among party rivals for petitioning Westminster to lift this restriction. But the degree of partisanship, especially between Labour and the SNP rules out such pragmatism. The most pressing project is a new transport link across the river Forth, vital for the Scottish economy. But at the end of 2008, the Labour chancellor of the exchequer, Alistair Darling, turned down a Scottish government request for a £2 billion cash advance to be taken out of the Treasury grant over the next twenty years. The SNP in turn refuses to drop its opposition to Labour's funding mechanism, the public-private-partnership. If the bridge is to be built this only leaves Salmond with the choice of taking the money from his current budget.[41]

It is likely that David Cameron will shortly find himself grappling with the intricacies of Anglo-Scottish relations if, after months of polls showing a clear lead over Labour, the Conservatives are returned to office in 2010. He will have to decide whether to confront or accommodate a strident group of Conservatives who have moved from being gatekeepers of centralism to being noisy regionalists. Their power-base is mainly located in the three wealthiest regions of England, which

some claim subsidise Scotland. They stand comparison with the Italian Northern League or the autonomists of Catalonia who wish to refrain from having to contribute to central funding out of which poorer parts of the Italian and Spanish states will be subsidised. These are territorial Nationalists opposed to the continuation of Spain and Italy in their present forms. It is surprising that a party with the Conservatives' long tradition of being a defender of the British state now contains a minority of members ready to embrace insular positions that could result in its complete unravelling and Britain being replaced by a series of territorial units that would count for far less than they do now in Europe and the wider world.

Cameron belongs to an Anglo-Scottish family with Aberdeenshire roots which prospered in the City of London. He is well aware of the feeling rife in sections of his party that the English pay the Scots so they can exercise the privilege of complaining about them.[42] But he appears to see the risks in playing to the Little England gallery by directing barbs at government leaders with Scottish backgrounds. In a speech delivered in 2007 he told English critics of the Union that what they should be doing is pursuing the Labour Party: 'Don't blame the Scots. Don't blame the Union. It's not because of the Union that your aspirations are not being met. It's not because Scotland is taking and not giving. It's because your Government is failing and not delivering.'[43]

It remains to be seen if he can find the eloquence to explain to people on both sides of the border that the relationship with England will always be the most important one for Scotland because of the numerous ties that bind the two countries. Will he look for allies across party lines prepared to state boldly that Scottish prosperity and security are more likely to flourish within the context of a renewed Anglo-Scottish partnership than through independence? Will he be prepared to argue that there may be a case for state spending being higher in Scotland than in the rest of mainland Britain for a variety of socio-economic and defence factors? The viability of the Union may depend upon how clear-sighted he is in preventing such financial issues plunging Anglo-Scottish relations into the deep freeze.

If Cameron has the time and inclination to seize the initiative back from cultural militants on both sides of the border, he will need to frame the Union in a more appealing way than Gordon Brown has managed to do, and this will involve taking on the Scotophobic ten-

dency in English nationalism. If he lacks the imagination and stamina to offer a right-of-centre justification for the Union State (in completely non-Thatcherite terms), he could find that any future premiership will be spent managing separation, and that historians will assign him a principal role in the events leading to the era of a Balkanised Britain.

But if Cameron manages to bury the ghost of Margaret Thatcher, perhaps by pursuing decentralisation measures in England that give local communities influence over state services, then perhaps he can contain the SNP. Not unnaturally, the Party assumes that with the Tories unlikely to pick up many seats in Scotland, a Tory government at Westminster will appear illegitimate in the eyes of many Scots. Inhibitions about choosing the independence option in a future referendum will, it hopes, recede further. If moves are taken to curtail Scotland's role at Westminster or cut its funding allocation, the Union could plunge into its final crisis. But Salmond could yet find that a Cameron in Downing Street is a far more formidable foe than Brown. The latter's rise is the archetypal Scottish success story but millions of Scots and English agree that his premiership has been a lamentable failure. Cameron is likely to be prepared to meet and thrash out policy issues with Salmond, unlike Brown who has only agreed to see him briefly on a number occasions since his premiership began. The smooth-tongued Nationalist may not come off best in such an encounter, since Cameron also has brains and self-belief, and has displayed plenty of guile in a career far shorter than Salmond's.

If the Tories fail to be cornered by the SNP, deliverance for the separatists could come from Labour. At the time of writing this book in the spring of 2009, Labour has an increasingly stricken appearance on both sides of the border. In August 2008, a YouGov poll gave the SNP a nineteen percent lead in voting intentions for Holyrood.[44] By March 2009, the SNP was ahead by just one point in the Holyrood constituency vote.[45] However, a few days before the release of this poll, a by-election victory gave the SNP control of Dundee. There is no shortage of evidence that Labour is struggling to hold on in urban seats, with Edinburgh, previously a citadel of Unionism, a cause of real concern. With Gordon Brown staring into an electoral abyss, Labour is in a worse condition in Scotland than in England, a reverse of the pattern that has applied for many years. The SNP is not confronted by any British party which enjoys strong reservoirs of support. Perhaps this may be a weakness since Nationalist ranks now display a touch of

hubris and arrogance. But it is hard to see how the SNP's march to power can be halted if a sclerotic Labour Party fails to recover its popular standing.

By June 2009, the party was in electoral free-fall due to the deep unpopularity of Gordon Brown and his manifest failings as a political leader and arguably also as an economic manager. Twenty-two of Scotland's thirty-two local authority areas voted for the SNP in the European elections of 4 June. Interestingly, Labour's support held up better in Scotland than in other territorial strongholds such as Wales. Here, the Conservatives emerged in first place on 4 June; in what was once known as 'the Socialist republic' of South Yorkshire, it was the British Far-Right which gained at the expense of Labour. With the exception of figures like Tom Harris and David Cairns, nearly all of Scotland's thirty-eight Westminster Labour MPs then rallied around Brown even when his unfitness to deliver effective government was proclaimed by a string of resigning ministers. Michael Connarty and Eric Joyce were MPs who argued in the media that a party, in many places increasingly confined to beneficiaries of Labour Party patronage, somehow still had what it took to place Britain on a winning path a year before a general election.

Labour membership figures are increasingly dire. Relations between Labour MPs at Westminster and their Holyrood counterparts have often been poor. Unseemly factional disputes have erupted inside different party branches, in one case enabling the SNP to seize control of Dundee council from Labour. These disputes show the party is finding it hard to close ranks when deprived of the oxygen of power. There is the danger in several places that party branches will be dominated by a small number of families, which is a terrible position to be in when facing an opponent as lean and hungry as the SNP.

The bedrock of Labour support is probably now located among the elderly as well as the salariat belonging to the bureaucracy which has surged in size since the advent of devolution. Many different groups which had stuck with Labour through lean times, from college intellectuals to politically aware members of the working-class, now believe the party has sold its soul to the devil over foreign policy and private financing of public sector projects. It is true that in its second and third terms the United Kingdom government ratcheted up public expenditure in the areas of health and social welfare, but it found it hard to sell the changes, especially since much of the spending went on new

tiers of managers and salaries. The SNP, particularly the media savvy health minister Nicola Sturgeon, has been far more adept in the public relations of health spending even though she has relatively few extra resources at her disposal.

In 1969 William Wolfe had counselled Michael Grieve, the son of the poet Hugh McDiarmid-and Wolfe's challenger for the SNP leadership, against an all-out attack on the Labour Party, saying: 'you don't attack those you need to win over'.[46] This gentlemanly attitude towards the Labour Party did not last for long in the SNP, it was rarely reciprocated by Labour and, indeed, after 2000 it is hard to find such enmity between two parties still committed to the democratic process in any other established European democracy. Not untypical was the incident at the 2008 Glenrothes by-election when the Labour victor, Lindsey Roy, pledged to work with his opponent, leader of the SNP-led council Peter Grant, only for the SNP's Tricia Marwick to shout 'Get lost' from across the polling hall.[47]

When Jack McConnell stood down as Scottish Labour leader in the summer of 2007, only one MSP was prepared to apply for the post, which showed the lack of enthusiasm for taking on Salmond and his Party. The economist Wendy Alexander was chosen without a contest in September 2007. She had faded from view after holding a series of ministerial posts in Labour's first term. Salmond viewed her appointment as a disaster for Labour and a gift for the SNP, a journalist describing her as 'overbearing and mechanical, someone he will be able to swat aside with a few deft jabs'.[48] Upon her appointment she said: 'the SNP honeymoon seems over'.[49] A year later, with Alexander out of front-rank politics and Labour about to select its third leader in a year, the Nationalist honeymoon still showed no sign of ending.

But her ten months leadership were not devoid of achievement. Alexander had the foresight to try and prepare the Party for the adverse political conditions it was facing. She repudiated Gordon Brown's view that the devolution settlement needed no further work. In some quarters, such inflexibility had been seen as contributing to Labour's loss of power in 2007.[50] As leader, Alexander argued that it was time for devolution to move on which meant the Scottish Parliament being given additional responsibilities, especially over financial matters. As early as 2003, Sir David Steel of the Liberal Democrats had stated that 'no self-respecting Parliament could exist permanently on a grant from another Parliament ...'[51] In 2006, his Party had

produced a detailed report showing how greater fiscal autonomy could be achieved which would stabilise the Union rather than tear it asunder.[52] Among several imaginative proposals, it called for the Scottish Parliament to have a partnership role in policy areas currently controlled and resourced by the United Kingdom.

Alexander had been a protégé of Donald Dewar who had argued that devolution was a process and not an event. Accordingly, she was prepared to work with the Lib Dems and the Tories and a cross-party group emerged to examine how to strengthen devolution. In December 2007, she persuaded the other pro-Union parties to participate in a Scottish Constitutional Commission to review devolution and focus on tax-raising powers and greater financial responsibility for Scotland. It was established in April 2008 under the chairmanship of Sir Kenneth Calman, the chancellor of Glasgow University. The Calman Commission was instructed to explore wide areas of United Kingdom constitutional reform in order to strengthen both devolution and the Union while specifically excluding the independence option.[53] Calman's findings were announced on 15 June 2009 with the support of the three main non-separatist parties. His report recommended that Holyrood should take charge of half the income tax raised in Scotland and that the Scottish government should be given the borrowing powers it currently lacks. Brown indicted that he would rush the proposals into law clearly in a bid to head-off the SNP. But Labour dissenters argued that the proposals were a surrender to the SNP while there were isolated Tory calls for a snap referendum in order to hopefully put the constitutional future of Scotland to bed for a long time. But if the SNP became the largest Scottish party at Westminster in 2010 or consolidated its majority at Holyrood in 2011, there will be little to stop it trying to stage another referendum

In her last month as Labour leader, Wendy Alexander had called for a referendum on independence, declaring in May 2008 that she was ready to 'bring it on'. Only when the people were given the option of a straight 'yes' or 'no' on independence, would it be possible to focus energies on improving the home rule settlement within the United Kingdom as a whole.[54] (Michael Forsyth, now Lord Drumlean, had called for an early referendum within four months of the SNP assuming office). But this attempt to steal a march on the SNP was bungled since she had not involved Downing Street. Alexander's hard work and strategic shrewdness was not reinforced by the common touch. She

'had a reputation for being abrasive, hectoring those she regarded as intellectual inferiors, which is known as being "Wendied"...'[55] In the MRUK poll released in March 2008, Salmond out-polled Wendy Alexander by a huge margin. She clearly trailed the first minister even among Labour voters.[56]

Perhaps being a woman didn't help. Arguably, there is little room for women in Scottish politics, certainly on the left. The 'cultural self-representation in west-central Scotland ... stressed the masculinity, skill, hardness, endurance, decency, solidarity and egalitarianism of the Scot...'[57] Historically, women have been seen as a threat and the radical educationalist A.S. Neill decried the 'aggressive women' whom he believed exercised considerable influence in Scottish society from behind the scenes.[58] Simmering discontent in the SNP about the egotistical behaviour of high-profile women like Margo MacDonald (now outside the party) and Nicola Sturgeon has not been uncommon over the years. Referring to Mrs Thatcher, Dennis Canavan advised his electors in 1979: 'Don't let that witch hang up her curtains in No 10 Downing Street.' The journalist Arnold Kemp wrote that 'this sentence combines chauvinism—with its underlying idea that a woman might not be fit for high office—with an appeal to female dislike of a woman who had got above herself.'[59] It didn't help that after 1997, Labour at Holyrood appeared to be composed of a lot of undemonstrative men and strident women.

Wendy Alexander resigned in June 2008 over the failure of her office to register a minor donation to her leadership campaign. Dominated by political enemies, Holyrood's Standards Commission suspended her for a week but she was absolved by a full vote of Parliament later in the year. She was succeeded as leader by Iain Gray who has been overshadowed by Jim Murphy, Scottish Secretary since the autumn of 2008. After 1999, this post, along with the Scottish Office in London, were seen as peripheral in the devolutionary era. But Murphy, with a sunny disposition and media skills almost matching those of Salmond, has managed to blunt the SNP leader's anti-London offensive by being prepared to talk with the SNP rather than exchange insults. On 23 June 2009, he even held a meeting with the entire SNP cabinet in order to explore ways of cooperation in such a time of economic difficulty. Salmond was careful to avoid being photographed with his self-confident Labour rival just as he has refused to debate on television

with the few Labour figures who possess some of his armoury of media skills.

Murphy works in tandem with Iain Gray who in September 2008 received a clear endorsement from the Electoral College of members, councillors, trade-unions and affiliated bodies entitled to vote. Gray is an Edinburgh ex-teacher and former aid worker in Africa who had been a minister before losing his seat in 2003. Viewed as low-key and uncharismatic, he nevertheless managed to put in quite strong performances against Salmond in Parliament. He committed himself and his team to develop 'policies ... in line with Labour values but in touch with the wider Scotland'.[60] His official title is only that of Leader of the Labour Group at the Scottish Parliament but he has a mandate from the Party which Gordon Brown lacks (having been appointed leader of the United Kingdom Party without a ballot). His elevation coincided with numerous calls for devolution, if not outright independence, to be swiftly given to the Scottish Labour Party. The Party has effective MSPs in its ranks, including Cathie Jamieson and Andy Kerr, who challenged Gray for the leadership. But it is hard to see how Labour can mount an effective challenge to the SNP if it is micromanaged from London. It makes sense if Labour, in its own internal arrangements, reflects the decentralised nature of the Union. At a time of searing unpopularity for Labour across Britain, a self-regulated Scottish Party is less likely to suffer provided it is detached from the failing central machine.

"What kind of Labour Party will exist in Scotland in 2010? Will it still have the ideas and dynamics to create the policies and organisational momentum to deliver change?"[61] This was a question Jack McConnell asked in 1999. But a decade later, the British Labour Party appears to be staggering to a defeat perhaps approaching 1931 proportions. It might even crater in parts of its urban heartland. Michael Martin, the MP for Glasgow North-East, announced his intention to resign as Speaker of the House of Commons on 19 May 2009. The opposition parties withheld their confidence from him due to the way he had handled the MPs expenses issue. The revelation that numerous MPs had supplemented their salaries by taking advantage of lax rules for claiming expenses produced a crisis of confidence in Parliament perhaps not seen for centuries. It is one likely to have major electoral consequences even beyond the 4 June European elections. Conservatives had long accused Martin of showing excessive understanding

towards the Executive when he was supposed to defend the interests of MPs before the government. He had deftly used the levers of power in his rise through the trade-union and Labour movement and had shown commendable qualities of public service as a constituency representative. But he had been unable to fully transcend his origins in the highly conformist and even tribal world of Glasgow Labour politics. The Labour Parliamentarian Lord Foulkes claimed that he may even have been a victim of anti-Catholic sectarianism without offering much in the way of supporting evidence.[62] Ironically, one of the few public figures to praise his role as an elected representative was Mario Conti, the Roman Catholic Archbishop of Glasgow.[63] Due to his inability to unify the Commons and skilfully preside over its affairs, his position became untenable.[64] He intends to move to the House of Lords which means that Labour will face another Glasgow by-election in a desperately-weakened state.

If Labour unravels completely rather than staging an orderly retreat to the opposition benches, the Union itself could be a casualty. Alex Salmond is likely to assist any radical Left challenge to Labour perhaps by withdrawing SNP candidates from several seats where its chief foe stands a good chance of being defeated by a left-wing challenge. The benefits for the SNP could be incalculable.

Besides the possible return of the Tories and the malaise besetting its main Labour rival, the SNP is boosted by deepening questions over British identity. A decade ago, a few SNP modernisers were to be found who had imaginative ideas about the issue of Britishness in Scotland. In 1999, the party's then finance spokesman, Andrew Wilson, suggested that in an age of multiple identities, the SNP could afford to be relaxed about the British strand in Scotland's history, and need no longer reject it as a canker to be rooted out ...'[65] But Alex Salmond had no qualms about telling the world that he doesn't feel British at all. He demands that the Lewis chessmen be repatriated from the British Museum while he is content for the Book of Kells, composed on the island of Iona, to remain in Dublin. Clearly, he feels closer to Ireland than to England (though it is debatable whether the Irish are comfortable with the strident anglophobia of many Scots, something which has not been a feature of their own make-up for many decades). While Salmond is prepared to welcome English recruits to the Party, his horizons are firmly Scottish and this is true for the SNP as a whole. He has frequently employed the tartan, as a metaphor for Scotland,

insisting that the nation will only gain if its leaders work with 'every weave' of this Highland cloth.[66]

British identity has perhaps never recovered from the dismantling of institutions which had helped maintain solidarity at the level of the Union. In the 1980s and 1990s, first Margaret Thatcher and then John Major greatly reduced the state's role in the social and economic life of Britain. This diminution had a bigger impact on the non-English territories as well as the North of England than anywhere else and arguably weakened the sense of Britishness. Increasingly, it was private companies, often controlled from beyond Britain, which provided the requirements essential for civilised living in a crowded and busy island. Matters were made worse when local taxation was drastically altered so that it became a tax on people rather than on property. Much of Scotland was unimpressed by this assault on the state by economic liberals. The belief that capitalism must operate within clear constraints imposed by the state remained popular in Scotland as it appeared to be falling into disfavour in much of England.

Not surprisingly, Scottish voting behaviour started to diverge sharply from England's and attachment to a British identity declined, especially among the generation that grew up during Thatcher's years in power. England appeared to be more at ease with a grossly over-commercialised way of life than Scotland, though much of the North of England shared this distaste for Thatcherism, as shown by its doggedly pro-Labour voting habits. But the standing of Britishness languished during what became known as the Blair era. According to the historian, Robin Harris, Tony Blair's New Labour government soon managed to make the concept of British nationhood appear 'rebarbative and ridiculous'. Blair's premiership was not very old before he remarked that 'British pageantry is great but it does not define what Britain is today'. Neither he nor his successor had much understanding of the need to uphold the identity of British military regiments, particularly in Scotland, given the insensitive way they were amalgamated. Pillars of Britishness such as the armed forces had little place in the 'Cool Britannia' with which he sought to rebrand the country in the eyes of the rest of the world. The Millennium Dome was to be the flagship of a country that had suddenly become young and exciting. The creative director of the project made it plain that there was no place in the dome for the Union Flag, or for other 'Nationalistic' features that would 'give the wrong signals'.[67]

Numerous policy failures under two Labour premierships have rein-
forced the belief that the Westminster political system is broken and
that it is unable to run an increasingly complex society in an effective
way. The store of credibility possessed by central institutions has been
seriously depleted and the quality of the political elite has declined at
virtually all levels. This is in no small degree due to the way they have
pursued neo-liberal and managerial strategies which alienate far more
citizens than they convince.

Unifying narratives underlying a sense of Britishness have ceased to
be reproduced. Instead politicians have embraced the false gods of free
market capitalism and divisive multiculturism across the public sector
without realising the corrosive effects on the unity of an increasingly
fragile multinational state.

Colin Hay and Gerry Stoker identify a lack of shared cultural under-
standing of what it means to be British.[68] Americans by contrast have
long identified their country with political values and practices. These
are often referred to as the American Creed and were summed up by
James Bryce, the British ambassador to the United States a century
ago, as (1) the individual has sacred rights; (2) the source of political
power is the people; (3) all governments are limited by law and the
people; (4) local government is to be preferred to national government;
(5) the majority is wiser than the minority; (6) the less government the
better.[69] For over two hundred years, Americans have continued to
renew a contractual form of government based on political ideas.
Political documents such as the Declaration of Independence, the Con-
stitution of 1787 and the constitutions of the states were the basis of
political existence and contributed greatly to the emerging national
identity. The historian Richard Hofstadter well-observed that 'it has
been our fate as a nation not to have ideologies but to be one'.[70]

British identity used to be more organic and drew on culture, tradi-
tions, and collective behaviour patterns far more than on political
values. Due to the pace of social change and the decline of institutions
like the monarchy and the established churches, both in England and
Scotland, this organic identity is but a shadow of its former self. In
place of institutions, empire and heritage, a mosaic identity has instead
been legitimised due to the rise of multiculturalism. Rather than
emphasising common values, from the 1970s onwards, group identities
were promoted by the state and its service providers. Members of these
groups should be encouraged to 'express their identities, explore their

own histories, formulate their own values, pursue their own life-styles'.[71] Dr John Sentanu, the second-ranking Anglican bishop, has warned about the attendant collapse of a common British culture due to the tendency of state service providers to relate to people on the grounds of their ethnicity or religion. The Ugandan-born cleric has no counterpart in Scotland among leading clergy in calling for a sense of national identity based on 'participation, involvement, and commitment from individuals and communities'.[72] But there are numerous clerics with ready access to the media who are ready to condone policies similar to the ones he deplores. Ian Galloway, the Church of Scotland minister who has asked for consideration to be given to the introduction of a form of Sharia law in Scotland, is just one who springs to mind.[73] They promote a group identity with a loose association to a synthetic Scottishness but are silent about the public values needed to strengthen citizenship, especially in the midst of an economic crisis.

A desperate attempt to revitalise Britishness has ensued, especially since the alienation of youthful members of ethnic minorities has led to bomb plots and one attack in London in 2005 causing large-scale loss of life. Definitions have been spawned by politicians and officials charged with breathing life into a concept increasingly drained of meaning by the pace of social change. Lord Sewel, the devolution expert, wrote in 2007:

'The political, social and cultural essence of Britishness lies in its celebration of diversity and distinctiveness, while at the same time asserting the centrality of values and interests held in common even when approached from different traditions. It is the combination of diversity and solidarity that provides the conceptual underpinning for devolution'.[74]

But the consultations on high which give rise to efforts to repackage national identity and equip it for a plural age have a contrived and unconvincing feel to them. It is unlikely anything enduring will emerge from these debates and deliberations, especially when the politicians who initiate these exercises are held in such poor esteem.

Alex Salmond's popularity ratings eclipse those of most British politicians. Soon after taking office, he launched a 'National Conversation' on Scotland's future. It is a three-year campaign of road shows and public meetings designed to make the argument for independence. The White Paper issued on 14 August 2007 contains details of a bill which would authorise a referendum on independence. At this launch Salmond

expressed the hope that 2010 would be the year when the referendum would be called.[75] But the 'conversation' failed to ignite in a country lacking a tradition of freewheeling debate. It did not stimulate new thinking on the contours of Scottish identity. So it is fair to ask if, behind the tartan hokum, the nation's identity is in such marvellous shape. It is certainly no longer based on venerable institutions with centuries of experience, such as the Presbyterian Church, the financial sector, or the distinctive Scottish legal system. The man of stern moral convictions and sober conduct is disappearing with the demise of Presbyterianism, which contributed greatly to the image of the archetypal Scot.

Those accused of moral dereliction by the Presbyterian Kirk used to have to sit upon a stool of penitence in front of their neighbours. Scottish opinion is now far more forgiving to public figures whose difficulties with drink or else a roving eye has brought them into conflict with members of their own party. As long as they are effective performers with perhaps even a 'gallus' [brazen] streak, they can shrug off these frailties and fight another day. The rise of this generation of extrovert politicians may finally sound the deathknell for an era marked by public self-effacement in public. It may show perhaps that Scotland had fully caught up with its southern neighbour whose outpourings of emotion following the death of the deliberately controversial Diana Princess of Wales in 1997, were not emulated in Scotland. Those turning out at local commemorations were at most 14,000 compared with perhaps two million in London.[76] But by 2009 several in the SNP 'wish to revise history and pay service to' Mary Queen of Scots: in the words of Christine Grahame MSP, 'an iconic historic figure' whose remains must be transferred back to Scotland.[77]

Alex Salmond has used several of the same weapons as the dissident Princess Diana to turn the heat on his establishment opponents. He also operates on a world stage, promising to turn a Scottish army into a peace-keeping force doing good in troubled parts of the planet. The days are also long gone when the only international support for Scottish Independence came from the African dictator Idi Amin, who in 1973 made headlines and embarrassed the British government when he said:

'I call upon you to seriously consider granting freedom and full independence to Scotland, Wales, and Northern Ireland ... Each of these countries should be

permitted ... full sovereign independence with their own flags and thus limiting the Union Jack to England only.'[78]

The SNP conference has moved from being a largely social gathering of Nationalists to a 'must attend' event for anyone wanting to influence public policy in Scotland. At the 2007 SNP conference in Aviemore, diplomats paid steep admission fees to attend as observers. There was even interest in the SNP from worldwide corporations, as shown by the presence of Coca Cola, the global drinks giant. United Kingdom-based 'organizations are sending their most powerful figures to an event they ignored just a few years ago'.[79] This sharp increase in outside interest was partly caused by the then steep rise in the oil price, which lent sudden plausibility to the SNP's claim that Scotland could be economically self-reliant.

At the 2008 conference Salmond's ally Nicola Sturgeon introduced him as 'a colossus, not just on the Scottish but on the United Kingdom political stage. He is a first-class leader of our party. He has seen off three opposition leaders and he has the rest of them on the ropes too.'[80] But this time the diplomats were mainly conspicuous by their absence. The price of oil had collapsed along with Ireland's economic miracle, so the trek north to Scotland appeared less of a 'must do' event.

Barack Obama's election as America's forty-fourth president momentarily lightened the gloom. Alex Salmond indicated to the world that the US president might even find the time to turn up in person to one of numerous Burns events that a busy Scottish culture industry was organising.[81] He gathered together his Cabinet to watch Obama's inauguration on television. But the new US president aside, Salmond principally identifies with nations and groups which share the SNP's 'victim ideology'. Currently, the stateless nation of Catalonia is a prime ally. It also has a pro-independence left-wing government, and one which is not afraid to put out the red carpet for Islamist groups. It distinguished itself in January 2009 by banning the commemoration marking the holocaust of Jews across much of Europe.[82]

Probably one of the most satisfying events in Alex Salmond's 2008 calendar was hosting a talk in Edinburgh on 4 March given by Tom Nairn, the intellectual patriarch of Scottish nationalism. He returned from his home in Australia to argue that globalisation will enable Scotland and other small nations to be in the vanguard of history and that it will no longer be the major powers which shape the rules of the glo-

bal future.[83] A year further on it is not clear whether globalisation will, after all, be a stimulus for a new type of nationality politics. But Nairn's older proposition, that the strongest argument for a Scottish state is neither the strength of Scottish culture nor the threat to Scottish identity but 'the failure of the British state', looks more persuasive than ever.[84]

Will history be doing such a favour to Scottish Nationalism if its opponents simply capitulate rather than fiercely contesting its claim to be entitled to shape Scotland's destiny? It is struggles for power which test the mettle of a movement with revolutionary plans for change. They bring leaders and followers together and create the tales of epic drama which provide an identity and sense of solidarity that nourish the party far into the future. But since 2007, Alex Salmond has had the stage largely to himself. Labour and the Conservatives are deeply wounded, one party by an increasingly dire performance in office, the other by its ideological excesses under Thatcher and Major.

Indeed, it is because of the lack of a firm challenge from his conventional opponents, or even the existence of a set of alternative viewpoints within the SNP, that I have gone ahead and written this book. It will be bad for the SNP and worse for Scotland if the SNP secures its objectives because of the uninspiring performance of the British state and the weakness of British-focused parties in Scotland. The Party is likely to be infected with triumphalism and of course it will inherit many of the personnel and structures of the Union state which will soon shape its behaviour and outlook. There are already signs that the SNP is content simply to inherit the bureaucracy built up by its predecessors, however much it denounces their performance. A party with such vaulting ambitions needs to be tested every step of the way. It needs to prove that it has original plans for rebuilding the social and economic fabric of Scotland and that under it the convention that it is best to 'involve as few people as possible' to govern Scotland will finally end.[85] If its nationalism is ventilated primarily by frustration and resentment and expresses itself mainly through symbolic gestures at home and stunts on the world stage, then it is clear that the movement still lacks the maturity to be trusted with power and responsibility.

Alex Salmond, who appears to be the SNP's strongest asset, could yet turn out to be one of its biggest drawbacks unless he encourages this maturing process.

On 8 July 2009 he demonstrated his fixation with the media when he cancelled a crisis meeting over the loss of 900 jobs, to appear on a BBC lunch-time chat show.[86] The disappearance of the whisky industry from Kilmarnock could be the death-knell for this declining town. But a political establishment in which the public media now occupies a front-rank place, has not bestirred itself. The journalist Kenneth Roy noted that BBC Scotland's first reaction to the news was to announce it as 'the closure of a packaging plant'. He went on to write: 'If you want to be hideously insensitive about the collapse of a local economy, and about the loss of an industry established 24 years after Robert Burns's death, then, sure, you will describe it as the closure of a packaging plant and maintain your growing reputation as the regurgitator of official versions of reality'.[87]

Within days it was reported that David Kerr, a BBC Scotland political journalists, had resigned in order to seek the SNP nomination for a by-election. When he was initially unsuccessful the press reported that, as a consolation, he was being lined up for a position as special advisor to the First Minister.[88] Under Scottish Labour, the relationships between those who governed and those who supposedly held them to account in the media were particularly entangled ones.[89] Jack McConnell and his deputy had twelve special advisers which cost the tax payer £750,000.[90] So far the SNP has seven who mainly offer the First Minister advice on communications issues. If Kerr becomes the latest journalist who crosses over to work for the ruling party, it surely indicates how much of an establishment force the SNP now is. By his decision to select the winner of a television raffle rather than to meet a business chief in order to try and avert a closure spelling devastation for a struggling West of Scotland town, Salmond can be seen as making his priorities quite plain. He is the media impresario who just happens to be holding down a top political job rather than the builder working to secure Scotland's long-term political future. He can no longer spend much time in Westminster, but he is determined to reinforce the incestuous ties between the political class and the media which arguably has done so much harm to United Kingdom politics. Unless, he realises the need to confront grim economic and social challenges long before independence occurs, the SNP is likely to be just another party with seductive rhetoric concerned primarily with its place in the Scottish power-structure.

PREPARING FOR SEPARATION
IN A COLD CLIMATE

It was unfortunate for the SNP that the severe economic downturn occurred during its second year in office. Perhaps by then there were even some in the Party who wished that in 2007 the Labour-led coalition had obtained a third-term. The immense challenges it would have confronted, and the unavoidable tensions between London and Holyrood, would have greatly strengthened the hand of the SNP. Its chance of winning a knock-out victory in 2010 on a manifesto highlighting the systemic failure of Unionism, could well have been substantial. But instead the SNP showed little more inclination than its political rivals to get to the bottom of corporate errors that will cost many thousands of Scottish jobs. It displayed a sluggish reaction to the severe economic downturn and often seemed to have its mind firmly fixed on other matters. By early 2009, three leading Scottish businessmen who had contributed generously to the SNP's election funds were expressing their disappointment with its handling of economic matters. The SNP government had failed to differentiate itself sufficiently from its Labour predecessor. They did not demur when the press reported that the government was seen by them as 'a Labour administration in SNP clothing'.[1]

For much of 2008, the Scottish government has been absorbed with its plans for a new delivery mechanism for funding projects that would replace Labour's PFI building contracts. It has been equally determined to bring an end to nuclear energy in Scotland, without being able to guarantee clean alternative supplies. Mounting economic woes have not dimmed the attraction of a referendum on independence in 2010.

This drew unusual criticism of Alex Salmond from a fellow SNP member. The academic Rob Brown wrote:

'Salmond is in a hurry to make history. But party members should be wary of his impatience because this inveterate gambler wouldn't just be risking further economic instability and his own political legacy with an ill-timed referendum; he would be risking the very future of the self-government cause.'[2]

Brown was writing several months after Scotland's financial sector had been devastated by the near collapse of two banks, Halifax Bank of Scotland (HBOS) and the Royal Bank of Scotland (RBS), both seen by the SNP as the likely drivers of an independent Scottish economy. The apparently vibrant Scottish banking sector was seen as the foundation for a viable separate economy. In the event, only prompt intervention by the Treasury, injecting £38 billion to prop up the stricken banks, averted their complete collapse. Rob Brown joined past admirers (as well as critics) of Salmond in the media who noted his readiness to defend the banking establishment in Scotland even as the signs were accumulating that it was likely to pay a heavy price for ill-judged investment decisions at the height of the credit boom. Salmond had obtained his first job as an economic analyst at the RBS in the early 1980s. Nationalist policy analysts and public relations experts enjoyed high positions in the bank. The most prominent of these was undoubtedly Andrew Wilson, head of group corporate affairs in the RBS when disaster struck. This former MSP had been the SNP's spokesman on finance and enterprise until 2003.

The core strengths of Scotland's financial services industry—skills, history and an internationally-respected investment culture based on accumulated knowledge and caution—had enabled it to flourish as manufacturing was fast eroding.[3] But success deriving from financing the exploitation of North Sea oil instilled a more adventurous spirit in its chief banks. Both RBS and HBOS made hefty profits as the price rose far beyond the $4 a barrel which was needed for investments like HBOS's £360 million in the Forties Field to be viable.

The RBS bought up US banks and also acquired NatWest in 2000. Then in charge was Sir George Mathewson, who before the RBS crisis was chiefly remembered for saying: 'I see no circumstances where independence [for Scotland] would be a serious economic disadvantage.'[4] Retiring as chief executive in 2001, he was chairman of RBS from 2001 to 2006 and then a £75,000–a-year consultant on strategy during a round of even more frenetic acquisitions under his successor, Fred

Goodwin.[5] A non-banker by training with a degree in law from Glasgow University, by 1996 Goodwin headed the Clydesdale Bank at the age of just thirty-eight. From 2001 he drove the RBS forward in a dizzying round of acquisitions, mainly in America, and funded by ruthless cost-cutting which earned him the nickname, 'Fred the Shred'.[6] When the Queen opened RBS's £350 million headquarters on the western outskirts of Edinburgh in 2005, RAF tornado jets flew overhead and the campus-style centre was hailed as a symbol of the success of the whole Scottish financial services sector. With these thrusting 'masters of the universe' placing Scottish banks at the centre of what seemed limitless financial expansion, for many the case appeared to be made for Scottish self-reliance.

The lessons of past surges in growth were forgotten at the heart of government in both London and Edinburgh and it was assumed that endless cheap credit would drive the world economy forward for a long time to come. Many bankers had probably never heard of John Law, the eighteenth century Scottish financier, who still has defenders but who was recently described by the American writer P.J. O'Rourke as 'the Bernard Madoff of the day'.[7] The father of paper money, Law was given control of France's royal bank by the French regent Philippe duc d'Orleans, but his highly unorthodox financial methods led to a collapse of the French economy in 1720, with major reverberations across Europe.

The alchemy being practised in Wall Street thanks to the invention of intricate parcels of mortgages and loans which only a few financial minds could really understand, might even have taxed the ingenuity of John Law. Such schemes yielded massive sums that were ploughed into even more frenetic and risky lending. Lucrative bonuses went to bank chiefs and their most adventurous outriders. People who preached caution, like Bruce Patullo, the Bank of Scotland's head for much of the 1990s, fell into disfavour. Derivatives trading was assumed to be an endless seam of gold that would sweep the banks and their heads on to fresh glory.

Much of the banking expansion had been based on fuelling an overheated housing market. Such thinking has influenced Salmond's outlook on economics issues, notably regarding the housing market. In August 2008, he described Scottish house prices as 'fairly stable in comparison to other areas ... with prices in Scotland increasing by 2.9% since the start of the year compared to a fall of 2.8% across

the UK'.[8] This turned out to be estate agent spin since house prices fell in Scotland by 5.1 percent in the first quarter of 2008.[9] Moreover, for someone who insists that he belongs to the social democratic tradition, he appears to view the high price of housing in positive terms. Inflated house prices contributed markedly to Ireland's epic growth at the turn of the millennium, a model Salmond openly admires. He wished to use state money to 'help first time buyers' at a time when the housing market was collapsing, and had few words of criticism for the reckless lending by banks—issuing 125 percent mortgages—that inflated the housing price bubble in the first place.[10]

Just under a year before the RBS registered the biggest loss in British corporate history, Salmond had declared in February 2008 that 'the Scottish banks are among the most stable financial institutions in the world.'[11] His upbeat message persisted even after RBS issued an emergency cash call, in June 2008, for £12 billion, the largest corporate rights issue in history, in order to try and maintain its liquidity. In August 2008, upon the announcement of the second-largest losses in banking history, he issued a statement 'which read like a Royal Bank press release': 'I am certain that the RBS will overcome current challenges to become both highly profitable and highly successful once again.'[12] There was no word of criticism for the bank's folly in piling into sub-prime lending in America and having to write off billions in losses. Finally, on 19 January 2009, the RBS reported its enormous losses of £28 billion. Shares in Scotland's largest company and, for a brief time, one of the five biggest banks in the world, had plunged 94 percent in seven months.[13]

In an interview given to *The Times* in April 2007, Salmond said of his plans for independence:

'We are pledging a light-touch regulation suitable to a Scottish financial sector with its outstanding reputation for probity, as opposed to one like that in the United Kingdom which absorbs huge amounts of management time in "gold-plated regulation".'[14]

He insisted on regarding Bank of Scotland as a primarily Scottish institution even after its merger with the Halifax Building Society in 2000 when its main business became retail mortgages—a side of its operations run from Halifax. He showed no alarm about high-risk acquisitions by RBS nor for that matter did the Scottish Parliament as a whole. So cross-party consensus is likely to block any kind of enquiry into the devastation that overwhelmed the financial sector. With the

global economy slowing down and the term 'credit crunch' already entering everyday parlance, Goodwin took RBS into a consortium bid for Dutch bank ABN Amro in 2007. What turned out to be risky assets were purchased for £10 billion. Within just over a year, RBS had to raise new capital as the extent of its exposure to the contagion in much of the banking sector became clear.

On 24 September 2008 Salmond declared that 'spivs and speculators' brought down HBOS, specifically those engaged in 'short-selling'.[15] Rather embarrassingly for him, it soon transpired that Sir George Mathewson, his chief economic adviser, chaired a £3.5 billion hedge fund engaged in the practice of short-selling (which is completely legal). But anyway Salmond's theory was quickly discredited, as evidence emerged that the chief reason for HBOS's demise was the extremely poor judgment of the bank's senior officials in the mortgage market. According to bank insiders, it was the reckless actions of senior people in the HBOS management offices at the Mound in Edinburgh who placed the bank in such jeopardy. The corporate banking sector, run from Edinburgh, continued to back house-builders long after the property market had peaked.[16] At the height of its success, the entire financial sector in the capital employed 30,000 people, one in ten of the city's workforce—a further 53,000 jobs being reliant on the buoyancy of this sector.[17] It remains to be seen how much of this will be left once the dust has settled.

The British government of course bore far more responsibility than Salmond's administration for what was soon being dubbed 'a financial Culloden' for Scotland.[18] It had neglected to ensure that an untidy and over-extended financial system was properly regulated and had encouraged irresponsible spending habits among millions of its citizens. The *Financial Times* remarked that this model of 'cheap money, easy credit, high public spending, and feather-touch regulation is now thoroughly broken'.[19] Hopes that Prime Minister Gordon Brown's decisiveness had stemmed a full-blown economic collapse quickly faded as desolate High Street retail outlets on both sides of the border spelled out the grim message that the recession would be deeper in Britain than in any other major Western economy.

But in the autumn of 2008, Brown's apparent decisiveness resonated with nervous voters, many fearing that a collapsing housing market might bring them ruin. The SNP found itself sidelined. RBS and HBOS were part-nationalised and preparations went ahead for the latter's

merger with Lloyds Bank by the close of 2008. The crisis management of a hitherto deeply unpopular prime minister won praise, while his responsibility for policies which contributed to the recession was overlooked, at least temporarily. Jim Murphy, the new Scottish secretary, declared: '... most Scottish families know that we're better off and stronger inside the fifth biggest economy in the world.'[20]

Murphy also made light of the 'Arc of Prosperity', a term Salmond had bestowed on three north-west European countries, Ireland, Iceland, and Norway, which had experienced fast growth rates after 2000. The SNP argued that with independence Scotland would also enter that arc of plenty and its 'Celtic Lion' economy would grow to roar as mightily as Ireland's 'Celtic Tiger'. In February 2008 Salmond visited Dublin to announce that, with the SNP now in charge, Scotland was ready to pursue the kind of catch-up which had enabled Ireland to move from being an economic basket case to being one of the most dynamic countries in the EU. But before many months had elapsed, Ireland was the first Eurozone country to go into recession and in 2009 it even looked for a time as if it might approach the IMF for a bailout—while Iceland was confronting outright bankruptcy.[21] Salmond was still insisting in late 2008 that the model remained valid. Norway was forecast by the IMF to keep growing economically. Ireland had moved into recession but at that stage it was still nearly forty percent more prosperous per head than the United Kingdom. By referring to 'the arc of insolvency', Jim Murphy had 'smeared' Britain's near neighbours.[22] One commentator, not close to the SNP, also remarked that 'Ireland may be in recession with a housing crash but, after ninety percent growth in the last ten years, most Scots would take its recession over our recession any day.'[23]

Even before this economic turmoil, the SNP's use of Ireland as a model Scotland could emulate did not bear scrutiny. Ireland had rejected the social democratic path, and someone who later joined the SNP referred to it in 1999 as an 'Anglo-Saxon-style freebooting economy ...'[24] Ireland's starting position was that of a low-cost, low-wage environment (although the size of the public sector grew after 2000). In Scotland painful adjustments would be needed before Ireland's initial competitiveness could be matched. Salmond never appears to have been put off by Ireland's low-tax, low-regulation economy. He skirted around the fact that many state infrastructure projects were being financed by the types of public-private finance projects he loudly

despised. He overlooked the key ingredient of EU assistance, amounting to six percent of GDP annually over many years, which a cash-strapped EU would not be able to find for any new member, whether Scotland or the Ukraine.[25] He failed to acknowledge that as long as Scotland's large public sector workforce enjoyed protection, it would be hard to emulate the low tax strategy that had prompted foreign firms to locate in Ireland since the late 1980s. Even with its much vaunted lean state, Ireland was unable to prevent Dell, the flagship computer firm whose investment was equivalent to four percent of Irish GDP, from relocating to Poland at the start of 2009. In demographic terms there were also major differences. Scotland's population reached its peak of 5.24 million in 1974. It has fallen since then and is less productive than Ireland's, which is one of the youngest populations in Europe. The total fertility rate in Scotland is less than 1.5 births per woman which is well below replacement needs and is less than half of what was seen in the fifteen years after the Second World War, the period of the so-called 'baby boom'.[26]

On 19 October 2008, at the annual conference of the SNP, Salmond was unable to say what he would have done about the banking crisis had he been leader of an independent nation. Instead he directed fiery rhetoric against his foes in Westminster. He accused Tony Blair of creating the culture of deregulation and big bonuses that had brought the financial system to its knees. 'This is London's boom and bust', he claimed, suggesting that it had nothing to do with bankers, many of whom were Scots.[27]

A number of high-fliers in the SNP are entrepreneurs, young bankers, and high tech engineers.[28] It is an achievement that a party with few direct links to the economic sector during most of its history, has won such converts. They relish the loose planning rules which have been a notable and controversial feature of the Irish model, driving the property boom whose collapse hastened the Irish dive into recession. Salmond obviously feels comfortable with financial young turks and, over the Trump affair, showed a readiness to circumvent Scotland's strict planning regime.[29] In an interview given shortly after the crisis began with Iain Dale, an influential English conservative journalist, he offered a strong indication that he was also relaxed with free market economic policies: 'The SNP has a strong beating social conscience, which is very Scottish in itself. One of the reasons Scotland didn't take to Lady

Thatcher was because of that. It didn't mind the economic side so much. But we didn't like the social side at all.'[30]

Jim Sillars commented: 'It is revisionist nonsense for Alex Salmond to suggest that our society only objected to her social policies, while we accepted her economic ones.' Salmond tried to limit the damage by taking the unusual step of phoning in to BBC Radio Scotland's Saturday 'Morning Extra' programme to say: 'I'm well on the record as having never approved of either Margaret Thatcher's social or economic policies—that is clear if you look at the interview.'[31] But as early as 2003 one of his closest allies, Jim Mather, enterprise minister since 2007, had said: 'We want more millionaires, and any notion that an independent Scotland would be left-wing is delusional nonsense ... Most Scots have enough experience of left-wing policies to know that they only make matters worse.'[32]

There was fiercer criticism from the left-wing political thinker Gerry Hassan:

'The quote that Scots 'didn't mind the economic side so much' is a tacit acceptance and endorsement of Thatcherism's economic agenda ... [Salmond] has now undergone a full conversion to celebrating and advocating corporate interests.'[33]

He believed Salmond's acceptance of the dominant economic order was evident in remarks in the same interview that didn't receive as much attention:

'I suppose I have tried to bring the SNP into the mainstream of Scotland. We have a very competitive economic agenda. Many business people have warmed towards the SNP. We need a competitive edge, a competitive advantage. That side of SNP politics—get on with it, get things done, speed up decision-making, reduce bureaucracy.'[34]

For Hassan, the political project of the SNP is a 'Scotland plc' and 'one of the defining features of Scottish politics ... [is] the lack of a real, distinct set of political differences between Labour and the SNP beyond independence.'[35] This complaint was very similar to the one emanating from business backers of the SNP six months later.

Salmond's mastery of debate and the media perhaps led him to assume that he could attach a palatable Scottish flavour to free market policies even of the kind that he once roundly condemned. There was plenty of evidence that, in the words of a fellow member of the SNP, 'the Scots have been seduced every bit as much as their English neighbours by money, status and possessions.'[36]

Having indulged in the consumer boom, Scots now appeared willing to trust Labour to somehow shield them from the chill winds of recession bearing down in the autumn of 2008. Financial meltdown coincided with a by-election in the Fife seat of Glenrothes. Ever since capturing Labour's third safest Scottish seat, Glasgow East, in July, it had been widely assumed that the SNP bandwagon was now unstoppable. But the SNP candidate Peter Grant had headed the local council for several years and his party found it hard to duck the blame for unpopular cuts that had been made due to the squeeze on local authority spending. Labour was able to argue with good effect that the SNP government was putting essential public services in peril due to its preoccupation with keeping the council tax down and reducing business rates.[37] The SNP had to defend its policy choices instead of holding out independence as a panacea. Its campaign was dominated by the first minister, who seemed content to allow civil servants to run the country while he spent his time on the hustings.

J.Arthur MacNumpty, a civil and astute pro-SNP blogger, made this pertinent observation after Labour held the seat with an increased 3.2 percent share of the vote:

'The First Minister needs to delegate—Alex Salmond should let the candidate be the candidate ... it becomes a problem if the Leader does all the talking ... Yes Alex is good, but if he's not the candidate, he shouldn't act like it ... a balance needs to be struck and its overly weighted in favour of the FM's intervention.'[38]

Jim Sillars used his access to the media to argue that the SNP had turned into a 'one-man band'. 'Since the Glasgow East by-election, the party has been infected by hubris'.[39] He particularly faulted Salmond for not using Glenrothes as a platform for advancing the case for independence. But voters by now were well aware that going it alone was the SNP's main objective. At least in the midst of a deepening recession, this prompted Conservative and Lib Dem voters to switch massively to Labour. As a result, the SNP was nearly ten thousand votes short of winning the by-election, even though it actually enjoyed a 13.1 percent swing in its favour.

The merger of Lloyds and HBOS was the key government response to the financial crisis. By creating a super-bank, it would defy the state's own anti-monopoly laws. At his party's autumn conference, Alex Salmond also pointed out that the 'merger ... would result in Scottish banking customers having the least choice (and probably

paying the highest charges) in Britain'.[40] But he was careful not to throw himself into the campaign to halt the merger. Sir George Mathewson attempted to maintain an independent HBOS but could find no large foreign backer. Holyrood did not become a venue for any special debate on the issue. (If the SNP had failed to gain an extra seat in May 2007 and the Labour-Lib Dem coalition had continued, it appears unlikely that it would have survived much more than a year given the sharp divergences between the two former partners over the financial crisis and its effects on Scotland).

On 30 October 2008, it was a Liberal Democrat motion, not an SNP one, which claimed there was a very real possibility HBOS could remain an independent institution. It passed by sixty-one votes to forty.[41] Tavish Scott, the Lib Dem leader since the summer, said of the proposed merger: 'It's a disgrace what has been going on. This will be hugely damaging for Scotland and will cost thousands of people their jobs. I hope the redundancy notices have Mr Brown's name on them.'[42] The SNP backbencher Alex Neil played an effective role in revealing the big downsides of the merger (and he would join the government as housing and communities' minister early in 2009). He was associated with a non-party Merger Action Campaign hurriedly set up to focus public awareness on how disadvantageous the terms appeared to be for the Scottish economy. This was a widely held view that won the support of the *Financial Times* and the *Scotsman* and, in the Edinburgh architect Malcolm Fraser, it had an effective and politically non-aligned campaign head. But the merger was approved overwhelmingly at a meeting of HBOS shareholders on 12 December 2008, no other clear bid having materialised. Mathewson and Sir Peter Burt, (ex-chief executive of HBOS) did a *volte-face* and described Lloyds's acquisition as 'the deal of the century'.[43] The likelihood now is that Scotland will be deprived of the major banking roles it has enjoyed for centuries. World-famous banks with a Scottish identity will pass into history. Banking competition in Scotland will be reduced as a result of numerous branch closures and businesses looking for loans for expansion could well face rejection with dire results for the Scottish economy.[44] Meanwhile, Salmond appeared to cut loose from Mathewson, who had fallen into some disgrace in Nationalist circles for defending the personnel and policies associated with the brief years when RBS was a colossus of global banking.[45]

Consumer and investor confidence has been shattered by the worst recession in seventy years but until 2009 the SNP remained determined to introduce a 'local income tax'. The phrase was misleading because the rate would be set by Holyrood not by local authorities. CBI Scotland said that a local income tax of three pence in the pound (replacing the council tax) would make it more difficult to recruit skilled staff, and therefore damage the Scottish economy.[46] In the Scottish Parliament on 30 October 2008, Alex Salmond refused to say whether Lloyds TSB managers, whom he had earlier met in London, told him that his local income tax plan would deter them from keeping jobs and banking functions in Scotland.[47] Finally, the idea was publicly ditched on 11 February 2009 in the face of opposition from much of business and local government and the absence of a Holyrood majority for any such scheme.

Being a poor country, Scotland was often chronically short of cash. The inability to maintain a system of coinage meant that it led the way in establishing a paper money system in the eighteenth century. Traders and industrialists needed to circumvent a relatively weak economic base by having access to lending facilities. To facilitate this, the RBS invented the cash credit, effectively the first overdraft. It was described by David Hume as 'one of the most ingenious ideas that has been executed in commerce'. This novel form of commerce soon spread all over the world.[48]

The SNP in its turn is prepared to explore novel ways of generating investment in a globalised world economy. It set up the Scottish Futures Trust in 2007 to attract investment 'for new schools, hospitals, and transport projects at better value to the public purse'.[49] Originally, it hoped that a secure funding source would come from the sale of bonds to patriotic Scots. But the Scottish government cannot issue bonds because it cannot borrow (however, local authorities are able to do so). It is surprising that Salmond and his finance minister John Swinney, an ex-management consultant, were not aware of this. It is keen to shun what it views as neo-liberal capitalism as exemplified by the private finance initiative (PFI), but is prepared to embrace an Islamic variety based around the concept of 'not-for-profit distribution'. It was the Pakistani Islamist movement Jama'at-Islami which popularised an Islamic economic system in the West from its base in Leicestershire.[50] In 2008–09 visits to Qatar, trailed in advance by the first minister, to seek funding for infrastructure projects have been

repeatedly postponed.[51] It was hoped that up to £60 billion could flow into the Scottish Futures Trust from this source. The SNP government appears to have no other sources for financing the badly-needed extra transport link over the Firth of Forth.

If the investor proves unreliable, Scottish citizens could face onerous costs. Under Islamic precepts, Qatar could pay to build the bridge and then rent it to the Scottish government for a period of decades. Alternatively, the Scottish government might pay Qatar a monthly fee where so much is rent and so much is payment. The word used is 'rent' instead of 'interest', but Scotland would still incur a large debt through financing infrastructure projects in this way.

Professor John Kay, a member of the SNP government's own Council of Economic Advisers, criticised the way ministers intended to pay for new infrastructure projects. He claimed that their not-for-profitscheme was 'PFI with window-dressing'.[52] He and other economists believe that contractors will make just as much money from the public but in a different way. Qatar is on a fault-line between Shia and Sunni interests in the Muslim world. It has the second highest per capita GDP in the world yet some migrant workers lack basic rights and its political structures remain dominated by the ruling Al-Thani family.[53]

This unconventional money-raising proposal went ahead without any serious discussion at the SNP's 2008 conference. The documentation made available to Parliament and the public about basic operational issues was very vague. In eighteen months of existence, the Scottish Futures Trust had failed to build anything and was not mentioned when the Scottish government published its long-term transport projects at the end of 2008.[54] Labour dubbed it a half-baked expensive quango and urged Salmond to revert to PFIs which had been used for many years to fund schools, hospitals and roads. This would help end the investment 'black hole' that placed up to 100,000 construction jobs at risk, and enable delayed building projects to go ahead.[55] It is likely that Islamic finance will prove as much of an empty talisman for the SNP as the Social Credit idea for bypassing the capitalist slump which gripped the imagination of many in the party during the 1930s. The Scottish Chamber of Commerce survey for the fourth quarter of 2008 painted a bleak picture, indicating that the damage to the structure and fabric of the Scottish economy was already so severe as to impair recovery when it eventually comes.[56] The SNP government has

found that there are no quick fixes in trying to promote economic self-reliance.

As a political party with an evangelical approach to its main goal of independence, the SNP finds it difficult to put aside ideological concerns in order to respond in a swift and pragmatic way to the current emergency, in which it seems certain that the Scottish economy will shrink by 2.6 percent.[57] Michael Russell, a former environment minister, offered some clues as to why the SNP can appear like an exclusive church frozen in a dogmatic posture, during a fringe meeting at the party's 2008 conference. He recalled his frustration when, as general secretary of the SNP, some branches of the party appeared always to be full up. He pointed out that political parties are 'inimical to new members and fresh thinking', refusing to absolve his own from these defects: 'They are not bodies which everyday folk are keen to belong to.'

Part of the solution, according to Russell, lay in 'moving away from representative democracy to participatory democracy'. He complained that in Scotland 'we get a "principal agent" democracy. Scotland has a long tradition of the people having democracy done for them; we don't actually do democracy ourselves. People are also sent away somewhere else to do it.'[58]

The SNP is finding it hard to resist the temptation to centralise while in government. It is strengthening the culture of dependency by imposing its will on bodies that previously enjoyed some level of autonomy. One of its few major pieces of legislation has involved joining together various state-sponsored cultural bodies into a single entity called Creative Scotland. This initiative has been plagued by escalating costs, interminable delays and the spectacle of legions of consultants swallowing up precious arts resources.[59] But the prospect of acquiring an important level of control over cultural policy spurs the party on even after its original bill was defeated in Holyrood in mid-2008.

There is little sign that struggling artists will benefit from an overhaul of Scotland's central arts body. James MacMillan, the composer who wrote the fanfare for the opening of the Scottish Parliament, had already declared some years earlier that Scotland is 'no place for a poet, no country for a man or woman of letters'. Alisdair Gray, the novelist and painter, said he 'totally agreed' with MacMillan. 'If you want to make a living out of art you should become an art administrator' he said.[60]

In its understanding of power, the SNP appears no different from its opponents: it flows from the top down, not the bottom up. The people may be frequently invoked, especially during the occasions in history when they have displayed their national-mindedness, but the SNP is rather scared of the concept of power to the people. It has independent professionals like Christopher Harvie, Alex Neil, and Nigel Don, but a close look at its Parliamentary benches indicates they are dominated by solicitors, and management, media, and marketing figures as well as ex-councillors and numerous others who have spent nearly all their adult lives as political activists. As has been shown with New Labour, these are not the types of politicians who are natural pluralists, but rather ones who prefer to husband power. So it is hardly surprising that little thought has been given to devising a political system which will give Scots numerous ways to influence the political process and obtain regular access to it. Americans enjoy this through the opening of numerous offices to public election. The SNP appears to be too absorbed with campaigning for independence. By contrast, the founding fathers of the USA thought it vital to devise a political system with enough participation to ensure that some new form of autocracy didn't gradually prevail again.

The influence of John Witherspoon, a Scottish-born Presbyterian minister who founded Princeton University and signed the Declaration of Independence, was vital in this regard. Along with his student, James Madison, America's fourth president, he came to see the need for 'countervailing interests' in the federal government or, in other words, check and balances. These would minimise the risk of tyranny.[61] Influenced also by his reading of David Hume, Madison's voice proved decisive in promoting a federal system for the young self-governing republic. So power was distributed rather than concentrated in a narrow and all-too-fallible set of hands. Vertical power sharing between the states and the federal government, and horizontal power sharing among three federal branches: Congress, the Presidency, and the Supreme Court, was felt to be the form of government most likely to avoid degenerating into tyranny. The pessimism about human nature which shaped the outlook of Witherspoon and Hume had a decisive influence on the nature of US politics. But this classic Calvinist reflex appears to have little resonance in today's Scotland, where it is ideas, with their roots in Rousseau and the French revolution, concerning the ultimate perfection of mankind which appeal to both National-

ists and the influential radical left. So it is unlikely that if and when plans for an independent Scotland are eventually drawn up, the architects of the scheme will revisit the debates which took place in the early USA about the future shape of politics and government.

Nationalists mainly see themselves in romantic and even heroic terms as setting free a caged nation and allowing energy once more to flow into its arteries. But there is no attempt to explain how Scotland can safeguard its right to self-government in a European Union dominated by unelected entities which are acquiring increasing powers from the national members. A stream of directives pour from Brussels which regulate life down to the most minute level. The European Parliament is a talking-shop absorbed with its own perks and privileges. It fails to check executive power and Scottish members (MEPs) find it hard to explain its relevance to our lives; indeed, some are not particularly visible for years on end. Cynical deals are cooked up at summits of the European Council that affect our lives sometimes profoundly but which Holyrood with full sovereignty would be less able to influence than Westminster. Majority voting on matters of justice and home affairs creates the real likelihood that Scotland's policing and courtroom proceedings will be altered to comply with the inquisitorial system found in Eurozone countries influenced by French norms. Already, more than sixty percent of laws originate in Brussels. In practice these laws are not interpreted and implemented with any degree of consistency. Often the most powerful or obstructive members apply the laws if they are beneficial and flout the rest.

A debate about the EU occurred at the 2008 conference of the SNP. It was mainly SNP veterans who expressed concern about the assumption of party leaders that upon independence, Scotland would want to be inside the EU. Two of them, Gerry Fisher and Ian Goldie, drew attention to the fact that a motion with leadership backing did not require the Scottish people to be asked their opinion. They reminded the leadership that the Constitution commits the party to establish an independent sovereign state that may make agreements with other bodies that restrict sovereignty—but only in agreement with the Scottish people.

Powerful EU functionaries had earlier that year shown their displeasure with Ireland for voting down the Lisbon Treaty, which was a rehash of the European Constitution rejected by French and Dutch voters in 2005. Valery Giscard D'Estaing, the former French president,

had been its chief architect. 'Public opinion will be led to adopt without knowing it, the proposals that we dare not present to them directly', was how he expressed the means by which he hoped to secure its adoption.[62] But tactics meant to ensure a vast increase in the centralisation of power at the European level blew up in the EU's face. The Lisbon Treaty, successor to the Constitution but without the flags and bunting, was delayed because of its unexpected defeat in the Irish referendum of 13 June 2008.

The Irish Constitution requires any new development which affects the country's sovereignty to be placed before the people in a referendum. Instead of accepting the decision, powerful figures like José Manuel Barroso, the president of the European Commission, and France's president, Nicolas Sarkozy, insisted that the Treaty must go on and that the Irish needed to be herded back into the polling booths in order for the right result to emerge.[63] The European Parliament even urged the Dublin government to investigate the finances and motives of the Irish businessman Declan Ganley, who lead the 'No' campaign.[64] Afterwards, he decided to set up an EU-wide party called Libertas which sought to defend the interests of ordinary citizens against the bureaucratic leviathan and the grip of the bigger member states.[65] Until now, a Europe-wide party has been lacking and instead loose conglomerations of liberals, socialists, far-leftists and conservatives exist who follow their own national interests. But instead of Ganley's initiative being seen as a maturing of the European political process, he was vilified in EU circles as being an interloper whose business connections with the USA strongly indicated that he was a stooge of nefarious American interests.[66] The European establishment was closing ranks to prevent unwelcome trends that might see some of the power in Europe flowing in a new bottom-up direction.

When French and Dutch voters in 2005 rejected the predecessor of the Lisbon Treaty, the SNP merely noted the decision, as was the case with the 2008 Irish vote. The party shows no desire to link up with Ganley even though he wishes to democratise the EU and reform some of its workings rather than provoke its break-up. For several centuries Scotland was able to preserve its legal, religious, and educational autonomy in union with a larger and powerful neighbour. But it is unclear whether as a member of the EU, Scotland would be able to retain its identity or would have the power to pursue its own specific economic policies (which of course it lacked within the Union). Justifi-

able complaints were often raised in Scotland about British economic policies invariably benefiting the financial requirements of the south-east and hastening the decline of manufacturing in the north of Britain. But in the EU, especially if it enters the Monetary Union and embraces the euro, Scotland would risk a sharp diminution of its economic independence. While on a visit to Catalonia in December 2008, Alex Salmond for the first time expressed his backing for Scotland joining the euro.[67] His timing was perhaps not the finest since Spain was in the midst of a deepening depression which might have been alleviated by lowering interest rates. But a decade ago Spain gave up control of domestic interest rates to the European Central Bank in Frankfurt. A lowering of interest rates and a softer currency do not suit Germany, the Eurozone's dominant force. Despite himself being an economist, Salmond does not see the harmful implications of giving up a vital instrument of macroeconomic control, or of being shackled to a Monetary Union in which some nations are running trade and fiscal surpluses while others amass huge deficits.[68] With independence, it is likely that most of Scotland's exports will go to England, which is almost certain to stay out of the Euro. Ireland's grave difficulties have been compounded by the fact that its two main export markets, Britain and America, do not share its currency.

Perhaps Salmond's main motivation is to adopt a posture that places Scotland most at variance with the rest of the United Kingdom. This is not a new idea. In the 1975 referendum on whether Britain should remain inside the EU, the SNP campaigned for withdrawal, the only party with elected MPs from mainland Britain to do so. It saw the chance of radicalising opinion if Scotland voted 'No' while England backed entry. Instead, it just found itself on the losing side.[69] Nowadays, it is in England that opposition to the oligarchic features of the EU is most apparent. This could be seen as English public opinion belatedly catching up with the SNP. George Reid, a former MSP and one of the ten SNP MPs elected in 1974, actually recalls being 'punished by the SNP in the 1970s for going to meetings with the European movement'.[70] But in 1988, at the instigation of Jim Sillars, the SNP embraced the position of 'Independence within Europe'. It believed that the EU's promotion of regional development strategy would benefit a small peripheral country like Scotland even as a centralisation of economic power occurred. But in political terms the rewards seemed even more tangible. Embracing the EU would be a means of gaining

independence by bypassing Westminster, escaping finally from the accusation of being narrow separatists, and finding a way out of practical and psychological dependence on England.[71] However, sceptics like Isobel Lindsay believed that the unmistakable impetus towards economic centralisation was bound to reproduce the core-periphery imbalance inside the EU which had destabilised the Anglo-Scottish Union during the twentieth-century. Jim Sillars himself has retreated from much of his earlier Euro enthusiasm.

If a majority of the SNP is content to be part of a centralised European entity where there is a concentration of executive power along with definite advantages for centrally-placed economies like Germany's, then the extent of its commitment to breaking with Britain's centralising political and economic arrangements has to be questioned. The EU appears like a continental remake of the 1688 Glorious Revolution, in which power was centralised in a Parliament based on an oligarchy of notables that slowly widened over time. The people would remain subjects not citizens. They would not rule themselves but be ruled over. Successive SNP writers like Oliver Brown railed against such autocratic arrangements. The United States actually emerged as a revolt against the crown-in-parliament formula and from a desire for territorial self-rule to be combined with widely-dispersed political freedoms and opportunities for individuals to make their voices count in politics.[72]

The evidence is becoming overwhelming that the SNP, instead of following the American approach to political power, wishes to embrace a Scottish version of the top-down British political system or of its European counterpart. Scotland is likely to remain not greatly altered from the way it was seen by Charles McKean, an Edinburgh arts administrator and journalist writing at the end of the 1990s: '... a small country run largely by unelected and unaccountable people, based on a system of mutual favours'.[73]

Wilful politicians in the mould of Willie Ross or Nicola Sturgeon will dictate the correct attitude on certain core issues and expect to be obeyed. Thus at the 2008 SNP conference Sturgeon insisted that: 'The NHS is a wonderful organisation. The people who work in it do a fantastic job. We owe every one of them a fantastic debt of gratitude.' Following the attempted bombing of Glasgow Airport in 2007, she had also insisted that 'Islam is a religion of peace.' To remain in touch with reality, it is hard to view both the NHS and Islam in monolithic

terms. The NHS has careless as well as dedicated staff, as Sturgeon was later forced to concede when her health department announced that 'Doctors and nurses who do not wash their hands could be sacked following the introduction of a zero tolerance regime on hand hygiene in 2009 to try and curb the toll of deaths from infections largely confined to NHS hospitals.'[74] Similarly, Islam contains within its worldwide following a persistent minority who feel entitled by their religious tenets to wage violence against those whom they view as enemies of their faith. Courageous Muslim activists and scholars have admitted as much but it is a step too far for Nicola Sturgeon, who needs to promote a stereotypical image of a Scotland where progressive minorities and public institutions offering dedicated service reveal a pluralistic and generous-minded country awaiting self-determination.

At the end of 2008, the Council of Economic Advisers set up by Alex Salmond drew attention to one particularly sensitive issue. It expressed 'serious concern' about Glasgow's willingness to participate fully in economic progress given the 80,000 inhabitants of the city claiming unemployment benefit. This drew an angry response from Margaret Curran MSP who failed to retain the Glasgow East seat for Labour and who asserted that too many people saw Glasgow as 'a problem and not a solution'.[75] It could easily have been one of the city's SNP MSPs who spoke in such defensive tones.

It seems clear that the SNP is going to be a traditional top-down Scottish political movement. There will be an emphasis on strong leadership, on simplistic explanations for complex issues, and deliberate vagueness about what should be the ethical basis on which a supposedly independent order ought to be based. Checks and balances restraining the power of leaders are likely to be limited. Certainly, political centralism is more likely to shape a post-British Scotland than constitutional arrangements allowing power-sharing between the executive and legislature, or allowing citizens opportunities to exercise self-rule at local level.

It is difficult to see how the SNP can be persuaded to dispense with a large centralised state unless dire economic necessity absolutely dictates it. Like its Labour rival, the SNP was tight-lipped when a report commissioned by a leading newspaper from the Centre for Economics and Business Research (CEBR) found that in 2008 the public wage bill had reached a third of Scotland's £33 billion annual public spending budget. It claimed that Scotland was on course to become the world's

third most state-dependent country after Cuba and Iraq. By 2012 falling output and rising unemployment is likely to mean that state spending will comprise sixty-seven percent of gross domestic product (GDP). The public sector wage bill has actually risen by sixty-one percent since devolution, with one in four Scots employed by the sector. Scotland's private industries comprised an unstable quartet of financial services, construction, retail industries and tourism, none of which had especially bright prospects in the economic downturn.[76] But the response of the finance minister, John Swinney, was to issue a public statement in the best tradition of Whitehall bluster: the findings were 'completely misleading, factually inaccurate and based on patent nonsense'.[77]

The SNP has failed to acquire a consistent outlook on economic policy, the size and role of the Scottish state, and on the extent to which it will allow national sovereignty to be swallowed up in a greater Europe. Alex Salmond displayed an uncritical outlook towards the badly-managed Scottish financial sector because its dynamic image until 2008 suggested it could be the basis for a separate Scottish economy. Similarly, his enthusiasm for each initiative designed to centralise the European Union appears to stem from the belief that it is bound to weaken Great Britain, the chief obstacle to full Scottish statehood. He looks abroad for catchy ideas and funding sources that might build expensive infrastructure without being concerned about potentially problematic details. Although enjoying the exercise of office, the party remains oppositional in nature. It is ready to renounce key attributes of sovereignty as long as it will enable differences between Scotland and England to be underscored. It views Scotland in much the same partisan fashion as a fanatical supporter views his football team. Nicola Sturgeon reminded me of this when she reached the climax of her speech at the 2008 SNP conference:

'Scottish people will not forgive Tony Blair, Gordon Brown, or New Labour for getting it so badly wrong.
Scotland has moved on. Scotland has outgrown Labour.
Scottish self-belief was shown in May 2007.
There is no turning-back now.
We are a First class country that deserves a First class state that only independence can bring.'

Such self-confidence is based on even less tangible grounds than Ally McLeod, the Scottish football manager, had when he inflated Scot-

land's World Cup chances in Argentina to sadly ridiculous lengths back in 1978. The SNP leadership, aided by a clever and hyperbolic media operation, often appears detached from the real Scotland which struggles with a range of deep social maladies and a crippling waste of human energy. Salmond invokes William Wallace, Mary Queen of Scots, or Burns more often than he does people living in bleak housing estates or run down post-industrial communities. Words used to describe the autocratic Catholic prelate, Cardinal Winning, fit him well and indeed the Nationalist most likely to succeed him as leader, Nicola Sturgeon:

'He suffers from the isolation of authority ... He is surrounded by priests who tell him what he wants to hear ... He is used to telling people what to do—and having them do it.'[78]

Currently, the SNP is not a force where partnership and cooperation are recognisable hallmarks. Alex Salmond rules through a small group of loyalists, some of whom have been by his side for a long time while others, still in their twenties, have only recently hitched themselves to his star. There is currently no other major British party where a leader can make such damaging mistakes—over Kosovo, using radicals as intermediaries with a sensitively-placed ethnic minority, or shunning a crisis meeting designed to save jobs to appear instead on an ephemeral television show—and not face open criticism. Often, the SNP resembles an evangelical movement whose pastor cannot be doubted rather than a mature pluralist force where the leader has to take the rap for dumb moves. Salmond's decision to pay the Duke of Sutherland £17 million in order that a Titian painting could occasionally be viewed in Scotland shows the degree he is now above criticism. It is doubtful if any SNP colleague warms to this idea but instead silence reigns. If there were concerns that a leader with a runaway ego and a preference for conspiratorial methods might, one day, go too far, they are kept far from public view. Undoubtedly, one of the biggest tests facing the SNP will be how to ensure that the leader's volcanic energy, impulsiveness and autocratic traits do not do lasting damage to the character of the party even as he brings it electoral success. The SNP may only be capable of doing real service to Scotland if it prevents Salmond playing the ultimately destructive role that other anti-London figures such as Parnell and Lloyd George performed for their countries. [end of new text] Salmond in 2009 is the equivalent of a rich oil well for the party. Eventually, the supply of high-octane energy will run out and if the

SNP becomes too dependent on the Salmond effect, it will face the dismal fate of countries which allow oil wealth to go to their heads'.

Allan Massie wrote of Salmond in 2008: 'he behaves as if he represents the whole of Scotland, even as if he is Scotland today.'[79] He is the 'Big Man' in the style of Kwame Nkrumah, who took Ghana to independence, or Jomo Kenyatta in Kenya.

Repeatedly, we have seen in this century how a certain school of nationalism (not invariably anti-democratic) seems to require an heroic leader, usually a false hero. This trend has indeed been developing throughout the world since Napoleon. The modern false hero is married to the nation and as such fulfils the warning of the ancient Greek dramatist Euripides—'Power and eloquence in a headstrong man spell folly; such a man is a peril to the state.'[80]

Nkrumah and Kenyatta were anti-colonial figures in Africa. It is not completely far-fetched to compare the political position of Scotland in 2007 to that of an African territory hurriedly pushed towards self-rule by its colonial masters. Parties groomed to rule hastily-devised institutions of self-government soon proved unequal to the task and they were elbowed aside by radicals promising a noisy but ambiguous liberation. For centuries, the country had no tradition of indigenous parliamentary government and its elected representatives had gone to the capital of another country to engage in politics. In public life, there had been a strong absorption with religious matters even after the onset of secularism and the growth of a numerically dominant working-class. In a still hierarchical society dominated by interest groups which straddled the left-right divide, there was a tradition of nomination from above for public positions rather than active democracy. Many African countries have stagnated or worse because they have fallen back on unsuitable past legacies rather than realised that true freedom stems from ensuring that their citizens participate in the growth of the nation and enjoy its benefits. As long as the SNP remains convinced that true freedom consists of liberation from 'foreign' control and that what comes next is of secondary importance, it is poised to repeat painful errors committed in many newly independent states over the last fifty years.

9

DANCING THE PATRIOTIC JIG
IN A BROKEN SOCIETY

Alex Salmond has been unable to resist the temptation of asserting that the birth of his government coincided with the emergence of a new confidence among the Scottish people, 'young and old alike'.[1] His projected image of the happy warrior may have been infectious. A survey carried out on behalf of the Scottish government conveniently reinforced the first minister's cheery perspective. Released in August 2008, it claimed that Scots are the happiest people in the United Kingdom and among the most satisfied in Europe. On a ten-point scale, Scots scored a 'life satisfaction' rating of 8.06 compared to 7.2 for the rest of the United Kingdom.

People were asked to rate on a scale of one to ten how happy and satisfied with their lives they were, and how satisfied they were with their jobs and their standard of living. Scotland was just one of thirteen European countries to score eight out of ten for happiness.[2]

Unfortunately, a wealth of health statistics built up over many years paints a devastatingly different portrait of the country's collective well-being. The proportion of Scotland's working population reporting 'depression, bad nerves, or anxiety is nearly a third higher than for the United Kingdom as a whole'.[3] Suicide rates are also high compared to the rest of the United Kingdom. In 2000 Scotland topped the EU death league table, according to figures from the Register General for Scotland, with a death rate of 11.8 per 1,000 of population. This places Scotland behind East European nations such as the Czech Republic, Slovakia and Poland and on a near footing with Romania (12.0), Russia (13.6), and Hungary (13.9). The Scottish death rate figure compares with 10.5 in England, 10.4 in Germany and 8.6 in the USA.[4]

The social psychologist Carol Craig has produced groundbreaking research to show that many Scots suffer a chronic lack of self-confidence. This she puts down more to aspects of the indigenous culture than to external interference. In particular, she believes that Calvinism has been an important contributory factor because it emphasised the ultimate worthlessness of human beings. Defenders of the Scottish Protestant record would assert that the Reformation was, in large part, about allowing individuals to have a direct relationship with God and that Calvinism often manages to tell people that they are valued by God even if they are guilty of original sin.

But there is no doubt that lack of confidence impaired innovation and progress outside the technical realm. Happily, she found evidence that individuals were receiving greater encouragement and that a strongly judgmental blame culture was less dominant. Nevertheless, she warned that 'in Scotland there is still a prevailing sense that you need to prove your worth …To be a worthwhile person in Scotland means:

Not making mistakes
Not getting 'it' wrong
Not failing
Not being criticised or blamed

'All Scots understand immediately what getting it wrong means: It either means being factually incorrect or that there is an accepted, right way of doing something which you have to comply with … and God help you if you don't conform with it.'[5]

A social pathology of teenage pregnancy, violence, criminality, underage drinking, and consumption of illicit drugs points in part to a lack of self-confidence and a lack of strong motivation to do well in life. There is no sign of administrations based in Edinburgh or London asking for an urgent debate on the scale of the problem and what should be done. This might provoke interest groups which insist that the problem of child welfare is overwhelmingly one of raw poverty. Tom Harris, MP for Glasgow South, and a rare independent thinker in Scottish Labour ranks, spoke for many when he declared in March 2009 that 'the army of teenage mothers living off the state' was a national catastrophe.[6] British Labour pioneers in the pre-1914 period who believed that the parasitic underclass was a huge obstacle blocking working-class emancipation, would have perhaps recognised this sentiment.

At least justice minister Kenny MacAskill pledged to make Scotland's damaging relationship with alcohol top priority for his second year in office. According to NHS figures for 2008, 'More than 100 children a week are being treated in Scottish accident and emergency departments for problems caused by alcohol abuse.'[7] But by early 2009 some detected a retreat, while the government insisted on trying to secure a mimimum price for alcohol.

For nearly fifty years, liberal social policy disregarded the importance of stable family units for preparing children for a fulfilling and responsible adult life. The harshness of the industrial revolution in Scotland meant that there were plenty of broken families, with boatloads of orphans being sent to Canada between the two World Wars. Children were deprived of fathers who were killed in action or had to work far beyond Scotland to support their families. Today, the absence of family stability is finally starting to be recognised as a key contributor to social breakdown in large parts of Britain.

One outspoken doctor believes that the British, never fond of children, have lost all knowledge or intuition about how to raise them; as a consequence, they now fear them, perhaps the most terrible augury possible for a society.[8] The signs of this fear are unmistakable on the faces of the elderly in public places, as anyone who has travelled frequently on public transport in some Scottish cities cannot help noticing. In Scotland, even in well-off families, hungover parents are leaving their children to fend for themselves as they sleep off the effects of their drinking the night before. There are also between 40,800 and 58,700 children in Scotland who have a parent who is a problem druguser. This comprises about 4–6 percent of the one million children aged under sixteen.[9]

Children join gangs in large numbers where they find the sense of solidarity lacking in their world of broken families. Estimates vary regarding the number of street gangs in the city of Glasgow. Some place it as high as 170, more than London, a population six times as large, but Strathclyde Police believe there are fifty-two active gangs in their area, each with up to twenty members.[10] This form of often violent companionship comes at a stark price. Groups of youngsters wander the city centre at night armed with knives and heavy leather belts, often high on drink or drugs. The gangs also trade insults in cyberspace, because some of the groups possess websites boasting of violent exploits and glorifying the gang culture.[11]

According to the World Health Organisation, Scotland's murder rate for teenagers and young adults is five times that of England and Wales. About 3,000 people were seriously assaulted with a weapon in Glasgow in 2007, but only about 1,000 reported it because either they fear reprisals or they dislike the police.[12] Figures for 2002 showed that Glasgow had a homicide rate of 58.7 per million of population, the highest rate of any city in Western Europe—a grim accolade which the city has retained in subsequent years.[13] Edinburgh was the safest city in Scotland with just 15.6 fatalities.[14] But in the summer of 2008, two soldiers just recently returned from Iraq, dubbed that country safer for them than Edinburgh after being attacked and stabbed by a gang while returning to their barracks.[15] The Rev Peter Gill, the Church of Scotland's first Asian minister, branded his native Lahore safer than the Glasgow conurbation after five years of living there. With a parish in a run-down part of Paisley, he said he was more afraid to walk the streets at night in the west of Scotland than in Pakistan. He said that 'youngsters lacked respect for authority, and blamed single-parent families, which he said denied children positive role models and made them vulnerable to the corrupting influence of gangs.[16]

For many years, until a new policy became evident in 2008, the police were rarely seen in central Glasgow outside of their patrol cars and arguably they still often fail to enforce the law in poorer communities. In Edinburgh, a journalist admitted having to pull political strings before a long campaign of intimidation directed against him, his wife, and their property came to an end.[17] Organised crime, often drug-related, has established a tightening grip, particularly in Glasgow, as the police have increasingly become absorbed in desk-related duties and conform to a multicultural agenda upon which promotion prospects increasingly depend. Graeme Pearson, an energetic police officer appointed to head the Scottish Crime and Drugs Enforcement Agency, quit after less than a year in the post in 2007 when he was made answerable to a police quango whose commitment to vigorously tackling organised crime was not always easy to discern.[18] Both the Labour and SNP administrations endorsed its bureaucratic approach to the mounting scourge. Not unnaturally, fear of crime and disorder keeps business away and deepens the isolation of poor neighbourhoods.[19] Crime thus often goes hand in hand with poverty. The poor congregate in specific areas, not just of Glasgow but of other towns

and cities. Such segregation is connected to low educational outcomes, childbearing outside marriage and heavy youth unemployment.

A 2008 report from the Reform Scotland think-tank found that Glasgow was more violent than New York. But the Nationalist MSP Margo MacDonald said: 'I just don't believe any Scottish city compares with the lawlessness … in a number of American cities …'[20] Her husband, Jim Sillars, also still a respected commentator, puts the deep social malaise down to Mrs Thatcher's ideological offensive against working-class communities: 'the society we have today, with generations who have never experienced the world of work, with all the attendant social ills that has created, is a direct consequence of the brutal market economy she sponsored with so much relish.'[21]

Looking at mining communities in the north of England and Scottish small towns devastated by the brutal industrial contraction that occurred due to her deflationary policies of the 1980s, it is hard not to agree—but only up to a point. The economic slump was steeper in the interwar period and the safety net provided by the state meagre by comparison. But family life bore up well despite the crushing poverty. Glasgow had its gangs even then, but they were prominent only in a few parts of the city and their violence was less indiscriminate than it often appears nowadays. The 'hard man' approach to life involved drink, young men and knives. The behaviour of young girls was usually exemplary and they often helped their mothers keep together a home in difficult economic conditions. A radical change has occurred in recent decades. In 2008, official data from the World Health Organisation shows that by the age of 15, girls in Scotland are consuming alcohol at a greater rate than anywhere else in the world. They are also the youngest in the world to get drunk for the first time.[22] Obesity rates among teenage girls have helped make Scotland the second-fattest nation in the developed world, with only the United States having higher obesity levels according to a report from the Scottish Public Health Observatory.[23] Teenage girls have also started to be prominent in violent youth crime, a sad new trend.

School disorder knows no gender distinction. In Scottish education, between 1999 and 2005, incidents of classroom violence increased from 1,898 to 6,899, while the number of schools that cater for children with special educational needs has fallen sharply.[24] Unable to chastise pupils using corporal punishment, teachers have found it difficult to maintain discipline. In one United Kingdom-wide survey fifty-

three percent of teachers reported having objects thrown at them. Nearly forty percent have taken time off to recover from violent incidents at students' hands.[25]

Kenny MacAskill, the justice minister, has shown a readiness to match his desire for political independence with independence of thought, on occasion renouncing the almost tribal conformism of his colleagues. In 2004 he wrote:

'Scotland does not have its problems to seek. It has too often blamed them all on others or circumstances. This is not the case and must cease … Some do come from the Union … Many, though do not. Thatcherism caused pain and massive social dislocation, damaging individuals and fracturing communities … social problems abound in Scotland that can neither directly or indirectly be laid at the door of Thatcherism … From binge drinking to a deep-fried Mars bar diet and from domestic violence to a knife culture, there are aspects of our society that are wrong and flawed.'[26]

But the SNP appears disinclined to treat urban violence and disorder as a priority. In May 2009 MacAskill announced plans to strip judges of the power to impose short-term prison sentence and replacing these with community service orders. Due to the need to accommodate a growing number of criminals convicted of serious violent crime, prison overcrowding was becoming chronic. But rather ingeniously, MacAskill argued that prison was the soft option for offenders: 'You lie in your prison cell. You've got your flat-screen telly [television]. You play the Nintendo. You play pool. You met up with your old mates. You work out new crimes…'. He described prison in Scotland as a 'a bit of a skoosh', a Scottish phrase meaning it was a painless experience.[27] Clive Fairweather, for eight years the chief inspector of Scottish prisons, supported the emphasis on community service, provided it was 'tough, well-administered and well-led'. But one of the SNP government's spokesmen indicated this would not be the approach: 'Humiliation and shame do not work. That is not the route we are choosing to take. We need to grasp that offenders are not aliens. They are people from our communities'.[28] Judges and sheriffs warned that this kind of 'soft touch' community service would backfire and that it was already becoming well-known in some localities that the penalties for ignoring community service orders were not always enforced.[29] The SNP's approach to criminal justice suggests that it is reconciled to many working-class communities experiencing high-levels of lawlessness as its control over Scotland's political direction is tightened.

A Scottish politician who has the reputation for really innovative thinking on social problems has yet to step forward. English MPs like Labour's Frank Field and the Conservative Iain Duncan-Smith have shown a willingness to rethink such problems. A visit to the sprawling Easterhouse estate on the north-east edge of Glasgow in 2003 prompted Duncan-Smith to set up the Centre for Social Justice in 2003. Return visits by the Scottish-born MP, briefly leader of his party from 2001–03, convinced him that much of the explanation for social fragmentation stemmed from welfare dependency. Jack McConnell himself declared in 1999 that 'The truth about life in Scotland today is that existing public services fail too many working-class communities ...'[30] But over the next five years, the inactivity level of men aged 18–24 in Glasgow exceeded thirty percent.[31] 'Incapacity benefit is a payment for those—of any social class—who are physically or mentally unable to work. In practice, it is open to wide abuse and can be converted into never-ending unemployment benefit.'[32] Ministers admitted in 2005 that only a third of the 2.7 million claiming the benefit were genuinely unable to work. (Britain's immigration surge is partly stimulated by the vacancies for unskilled jobs spurned by natives and which self-reliant East Europeans have been willing to perform).[33] Taken together with housing support, disability living allowance and other parts of the welfare system, these benefits can exceed the minimum wage. If all of Scotland's invalidity benefit population were to live together, it would outnumber the combined populations of Dunfermline, Falkirk, Kilmarnock, Paisley, Perth and Stirling.[34]

Neither the tax nor the benefits system encourage stable family units: the system is so perverse that an average family would receive £5,000 more in benefits than it paid in tax if it split up—and would pay £7,000 more in tax if it stayed together.[35] Based on his experience in promoting initiatives in Easterhouse committed to personal and social renewal, Duncan-Smith reiterated the importance of fathers, citing evidence that children in homes without fathers are more likely to be truants, face exclusion, and become teenage parents or criminal offenders ...'[36]

Easterhouse made United Kingdom headlines in 2008 because it was the scene of a crucial by-election in which the beleaguered Gordon Brown faced a buoyant SNP still enjoying its honeymoon among Scottish voters. It was caused by the departure of the long-serving Labour MP David Marshall. He was one of a phalanx of Clydeside Labour

MPs who, in the past sixty years, had seemed to disappear without trace after being sent to Westminster. In a rare public declaration, he wrote in 1988:

'Being a Labour MP since 1979 ... has been heart-breaking—seeing the destruction of what took the Labour movement generations to build, and seeing attack after attack on the living standards of decent ordinary men and women and the tragic levels of youth unemployment ... I achieved two ... ambitions, putting the Solvent Abuse (Scotland) Act through Parliament in 1983 ... and being elected chairman of the important and influential House of Commons Select Committee on Transport ... the only Scottish MP to chair a United Kingdom Select Committee in this Parliament. No mean feat for an ex-tram conductor.'[37]

These were the self-congratulatory tones of a Labour MP who assumed that what were rather modest successes at the apex of British politics somehow rubbed off on his working-class constituents. This kind of windy language enabled Labour MPs to represent safe seats for decades, but the impact of Thatcherism, and Labour's inability to shield Scots from many of its adverse effects, gradually eroded the party's hegemony.

The party in fact had never enjoyed a large membership in the west of Scotland. In the 1950s there were probably no more than 500 regular activists in the whole of Glasgow.[38] Powerbrokers in local government and also the unions were not keen on having a party with an active democratic life where they could be held to account for naked careerism and occasional outright graft. In 1975 Donald Dewar had told Bernard Donoughue, an adviser in 10 Downing Street, 'horrifying stories about corruption in Glasgow'.[39] But a somnolent party which only stirred into life for ritual battles with its main foes to the right would be acutely vulnerable when it came up against a lean political outfit espousing both left-wing progressivism and patriotic politics. Labour high-handedness in Glasgow enabled it to be the scene of several SNP parliamentary breakthroughs, starting with Margo MacDonald's 1973 victory in the Govan seat.

Long before the 21 July 2008 Glasgow East by-election, voters here were more likely than in any other part of urban Scotland to feel that they were poorly represented by those they had elected. But this failed to undermine Labour's primacy because no better alternative appeared to be in the wings.[40] However, after losing office and control of considerable swathes of patronage, Labour showed alarming signs of

disintegration. In its third safest Scottish seat, the favoured candidate pulled out at the last minute and others could not be persuaded to stand. Labour workers had to be drafted in from England, as a confident Alex Salmond swept through the constituency, winning loud applause when he made impromptu appearances in bingo halls and supermarkets. The SNP triumphed on a twenty-two percent swing and until the financial meltdown enabled him to attempt a resurrection, Gordon Brown (who had refused to campaign in the by-election) appeared set to be ousted in a party putsch by the autumn.

The social composition of this part of Glasgow included a large underclass which overshadowed stable working-class households, where the great majority of children could hope to finish school, find a job and avoid drugs and crime. Labour had not overlooked this difficult social sector. In 2005, planned government health spending was £1620 per head for Scotland and just £1300 per head in England, with Glasgow setting the record. The city's NHS budget was £1950 per person for 2004/5, enough to put every man, woman, and child into BUPA, the best-known private health care scheme.[41] But the life expectancy of electors in parts of this constituency was far lower than in many parts of the Third World. In the Calton district, it was fifty-three compared with 70.5 in the Gaza Strip.[42] These low-income voters have been managed by an elephantine bureaucracy which has launched strategies and action plans galore to improve conditions of life. This top-down approach, and the reluctance to work in partnership with local people committed to improving the community, has meant that a costly welfare bureaucracy has yielded few results. Nor has it instilled a sense of loyalty in Glasgow's underclass to its Labour benefactors. Many residents of Easterhouse preferred the mood music of Alex Salmond as his electoral charabanc swept through the Glasgow East constituency in 2008. He treated the seat as the urban stage set for a remake of 'Braveheart' with Labour substituted for the English monarch Edward I. The spiral of social decline had led to depoliticisation and it was the *spectacle* offered by the SNP rather than their plans for the area which proved attractive. There was no sign that Salmond was ready to embrace Iain Duncan-Smith's social justice agenda designed to ensure that local citizens could play a role in the regeneration of communities. Instead, the rhetoric of the party suggested that the SNP shared Labour's autocratic approach for managing working-class communities across urban Scotland.

This was shown when John Mason, the former Glasgow councillor who won the seat for the SNP, branded critics of Jahangir Hanif, a party colleague, and a Muslim, as 'racist' and 'colonialist' in August 2008. The row arose when a newspaper published pictures of Hanif firing a Kalashnikov AK-47 assault rifle at a military-style camp during a trip to Pakistan with five of his children in 2005. His seventeen-year-old daughter Noor told how she and four of her siblings—one as young as five—were also allowed to use the weapon. Mason said he opposed guns being freely available in Scotland but he totally supported the right of other countries to take a different view. If we start implying they are second rate for doing so, 'we are surely being racist'.[43] The assumption appeared to be that it was prejudice and not concern about the record of this councillor which had caused alarm. Yet among Councillor Jahangir Hanif's critics were fellow Muslims who were just as appalled as others that he had fired a Kalashnikov rifle in Pakistan and allowed his young children to be photographed doing the same.

Hanif has campaigned against landlords who keep their properties in poor conditions. This is a major problem in the Govanhill ward which he represents. This inner-city district has seen a large influx of Roma from Slovakia and Romania, some of whom struggle to adapt to the norms of a previously well-integrated mixed-race community.[44] Days after he spoke out against deteriorating local conditions and promised to enlist the help of health minister Nicola Sturgeon, it emerged that he himself rented out a flat to Romanians for which he obtained a rent of £500 a month (though no categorical evidence exists of this property having been in a poor state).[45]

The SNP displays impatience when attention is drawn to unwise social policies that plunge a district into crisis. 2008 produced the first hard evidence that the SNP was just as determined as Labour to keep ordinary people unconnected from political power. It prefers to preach to Scots in vulnerable communities unable to cope with the difficult side-effects of globalization. In the case of Govanhill whole families have relocated from Central Europe to Glasgow lured by the promise of cheap accommodation and state benefits that eclipse the meagre welfare available to them in Slovakia or Romania. Unfortunately, it was never pointed out to the Roma that the rules for living might be different in Britain than in their former shanty-towns, where late night carousing, factional disputes, and the often severe mistreatment of

women go together with a passion for music and the survival of valued old crafts.

John Mason is a Baptist lay preacher. Sandy Weddell is another local Baptist, a minister with a somewhat different perspective. He seems to be aware that a local state run by parties which refuse to heed many of the problems of the people it is supposed to be representing will continually waste money on programmes of infrastructural renewal, until in the end there is none left. Referring to the deterioration of housing, he remarked in 2008:

'Remember, these were put up after the war to house the slum dwellers in central Glasgow and they have to rebuild them now ... They'll be doing it again soon. For unless the hearts of the people who live here change, then they will make the buildings reflect their own lost lives.'[46]

Undoubtedly, a sizeable part of the answer lies in rehabilitating a culture of work in order to revive a sense of personal dignity and fulfilment. In parts of Glasgow East, somewhere between fifty and sixty percent of the working-age population are economically inactive—often two generations of a household languish on benefits and are out of work.[47] A sense of solidarity in early America sprang from the need to work for a living; people proved their social worth through their productiveness. To work with one's hands was not to lower oneself socially.[48] This powerful sense of initiative enabled migrants in the USA to break free of dependence on imperial Europe's hierarchical culture. They developed non-European ways of thought and behaviour more quickly and more completely than in South America, still dominated by the Spanish imperial system.[49] Scots were often to the fore in this search for personal independence. But today the European *ancien regime* has been replaced by an omniscient bureaucratic state and it is one whose privileges the SNP appears as keen to conserve as any Labour grandee. On present trends, this means that an independent Scotland is more likely to resemble colonial Spanish America than the self-governing early United States.

For over a century, Latin American failures that were often primarily local in origin, were blamed on the interference and exploitation of 'Uncle Sam'. All the signs are that the guardians of Scotland's own grievance culture will continue to point the finger of blame at England even if that country's practical influence over Scottish affairs ebbs away. Anglophobia is deeply entrenched in Scottish life. A party of Scottish home rule supporters who toured the country in a bus on the

eve of the 1997 referendum were surprised by its virulence, especially in small-town Scotland.[50] English people employed in the oil and gas industry in the north-east of Scotland have learned to keep a low profile on the streets of Aberdeen on evenings and at weekends. Pupils with an English accent often face playground bullying due to their ethnic origins. It is not an issue which the media usually highlights unless a tragedy occurs such as the one in the neat Edinburgh suburb of Balerno, where teenager Mark Ayton's English accent marked him out for attack by two local youths who kicked him to death in 1997, a crime for which they served two years in prison.[51]

There are at least 400,000 English people living in Scotland, which makes them by far the country's largest ethnic minority.[52] In 1996 Alistair Dunnet, the veteran newspaper editor, largely escaped censure when he remarked that 'the English have stirred up animosity for themselves everywhere. They have offended and oppressed most of the countries of the world and especially those of Europe.'[53] The 2003 Scottish Social Attitudes Survey found that English birth is 'a significant barrier to a successful claim to be Scottish'. Yet seventy percent of Scots are more inclusive when it comes to regarding 'non-white' Scottish residents as Scottish.[54] The Equality and Human Rights Commission in Scotland whose head, Morag Alexander asserted in December 2007 that there was a need for Scots to be 'at ease with all aspects of diversity', has devoted only a fraction of its attention to Anglophobia, despite its prevalence.[55] It is a sure sign of deep-seated insecurity and lack of confidence in Scottishness that such chauvinism has enjoyed an extended lease of life.

The experience of the English in Scotland is a varied one. Some insulate themselves from the local community into which they have moved, provoking resentment. Organisations with names like Settler Watch have been set up as a response to English immigration which, if formed in English cities like Leicester or Bradford that have experienced far greater demographic upheaval, would be dubbed racist. Other new arrivals from the south have played a key role in revitalising moribund communities especially in the West Highlands and some of the islands. A surprising number have even joined the SNP which faces the shortage of committed activists seen in all contemporary parties, a factor that usually wins them acceptance. But in 2008, no less a figure than the moderator of the Church of Scotland, the Rt Rev Sheilagh Kesting, warned about the prevalence of anti-English attitudes and expressed

the fear that this was stoking anti-Scottish resentment south of the border.[56]

Kenny MacAskill, previously known for his flinty separatist outlook, has tried to repudiate the expressions of anglophobia which are sometimes to be found in the guardian of the party's purity, its newspaper *The Scots Independent*. Writing in 2004, he said: 'Those who come from south of the Border must be equally accepted (as migrants with a different racial origin) ... Most English people who choose to move to Scotland permanently do so because they wish to live in a different land not to change it into their former land ... As our largest neighbour inward migration from England is inevitable. It is in any event ongoing. It should be welcomed rather than opposed.'[57]

Nevertheless, there is a widespread tendency in Scotland to adopt positions of stereotypical hostility towards England and the English.[58]

In 2008, sport briefly emerged as a major factor in Anglo-Scottish relations. The British government tried to persuade the four football associations in Britain to field a single British footballing side when Britain hosted the Olympic Games in 2012. One of Salmond's chief advisers declared that it was more important for Scots to compete as a separate team than win under the Union banner.[59] There was scant enthusiasm from most sportsmen and women for this sporting separatism. They were able to rely on superior facilities mainly in England while cities like Edinburgh were intent on slashing their budget for recreational and training facilities. In 2007–09 a huge battle was fought between local campaigners and two city administrations, in which all the main parties were to be found, which wanted to demolish all or a large part of Edinburgh's Meadowbank Stadium and erect private flats instead. Chris Hoy, the Scottish cyclist who won three gold medals at the 2008 Beijing Olympics had practised at Meadowbank, but most of his intensive training had been carried out in Manchester. Without access to the facilities in Manchester, he didn't believe he could have achieved what was the highest ever haul of medals a Briton had earned at the Olympics. To the undisguised irritation of the Scottish government, he distanced himself from the campaign for a separate Scottish team. Shortly before he and fellow medal winners paraded down the Royal Mile in an open-topped bus in September 2008, he declared that for Stewart Maxwell, the then sports minister, 'to call for a separate Scottish team at this stage is ridiculous ... I wouldn't have three gold medals hanging around my neck if I wasn't

THE ILLUSION OF FREEDOM

part of the British team ... I'm a Scottish athlete in a British team, and I'm proud to be a British athlete.'[60] Here was an eloquent expression of Britishness from a Scot with a level of international achievement not seen for years.

Not surprisingly, the government shunned the celebration in Edinburgh marking the triumph of the Scottish olympiads. The SNP knows how vital sporting achievement is for popularising the cause of political nationalism. It has turned the Scottish tennis star Andy Murray into an icon and the 2008 party conference dissolved into delirious applause when Nicola Sturgeon broke the news that he had defeated Roger Federer in a championship event. Months earlier, when rugby's Calcutta Cup was on public display, the first minister lunged at the trophy and sought to obtain a photo which placed him at the centre of what was supposedly a neutral event, until somebody else complained. During Scotland's abortive attempt to qualify for the 2010 World Cup, he also gave press interviews before key matches in which he conveyed the impression that he was now the country's chief soccer fan.

At the end of 2008, tens of thousands of people from all over Britain voted Chris Hoy Britain's BBC Sports Personality of the Year against tough competition from stars like Lewis Hamilton, winner of the Formula One World Motor Racing Championship. It was a sign that sport had not yet become an arena of sharp cross-border antagonism and that it remained one where an individuals' prowess could be seen as a *British* achievement.

There is one SNP politician who has gone even further than Kenny MacAskill in urging an end to irrational hostilities with England over sport and other matters. Andrew Wilson was the SNP's spokesman on economic policy when, in 2002, he used a column in a Scottish newspaper to urge Scots to support England in the World Cup finals of that year. He wrote: I cannot wait for the day when we are so confident of ourselves as a nation that we can bring ourselves to support the so-called Auld Enemy.' In what must be viewed by many as a rank heresy, he went on to say that 'None of Scotland 's problems are the fault of England or the English. All are of our own making.'[61] But in 2003, an election year in which the SNP activist base was given the power to rank candidates in order of preference, Andrew Wilson was demoted and failed to return to Holyrood despite being famed for his economic expertise. The same fate awaited Michael Russell, whose intellectual approach to nationalism wasn't appreciated by grassroots members

whose nationalism was instinctive and sometimes visceral. David Steel was told by one SNP MSP that in their region, only twenty-four people decided the composition of the list, thus determining the election of two or three MSPs. This was a situation perhaps not seen in Scotland since before the 1832 Reform Act.[62] By contrast Christine Grahame, an SNP MSP from the Borders, has been a darling of the party's grass-roots. She is not frightened of ditching genteel nationalism for slightly bolder politics, arguing in 2008 that the town of Berwick-upon-Tweed should be restored to Scottish control after five centuries of English control.[63]

Her colleague Bill Wilson MSP caused incredulity when he wrote to supermarkets in mid-2009 demanding that all fruit and vegetables on display be given Scottish sub-titles.[64] There is little in the SNP's current profile to suggest that it is ready to put aside linguistic and historical obsessions in order to devise solutions for the large number of Scots leading dysfunctional lives. Occupational groups in the health and education sector, often with powerful professional associations and trade-unions, have benefited from a decade of mounting salary increases. Teachers obtained a twenty-three percent salary increase under Jack McConnell, amounting to £2.5 billion, but education standards have slipped behind England's, where proportionately less funding is devoted to the sector.[65] The National Health Service has ballooned into a managerial empire where the spin of politicians is imitated in fatuous statements about good performance which often conceal the fact that the welfare of patients is given quite a low priority in many places. John McLaren, an economist who helped design the 1998 Scotland Act, believes that life expectancy is the most significant indicator of the performance of the health service. But here again Scotland has fallen further behind England despite the public sector budget having doubled in size during the first decade of devolution.[66]

The SNP remains fixated with shifting the constitutional furniture in order to usher in independence. It shows no inclination to challenge powerful vested interests which have grown fat on increased state spending while the quality of life of ordinary citizens has often suffered. Both the SNP and Labour share a collective style often reminiscent of a managerial elite, so the large state bureaucracy appears to have nothing to fear if either independence occurs or devolution is maintained. The SNP has to focus on the big prize of independence in order to avoid having to mend broken communities and failing public

institutions. It is too small in talent and resources to do both. But even when, in April 2009, it unfurled the new election slogan, 'We have what it takes,' it is clear that the SNP remains obsessed with the constitutional warfare being waged with Labour and the Whitehall bureaucracy. Therefore if independence comes, Scotland will lack a political elite with the inclination or aptitude to reform an under-performing state. Instead, whichever party is in the ascendant is likely to try and colonise Scotland for electoral purposes, which will make a mockery of self-government.

At the end of 2008, Allan Massie wrote that 'if Salmond wants to be a real national leader ... he should be making the problem of addressing our broken society his priority.'[67] But instead his press statements aver that strong leadership is what Scotland is crying out for and that he and his chief lieutenant, Nicola Sturgeon, have the answers for numerous problems that have baffled others. This has been shown in relation to health matters. Until 2009, Sturgeon held out against authorising an investigation into the cause of the outbreak of C difficile, the infectious disease which killed numerous patients in the Vale of Leven hospital. In office her party was bound to be more mindful of the world view of the NHS management, a sector which has been in the firing line elsewhere over this kind of outbreak.

Alex Salmond frequently refers to heroic or tragic personalities from history whose lives provide parallels for Scotland's unequal struggle to break free from English overlordship. But he is remarkably uncurious about how behaviour patterns grew up which sapped self-confidence and instead contributed to social pathologies which give Scotland an unenviable ranking in global league tables. It is worth trying to identify what kind of ethical heritage history has bequeathed Scotland. The late Eric Linklater believed that religious and economic upheavals had left deep scars. He wrote in 1935:

'To Scotland the Industrial Revolution came with singular violence, and its attendant atrocities were aggravated ... by that headstrong rage which ever and again appeared in Scotland, and by an hereditary sadism that was the product of our two misconceptions: patriotism-as-hatred and religion-as-hatred.'[68]

In relation to the United States, the French philosopher Alexis de Tocqueville was able to detect 'a body of mores, or moral habits and beliefs and conventions and customs, joined to certain intellectual disciplines' which had been the cause of the success of the American

Republic by the 1830s.[69] It is hard to find much interest among the SNP and its intellectual allies in exploring Scotland's mores and what role they have played in shaping the general culture of the nation. Instead, there is a preference not to peer too deeply under the social surface in case what it is discovered has a troubling and demotivating impact. The Scottish government will not share information about drug problems in Scotland with Whitehall.[70] Maureen Watt, schools minister until February 2009, praised the decline in numbers of pupils facing permanent exclusion from school for seriously disruptive behaviour, even though serious incidents continue to mount.[71] Meanwhile, owing to government plans to curb the use of short-term jail sentences, as many as 850 knife-wielding criminals will be able to remain at large.[72] The likelihood is that innocent lives will be needlessly extinguished thanks to such a policy.

Those politicians charged with overseeing the justice system rarely ask how far the law and its application are necessary for safeguarding society as a whole. But how can people live in a community protected by the law from violence? The rule of law needs to be based on a code of human values and a sense of societal cohesion, both of which are lacking in Scotland. But the SNP does not appear to regard this as an issue of pressing concern. Instead, the party shows depressingly little interest in reducing violence within its own national borders, which is surely one of the functions of a properly-functioning nation-state.

The SNP seems very much at home with a shallow entertainment culture, one that pays homage to celebrities, particularly if they are Nationalist in their sympathies. Across much of the West, a relentless trivialisation has led to the fragmentation of general culture. This leads to the danger of a slide back into tribalism, which has surely happened in parts of urban Scotland disfigured by gang warfare. The urge to violence is also shown in the blogosphere. In not a few cases, the anonymous cybernats who regularly write in defence of the SNP show a level of fanaticism straight out of previous eras of untrammelled nationalism.

Is Scotland currently too tired and demoralised to embark on a venture like independence? To Alex Salmond this is talking down Scotland's prospects, a practice that in the Nationalist lexicon is near to treason. But whereas the nation ought to be able to handle the everyday responsibilities of the exercise of sovereignty, it is the more intricate ones of promoting beneficial social and economic changes, crucial

for the exercise of sovereignty to be meaningful, that provoke real doubts. The government shows no *enthusiasm* about allowing public bodies like education authorities and health trusts to be elected. Education authorities were elected up to early in the last century and there is a proposal that instead of being nominated, those on health care boards be subject to popular election. The SNP made direct elections to NHS boards a manifesto commitment in 2007 but the government has not continued to speak out in favour of more popular control, nor has it put resources into a media campaign to encourage voters to stand up and be counted if they really want to see a health care system based on a partnership between local communities and the state.[73]

Lower tiers of government are often not much better. Despite widespread misgivings in East Renfrewshire, at the end of 2008 the local council agreed to rent a council-owned hall (with the option to buy) to a group of mainly Muslim businessmen who proposed to set up a multicultural centre run by a community trust. The trust appears to be an exclusively Muslim organisation, using the title 'multicultural' as a flag of convenience. Prior to agreeing to lease the hall to the trust, the council does not appear to have pressed the trustees to form a multicultural board, or issue a mission statement, or draw up a constitution setting out an agenda which might encompass themes like diversity and inclusion. Instead, without public consultation, or opening up the option of letting or purchasing to other organisations, the council rapidly approved the application when more cultural sensitivity might have ensured that a genuinely multicultural solution could have been arrived at.[74] Arguably, a situation of incipient racial tension has been encouraged which is now being exploited by the Far Right.[75] The 3,000 Muslims in East Renfrewshire have a case for having their own mosque, even if there are local residents unhappy with such an idea. The council may just be storing up trouble by allowing this 'multicultural' initiative instead, while taking no steps to ensure that it does not become a monocultural undertaking, while defensively-minded Muslims face off non-Muslim residents who feel disempowered by the behaviour of many of their public representatives.

The success of a self-governing Scotland, whether devolved or fully independent, is bound to depend in no small way on the degree to which the state is run along democratic and participatory lines. If Scots wish to have entitlements in an area like health care but not enough of them wish to exercise the right to shape the way this care is delivered

to the community, then it indicates that their appetite for real change is not as great as many might have previously thought. Citizens normally desire this level of rights. Subjects are normally content with entitlements. The monarchical and aristocratic origins of Britain's democratic system are not easily uprooted. One day, the SNP could find that it is running a supposedly free Scotland that actually preserves a lot of the top-down Westminster system that is supposedly being repudiated.

Some, like Michael Russell, have observed a phobia about democratic participation even lurking in some corners of the SNP. If British patterns of domination and subordination are not to shape the texture of an independent Scotland, then much thought and preparation will be needed to ensure that large numbers of Scots become responsible for running their own affairs. Alex Salmond's posturing during the 2008 Glasgow East by-election was that of a latter-day clan chief ready to inspire and lead but numb about consultation and participation. A lot of the electors in a constituency with some of the most concentrated social problems to be found anywhere in Britain are unlikely to wish to better themselves if a Scottish state has the same paternalistic mindset towards them as the current British one.

A post-independence government strongly influenced by Alex Salmond is unlikely to pursue generous welfarist policies, even if it had the means to finance them. He has made it clear that the Irish model of low tax, small state economy is one he prefers. But communities like Easterhouse need to be supported by an enabling state unless they are destined to be broken up and their inhabitants subjected to a postmodern Clearance. The social meltdown occurring in parts of Scotland is perhaps the most challenging issue confronting the nation. In the past Nationalists all over the world have said that tough issues of domestic governance will need to await the dawn of independence before they can be confronted. If this is also the attitude of the SNP, and searching debate is not encouraged to try to find some answers for the large parts of Scottish society which are indeed broken, the path to freedom is likely to be even longer and more twisted than it appeared to be during the heyday of the Union.

CONCLUSION

I've spent over five decades observing Scotland from near and afar and would not wish to convert to centralising Unionism now. But I fear this could well be the fate awaiting Scotland if the SNP succeeds in routing its opponents. The tragedy of devolution was that Labour, the party which had the main responsibility for ensuring its success, was dominated by narrow centralisers from 1997 onwards. Blair and Brown were unwilling to establish a partnership with their Scottish colleagues to ensure that devolution improved the quality of representation in Scotland.

After six years of devolved government lapping at the borders with Northumbria, the people of the English North-East decisively rejected a limited form of devolution when it was offered to them in a referendum in 2005. Ironically, the likely return of the Conservatives to power at Westminster suggests that it may be David Cameron's party that takes the decentralist route. Policies are being devised to enable communities to enjoy control of their own schools and a range of services provided by the state. This functional decentralisation, if properly handled, could well prove more popular than the Scottish devolution experiment, which has primarily benefited political parties and mobilised interest groups. In January 2009, two Green MSPs, individuals who had received insufficient votes to be elected as constituency MSPs, successfully voted down the Holyrood budget, plunging the government into turmoil at a moment of already deep economic anxiety. It is not surprising that many Scots are unaware of how the Scottish Parliament works and, more to the point, what benefits they obtain from its existence.

Understandably, disenchantment with devolution at a time when attachments to a British identity are weakening has boosted the appeal of full-throated nationalism whose objective is a completely separate

Scotland. It is striking the depth and extent of support the Nationalists now enjoy among many different social groups, even though it is palpably obvious they lack policies for transforming the face of Scotland and in fact have been content to allow the civil service to govern for them since coming to office in 2007. The party has maintained a high profile by a series of clever stunts including stage-managed quarrels with London, cultural festivals, and a taxpayer funded 'National Conversation' destined to culminate in a referendum on independence

With Labour refusing to support such a referendum, it looks as if the SNP may try to turn the 2010 general election into a surrogate one. With Labour poised to do badly because of the government's contribution to the economic crisis, the SNP might stand a chance of emerging as the largest party, benefiting from the vagaries of the first-past-the-post electoral system. But the SNP will be as characteristically vague about what kind of state and policies will follow the acquisition of independence. Indeed, given the unprecedented global financial turmoil, the party's leaders are faced with a situation they do not understand. Disguising their disorientation with angry rhetoric and campaigns around nuclear power or Westminster overlordship will maintain their credibility among the growing army of alienated citizens, but are unlikely to convince Scots with conventional economic concerns.

The international scene is likely to change, perhaps a great deal. But Scotland will remain a small territory with little capacity to influence how it is treated by the larger entities to which it belongs. If the SNP disappears from the scene it may be owing to a split, perhaps over the fate of the bloated state which will still be around after independence. But the party has no intention of voluntarily allowing a post-Nationalist party system to take shape. Alex Salmond's SNP believes it possesses the answers to national problems and it wishes to impose those answers from above. It is likely to want to be the arbiter of what is right or wrong, national and anti-national. It is possible to get some glimpse of the politics of a fully independent Scotland from the conduct of the SNP in government.

The SNP's parliamentary managers prefer symbolic or populist issues to be brought forward for debate, ones that usually do not require any change in the law. In the SNP's first year in office, only nine bills were introduced by fifteen ministers with fifteen departments and hundreds of full-time staff.[1] The SNP has embraced flagship policies on non-nuclear energy and non-profit financing of infrastructure

CONCLUSION

projects which have been unable to generate much energy and few capital projects. Scotland faces a looming shortfall in energy supplies and, in 2008–09, thousands of building workers stood idle as plans for vital transport schemes gathered dust. By refusing to adopt a pragmatic attitude to nuclear fuel for peaceful purposes or to contemplate a version of the private finance initiative with more safeguards for taxpayers, it has encouraged an energy and employment slow-down.

Fierce disputes have opened up with its opponents over this purist approach, and the SNP seems happy to see Parliament converted into a chamber where partisan rivalries predominate, rather than consensus and a search for practical reforms that can benefit Scotland. The SNP's two most controversial policies, the introduction of local income tax (suddenly dropped early in 2009), and a referendum on independence appear designed to engender controversy and absolve the SNP from seriously engaging in the business of governing Scotland. There is much indignation about areas of policy reserved to Westminster, but the Salmond government has been remarkably complacent about taking action on devolved matters over which it *does* have freedom of action.

Of course, there has been a *long-term* reluctance to transform Scotland from within. Between 1550 and 1850, bouts of energy were displayed that transformed the productive capabilities of Scotland and pointed towards a new moral settlement. But the more recent efforts at social engineering and economic reconstruction have been based on ideas in vogue elsewhere, which turn out to be shallow and leave the problems of an underperforming society and economy substantially unaltered. There is little sign that contemporary politicians, whether Nationalist or Unionist, have fresh ideas to offer.

Where there has been striking continuity, irrespective of party affiliation, has been in the desire to look beyond Scotland for escape or renewal. This has been a personal desire for millions of Scots, since large numbers began to eke out a livelihood as merchants or pedlars in the Baltic over four hundred years ago. Scots have also distinguished themselves by going off to fight in other people's wars, whether as soldiers in the service of continental monarchs and emperors, or else as idealists committed to a freedom struggle. Thousands of missionaries spread Christianity and simultaneously kindled individual endeavour in hierarchical tribal societies. Only the global nature of the recession appears to stand in the way of a fresh exodus of people from Scotland,

whether they be laid-off workers in the stricken High Street or members of Edinburgh's prostrate financial community.

In seeking a transformation in Scotland's circumstances through 'Independence in Europe', or flexible funding from the Middle East for infrastructure projects, the SNP might appear bold and imaginative. But it is very much in the tradition of Scots who, ever since the Darien scheme of the 1690s, have looked for millenarian solutions elsewhere to heal the ills of the nation. Communists like Willie Gallacher believed that the human energy released in torrents by the 1917 Russian Revolution could in turn revolutionise Scotland. Sir Patrick Dollan, who made Red Clydeside safe for welfare capitalism, believed American economic investment was the answer for a society traumatised by depression and war and, in the five years up to 1951, Scotland attracted over seventy percent of all American investment into Britain.[2] But decades as a branch-line economy for foreign multinationals producing everything from low-quality cars to silicon chips stretched ahead. The SNP has thrown its weight behind schemes for harnessing wave and wind energy that could indeed have a catalytic effect on Scotland's economic prospects—if the technology to make them work is discovered.

Such boldness marks it out from its main competitors. But even if further electoral success awaits it in the time ahead, the party is unlikely to be able to be an agent of transformation unless it learns to collaborate with others and encourage people to participate in changing their communities. It is, and will surely remain, too small a platform from which to lever Scotland into a new era of accomplishment. This was implicitly recognised in 2004 by Kenny MacAskill when the party was in the doldrums. He wrote then:

'The SNP...is in the vanguard of a wider Independence movement encompassing both political parties and wider civil society. It requires being a Party that is inclusive not exclusive—working not just with other political parties but people from all walks of life'.[3]

MacAskill was appealing to a sense of mutuality, characterised by common loyalties and interests that stand above party political rivalries. This is vital for the maintenance of a robust and credible democracy, but such views have fallen into disfavour since the triumph of the idea that Scottish politics is a zero sum game in which compromise is dishonourable. Not surprisingly, these days his party shows an obsessive appetite for campaigning and networking, even when it is supposedly

preoccupied with the business of government. If it emerges as a dominant force, there is every chance it will erect a patronage system to deliver small-scale concessions to lower-income voters in return for them falling into line as business interests establish control of the party.

This is what has happened in Ireland where Fianna Fail, a synthetic Nationalist party, has enjoyed decades of hegemony. Eighty years ago, before beginning its marathon stretch in office, it was far more radical than the SNP is now. Slum landlords and millionaire businessmen would have found it hard to establish a foothold. Trade-unions were close allies of the party. I suspect the Scottish trade-unions, who have been wooed relentlessly by Alex Salmond, may find the SNP numb to their concerns if its mastery of the political scene is accomplished. It was noticeable that Salmond was one of the few public figures ready to speak up for Sir Fred Goodwin when the catastrophic nature of his stewardship at RBS had become clear. In October 2008, when asked by a BBC interviewer if Goodwin ought to remain as chief executive, he replied: '...let the people in charge guide these institutions into safer times and let's get behind that effort'.[4] He found it very hard to distance himself from a bank whose listings are fifteen times bigger than Scotland's GDP. The Liberal Democrat Vince Cable has pointed out that if events had gone the SNP's way, Scotland would be an independent country attached to a large bank.[5] In Ireland, a Nationalist establishment has insisted that the bankers and land speculators know best. There has been little criticism of obscenely big bonuses and tax avoidance schemes. Similar silence exists in the SNP about the RBS which had a whole division dedicated to avoiding paying taxes in the United Kingdom.[6]

If a culture of low standards in high places shapes politics in the future, there will still be a politically-organised Left, but it is likely to be dominated by angry radicals with no chance of acquiring power. In a discreet but persistent manner, the Nationalists are currently working with such fringe forces, in the hope that they will advance at the expense of crisis-ridden Labour. If that happens, the SNP will enjoy the best of all possible worlds: a vocal but ultimately tame opposition which poses no threat to its retention of power.

Some SNP voices are prepared to diverge from the current leadership and draw attention to the country's internal malaise. The academic Rob Brown stated in 2008 that the triumph of a culture of materialism meant that '[N]arcissism has been as rampant as nationalism in Scot-

land as has nihilism.'⁷ During 2005, Kenny MacAskill drew attention to what he believed was an inherent lack of self-belief and ambition, particularly among young Scots.⁸ Later, as justice minister, he has been less keen to massage the collective egos of the Scots than his leader, and readier to point to alarming behaviour patterns in Scottish society.

Abandoning partnership in favour of a radical bid to achieve the party's maximum objectives means leaders like Salmond could still be around to bask in the glory of independence if and when it comes. But the change that the SNP will usher in is likely to be superficial. A small party lacking a strong implantation in society, and dominated by just a few capable leaders, will find it hard to avoid reinforcing continuity even as the rhetoric proclaims change. The SNP is very coy about its future intentions, but the settled view appears to be that much can still be accomplished by operating through a powerful interventionist state and a clutch of interest groups. These are the forces which have traditionally dominated Scotland. Of course this emphasis might change if management and financial types flood into the party, bolstering the Peter Mandelson-style alchemists of power who hope that the SNP could take them far in terms of personal success. There will be no sensible counter-balance to hold in check such ambitions. The party is also top-heavy with lawyers in a country where the profession arguably still does not enjoy effective regulation. The SNP lacks a grassroots base emphasising the concerns of vulnerable economic groups, fragile communities, or people who are altruistic in outlook perhaps from a religious perspective, so their concerns are likely to be of secondary importance even though acquiring their votes is currently crucial for the party's success.

The SNP would leave a stronger historical legacy if there was more emphasis on remaking the political architecture of Scotland so that it was not just those at the apex of politics who count. In a top-down Scotland decked out in Saltire flags and tartan bunting, heavy political controls will be hard to avoid and subservience may well be as prevalent as in the heyday of Unionism. After all, stagnation and deep introspection, with powerful institutions crushing human creativity, was the fate that awaited Ireland after semi-independence was acquired at such a steep cost in 1922. The factional spirit in politics re-emerged in the aftermath of a short but destructive civil-war. It would be a calamity if the deep enmity between the SNP and Labour was to cast the equivalent shadow over Scotland for a so long a time. If such polarisation

does indeed persist, it will signal the triumph of the Westminster political system at its most unconstructive in a supposedly independent Scotland.

It will also be a rich irony if political convenience and financial necessity compel Alex Salmond and the SNP to pursue those neo-liberal and managerial strategies which eroded the credibility of central state and political institutions in the three decades after 1979. Unfortunately, there are numerous signs that he and much of his party favour the political managerialism associated with New Labour, and which has a deep pedigree in a Scotland dominated for centuries by close-knit administrative, business and religious elites. But Scotland has a rival tradition associated with an analytical approach to solving major problems using rationalist principles. This was demonstrated by the remarkable intellectual flowering known as the eighteenth century Scottish Enlightenment. A philosopher like David Hume argued that striving to ensure the people's safety represented the highest political goal. Along with Adam Smith, Adam Ferguson and others, he believed that ordinary citizens were capable of understanding their own interests without being directed by politicians. On a tour of the United States in March 2008, addressing university and business audiences, Alex Salmond invoked these Scottish thinkers to highlight the analytical brilliance his nation was capable of producing.[9]

But Hume and the other anti-Utopian thinkers welcomed the creation of a British state after centuries of Anglo-Scottish strife. They feared the despotic instincts of the Stewart monarchs, absolutists who are nowadays seen by many on the Left as historically progressive figures rallying Scots against external overlordship.[10] Nationalist-minded intellectuals all too often view the British state as an irredeemably negative force, indeed an artificial construct which emerged in the eighteenth century largely for the purposes of conquest and plunder. Not only does this view enjoy an unprecedented degree of cultural appeal, but this is how Britain's past is often regularly depicted in classrooms and the public media on both sides of the border.

The SNP scorns any attachment to what has been achieved within the Union. The horrific collapse in the value of RBS, Scotland's largest and the SNP's favourite company, has not given Salmond or his party pause for thought. After reporting losses of £28 billion, the British government took a seventy-five percent stake in the bank, so that taxpayers are now underwriting billions of pounds of toxic loans incurred

while Salmond was hailing its success. But the rhetoric blaming the British link for Scotland's multiple ills continues unabated. It indicates an underling contempt for the intelligence of many adult Scots. Not a few Nationalists are incapable of covering up their contempt for their southern neighbours. England and many of its inhabitants can be criticised on various grounds but it is widely recognised to be one of the most fair-minded countries on the planet where not only bogus asylum seekers and benefit cheats yearn to make a new life. There are plenty of Scots who view the urbanity and imperturbability of many English people, even as their society confronts pressures unknown a generation ago, not as admirable characteristics but as evidence of a weak and shallow society. They fuel their racial outlook by inhabiting a world fixated on wars fought long-ago between the Scots and the English. Vocal elements in the SNP emphasise past Anglo-Scottish disputes and warfare and overlook the much longer period of intense cooperation between the two nations, remarkable in the story of modern Europe. Unless this deep-seated prejudice is challenged the risk remains that an SNP-dominated Scotland will exhibit an attitude towards its main neighbour as destructive as that which the Stormont Parliament in Belfast used to display towards the Republic of Ireland.

A remarkable insight into the mindset of at least one Nationalist close to prominent MSPs was provided when the thoughts of Mark Hirst, a researcher for Christine Grahame MSP, were reproduced in the Scottish media in 2009. Contributing to the pro-SNP monthly, the *Scots Independent*, Hirst disparaged the violent actions of dissident Irish republicans as 'repugnant' but he then denounced the Unionist majority in Northern Ireland as a 'brainwashed' people with 'no moral authority' who would soon be outbred by Catholic Nationalists.[11] He had earlier left the employ of another MSP, Sandra White, after describing the Union Flag as 'the Butcher's Apron'.[12] Mark Hirst remains a vocal member of a party which claims to have the qualities needed to turn Scotland into a venue for peace negotiations between conflicting Nationalist forces elsewhere in the world. Such an unconstructive approach to a neighbour which has emerged only with the greatest of difficulty from thirty years of savage internecine conflict, shows how ill-equipped the SNP is for such a role. No less a figure than David Trimble, who won the Nobel Peace Prize for his contribution to the 1998 Ulster peace process, criticised Alex Salmond himself for, in his view, doing his utmost to break up the United Kingdom.[13] It

might have served the SNP better if hardball tactics had been ditched in favour of the more pragmatic approach to securing party objectives exhibited by the late Neil McCormick. This giant of legal studies and former MEP was a formidable advocate of independence. But he had no qualms about accepting a knighthood and he even played a lament on the bagpipes at the funeral of Labour's John Smith in 1994.[14] Clearly, the Nationalists are committed to a fresh start. History begins with them. This suggests that independence might be fraught with deep hazards as reckless millenarian tendencies come to the fore. Much to the irritation of many Nationalist readers, I can only repeat there is little likelihood that representational politics will fare well in the hands of a Scotland controlled in the future by the SNP. Instead, all the signs are that a centralising top-down form of politics will enjoy a renewed lease of life. Political dissent will be discouraged in an atmosphere where leadership is based on fuelling resentment against supposed external foes of Scotland and their internal accomplices.

The European Union is likely to acquire a powerful hold over Scottish affairs because its approval will be needed in order for an independent Scotland to join as a new member. It is hard to see how the Scottish people can control their own destiny within a body dominated by the economic and political interests of the core EU states, particularly France and Germany. Scotland will find that its own dependency culture is powerfully reinforced by being a subordinate tier of this corporate entity whose confusing multilevel institutions provide little scope for individual citizenship to be exercised.

As for the SNP's attitude to the United States, it appears to share much of the anti-Americanism prevalent among European intellectuals and parties not just on the left. Alex Salmond's regular visits to the USA are part of a strategy to build up a political lobby of Americans of Scots ancestry and to convince opinion-makers that his plans for Scotland pose no dangers for the USA. At home, he does nothing to rekindle the close relationship that existed between the United States and western parts of Scotland, in particular down to the 1920s. He is hostile to NATO and shows little awareness of the debt not only Scotland, but western Europe as a whole has to America, without whose help it would have succumbed to tyranny. The SNP hardly bothers to conceal its view of the USA as a superpower chiefly absorbed with maximising its wealth and influence. The 2001–08 Bush Presidency of course strengthened this view. Also understandable is the SNP's

campaign for the removal of nuclear weapons from Scottish soil. But if the EU acquires its own security arm, for which access to a nuclear deterrent is regarded as vital, it will be interesting to see if SNP commitment to banishing these weapons from the Firth of Clyde still persists.

Before the Obama administration becomes too preoccupied by the demands of office, it will hopefully realise the need to speak in a friendly but frank way to increasingly wayward European allies about common civilisational objectives which have brought them together during times when the world has been menaced by totalitarian dangers. Washington could do worse than direct its message to the British public, much of whose thinking is done for it by the still ascendant multicultural left. In Scotland, distrust of America is the default position for cultural elites and media institutions; it extends across much of the political spectrum. There is no tendency within the SNP to recognise that on several occasions the USA has risen above its particular interests to defend core freedoms when these have been threatened in the West.

Alex Salmond's decision to enlist the help of the Burmese and Iranian regimes to gain observer status for Scotland on a UN nuclear disarmament commission reveals a gaping ignorance on his part of the realities of tyranny and dictatorship which still exist in much of the world.[15] During the Russia-Georgia crisis Alex Salmond pointedly kept silent about the sufferings of a small country at the hands of a powerful neighbour, which was at variance with his stance in March 1999 over Kosovo when he assailed NATO for its actions against Serbia.

Ad hoc international alliances to serve short-term interests are perfectly in keeping with the way the SNP has made opportunistic alliances at home with groups such as political Islamists in order to pile up votes. But if the SNP is as naïve in its relations with international forces, whether it be foreign moguls waving cheque books as they buy up pristine chunks of Scotland, or else Third World demagogues or *revanchist* superpowers, an SNP-led Scotland could rapidly be placed in harms way by its self-proclaimed liberators.

Much of the SNP's difficulty stems from the fact that it is not really committed to Independence in any form where the people might exercise meaningful sovereignty. The party is committed to membership of a continental federation where powerful cartels are intent on turning national Parliaments into conveyor belts for a uniform raft of policies.

Similarly, as a devotee of radical forms of multiculturalism, the party emphasises group rights over the exercise of individual citizenship. Seventy years ago many Nationalists would have viewed a willingness to swap Westminster tutelage for such extra-territorial overlordship as being a new form of super-Unionism. This is what the SNP really stands for and many of its policies have already been tried out by New Labour, especially in the heyday of the Blair era.

This book should not be concluded without pointing out the comparisons between Blairism and Salmondism. New Labour was all about a leader and his hand-picked team imposing an ambitious political agenda on the country without the public being consulted. The party leader was invested with a degree of authority more normally to be found in single-party states. He operated through interest groups, and especially the media, in order to impose his agenda. It meant that his own party and Parliament became echo chambers for his wishes. Team Blair insisted on conformity even when ill-devised policies fraught with risk were rushed into law. In the end, such hubris went horribly wrong and Blair made a hasty exit leaving a shattered party and an ill-governed country.

The first minister's media advisers enjoy more influence than Cabinet ministers and some are just as clever as Alistair Campbell in the devious arts of news management. Whenever a news story breaks that places the SNP administration on the defensive, the blogosphere soon fills with self-righteous comments justifying the party's action irrespective of its connection with nationalism. Given the recurrence of SNP factionalism, it is likely only to be a matter of time before the level of organisation behind such media operations becomes clear. New Labour bullied civil servants to support the party's media offensive and it will be interesting to see if the neutrality of the Scottish public administration has been similarly dented by the SNP's administration. But government by soundbite can be a fatal addiction. Policy launches and relaunches, and attempts to prevent the recovery of political foes, become more important than the substance of policy and the way it is delivered. So already, it is the marketing-people who have become some of Salmond's key lieutenants. They are working to ensure that the priority for ministries is to comply with the political timetable of the SNP even if it impedes the delivery of better services. Since becoming first minister, he has moved away from the SNP's emphasis on a civic nationalism that promotes individual self-reliance as well as com-

munity solidarity. Instead, the emphasis is on creating a Scotland based around groups, some ethnic, others professional, directed by the state. New Labour also moved far from its core beliefs, the members convinced for nearly a decade by their leader that the party could remain progressive without being attached to any fixed principles. Nationalism is a potent ideology and, arguably, Salmond is a far more adept populist than Blair. He surpasses him in his addiction to publicity and has the look and manner of a game show host rather than a trendy vicar. If, like Blair, Salmond opts for personal rule guided by courtiers who manipulate the media and abolish the neutrality of the public services, then it is likely that Scotland's rhetorical nationalism will have a longer lease of life than New Labour, even as the country's social problems stubbornly persist.

But the SNP has no right to place the five million inhabitants of a small and fragile country at risk with a half-baked scheme for Independence. It should learn from the reckless and arrogant behaviour of New Labour, which badly weakened Britain with policies that were often based on little more than sound bites and gimmicks dreamed up by court propagandists. The SNP appears to sense that not enough Scots will endorse their independence scheme. So instead, they have deliberately riled English voters in the hope that a Nationalist backlash in the south will result in Scotland being marched to the exit by its estranged partner. Alex Salmond has also cultivated religious interests in the hope that they will deepen the popular longing for separation. At times, it almost seems that prelates like Keith O'Brien have been turned into recruiting sergeants for the party and the SNP has gone to great pains to ensure that it is politicised forms of Islam that make the running among Scotland's Muslims. In some quarters this might reasonably be seen as a form of aggression towards Muslims from the government of the country. The SNP appears intent on forging a community defined by faith and imposing a narrow identity on it. Bureaucrats and local politicians in English conurbations sought to manage immigrant communities from the 1980s onwards by imposing identities on them and by playing down class, gender and intra-religious differences. Ethnicity was the key to entitlement. Society was seen as comprising uniform cultures which revolved around one another. The multicultural policies which followed created a segmented society and fixed identities that played down individualism and concentrated power in the hands of 'community leaders' who acted as intermediaries

with the state.[16] If the SNP has its way, Muslims for whom their faith was only a particular element of their identity will have to get used to a fixed identity, just as most other Scots may have to become reconciled to a stereotypical expression of Scottishness firmly wedded to political nationalism.

Entrenching communal identities in the name of multiculturalism has helped radicalise young people and created hostility between ethnic groups which previously had been noticeably absent. Nicola Sturgeon is disinclined to reflect on the troubling impact in England of creating rigid and introspective communities through such forms of social engineering. Instead, she has loudly distanced herself from the alleged 'criminalisation' of the Muslim community that some have detected as occurring in England.[17] But arguably a greater danger is the importation from England of the concept of 'Islamophobia'. It has little or nothing to do with protecting individual Muslims from discrimination and instead is designed to protect from criticism Islam and Islamic forms of politics and cultural practices found within the sub-culture of some British Muslims. The emphasis is no longer on privileging the dignity of the individual against racial prejudice but privileging the religious authority of Islam and politicised versions stemming from it. Not only racists are constrained, but also secularists and those committed to genuine intercultural debate. Perhaps the biggest losers from this reinterpretation of racism as discrimination primarily directed, not at individuals, but at groups with a religious identity, are modernisers and reformers within Muslim communities who wish to subject expressions of their faith to critical examination; a venerable tradition in Britain for centuries.[18] But Scotland has never been relaxed with challenging dominant religious positions. The once influential Communist Party had a dogmatic quasi-religious outlook largely absent in England. Given the authoritarian temper of the state and indeed the political forces struggling to obtain control of it, the danger remains that a stifling conformity will descend that will close down public space for debate and plunge ethnic minorities, like the Muslims, into a form of isolation quietly sanctioned by the state.

It is not easy to convey these concerns to many in the SNP who don't see beyond patriotic slogans, casting out English overlords, renaming streets, and distributing embassy posts. In England, some former Islamists have developed qualms of conscience about exploiting Islam for political advantage. Perhaps there is after all hope for the

SNP, and indeed for Scotland in the wider sense, if people with similar scruples from a Muslim background come to prominence, perhaps even within the party, and attempt to save it from itself.[19]

Since the SNP's plans for Scotland are so radical, it is fair to expect it to devise a set of common values, a kind of collective morality, that will enable Scots to live together in harmony during a period of unavoidable upheaval. But instead, all that the party offers is a cacophony of public relations events celebrating songs, poems, and paintings by writers and artists alive and dead. Clearly, any national culture which requires such heavy-handed intervention from politicians is hardly in the best of shapes.

Undoubtedly, Scotland could confront change more resolutely if a sense of public service was rekindled, with citizens animated by a moral outlook putting aside private preoccupations to engage in public affairs. Just over fifty years ago, T.S. Eliot wrote: 'A people without religion will in the end find that it has nothing to live for.'[20] In the light of the decline of the main Christian churches, Scots have increasingly worshipped at the altar of consumerism. It has blunted their political antennae, and made many parochial and short-term in their outlook. A growing attitude of servility, which has never been absent in a country where democracy arrived late and incomplete, has been discernable. This has been amply shown during the credit crunch by the passive attitudes of citizens on both sides of the border to finding they are the poorer, on average, by between £60,000 and £73,000 per head thanks to the banking collapse.

Calvinism continues to have a bad image in the story of Scotland. But it contained within it the Puritan concept of 'the call' based on the idea that God speaks to us through the moving of our conscience. This is a personally liberating impulse which in Africa today enables individuals animated by the word of God to actively engage in changing the environment around them for the better.[21] Similar moral and practical energy was released in Scotland during the depths of the industrial revolution. A miner's son from Blantyre received 'the call' to bring the gospel to Africa. David Livingston put himself through night school, studying medicine at Anderson College (now Strathclyde University), whilst working long hours by day. He endured incredible hardship but nevertheless reached the goal he had been called to fulfil.

It is likely that much of the ephemeral consumer culture in Scotland will be swept away by the gathering economic storm. Narcissistic

behaviour, long celebrated in the media, may even be knocked from its perch. But if Scotland is to survive and renew itself as a society that binds people together in civilised conditions, and hopefully for a moral purpose, then there will be little room for a politics based on sloga-neering and juvenile antagonisms. It may not yet know it, but the SNP is as much on the rack as its political rivals. Its 'nationalism' is just as counterfeit as the 'socialism' of Tony Blair, or even the 'conservatism' of Margaret Thatcher.

The Scottish print media has not distinguished itself during this period of turbulence, closing down debate on many vital issues and often failing to subject the SNP's policies to rigorous examination (except in the economic sphere). Robert McLaughlin, a distinguished editorialist in the last third of the twentieth century, might despair if he was able to see what a lightweight press organ the *Herald* in Glasgow has become. 'The Scottish edition of the *Daily Mail* now outsells both it and the other main Scottish broadsheet, the *Scotsman*. Of the Scot-tish broadsheets only *Scotland on Sunday* has offered regular coverage of the rise of political Islam. The topic generates far more concern in England, not because of any underlying prejudice but owing to genu-inely-held fears that hard-earned freedoms might be eroded as a result. Given Scotland's turbulent religious history, the lack of concern dis-played by much of the press and even organisations like the Humanists is striking, inevitably sparking concerns that basic political freedoms are less appreciated here than in other parts of the United Kingdom.

Economic issues have always dominated politics in Scotland more than ethical and libertarian concerns. That means there is a chance that a tough recession might lead growing numbers of voters to demand higher standards of representation and policies that are based on more than the career timetables of leaders consumed by personal ambition. Hopefully, the SNP will prove to be the last of the top-down parties which have served Scotland so ill during the era of Parliamen-tary democracy. With a very few exceptions, the only way their leaders knew how to connect with voters was by appealing to people's fears and resentments, or else by offering them poorly-conceived reforms. These did make a difference to appalling health standards and housing conditions but the absence of a moral principle behind them ensured that the drive for change drained into a huge bureaucratic swamp. Alex Salmond doesn't have the reformist urge which drove figures like David Lloyd George and even Harold Wilson early in their careers,

politicians he has compared himself with. He desires to recreate Scotland in his own image, extrovert, self-righteous and contemptuous of criticism. He hardly conceals his intention to use the arts and public broadcasting as agencies that will rebrand Scotland in a Nationalist manner.

Figures unable to conceal a morbid anglophobia flourish at different levels of the party. The base is increasingly composed of people who are very comfortable with the moral and political certainty that nationalism provides. They prefer the 'feel good factor' and the sense of moral superiority embedded in a doctrine which is quasi-religious in its appeal. Too many abhor critical thinking. They are disinclined to analyse the personal and strategic choices Alex Salmond makes despite their potentially great importance for Scotland's future. Thus they shy away from reflecting whether the SNP's policies on diluting sovereignty, embracing multiculturalism, and promoting Islamists might actually compromise it as a Nationalist force. Two years in office make it clear that Alex Salmond has precious little idea what ought to follow should his demolition of the Union succeed. A look at the SNP reveals few builders or people driven by compassion and concern for the condition of Scottish society in present times. Instead, there are many people motivated by driving ambition, ideological obsessions, and not a few who find it hard to contain their disdain for three centuries of the British experience or indeed the broader story of Western achievement which Scots contributed to in disproportionate numbers. It is hard to recall that, in the past, Nationalist ranks contained many figures who wished to reform the Union, not break it up.

Labour after 1999 failed to make the case for Scotland being a nation which also derives cohesion from its membership of a broader island community.

Both parties revealed traits that indicate a striking similarity in their culture and mind-set despite their by now legendary rivalry. Both are dependent on autocratic and driven leaders who are not held to account for their capacity to govern effectively but stand or fall on their ability to articulate the grievances and obsessions of their respective followings.

It also looks as if Labour might emulate the SNP by identifying an external foe in a bid to preserve solidarity among the party faithful. Class war rhetoric, having gathered dust for decades, is being revived in order to try and mobilise a shrinking base. This largely involves

CONCLUSION

pursuing a drive for greater equality of a kind that will result in an even more stifling bureaucracy, many of whose officials will glorify in holding non-jobs. But class warfare, anti-fascist rhetoric, and constitutional reform pushes are desperate spasms from a stricken government heading for a monumental defeat. The longer Brown survives, the greater will be the SNP's electoral windfall at the 2010 general election. One conformist and tribal party is poised to supplant another with the SNP ready, just like a desperate Labour Party, to pursue all manner of alliances, but with the goal of severing the link with the other nations and regions of Britain.

How much of an exaggeration is it to contend that Scotland is reverting to a teenage phase in its political life, where the desire to spurn familiar arrangements in return for experimentation for its own sake has become an all-consuming one? The era of the 1960s, when defiance and revolt filled the air, has finally caught up with a previously cautious and introspective nation. But the times of affluence which enabled restless youth and other discontented groups to test the limits of state tolerance, are also starting to disappear. Scotland is staring into an economic crisis of stark dimensions. If politics fails to address the crisis and its practitioners decline to explore possibilities of cooperation in order to reduce its effects, it will be hard to maintain faith in Scotland as an entity where solutions can be devised to improve the lives of its inhabitants. The 1930s were convulsed by sharp conflicts on left versus right lines. Today, the fault lines are between *narrow Nationalists* who desire complete separation and a denial of centuries of Anglo-Scottish cooperation, and *broad Nationalists* who wish most practical power to reside in Scotland while maintaining a strong constitutional link with the rest of Britain. The narrow Nationalists have the zeal, the slogans, and the leaders to dominate their currently irresolute opponents. If they enjoy success for their separatist project, then self-determination is likely to be as elusive as it was during the heyday of Unionism. Indeed a new Unionist future, courtesy of Brussels, or whatever new hegemonic powers emerge in the world, is far more likely than even the degree of autonomy de Valera's Ireland enjoyed during the last century. The Scottish National Party is being rather disingenuous when it argues that it has the ability to manufacture an independent nation in a world where sovereignty is so constrained. For Scotland to acquire greater control over its own destiny, cooperation between all nationally-minded people, whether nar-

THE ILLUSION OF FREEDOM

row or broad Nationalists, is indispensable. Until Scotland ceases being a battleground between factions masquerading as liberation movements, then it is likely to be ill-prepared to face the overwhelming difficulties besetting small countries, whether it finds itself inside or outside the United Kingdom.

NOTES

INTRODUCTION

1. Brian Taylor, *The Scottish Parliament*, Edinburgh: Polygon, 1999, p. 259.
2. Giuseppe di Lampedusa, *The Leopard*, London: Harvill, 1994, p. 41.
3. *Scotsman*, 14 March 2008.
4. *Times*, 15 March 2008.

Part One

1. 1707–1918

1. Eric Linklater, *The Lion and the Unicorn*, London: Routledge, 1935, p. 35.
2. Quoted in Colin McArthur, *Braveheart, Brigadoon and Scotland*, p. 18.
3. Hugo Rifkind and Kenny Farquharson, 'Braveheart battle cry is now but a whisper', *Times*, 24 July 2005.
4. Quoted in Tony Bartha, *Screening the Past: Film and the Representation of History*, New York: Praegar, 1998, p. 181.
5. Colin McArthur, *Braveheart, Brigadoon and Scotland*, p. 125.
6. Rifkind and Kenny Farquharson, 'Braveheart battle cry'.
7. Rifkind and Kenny Farquharson, 'Braveheart battle cry'.
8. See Colin Kidd, *Union and Unionisms: Political Thought in Scotland 1500–2000*, Cambridge: Cambridge University Press, 2008, p. 45.
9. Colin Kidd, 'Race, Empire and the Limits of Nineteenth-Century Scottish Nationhood', *Historical Journal*, Vol. 46, No. 4, 2003, p. 875.
10. Tom Nairn, *The Break-up of Britain: Crisis and Neo-Nationalism*, London: New Left Books, 1981 (2nd ed.), p. 147.
11. Massie, *The Thistle and the Rose*, p. 219.
12. See Kidd, *Union and Unionisms*, chapter 2.
13. Colin Kidd, "Heart of Unionism was built on Scotland's anti-English feeling', *Scotsman*, 22 December 2008.
14. Murray Pittock, *Celtic Identity and the British Image*, Manchester: Manchester University Press, 1999 p. 85.

15. Wallace Notestein, *The Scot In History*, Westport, Conn., USA: Greenwood Press, 1970 ed. p. 145.
16. T.M. Devine, *The Scottish Nation 1700–2000*, London: Penguin, 2000, p. 84.
17. Bruce Lenman, 'From the Union of 1707 to the Franchise Reform of 1832', in R.A. Houston and W.W.J. Knox, *The New Penguin History of Scotland: From the Earliest Times to the Present Day*, London: Allen Lane, 1999, p. 343.
18. Henry Drucker and Gordon Brown, *The politics of nationalism and devolution*, London: Longmans, 1980, p. 7.
19. Sir Walter Scott, *The Heart of Midlothian*, Edinburgh: T. Nelson & Sons, n.d. (original 1818), p. 57.
20. Lenman, 'From the Union of 1707', p. 281.
21. Devine, *The Scottish Nation*, p. 54.
22. Larry Eugene Rivers, *Slavery in Florida: Territorial Days to Emancipation*, Florida, Gainesville: University Press of Florida, 2000, p. 5.
23. Devine, *The Scottish Nation*, p. 122.
24. Linda Colley, *Britons: Forging the Nation 1707–1837*, London: Yale University Press, 1992, p. 120.
25. *Daily Telegraph*, 24 January 2009.
26. See Kevin Phillips, *The Cousins' Wars: Religion, Politics and the Triumph of Anglo-America*, New York: Basic Books, 1999, pp. 242–3.
27. Phillips, *The Cousins' Wars*, pp. 247.
28. Phillips, *The Cousins' Wars*, p. 262.
29. Massie, *The Thistle and the Rose*, p. 114.
30. Devine, *The Scottish Nation*, p. 65.
31. Norman Stone, *Sunday Times*, February 1992, quoted in Andrew Marr, *The Battle for Scotland*, London: Penguin, p. 7.
32. Vernon Bogdanor, *Devolution in the United Kingdom*, Oxford: Oxford University Press, 1999, pp. 4–5.
33. David Morse, *High Victorian Culture*, London: Macmillan, 1993, pp. 47–8.
34. Jonathan Rose, *The Intellectual Life of the British Working Class*, London: Yale University Press, 2002, p. 59.
35. Rose, *The Intellectual Life*, p. 59.
36. Rose, *The Intellectual Life*, p. 61.
37. Arnold Kemp, *The Hollow Drum: Scotland Since the War*, Edinburgh: Mainstream 1993, p. 76.
38. John Harmon McElroy, *American Beliefs: What Keeps a Big Country and a Diverse People United*, Chicago: Ivan R. Dee, 1999, p. 30.
39. Devine, *The Scottish Nation*, p. 200.
40. See George Davie, *The Democratic Intellect*, Edinburgh: Edinburgh Unversity Press, 1961.
41. Lenman, 'From the Union of 1707', p. 278.
42. McElroy, *American Beliefs*, p. 52.

43. McElroy, *American Beliefs*, p. 55.
44. See Bernard Aspinwall, *Portable Utopia: Glasgow and the United States 1820–1920*, Aberdeen: Aberdeen University Press, p. xii.
45. McElroy, *American Beliefs*, p. 153.
46. McElroy, *American Beliefs*, p. 30.
47. Rose, *The Intellectual Life*, p. 17.
48. William Storrar, *Scottish Identity: A Christian Vision*, Edinburgh: The Handsel Press 1990, p. 50.
49. John Robertson, 'Culture shock', *Daily Mail* (Scottish ed.), 24 February 2009; *Scotsman*, 28 February 2008.
50. Notestein, *The Scot In History*, p. p. 178–9.
51. Massie, *The Thistle and the Rose*, p. 147.
52. See Malcolm Chapman, *The Celts: the construction of a Myth*, Houndsmill: Macmillan 1992.
53. Flann O'Brien, *The Poor Mouth*, London: Paladin, 2003 edition.
54. Graeme Morton and R.J. Morris, 'Civil Society, Governance and Nation, 1832–1914', in R.A. Houston and W.W.J. Knox, *The New Penguin History of Scotland: From the Earliest Times to the Present Day*, London: Allen Lane, 1999, p. 407.
55. Morton and Morris, 'Civil Society, Governance and Nation, 1832–1914', p. 404.
56. Colley, *Britons*, p. 123.
57. T.M. Devine, *The Scottish Nation*, p. 288.
58. Graeme Morton, *Unionist Nationalism: Governing Urban Scotland, 1830–1860*, Edinburgh, Tuckwell Press, 1999, pp. 47–8.
59. Peter Jones, 'The downfall of the Scottish banks', *Scotsman*, 14 October 2008.
60. Peter Jones, 'The downfall of the Scottish banks', *Scotsman*, 14 October 2008.
61. Devine, *The Scottish Nation*, p. 263.
62. T.M.Devine, 'The Great Irish famine and Scottish History', In Martin Mitchell (ed), *New Perspectives on The Irish in Scotland*, Edinburgh: Birlinn, 2008, p. 29.
63. Kidd, 'Race, Empire and...Scottish Nationhood', p. 876.
64. Kidd, 'Race, Empire and...Scottish Nationhood', pp. 886–8.
65. Kidd, 'Race, Empire and...Scottish Nationhood', p. 881.
66. W.W. Knox, *Industrial Nation: Work, Culture and Society in Scotland, 1800–Present*, Edinburgh: Edinburgh University Press, 1999, p. 60.
67. N.T. Phillipson, 'Nationalism and Ideology', in J.N. Wolfe (ed), Government and Nationalism in Scotland, Edinburgh: Edinburgh University Press, 1969, p. 186.
68. Phillipson, 'Nationalism and Ideology', p. 186.
69. David Stenhouse, *How the Scots Took Over London*, Edinburgh: Mainstream Press, p. 124.

70. Gordon Donaldson and others, 'Scottish Devolution: the Historical background', in J.N. Wolfe (ed), *Government and Nationalism in Scotland*, Edinburgh: Edinburgh University Press, 1969, p. 5.
71. Morton and Morris, 'Civil Society, Governance and Nation, 1832–1914', p. 399.
72. Colley, *Britons*, p. 123.
73. David Black, *All the First Minister's men: The Truth behind Holyrood*, Edinburgh: Birlinn, 2001, p. 89.
74. Morton, *Unionist Nationalism*, p. 180.
75. See J. Fyfe, 'Scottish Volunteers with Garibaldi', *Scottish Historical Review*, Vol. 57, 1978, pp. 168–81.
76. Kidd, *Union and Unionisms*, p. 272.
77. Morton, *Unionist Nationalism*, p. 188.
78. See Ruth Clayton Windcheffel, 'Gladstone and Scott: Family, Identity, and Nation', *Scottish Historical Review*, No. 221, April 2007, pp. 69–95.
79. Vernon Bogdanor, 'In the footsteps of Scotland and Wales', *Financial Times*, 9 May 2002.
80. Kidd, *Union and Unionisms*, pp. 266–7.
81. Bob McLean, *Getting It Together: The History of the Campaign for a Scottish Assembly/Parliament 1980–1999*, Edinburgh: Luath Press 2005, p19.
82. Kidd, 'Race, Empire and…Scottish Nationhood', p. 889.
83. Kidd, *Union and Unionisms*, p. 268.
84. Christopher Harvie, *No Gods and Precious Few Heroes: Scotland 1914–1980*, London: Edward Arnold, 1981, p. 4.
85. Devine, *The Scottish Nation*, pp. 249–50.
86. Harvie, *No Gods and Precious Few Heroes*, p. 56.
87. John Foster, 'The Twentieth Century, 1914–1979', in R.A. Houston and W.W.J. Knox, *The New Penguin History of Scotland: From the Earliest Times to the Present Day*, London: Allen Lane, 1999, p. 421.
88. Foster, 'The Twentieth Century', p. 423.
89. Christopher Harvie, *Scotland and Nationalism: Scottish Politics and Society 1707 to the Present*, London: Allen & Unwin 1999, p. 73.
90. Eric Linklater, *The Lion and the Unicorn*, London: Routledge, 1935, p. 43.

2. 1918–1967

1. Foster, 'The Twentieth Century'. p. 420.
2. Christopher Harvie, 'Grasping the Thistle', in Kenneth Cargill (ed), *Scotland 2000: Eight Views on the State of the Nation*, Glasgow: BBC Scotland, 1987, pp. 6–7.
3. See Christopher Harvie, *Against Metropolis*, London: Fabian Society, 1982.
4. Edwin Muir, *Scottish Journey*, Edinburgh: Mainstream, 1979, p. 244.

5. T.C.Smout, 'Introduction', in Muir, *Scottish Journey*, p. xii.
6. Smout, 'Introduction', in Muir, *Scottish Journey*, p. xviii.
7. Aspinwall, *Portable Utopia*, p. 52.
8. Smout, 'Introduction', in Muir, p. xiv.
9. Richard Finlay, *Independent and Free: Scottish Politics and the Origins of the Scottish National Party, 1918–1945*, Edinburgh: John Donald, 1994, p. 91.
10. See Aspinwall, *Portable Utopia, passim*.
11. T.M. Devine, 'The End of Disadvantage? The Descendants of Irish-Catholic immigrants in modern Scotland since 1945', in Martin Mitchell (ed.), *New Perspectives on the Irish in Scotland*, Edinburgh: Birlinn, 2008, p. 193.
12. See *The Menace of the Irish Race to our Scottish Nationality*, Edinburgh: William Bishop, 1923.
13. Tom Gallagher, *Glasgow, The Uneasy Peace: Religious Tension in Modern Scotland*, Manchester: Manchester University Press, 1987, pp. 121–22.
14. Gallagher, *Glasgow, The Uneasy Peace*, p. 323.
15. Linklater, *The Lion and the Unicorn*, pp. 26–7.
16. Muir, *Scottish Journey*, pp. 233–34.
17. A.S. Neill, *Is Scotland Educated?* Edinburgh and London: The Edinburgh Press, 1936, pp. 16–17.
18. Massie, *The Thistle and the Rose*, p. 93.
19. Massie, *The Thistle and the Rose*, p. 102.
20. See *inter alia* Murray Pittock, *Celtic Identity and the British Image*, Manchester: Manchester University Press, 1999.
21. Massie, *The Thistle and the Rose*, p. 219.
22. Jack Brand, *The National Movement of Scotland*, London: Routledge, 1978, p. 219.
23. Knox, *Industrial Nation*, p. 244.
24. Muir, *Scottish Journey*, p. 249.
25. Massie, *The Thistle and the Rose*, p. 262.
26. David Kirkwood, *My Life of Revolt*, London: Harrap. 1935, p. v.
27. Knox, *Industrial Nation*, p. 240.
28. Iain Finlayson, *The Scots*, London: Constable, 1987, p. 152.
29. Brian Aldiss, *The Twinkling of an Eye*, London: Warner Books, 1999, p. 4.
30. Quoted in Vernon Bogdanor, *Devolution in the United Kingdom*, Oxford: Oxford University Press, 1999, p. 117.
31. Storrar, *Scottish Identity: A Christian Vision*, p, 72.
32. Murray Pittock, *The Road To Independence: Scotland Since the Sixties*, London: Reaktion Books, 2008, p. 64.
33. Brian Taylor, *Scotland's Parliament: Triumph and Disaster*, Edinburgh: Edinburgh University Press, 2002, p. 85.
34. Foster, 'The Twentieth Century'. p. 447.
35. Richard Finlay, *A Partnership for Good: Scottish Politics and the Union Since 1880*, Edinburgh: John Donald, 1997, p. 147.

36. Alan Taylor, 'An independent spirit', *Sunday Herald*, 28 September 2008.
37. Massie, *The Thistle and the Rose*, p. 279.
38. Harvie, *No Gods and Precious Few Heroes*, p. 56.
39. Massie, *The Thistle and the Rose*, p. 263.
40. T.M. Devine, *The Scottish Nation*, pp. 570–71.
41. Alan Clements, Kenny Farquharson and Kirsty Wark, *Restless Nation*, Edinburgh: Mainstream Publishing, 1996, p. 34.
42. Andrew Marr, *A History of Modern Britain*, London: Pan, 2008, p. 172.
43. David Torrance, *The Scottish Secretaries*, Edinburgh: Birlinn Ltd, p. 232–33.
44. Pittock, *The Road to Independence?* p. 18.
45. Jimmy Reid, 'Scotland's True Goal', *The Story of Scotland*, No. 3, Glasgow: Maxwell Publishing, 1988, p. 59
46. Alan Taylor, 'In Search of Middle Scotland' in Alan Taylor (ed), *What A State!: Is Devolution for Scotland the End of Britain?* London: Harper Collins, 2000, p. 147.
47. Angus Calder and Alisdair Gray, 'Past Caring', Part 5—Education' in in Alan Taylor (ed), *What A State!: Is Devolution for Scotland the End of Britain?* London: Harper Collins, 2000, p. 103.
48. Scottish Council of the Labour Party. *Annual Report*, 1958, quoted in Henry Drucker and Gordon Brown, *The politics of nationalism and devolution*, London: Longmans, 1980, p. 25.
49. Tom Johnston, *Memories*, Glasgow: Collins, 1952, p. 69.

3. 1967–1979

1. Mandy Rhodes, 'Still Gorgeous', *Holyrood Magazine*, (Edinburgh), 9 February 2009.
2. David Marquand, *Britain Since 1918: The Strange Career of British Democracy*, London: Weidenfeld & Nicholson, 2008, p. 239.
3. Clements et al, *Restless Nation*, p. 46.
4. Knox, *Industrial Nation*, p. 262.
5. Foster, 'The Twentieth Century'. p. 476.
6. Taylor, *The Scottish Parliament*, p. 166. (quotes belong to the author).
7. James Mitchell, *Strategies for Self-Government: the Campaigns for a Scottish Parliament*, Edinburgh: Polygon, 1996 pp. 202–03.
8. Mitchell, *Strategies for Self-Government*, p. 203.
9. Harvie, *No Gods and Precious Few Heroes*, p. 62.
10. Foster, 'The Twentieth Century'. p. 469.
11. Harvie, *No Gods and Precious Few Heroes*, p. 62.
12. Andrew Marr, *The Battle for Scotland*, London: Penguin, 1992, p. 107.
13. Clements et al, *Restless Nation*, p. 45.
14. Harvie, *No Gods and Precious Few Heroes*, p. 151–2.
15. Clements et al, *Restless Nation*, p. 12.

16. Clements et al, *Restless Nation*, p. 51.
17. Ibid.
18. Richard Crossman, *Diary of a Cabinet Minister*, London: Hamish Hamilton and Jonathan Cape, 1977, Vol. III, p. 106.
19. *Royal Commission on the Constitution, 1968–73*, Cmnd. 546, London: HMSO, 1973, para 327.
20. Andrew Marr, *The Battle for Scotland*, London: Penguin, 1992, p. 136.
21. Vernon Bogdanor, *Devolution in the United Kingdom*, Oxford: Oxford University Press, 1999, p. 128.
22. Clements et al, *Restless Nation*, p. 65.
23. Clements et al, *Restless Nation*, p. 65.
24. Clements et al, *Restless Nation*, p. 63.
25. Magnus Linklater and George Rosie, 'Secret plan to deprive independent Scotland of North Sea oil fields', *Times*, 14 February 2009.
26. Arthur M. Schlesinger Jr., *Journals 1952–2000*, New York: Penguin Press, 2007, p. 417.
27. Quoted in Christopher Harvie, *Fools Gold: The Story of North Sea Oil*, London: Hamish Hamilton, 1994, p. 248.
28. Harvie, *Fools Gold*, p. p. 92–93, 291.
29. Gavin McCrone, *The Economics of Nationalism*, memorandum drawn up in 1974 and released on 22 February 2006 by the Scottish Office.
30. McCrone, *The Economics of Nationalism*, p. 16.
31. Harvie, *Fools Gold*, p. 254.
32. McCrone, *The Economics of Nationalism*, p. 16.
33. Foster, 'The Twentieth Century'. p. 479.
34. Harvie, *No Gods and Precious Few Heroes*, pp. 161–2.
35. Harvie, *No Gods and Precious Few Heroes*, p. 162.
36. Bogdanor, *Devolution in the United Kingdom*, p. 141.
37. Marr, *The Battle for Scotland*, p. 122.
38. Marquand, *Britain Since 1918*, p. 273.
39. Bernard Donoughue, *Downing Street Diary: Volume 2: With James Callaghan in No 10*, London: Jonathan Cape, 2008, p. 146.
40. Donoughue, *Downing Street Diary: Volume 2*, p. 276.
41. Arnold Kemp, *The Hollow Drum: Scotland Since the War*, Edinburgh: Mainstream 1993, p. 129.
42. Jimmy Allison, *Guilty by Suspicion: a life and Labour*, Glendaruel, Scotland: Argyll Publishing, 1995, p. 164.
43. McLean, *Getting It Together*, p. 43.
44. Devine, *The Scottish Nation*, p. 388.
45. Donoughue, *Downing Street Diary: Volume 2* p. 453.

4. 1979–1997

1. David Torrance, *The Scottish Secretaries*, Edinburgh: Birlinn Ltd, p. 327.
2. Kidd, *Union and Unionisms*, pp. 4–5.

239

3. Kenyon Wright, *The People say Yes: The Making of Scotland's Parliament*, Glendaruel: Argyll Publishing, 1997, p. 142.
4. Margaret Thatcher, *The Downing Street Years*, London: Harper Collins, 1993, p. 619.
5. Bogdanor, *Devolution in the United Kingdom*, p. 133.
6. BBC Radio 4, 'Desert Island Discs, 29 May 1991.
7. Taylor, *The Scottish Parliament*, p. 144.
8. Michael Fry, *Patronage and Principle*, Aberdeen: Aberdeen University Press, 1987, p. 250.
9. McCrone, *The Economics of Nationalism*, p. 18.
10. James Campbell, *Invisible Country: A Journey Through Scotland*, London: Weidenfeld and Nicholson, 1984, p. 162.
11. Taylor, *The Scottish Parliament*, p. 39.
12. H.J.Hanham, *Scottish Nationalism*, Cambridge, Mass: Harvard University Press, 1969, p. 27.
13. Kemp, *The Hollow Drum*, pp. 167–8.
14. Taylor, *The Scottish Parliament*, p. 38.
15. See McLean, *Getting It Together, passim.*
16. Mitchell, *Strategies for Self-Government*, p. 127.
17. Taylor, *The Scottish Parliament*, p. 34.
18. See Harvie, *Fools Gold,..*
19. Marr, *The Battle for Scotland*, p. 221.
20. McLean, *Getting It Together*, p. 98.
21. Mitchell, *Strategies for Self-Government*, pp. 103–04.
22. Richard Parry, 'Leadership and the Scottish governing classes', in Gerry Hassan an Chris Warhurst (eds), *Tomorrow's Scotland*, London: Lawrence and Wishart, 2002, p. 149
23. Marquand, *Britain Since 1918*, pp. 352–3,
24. Harvie, *Scotland and Nationalism*, pp. 126–127.
25. Marr, *A History of Modern Britain*, p. 524.
26. Wright, *The People say Yes*, pp. 165–66.
27. James Mitchell, *Conservatives and the Union*, Edinburgh: Edinburgh Universty Press, 1990, p. 113.
28. Marquand, *Britain Since 1918*, p. 336.
29. Knox, *Industrial Nation*, pp. 102–3.
30. See Richard J. Finlay, 'Scotland in the Twentieth Century: In Defence of Oligarchy?', *Scottish Historical Review*, No. 195, April 1994, pp. 103–112.
31. Neal Ascherson, *Stone Voices, the Search for Scotland*, London: Verso, 2002, p. 238.
32. Wright, *The People say Yes*, p. 121.
33. Richard Finlay, *Modern Scotland: 1914–2000*, Profile Books 2004, p. 374.
34. Wright, *The People say Yes*, pp. 231–2.
35. Marquand, *Britain Since 1918*, p. 333.
36. Mitchell, *Strategies for Self-Government*, p. 275.

37. Taylor, *The Scottish Parliament*, p. 40.
38. Ibid.
39. McLean, *Getting It Together*, p. 117.
40. Marr, *The Battle for Scotland*, pp. 203–4.
41. Mitchell, *Strategies for Self-Government*, p. 129.
42. Allison, *Guilty by Suspicion*, p. 130.
43. Mitchell, *Strategies for Self-Government*, p. 130.
44. Mitchell, *Strategies for Self-Government*, p. 287.
45. Wright, *The People say Yes*, p. 230.
46. Clements et al, *Restless Nation*, p. 133.
47. Wright, *The People say Yes*, pp. 259–60.
48. Finlay, *Modern Scotland*, p. 373.
49. Clements et al, *Restless Nation*, p. 82.
50. See Allan Little, 'Scots nationalism's big debt to Thatcher', *Sunday Times*, 28 December 2008.
51. Taylor, *The Scottish Parliament*, pp. 67–68.
52. Bogdanor, *Devolution in the United Kingdom*, p. 198.
53. Taylor, *The Scottish Parliament*, pp. 70–3.
54. Wright, *The People say Yes*, pp. 241–54.
55. Lorraine Davidson, *Lucky Jack: Scotland's First Minister*, Edinburgh: Black and White Publishing, 2005, pp. 66–67.
56. Taylor, *The Scottish Parliament*, pp. 75–76.
57. Tom Brown and Henry McLeish, *Scotland: The Road Divides*, Edinburgh: Luath Press, 2008, p. 28.
58. Taylor, *The Scottish Parliament*, p. 133.
59. Taylor, *The Scottish Parliament*, p. 131.
60. Wright, *The People say Yes*, p. 128.
61. Muir, *Scottish Journey*, chapter 4.
62. Torrance, *The Scottish Secretaries*, p. 340.
63. Bogdanor, *Devolution in the United Kingdom*, p. 288.
64. Bogdanor, *Devolution in the United Kingdom*, p. 291.
65. Marquand, *Britain Since 1918*, p. 370.
66. Kenny MacAskill, *Building A Nation: Post Devolution Nationalism in Scotland*, Edinburgh: Luath Press, 2004, pp. 20–21.
67. Mitchell, *Strategies for Self-Government*, p. 131.
68. Taylor, *The Scottish Parliament*, p. 57.
69. Taylor, *The Scottish Parliament*, p. 171.
70. Taylor, *The Scottish Parliament*, p. 174.
71. Taylor, *The Scottish Parliament*, p. 59.
72. Allan Massie, 'Salmond's triumph brings a whiff of Gaullism', *Independent*, 26 July 2008.
73. Alan Cochrane, 'Looking to a new political alignment', in Bill Jamieson (ed), *Scotland's Ten Tomorrows*, London: Continuum, 2006, p. 113.
74. Pittock, *The Road To Independence*, p. 81.
75. Anthony King, 'Most Scots have no wish to separate from England', *Daily Telegraph*, 15 April 1999.

76. Jack McConnell, 'Modernising the Modernisers', in George Kerevan, 'From 'Old' to 'New' SNP', in *A Different Future*, edited by Gerry Hassan and Chris Warhurst, Glasgow: Centre for Scottish Public Policy, 1999, p. 66.
77. Davidson, *Lucky Jack*, p. 91.
78. Davidson, *Lucky Jack*, p. 91.
79. Brian Taylor, *Scotland's Parliament: Triumph and Disaster*, Edinburgh: Edinburgh University Press, 2002, p. 145.

Part Two

5. DEVOLUTION UNDER LABOUR

1. Davidson, *Lucky Jack*, p. 205.
2. John Curtice, 'Devolution and Democracy: New Trust or Old Cynicism?' in John Curtice et al, *New Scotland, New Society? Are Social and Political Ties Fragmenting?*, Edinburgh, Polygon 2002, p. 147.
3. Curtice, 'Devolution and Democracy, p. 155.
4. Curtice, 'Devolution and Democracy, p. 162.
5. *The Guardian*, 11 May 1999.
6. *New Statesman*, 16 January 1976.
7. *Scotsman*, 8 December 2008.
8. Marr, *The Battle for Scotland*, p. 213.
9. Paterson, 'Governing from the Centre, p. 215.
10. Torrance, *The Scottish Secretaries*, pp. 342–3.
11. McLean, *Getting It Together*, p. 168.
12. David Black, *All the First Minister's Men: The Truth behind Holyrood*, Edinburgh: Birlinn, 2001, p. 173.
13. Taylor, *The Scottish Parliament*, p. 117.
14. Black, *All the First Minister's Men*, Edinburgh: Birlinn, 2001, p. 180.
15. Black, *All the First Minister's Men*, p. 13.
16. Black, *All the First Minister's Men*, p. 212.
17. Pittock, *The Road To Independence*, p. 97.
18. Pittock, *The Road To Independence*, p. 157.
19. Pittock, *The Road To Independence*, p. 169; 'Building "a pearl beyond price" say visitors', *The Herald*, 22 February 2007.
20. See the caustic views of Susan Deacon, the former minister for Health and Community care, 'Fixing the Machine', *Scottish Left Review*, No. 13, November-December 2002.
21. Jamieson, 'Introduction', pp. 5–6.
22. Tim Luckhurst, 'Farewell to a cleric who thrived on the weakness of liberals, *Independent*, 20 June 2001.
23. *Sunday Herald* (Glasgow), 6 June 1999.
24. For this para. See Mike Watson, *Year Zero: An Inside View of the Scottish Parliament*, Edinburgh: Polygon, 20001, pp. 141–44.
25. *Sunday Herald* (Glasgow), 2 April 2000.

26. John Curtice, 'Outcome devalued by low-turnout', *Scotsman*, 31 May 2000.
27. Jimmy Reid, 'Morality is a private matter', *The Herald*, 5 June 2000.
28. Robbie Dinwoodie, 'What has changed is Scotland's view of itself', *The Herald*, 31 May 2000.
29. Iain MacWhirter, 'Four months of funk and fudge', *Sunday Herald*, 4 June 2000.
30. *Sunday Herald*, 23 January 2000.
31. Watson, *Year Zero*, p. 159
32. *Sunday Herald*, 19 December 1999.
33. Gerald Warner, 'Devolved Scotland: Britain's Potemkin Village', in Bill Jamieson (ed), *Scotland's Ten Tomorrows*, London: Continuum, 2006, p. 103.
34. Warner, 'Devolved Scotland', p. 103.
35. Iain MacWhirter, 'Four months of funk and fudge', *Sunday Herald*, 4 June 2000.
36. Taylor, *Scotland's Parliament: Triumph and Disaster*, p. 146.
37. Christopher Harvie, *Scotland and Nationalism*, London: Routledge, 1999, 3rd ed., p. 254.
38. Jamieson, 'Introduction', p. 3.
39. Jamieson, 'Introduction', p. 1.
40. Lindsay Paterson, 'Social Capital and Institutional Reform'in Curtice et al, *New Scotland, New Society?* p. 6.
41. *Scotland on Sunday*, 2 May 2005; *Spectator* 4 February 2009.
42. Allan Massie, 'Change is the best option for the status quo', in Bill Jamieson (ed), *Scotland's Ten Tomorrows*, London: Continuum, 2006, p. 33.
43. George Kerevan 'Devolution: a deepening economic policy failure', in Bill Jamieson (ed), *Scotland's Ten Tomorrows*, London: Continuum, 2006, p. 56.
44. Nelson, 'A tale of three Scotlands', p. 76.
45. Robert Huggins Associates, UK Competitiveness Index, 2005, quoted by Donald Mackay, 'How global forces will compel economic change', in Bill Jamieson (ed), *Scotland's Ten Tomorrows*, London: Continuum, 2006, p. 82.
46. Jamieson, 'Introduction', p. 7.
47. Kerevan 'Devolution…', p. 64.
48. Taylor, *Scotland's Parliament: Triumph and Disaster*, p. 29.
49. Taylor, *Scotland's Parliament: Triumph and Disaster*, pp. 36–37.
50. Kenny Farquharson, 'How bad was she'? *Scotland on Sunday*, 29 June 2008.
51. Taylor, *Scotland's Parliament*, p. 74.
52. Watson, *Year Zero*, pp. 100–08.
53. Gerry Hassan and Douglas Fraser, *The Political Guide to Modern Scotland*, London: politico, 2004, p. 13.
54. Davidson, *Lucky Jack*, p. 181.

55. Taylor, *The Scottish Parliament*, p. 187.
56. Davidson, *Lucky Jack*, p. 197.
57. Hassan and Fraser, *The Political Guide to Modern Scotland*, p. 316.
58. Mark Stuart, *John Smith, A life*, London: Politico, 2005, p. 350.
59. William Clark, 'Labour holds Smith's seat', *The Herald*, 1 July 1994.
60. Alex Salmond, 'Northern Ireland and the Scottish Question', *Scottish Affairs*, No. 13, Autumn 1995, p. 70; Stephen McGinty, *The Turbulent Priest: The Life of Cardinal Winning*, London: Harper Collins, 2003, p. 337.
61. Eddie Barnes, 'Police charges expose great bigotry divide', *Scotland on Sunday*, 9 September 2007.
62. Watson, *Year Zero*, p. p. 24–25.
63. Hamish Macdonnell, Jack's legacy is the loser in the great game of politics', *Scotsman*, 31 December 2008.
64. Lindsay Paterson, 'Governing from the Centre: Ideology and Public Policy', in Curtice et al, *New Scotland, New Society?* p. 216.
65. See the 2002 briefing of the trade-union UNISON, 'PFI—the gravy train rolls on', http://www.unison-scotland.org.uk/breifings/pfijune02.html.
66. 'Will Hurst, 'Fraser quits A&DS in PFI Protest', www.bdonline.co.uk, 9 February 2007.
67. Malcolm Fraser, 'How profits have shut out the light on public architecture', *Socialist Worker*, 28 April 2007.
68. Fraser, 'How profits have shut out the light...'
69. Lesley Riddoch, 'Labour needs to face home truths of what devolution means', *Scotsman*, 7 July 2008.
70. See Kenneth Roy, 'The road to Glenrothes', *Scottish Review*, 21 October 2008, www.scottishreview.net.
71. Taylor, *Scotland's Parliament*, p. 20.
72. Andrew Marr, *A History of Modern Britain*, London: Pan, 2008, p. 256.
73. *The Tablet*, 28 November 1998.
74. *Sunday Herald*, 23 January 2000.
75. Paul Vallely, 'Prickly prelate who will brook no dissent', *Independent*, 28 October 1996.
76. Eddie Barnes, 'Catholic leader backs Scottish independence', *Scotland on Sunday*, 15 October 2006.
77. Letter to the Editor, *The Sunday Times*, 4 December 2005.
78. James MacMillan, 'Why Gordon Brown will lose Glasgow East', *Daily Telegraph*, 8 July 2008.
79. Iain Mac Whirter, 'The battle for Scotland's Soul', *Sunday Herald*, 23 January 2000.
80. McGinty, *The Turbulent Priest*, p. 360.
81. 'Conclusions', in Curtice et al, *New Scotland, New Society?* p. 221.
82. John Curtice, 'The 2003 Election: Lessons for Devolution', Gerry Hassan and Douglas Fraser, *The Political Guide to Modern Scotland*, London: politico, 2004, pp. 28–29.

83. Cochrane, 'Looking to a new political alignment', p. 113.
84. Iain Macwhirter, 'Statesmanlike Salmond spreads his wings on the European stage', Sunday Herald, 15 July 2007.
85. See Bogdanor, Devolution in the United Kingdom, pp. 280–81.
86. Taylor, The Scottish Parliament, p. 241.
87. Mitchell, Strategies for Self-Government, p. 165–66.
88. Davidson, Lucky Jack, p. 262.
89. Bagehot, 'Labour's Scottish problem', The Economist, 2 December 2006.

6. FINALLY GOVERNING SCOTLAND: 2007–09

1. T.M.Devine, 'The Break-Up of Britain? Scotland and the End of Empire', Transactions of the RHS, 2006, p. 165.
2. Massie, 'Change is the best option for the status quo', pp. 32, 33.
3. Douglas Fraser, 'Swinney attacked on all sides in leadership race', Sunday Herald, 21 September 2003.
4. Jason Allardyce and Neil Rafferty, 'Men in grey kilts sharpen their knives', Sunday Times, 20 June 2004.
5. 'Profile: Alex Salmond', Times, 29 April 2007.
6. Alan Cochrane, 'A fine line between public duty and party advantage', Daily Telegraph, 27 August 2008.
7. John Osmond, 'In Search of Stability', in The State of the Nation, (edited by Alan Trench), London: University College London, 2001, p. 30.
8. Taylor, Scotland's Parliament: Triumph and Disaster, p. 94.
9. Charlie Jeffery and Daniel Wincott, 'Devolution in the United Kingdom: Statehood and Citizenship in Transition', Publius, Vol. 36, No. 1, p. 9.
10. Private view expressed to the author.
11. Gillian Bowditch, 'I watched my grandmother die from C difficile', Sunday Times, 7 December 2008.
12. Scotsman, 12 September 2003.
13. Scotsman, 25 January 2009.
14. The Economist, 27 October 2007.
15. Scotsman, 12 October 2007.
16. Hamish MacDonnell, 'Co-operation forged over eight years is brought crashing down', Scotsman, 12 October 2007.
17. Bill Jamieson, 'We Wuzz robbed Alex but not in way you keep moaning about', Scotsman, 12 October 2007.
18. Magnus Linklater, 'Honeymoon is over, but SNP may now forge a real marriage', Times, 7 November 2008.
19. Andrew Bolger, 'Trump determined to answer ancestral call', Financial Times, 1–2 December 2007.
20. Scotsman, 5 December 2007.
21. Scotsman, 25 April 2008.
22. Scotsman, 24 January 2008.

23. *Daily Telegraph*, 9 June 2008.
24. *Scotsman*, 25 April 2008.
25. *Scotsman*, 4 November 2008.
26. Hamish Macdonnell, 'Fury as building chief blames the Treasury', *Scotsman*, 30 March 2009.
27. Douglas Fraser, 'The honeymoon is far from over', 1 Febnuary 209.
28. Douglas Fraser, 'The honeymoon is far from over', *The Herald*, 17 March 2008.
29. Kenny Farquharson, 'Can Alex rise to the challenge', *Scotland on Sunday*, 18 October 2008.
30. Ibid.
31. *Financial Times*, 31 October 2008.
32. John Penman, 'Nuclear may be key to reaching eco-goal', *Times*, 3 August 2008.
33. Jenny Haworth, 'Man from Nasa slams Salmond coal plan as "sham"', *Scotsman*, 31 January 2009.
34. Haworth, 'Man from Nasa'.
35. Haworth, 'Man from Nasa'.
36. *The Herald*, 29 August 2008.
37. *Scotsman*, 5 August 2008; *Daily Mail*, 11 February 2008.
38. *The Economist*, 27 October 2007; *Scotsman*, 5 August 2008.
39. See his letter to the *Washington Times*, 11 April 2008.
40. *New Statesman and Society*, 10 March 1995.
41. Marr, *The Battle for Scotland*, p. 216.
42. Stephen Fay, 'Dice Man', *Independent on Sunday*, 20 September 1998.
43. *Scottish Catholic Observer*, 17 November 2008. He was the guest speaker at the 25th anniversary meeting of the Edinburgh Ecumenical Society which I attended.
44. www.moraymp.org, 21 August 2005, blog of Angus Robertson MP.
45. Craig Beveridge and Ronnie Turnbull, *The Eclipse of Scottish Culture*, Edinburgh: Polygon, 1989 quoted by William Storrar, *Scottish Identity: A Christian Vision*, Edinburgh: The Handsel Press 1990, p. 149.
46. Hamish Macdonell, 'More answers than questions as Scottish Cabinet drops in on Inverness', *Scotsman*, 6 August 2008.
47. Pittock, *The Road To Independence*, p. 60.
48. *Sunday Times*, 19 August 2007.
49. Figures provided by Professor James Mitchell while delivering the Donaldson lecture at the 2008 SNP conference in Perth, 18 October 2008.
50. Paterson, 'Social Capital and Institutional Reform', p. 25.
51. See Kenneth Roy, 'Fred's folly?' *Scottish Review*, 27 January 2009, www.Scottishreview.net/Kroy071.html.
52. *Scotsman*, 18 December 2008.
53. Stephen Fay, 'Dice Man', *Independent on Sunday*, 20 September 1998.
54. Angus Macleod, 'Scotland needs a news of its own, Salmond tells BBC executives', *Times*, 6 August 2007.

55. Eberhard Bort, 'Annals of the Parish: The Year at Holyrood, 2007–8', *Scottish Affairs*, No. 65, Autumn 2008, p. 4.
56. David Hutchinson, 'The State of the Scottish Newspaper Industry', All Media Scotland, 5 February 2009, www.allmediaScotland.com.
57. For both quotes see Jennie Erdal, 'A professor's bold thinking on terrorism', *Financial Times*, 7/8 March 2009.
58. Roger Scruton, 'Forgiveness and Irony', *City Journal*, Winter 2009, http://www.city-journal.org/printable.php?id=3647.
59. *The Scotsman*, 28 August 1998.
60. Patrick Reilly, 'Labour is hit by by-election after-shocks', *Scottish Catholic Observer*, 8 August 2008.
61. John Curtice, 'Support for independence takes a leap of faith among Scotland's Catholics', *The Scotsman*, 28 August 1998.
62. Robbie Dinwoodie, 'Anti-Catholic bigotry is deep and pervasive, says Cardinal', *the Herald*, 28 November 2006.
63. *Sunday Times*, 12 October 2008.
64. *New Statesman and Society*, 10 March 1995.
65. Alex Salmond, 'Northern Ireland and the Scottish Question', *Scottish Affairs*, No. 13, Autumn 1995, pp. 71–72.
66. For the quote, see *The Scotsman*, 14 December 2008.
67. Hamish Macdonnell, Jack's legacy is the loser in the great game of politics', *Scotsman*, 31 December 2008.
68. Dinwoodie, 'Anti-Catholic bigotry'.
69. *Sunday Times*, 12 April 2009.
70. ProgressiveScottish muslims.blogspot.com, 6 August 2007. This is the blog of Amanullah de Sondy a lecture in Divinity at the University of Glasgow
71. See Gillian Bowditch, 'A reluctant fundamentalist?' *Sunday Times* (Scotland), 22 June 2008; and *Scottish Islamic Foundation launch*, London: Commission for Social Cohesion, 25 June 2008.
72. *Daily Mail*, 9 March 2009.
73. Eddie Barnes, 'Salmond hit by "cash for cronies" row', *Scotland on Sunday*, 13 July 2008.
74. Eddie Barnes, 'Salmond hit by "cash for cronies" row', *Scotland on Sunday*, 13 July 2008.
75. Michael Howie, 'Salmond backs first state-funded Islamic school for Scotland', *Scotsman* (Edinburgh), 27 June 2008.
76. See David McRoberts (ed), *Modern Scottish Catholicism, 1878–1978*, Glasgow: J. Burns, 1979.
77. Louise Ellman MP, Hansard, 18 December 2003.
78. Osama saeed, 'those blasted cartoons', *Rolled up Trousers*, www.osama-saeed.org/osama/2006/02/those_blasted_c.html.
79. Osama Saeed, 'The return of the caliphate', *Guardian*, 1 November 2005.
80. Sohaib Saeed, 'If Qaradawi is an extremist who is left', *Guardian*, 9 July 2004.

81. See 'The Qaradawi Appreciation Society', *Harry's Place*, 8 April 2009, www.hurryupharry.org; for Qaradawi's exclusion, see *Guardian*, 28 October 2008.

82. For an assessment of this Europe-wide current in Islam, see Gilles Kepel, Chapter 7, The Battle for Europe', *The War For Muslim Mind: Islam and the West*, Harvard, Mass., USA: Harvard University Press, 2004.

83. Information on turnout was obtained from several invited guests.

84. Ed Husain, *The Islamist*, London: Penguin, 2008.

85. Quilliam Alert: Scottish National party to endorse Islamist candidate', 19 April 2009, www.quilliamfoundation.org.

86. Amanullah de Sondy, 'Alternative take', *Scotsman* (Edinburgh), 2 July 2008.

87. Quoted in Angus Macleod, 'SNP urged to drop "sectarian and divisive" Muslim candidate', *Times*, 24 April 2009.

88. See George Rosie, *Curious Scotland: Tales from a Hidden History*, London: Granta Books, 2004, pp. 65–71.

89. See Hansard, House of Lords debate 11 October 2005, columns 200–235; House of Commons debate, 31 January 2006, columns 216–235.

90. Hansard, 31 January 2006, column 230.

91. *Irish Times*, 27 March 2009.

92. *Wall Street Journal*, 6 April 2009.

93. The *Herald*, 28 December 2007.

94. It was published in the *Herald* on 31 December 2008.

95. See 'Debate call on "multicultural" United Kingdom', BBC News, 5 April 2004, www.bbc.co.uk.

96. Kenan Malik, 'what should integration mean in Britain today?' http://kenanmalik.com/debates/cick_jcwi.html.

97. Marr, *The Battle for Scotland*, p. 37.

98. Iain MacWhirter, 'Statesmanlike Salmond spreads his wings on the European stage', *Sunday Herald*, 15 July 2007.

99. See Bernard-Henri Levy, *Left in Dark Times: A Stand Against the New Barbarism*, New York City: Random House, 2008.

7. THE GREAT SEDUCTION: HOW TO MAKE NATIONALISM PALATABLE

1. *Independent*, 30 March 1999.

2. BBC News, 24 September 2004.

3. Taylor, *The Scottish Parliament*, p. 173.

4. 'The Salmond Years', Scottish/Grampian Television, 22 February 2001.

5. James Webb, *Born Fighting: How the Scots Irish Shaped America*, New York: Broadway Books, 2004, p. 183.

6. Alex Salmond, 'Stand-alone Scotland could look after itself', *Times*, 20 October 2008.

7. Hamish Macdonnell, Jack's legacy is the loser in the great game of politics', *Scotsman*, 31 December 2008.

8. Douglas Fraser, 'Salmond: set England free', *New Statesman*, 26 March 2007.
9. *Scotsman*, 20 June 2007.
10. Bill Jamieson, 'Big SNP donors to tell Salmond: We need more action', *Scotsman*, 6 February 2009.
11. *Scotland on Sunday*, 27 April 2008.
12. Neill, *Is Scotland Educated?*, p. 39.
13. Information from Professor Richard Finlay.
14. Webb, *Born Fighting*, p. 287.
15. Ascherson, *Stone Voices*, p. 263.
16. Allan Massie, 'Alex Salmond goes anti-tartan barmy', *Sunday Times*, 6 April 2008.
17. *Scotsman*, 25 February 2009.
18. Hamish Macdonnell, 'A tartan bond that goes beyond politics', *Scotsman*, 7 January 2009.
19. Macdonnell, 'A tartan bond'.
20. *Scotsman*, 28 December 2008.
21. Robert Brown MSP, 29 November 2007, debate on St Andrew's day, Scottish Parliament, www. Scottish.Parliament.uk.
22. Anthony Cronin, *No Laughing Matter: The Life and Times of Flann O'Brien*, London: Grafton Books, 1988, p. 184.
23. Simon Heffer, 'The Union of England and Scotland is over', *Daily Telegraph*, 14 November 2007.
24. Frank Field, 'If PM doesn't fly Union flag, the separatists win', *Daily Telegraph*, 14 August 2007.
25. Frank Field, 'The English question holds the key to victory', *Daily Telegraph*, 29 September 2007.
26. BBC 2 July 2006.
27. John Curtice, 'Tony Blair's lasting legacy could be end of the union', *Sunday Telegraph* (London), 26 November 2006.
28. 'Bagehot: Labour's Scottish problem', *The Economist*, 2 December 2006.
29. *Guardian*, 17 February 2009.
30. Lord Sewel, 'The union and devolution—a fair relationship', in Chris Bryant (ed), *Towards a New Constitutional Settlement*, London: Smith Institute, 2007, p. 76.
31. *Daily Telegraph*, 8 May 2006.
32. *The Steel Commission, Moving to Federalism—a New Settlement for Scotland*, Edinburgh: Liberal Democrat Party, 2006, p. 74.
33. *The Steel Commission, Moving to Federalism—a New Settlement for Scotland*, Edinburgh: Liberal Democrat Party, 2006, p. 117.
34. Torrance, *The Scottish Secretaries*, p. 286.
35. Taylor, *The Scottish Parliament*, p. 215.
36. Quoted in Taylor, *The Scottish Parliament*, p. 220.
37. House of Lords, 5 June 2007, col. 1015, 'Public Expenditure: Scotland'.

38. House of Lords, 4 July 2007, col. 1017, Select committee on Economic Affairs.

39. Lord Sewel, 'The union and devolution—a fair relationship', in Chris Bryant (ed), *Towards a New Constitutional Settlement*, London: Smith Institute, 2007, p. 79.

40. Tom Brown and Henry McLeish, *Scotland: The Road Divides*, Edinburgh: Luath Press, 2008, p. 115.

41. *Daily Telegraph*, 7 January 2009.

42. The phrase appears in Charles Moore's column, 'After Glasgow East, it's time to vote on the fate of the Union', *Daily Telegraph*, 26 July 2008.

43. *Daily Telegraph*, 11 December 2007.

44. *Herald*, 12 August 2008.

45. *Sunday Times*, 15 March 2009.

46. Clements *et al*, *Restless Nation*, p. 54.

47. *Scotland on Sunday*, 9 November 2008.

48. Tom Gordon, 'White Hot Alex', *Sunday Times*, 19 August 2007.

49. Kenny Farquharson, 'How bad was she'? *Scotland on Sunday*, 29 June 2008.

50. Editorial, *The Scotsman*, 22 June 2007.

51. Donald Dewar Memorial Lecture, 2003,www.nls.uk/events/donald_dewar_ledtures_2003_steel/index.html.

52. *The Steel Commission, Moving to Federalism—a New Settlement for Scotland*, Edinburgh: Liberal Democrat Party, 2006.

53. Eberhard Bort, 'Annals of the Parish: The Year at Holyrood, 2007-8', *Scottish Affairs*, No. 65, Autumn 2008, p. 6.

54. Kenny Farquharson, 'How bad was she'? *Scotland on Sunday*, 29 June 2008.

55. Tom Gordon, 'White Hot Alex', *Sunday Times*, 19 August 2007.

56. *The Herald*, 17 March 2008.

57. Murray Pittock, *The Road To Independence: Scotland Since the Sixties*, London: Reaktion Books, 2008, p. 36.

58. Neill, *Is Scotland Educated?*, pp. 141-57.

59. Arnold Kemp, *The Hollow Drum: Scotland Since the War*, Edinburgh: Mainstream 1993, p. 209.

60. Bort, 'Annals... 2007-8', p. 26.

61. Jack McConnell, 'Modernising the Modernisers', in George Kerevan, 'From 'Old' to 'New' SNP', in *A Different Future*, edited by Gerry Hassan and Chris Warhurst, Glasgow: Centre for Scottish Public Policy, 1999, p. 70.

62. *Daily Mail*, 20 May 2009.

63. Letter to the Editor, *Herald*, (Glasgow), 20 May 2009.

64. Ben Macintyre, 'Michael Martin: a Speaker as subtle as his nickname, "Gorbals Mick"', *Times*, 19 May 2009.

65. Joyce McMillan, 'Britishness after Devolution', in George Kerevan, 'From 'Old' to 'New' SNP', in *A Different Future*, edited by Gerry Hassan and

Chris Warhurst, Glasgow: Centre for Scottish Public Policy, 1999, p. 291–2.

66. His speech to the Edinburgh Ecumenical Society on 22 January 2009 included the by now obligatory reference to 'weaving the tartan'.

67. Robin Harris, 'Unto the Breach', in Alan Taylor (ed), *What A State!: Is Devolution for Scotland the End of Britain?* London: Harper Collins, 2000, pp. 20–21.

68. Colin Hay and Gerry Stoker, 'Who's failing Whom? Politics, Politicians, the Public and the Sources of Political Disaffection', in *Failing Politics? A Response to The Governance of Britain Green Paper*, London: Political Studies Association 2007, p. 4.

69. These elements of the Creed are paraphrased by Samuel Huntington in *American Politics: the Promise of Disharmony*, Cambridge, Mass.,: the Belknap Press/Harvard University Press, 1981, p. 22.

70. Huntington, *American Politics* p. 25.

71. Kenan Malik, 'the blankness of being british', *Bergens Tidende* (Norway), 30 September 2007, www.kenanmalik.com.

72. *Daily Mail*, 14 January 2008.

73. *Scotsman*, 10 October 2008.

74. Lord Sewel, 'The union and devolution—a fair relationship', in Chris Bryant (ed), *Towards a New Constitutional Settlement*, London: Smith Institute, 2007, p. 75.

75. *Scotsman*, 15 August 2007.

76. Christopher Harvie, *Scotland and Nationalism*, London: Routledge, 1999, 3rd ed., p. 246.

77. Christine Grahame, *Scottish Catholic Observer*, 17 October 2008.

78. Philip Ziegler, Wilson: *The Authorised Life of Lord Wilson of Rievault*, London: Wiedenefeld and Nicholson, 1993, p. 452.

79. Hamish Macdonnell, *Scotsman*, 15 October 2008.

80. *Scotsman*, 20 October 2008.

81. Tom Peterkin, 'Salmond uses Burns in Obama offensive', *Scotsman*, 18 January 2009.

82. 'Catalunya bans Holocaust commemoration', Harry's Place, 24 January 2009, www.hurryupharry.org.

83. *Herald*, 5 March 2008.

84. Gordon Brown and Douglas Alexander, *New Scotland, New Britain*, London: Smith Institute, 1999, p. 29.

85. Neal Ascherson, *Stone Voices, the Search for Scotland*, London: Verso, 2002, p. 162.

86. Scotsman, 9 July 2009.

87. Kenneth Roy, 'Seagulls over Kilmarnock', Scottish Review, 2 July 2009.

88. Scotsman, 10 July 2009.

89. Tim Luckhurst, 'Scotland: more cosy than brave', Independent, 19 December 2000.

90. Herald, 11 May 2006.

8. PREPARING FOR SEPARATION IN A COLD CLIMATE

1. Bill Jamieson, 'Big SNP donors to tell Salmond: We need more action', *Scotsman*, 6 February 2009.
2. Rob Brown 'Scotland the Broke', *New Statesman*, 27 November 2008.
3. Andrew Bolger, 'Crisis at the top darkens the picture', *Financial Times*, 31 October 2008.
4. Dominic Lawson, 'Economics will decide the fate of the union', *Independent*, 3 April 2007.
5. *Daily Mail*, 12 February 2009.
6. Cahal Milmo, 'The man who lost £28bn of RBS cash', Independent, 20 January 2009.
7. P.J.O'Rourke, 'Adam Smith gets the last laugh', *Financial Times*, 11 February 2009.
8. *The Times*, 21 August 2008.
9. Ibid.
10. Ian McWhirter, 'Salmond should be wary of the banks...and Thatcherism', *Sunday Herald*, 24 August 2008.
11. BBC News, 4 February 2008.
12. Ian McWhirter, 'Salmond should be wary of the banks...and Thatcherism', *Sunday Herald*, 24 August 2008.
13. *Scotsman*, 20 January 2009.
14. *Scotland on Sunday*, 18 October 2008.
15. *Aberdeen Press and Journal*, 25 September 2008.
16. *Financial Times*, 31 October 2008; *Daily Mail*, 28 February 2009.
17. *The Scotsman*, 13 November 2008.
18. Bill Jamieson, *Scotsman*, 14 October 2008.
19. 'The Brown Bounce' *Financial Times*, 8 November 2008.
20. *Sunday Times*, 12 October 2008.
21. Jenny Hjul, 'Financial meltdown leaves Nationalist vision in tatters', *Sunday Times*, 12 October 2008.
22. Alex Salmond, 'Stand-alone Scotland could look after itself', *Times*, 20 October 2008.
23. Hamish Macdonnell, 'A global downturn will not kill off nationalism', *Scotsman*, 21 October 2008.
24. George Kerevan, 'From 'Old' to 'New' SNP', in *A Different Future*, edited by Gerry Hassan and Chris Warhurst, Glasgow: Centre for Scottish Public Policy, 1999, p. 61.
25. Hamish McRae, 'The Irish can thrive, why can't the Scots?' *Independent*, 11 April 2007.
26. H.E.Joshi and R.E.Wright, 'Starting Life in Scotland', in Diane Coyle, Wendy Alexander, Brian Ashcroft (editors), *New Wealth for Old Nations: Scotland's Economic Prospects*, Princeton and Oxford: Princeton University Press 2005, p. 167.
27. Hamish Macdonnell, 'Rattled Salmond comes out fighting', *Scotsman*, 20 October 2008.

28. Kerevan, 'From 'Old' to 'New' SNP', p. 63.
29. Bill Jamieson, 'The Celtic Lion and the Celtic Tiger are two different beasts', *The Scotsman*, 15 February 2008.
30. Iain Dale, 'Extended interviw with Alex Salmond', *Total Politics*, September 2008.
31. Angus Macleod, 'Alex Salmond "screeches into reverse" over Margaret Thatcher gaffe', *Times*, 22 August 2008.
32. Douglas Fraser, 'Swinney attacked on all sides in leadership race', Sunday Herald, 21 September 2003.
33. Gerry Hassan, 'Thatcher's shadow falls over Alex Salmond', Open Democracy, 26 August 2008.
34. Iain Dale's Diary, www.iaindale.blogspot.com, 23 August 2008.
35. Gerry Hassan, 'Thatcher's shadow falls over Alex Salmond', Open Democracy, 26 August 2008.
36. Rob Brown 'Scotland the Broke', *New Statesman*, 27 November 2008.
37. John Curtice, 'How Labour found ominous chinks in the SNP's armour', *Scotsman*, 8 November 2008.
38. 'The Fall-out', 7 November 2008, http://macNumpty.blogspot.com.
39. Hamish Macdonnell, 'Sillars condemns leader's "one-man band"', *Scotsman*, 8 November 2008.
40. *Scotsman*, 21 October 2008.
41. *Scotsman*, 31 October 2008.
42. *Scotsman*, 17 November 2008.
43. *Financial Times*, 14–15 February 2009.
44. Bill Jamieson, 'HBOS: why there is an alternative to the Lloyds TSB takeover', *Scotsman*, 17 November 2008.
45. Paul Hutcheon, 'Salmond and his economic advisers at odds over bank bonuses', *Sunday Herald*, 22 February 2009; Iain Martin, 'Former RBS chief: "I don't believe in the sorry bit"', *Daily Telegraph*, 23 February 2009 (electronic edition).
46. *Financial Times*, 31 October 2008.
47. *Scotsman*, 31 October 2008.
48. Leah Lenman, 'Serious lMoney', *The Story of Scotland*, No. 36, Glasgow: Maxwell Publishing, 1988, p. 991.
49. 'Scottish Futures Trust', News Release, Scottish Government, 20 May 2008, www.scotland.gov.uk/News/Releases/2008/05/20101113.
50. Patrick Sookhdeo, *Faith, Power and Territory: A Handbook of British Islam*, McLean, VA, USA: Isaac Publishing, 2008, pp. 54–55.
51. The *Scotsman* on 30 September and 11 October 2008 previewed the visit and in early 2009, plans for a visit in February of that year were circulating around Holyrood.
52. *Scotsman*, 8 December 2008.
53. *Qatar: Country Report on Human Rights Protection, 2003*, Washington DC: US State Dept., 2004.
54. First Minister's Question Time, Scottish Parliament, 18 December 2008. www.scottish.parliament.uk.

55. *Scotsman*, 24 November 2008; *Daily Telegraph*, 10 October 2008.
56. Bill Jamieson, 'Big SNP donors to tell Salmond: We need more action', *Scotsman*, 6 February 2009.
57. *Sunday Times*, 18 January 2009.
58. Fringe meeting at SNP conference 18 October 2008.
59. Jenny Hjul, 'The tinkering SNP is in government, not in power', *Sunday Times*, 30 November 2008.
60. *Independent*, 24 November 1999.
61. Jeffry H. Morrison, *John Witherspoon and the Founding of the American Republic*, Notre Dame, Indiana: University of Notre Dame Press, 2005.
62. Anthony Browne, 'The Great Betrayal', *Daily Mail*, 15 October 2007.
63. *Irish Times* (Dublin), 16 July 2008.
64. Mark Mardell', 'Get Ganley', www.bbc.co.uk/blogs/thereporters/Mark-Mardell, 10 October 2008.
65. For his ideas, see Declan Ganley, EU must take road back to democratic accountability', *Irish Times*, 16 June 2008.
66. Mardell', 'Get Ganley'.
67. Alan Cochrane, 'The euro isn't the answer to Alex Salmond's prayers', *Daily Telegraph*, 7 January 2009.
68. Jeff Randall, 'Staying out of the euro has spared us a Spanish-style catastrophe', *Daily Telegraph*, 9 January 2009.
69. Mitchell, *Strategies for Self-Government*, p. 213.
70. Mandy Rhodes, 'Beyond Politics' *Holyrood*, 24 January 2008.
71. Isobel Lindsay, 'The SNP and the Lure of Europe', in Tom Gallagher (ed), *Nationalism in the Nineties*, Edinburgh: Polygon, 1991, pp. 87–88.
72. Jonathan Freedland, *Bring Home the Revolution: How Britain Can Live the American Dream*, London: Fourth Estate, 1998, pp. 17–27.
73. Quoted in Alan Taylor (ed), *What A State!: Is Devolution for Scotland the End of Britain?* London: Harper Collins, 2000.
74. *Metro*, 22 December 2008.
75. *The Scotsman*, 6 December 2008.
76. See the Scotland edition of *The Sunday Times*, 11 January 2009.
77. Scotland edition of *The Sunday Times*, 11 January 2009.
78. Paul Vallely, 'Prickly prelate who will brook no dissent', *Independent*, 28 October 1996.
79. Allan Massie, 'Salmond's triumph brings a whiff of Gaullism', *Independent*, 26 July 2008.
80. Euripides, The Bacchae, tr. Philip Vellacott, London: Penguin, 1954, p. 200, quoted in John Ralston Saul, *Reflections of a Siamese Twin: Canada at the End of the Twentieth-Century*, Toronto: penguin, 1998.

9. DANCING THE PATRIOTIC JIG IN A BROKEN SOCIETY

1. Alex Salmond, 'Stand-alone Scotland could look after itself', *Times*, 20 October 2008.

2. 'Scots are happiest people in UK', *the Herald*, 14 August 2008.
3. Maxwell, 'A poor response', p. 87.
4. *The Herald*, 22 July 2000.
5. These views summarise ones to be found in Carol Craig, Towards a Confident Scotland, www.carolcraig.co.uk/conferencecraig.htm; see also her path-breaking book, *The Scots Crisis of Confidence*, Big Thinking, Scotland 2005.
6. Gillian Bowditch, 'One man's war on the underclass', *Sunday Times*, 15 March 2009.
7. *The Herald*, 5 January 2008.
8. SeeTheodore Dalrymple, 'Childhood's End', *City Journal*, Summer 2008.
9. J.J.Heckman and D.V.Masterov, 'Skills Policies for Scotland', in Diane Coyle, Wendy Alexander, Brian Ashcroft (editors), *New Wealth for Old Nations: Scotland's Economic Prospects*, Princeton and Oxford: Princeton University Press 2005, p. 30.
10. Peter Ross, 'in the shadow of the blade', *Scotland on Sunday*, 20 July 2008.
11. *Independent*, 29 November 2003.
12. Peter Ross, 'in the shadow of the blade', *Scotland on Sunday*, 20 July 2008.
13. Mark Macaskill and Julia Belgutay', 'Scotland's murder rate soars',|*Sunday Times*, 15 February 2009.
14. *Independent*, 29 November 2003.
15. Auslan Cramb, 'Iraq safer than Edinburgh, say stabbed soldiers', *Daily Telegraph*, 4 August 2008.
16. Mark Macaskill, 'Peter Gill: "Glasgow scarier than Third World"', *The Times*, 14 December 2008.
17. David Maddox, 'What do we do with those youngsters who just won't play ball', *The Scotsman*, 18 November 2008.
18. Russell Findlay, 'The Enforcer: Pen Pushers have sabotaged the war on crime lords', *Sunday Mail*, 5 October 2008.
19. Glaeser, 'Four Challenges for Scotland's Cities', p. 88.
20. Margo MacDonald, 'Forget the stats: we're not thugs', *Edinburgh Evening News*, 16 April 2008.
21. Letter to the editor, The Herald, 23 August 2008.
22. Anna Mikhailova, 'Britons drink more heavily than Russians', *Sunday Times*, 2 March 2008.
23. the *Times*, 26 September 2007.
24. Brian Monteith, 'A view from inside: the failure of devolution', in Bill Jamieson (ed), *Scotland's Ten Tomorrows*, London: Continuum, 2006, p. 144.
25. Theodore Dalrymple, 'Childhood's End', *City Journal*, Summer 2008.
26. Kenny MacAskill, *Building A Nation: Post Devolution Nationalism in Scotland*, Edinburgh: Luath Press, 2004, pp. 68–69.
27. *Scotsman*, 11 May 2009.
28. *Mail on Sunday*, 10 May 2009.

29. *Daily Mail*, 13 May 2009.
30. Jack McConnell, 'Modernising the Modernisers', in George Kerevan, 'From 'Old' to 'New' SNP', in *A Different Future*, edited by Gerry Hassan and Chrs Warhurst, Glasgow: Centre for Scottish Public Policy, 1999, p. 68.
31. George Kerevan 'Devolution: a deepening economic policy failure', in Bill Jamieson (ed), *Scotland's Ten Tomorows*, London: Continuum, 2006, p. 54.
32. Fraser Nelson, 'A tale of three Scotlands', Bill Jamieson (ed), *Scotland's Ten Tomorrows*, London: Continuum, 2006, pp. 170–72.
33. Patrick Wintour, *the Guardian*, 15 December 2004.
34. Jamieson, 'Introduction', p. 9.
35. Jill Kirby, The price of Parenthood, Centre for Policy Studies, 2005, www.cps.org.uk/pdf/pub/396.pdf.
36. Andrew Anthony, 'The Second Coming of Iain Duncan Smith', *Observer*, 29 June 2008.
37. David Marshall, 'Green cars go east', *The Story of Scotland*, No. 15, Glasgow: Maxell Publishing, 1988, p. 395.
38. Harvie, *No Gods and Precious Few Heroes*, p. 106.
39. Bernard Donoughue, *Downing Street Diary: With Harold Wilson in No. 10*, London: Pimlico. 2006, p. 360.
40. Bromley and McCrone, 'A Nation of Regions?' p. 184.
41. Nelson, 'A tale of three Scotlands', p. 179.
42. *Guardian*, 21 January 2006.
43. Brian Currie', 'Racist and Colonialist', *Evening Times* (Glasgow), 11 September 2008.
44. Caroline Wilson, 'Hanif's silence over flat in "Ground Zero"', *Evening Times*, 7 August 2008.
45. *Daily Record*, 11 July 2008.
46. Iain Duncan Smith, 'Living and dying, on welfare in Glasgow east', *Daily Telegraph*, 13 July 2008.
47. Ibid.
48. John Harmon McElroy, *Finding Freedom: America's Distinctive Cultural Formation*, Carbondale and Edwardsville: Southern Illinois University Press, 1989, p. 39.
49. McElroy, *Finding Freedom*, p. 41.
50. Ascherson, *Stone Voices*, p. 157.
51. 'Killers freed on death anniversary', BBC News, 23 November 1999.
52. One of the most helpful academic studies of Scottish attitudes to the English is Isobel Lindsay's, 'The Use and Abuses of National Stereotypes', *Scottish Affairs*, No. 20, Summer 1997, pp. 133–48.
53. Quoted in Lindsay, 'The Use and Abuses...', p. 137.
54. Tom Brown and Henry McLeish, *Scotland: The Road Divides*, Edinburgh: Luath Press, 2008, p. 75.
55. Brian Donnelly, 'Huge rise in Scots with racist prejudices', *The Herald*, 12 December 2007.

56. *Scotland on Sunday*, 17 February 2008.
57. MacAskill, *Building A Nation*, p. 76.
58. ICM poll.
59. *Daily Telegraph*, 25 August 2008.
60. Ibid.
61. Tim Luckhurst, 'Scotland must stop feeling itself a victim of English oppression', *The Independent*, 26 February 2002.
62. Donald Dewar Memorial Lecture, 2003,www.nls.uk/events/donald_dewar_lectures_2003_steel/index.html
63. *Daily Mail*, 13 February 2008.
64. *Scotland on Sunday*, 21 June 2009.
65. Jason Allardyce, 'The Dream That Fell to Earth', *Sunday Times*, 19 April 2009.
66. Allardyce, 'The Dream That Fell to Earth'.
67. *Sunday Times*, 28 December 2008.
68. Eric Linklater, *The Lion and the Unicorn*, London: Routledge, 1935, p. 83.
69. Russell Kirk, *America's British Culture*, New Brunswick, New Jersey: Transaction Publishers, 1994, p. 11.
70. Eddie Barnes, 'Crackdown on addicts "blocked by SNP"', *Scotland on Sunday*, 25 January 2009.
71. Hugh Reilly, 'No more of this abject surrender to thuggery in schools', *Scotsman*, 4 February 2009.
72. Hamish Macdonnell, 'Knife thugs will roam free under government plan', *Scotsman*, 23 January 2009.
73. Tom Gordon, '£14 million: the cost of health board elections to patients', *Sunday Herald*, (Glasgow), 28 October 2008.
74. Minutes of East Renfrewshire cabinet, 18 December 2008, East Renfrewshire Council.
75. Jonathan Paisley, 'Racist vandals attack hall leased by Muslims', *Evening Times*, 10 February 2009.

CONCLUSION

1. Jenny Hjul, 'The tinkering SNP is in government, not in power', *Sunday Times*, 30 November 2008.
2. Foster, 'The Twentieth Century', p. 457.
3. Kenny MacAskill, *Building A Nation: Post Devolution Nationalism in Scotland*, Edinburgh: Luath Press, 2004, p. 16.
4. BBC, *The Politics Show*, 12 October 2008, 'Alex Salmond interview transcript', http://news.bbc.co.uk/1/hi/programmes/politics_show/7655519.stm.
5. *Sunday Times*, 15 March 2009.
6. *Guardian*, 13 March 2009.
7. Rob Brown 'Scotland the Broke', *New Statesman*, 27 November 2008.

8. Angus Macleod, 'A question of self-belief lays bare divisions within the SNP', *The Times*, 2 December 2005.

9. See Tartan Week, the website of those Scoto-Americans helping to organise his visit, www. Tartanweek.com.

10. See Murray Pittock, *Jacobitism*, Basingstoke:Macmillan 1997.

11. 'Flag in the Wind', *Scots Independent*, [electronic version] no. 459, 20 March 2009, quoted in 'Mark Hirst no stranger to controversy', 'The Grumpy Spindoctor', 24 March 2009, http://grumpyspindoctor. Blogspot.com.

12. *Daily Record*, 21 January 2006.

13. *Scotsman*, 29 September 2008.

14. *Sunday Times*, 14 April 2009.

15. David Maddox, 'First Minister branded an "international flop" over nuclear arms', *Scotsman*, 5 August 2008.

16. See Kenan Malik, *From Fatwa to Jihad: The Rushdie Affair and its Legacy*, London: Atlantic Books, 2009, pp. 65–71.

17. Sukant Chandan, 'Terror Alert', *Al-Ahram International*, (Cairo) 12–18 July 2007.

18. See Paul Sikander, 'On Islamophobia', *Butterflies and Wheels*, 16 December 2008, www.butterfliesandwheels.com/articleprint.php?num=323.

19. Ex-religious radicals in the Quilliam Foundation urged Alex Salmond to re-assess the SNP's close ties with Islamists on the day Osama Saeed was endorsed as a parliamentary candidate. See 'Quilliam Alert', 17 April 2009, www.QuilliamFoundation.org.

20. Quoted in Russell Kirk, *Eliot and His Age: T.S. Eliot's Moral Imagination in the Twentieth Century*, Peru, Illinois: Shewood, Sugden & company, 1988 ed. p. 390.

21. See Matthew Parris, 'As an atheist, I truly believe Africa needs God', *Times*, 27 December 2008.

INDEX

post-1999: achievements 107-8,
114, Barnett formula 126, 156-8,
bureaucracy 97, 119-20, coalition
104-5, criminal justice 111, 200,
dependency culture 191, 201-2,
economic biases 101-2, favoured
groups 100-1, funding system
122, 155-7, 161-2, greater
powers blocked 113, legislation
104, 107-8, local finance 184,
opinion and 125, planning
process 123-4, 179, predictions
117, public services 201, 209,
referendum plan 162, reserved
powers 89, 98, 111-12, sectarian
curbs 106-7, SNP centralisers
185, social policy 200-1, spend-
ing soars 191-2, state predomin-
ance 101-2, 191-2, Welsh
contrast 119
Dewar, Donald 70, 75, 78, 88-9,
92, 96-7, 102, 130
Diana, Princess of Wales 169
Dollan, Sir Patrick 42, 49, 218
Don MSP, Nigel 186
Donaldson, Arthur 151
Douglas Home, Sir Alec 71
drug problem 122, 196-7, 198, 211
Duncan, Alan 153-4
Duncan, rev Henry 30
Duncan Smith, Iain 95, 201, 203
Dundas, Henry 22-3
Dundee 159, 160
Dunnet, Alistair 206

economic conditions: commercial
take-off 19, demography and 19,
downturn (1980s) 76, energy
crisis 126-7, flawed strategy
(1980s) 79, independence case
65-7, industrial decline (1945-79)
53-4, 58, 60, 62, 218, inter-war
crisis 39-42, neglect 62, oil issue
65-7, 79, 155, 174, outlook
(2008) 184, planning 61, role of

empire 19, 59, Scottish Enterprise
102, state role 54, 74, 79, 191-2,
218, union benefits 19
Edinburgh: architecture 32-3,
Festival 57, financial sector 4, 30,
124, 177, Glasgow and 36,
intellectuals 20, political mood
(2009) 159, resist change (1960s)
57, safety 198
education: Catholic role 136, ethnic
tension 206, gay issues 98-9, high
literacy 22, Islamic schools 140,
212, quality drops 209, school
behaviour 199, 211, traditions
17-18, 22
Edward I, King 14, 48, 203
Edwards, Owen Dudley 9, 47
Elger, Willie 49
Eliot, T.S. 228
Elizabeth II, Queen 32, 51
Elliot, Sir Walter 52
Elvidge, Sir John 119
emigration 6, 23-4, 30, 41, 55,
217-8
England: anglophobia 205-7, 222,
attracts restless Scots 57,
backlash on devolution 153-5,
complaints about Scots 153-5,
decentralised union 17-18,
English Question 153-5, griev-
ances 3, identity 1, 21-2, impor-
tance 1, magnet for intellectuals
47-8, North-East vote 215,
progressive traits 26, resistance to
devolution (1970s) 68, 70-1,
Scotophobia 158-9, Scots
influence culture/media 22, 47-8,
union occurs 16-17
English in Scotland 206-7
Enlightenment, Scottish 20-2, 221
environment 123-4, 126-7
European Union: autocratic 189-90,
Britain joins 59, currency and
Scotland 189, elite traits 188,
fishing issue 104, 'Independence

INDEX

203-5, 209, 211, splits 76, 117, 194, sport and 207-8, symbols and 8, 152, trans-class 114, 118, 123, 125, 132, Union scorned 221-, victory (2007) 114, 117-18, vision for Scotland 133, 190, 205, 212-13, 218-19, youth appeal 59

Scottish nationalism: America and 150-1, 223, anglophobia and 61, 205-7, 222, 230, capitalists oppose 48, Celtic preoccupations 45, civic claims 133, 225-6, driven by economics 65, intellectuals and 43, 45, 211, inter-war ideas 44, Ireland and 43-4, 176, 178-9, 219, Labour discards 95-6, left criticisms 42. 45, looks abroad 24, 151, 221, marginalized 40, popular culture and 14, 211, religion and 4, 139-45, Scottish Covenant 50, Unionist version 15-16, 32, 33-4, 231, utopianism 223, Victorian flickers 31-3, 34-5, youth and 95

Sentanu, Archbishop John 168
Shakoor, Amar 144
Sewel, Lord 88-9, 154, 156-7, 168
Sheridan, Tommy 77, 104
Sillars, Jim 65, 75-6, 83-4, 87, 93, 121-2, 128, 180, 181, 189-90, 199
Sinclair, Sir John 25
Smart, Ian 18, 221
Smellie, William 47
Smiles, Samuel 32
Smith, Adam 18, 221
Smith, Joan 130
Smith, John 69-70, 75, 86, 106, 112
Smout, T.C. 41
society: abortion 98, adoptions 58, alcohol 197, 199, clash of values 98-9, 110, consumerism 219-20, 228-9, disempowered 5, 7, 23,

24, 28, 60, drugs 122, 198, fathers 201, girls 199, harsh conditions 24, 27, 28, 30-1, illegitimacy 31, literacy 31, orphans 197, pathologies 196-8, prison policy 200, regional splits 14-15, 28, restive 4, SNP disconnected from 220-1, social crisis (C21) 196-201, 228-9, social mobility 59, state control over 24, 60, teenage mothers 196, unemployment 41, 54, 199, urban malaise 7, 197-9, 203, welfare and 201, 203, work 205

Soutar, Brian 98, 99
Spain 158, 189
Steel, David 97, 109, 161, 209
Stephen, Nichol 121
Stewart, Rod 123
Stevenson, R.L. 47-8
Stoker, Gerry 167
Storrar, Rev William 129
Stuart, James (Tory politician) 53
Sturgeon, Nicola 117, 121, 161, 163, 170, 190, 191, 192, 193, 204
Sweden 135
Swinney, John 111, 117, 124, 183, 192

Taylor, Brian (journalist) 75, 92, 100, 105, 148
Taylor, Matthew 94
Taylor MP, Teddy 74, 125
television 4, 134, 171-2
Thatcher, Margaret 2, 73, 79-82, 85, 131, 159, 179-80, 199
Thomson, George Malcolm 48
trade-unions 28, 36, 41, 49, 53, 60, 92
Toothill, Sir John 61
Tocqueville, Alexis de 210-11
Trotskyites 76, 111, 128
Trump, Donald 123-4, 153, 179
Tyler, Wat 26